1000 Nudes
Uwe Scheid Collection

1000 Nudes
Uwe Scheid Collection

Text by Michael Koetzle

Benedikt Taschen

Contents
Inhalt
Sommaire

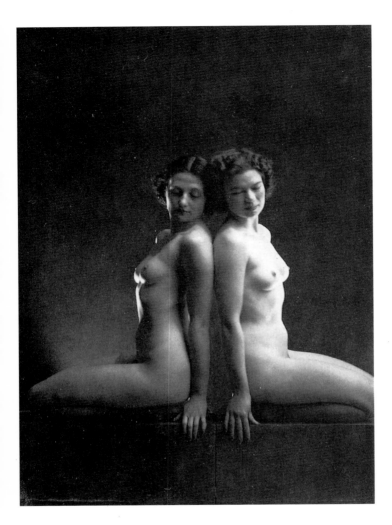

Anonymous
1939

1000 Nudes

Commentary on the artistic and social evolution of photographic representations of the human body from 1839 to 1939

The discovery of photography during the first third of the nineteenth century was the response of the technological era to the taste for images of a middle class of considerable economic means. Indeed, manual graphic techniques such as drawing, etching and lithography must have seemed outmoded to people living in an age when steam machine energy was being pressed into the service of capitalist production, when mechanical looms were gradually replacing the labour force, and when railroads were on the verge of bring distant regions within reach of one another, thus endowing humanity with new mobility. Above all, such manual and therefore largely subjective forms of representation hardly corresponded with the objective vision of the world and the environment to which the rational positivism of the times aspired.

Strictly speaking, the basic principles of photography had been known for some time. They only had to be combined and the final missing link supplied. The workings of the camera obscura, for example, had been known since ancient times and had also served as an aid to artists interested in achieving more true-to-life perspective in their work since the Renaissance. Similarly, the sensitivity to light of silver salts was a known fact by, at the latest, Johann Heinrich Schulze's (1727) time. What remained lacking up until the end of the eighteenth century was a socially rooted interest in obtaining pictures by mechanical means and a way of making permanent the camera obscura "sun pictures".

Various separate developments took place during the first half of the 19th century: in 1826, the Frenchman Nicéphore Niepce had succeeded in taking a photograph of the view from his workroom window by using bitumen coatings on a copper plate; since 1834, England's Henry Fox Talbot had been successfully experimenting with sensitized paper negatives; and by 1837, Louis Jacques Mandé Daguerre had succeeding in producing the type of photograph which was named after him, the daguerreotype. All such milestones notwithstanding, the official date for the start of photography is con-

sidered to be 1839: August 19th to be exact. On that day, during the height of summer, the Academy of Science and the Academy of Fine Arts met jointly in Paris to debate one last time the process invented by Daguerre and – after the French state purchased the inventor's patent at the price of a life annuity – made the world a gift of that process.

The international reaction to the publication of the technique was as immediate as it was tremendous, proof that Western industrial society had been waiting for just such a technical means of producing pictures. People were enchanted with the way the process brought out every detail of a picture equally, and with "the method's speed" (Arago). More than a few critics were to express disappointment with respect to the lack of colour. On the other hand, what fascinated and finally convinced most people was the mechanical, almost automatic nature of the process. In the words of the art critic Jules Janin (1839): this time it is no longer "man's unstable gaze, distinguishing shadow and light from a distance, no longer his shaky hand that captures on short-lived paper the capricious form of the world...". Here the "miracle" (Janin) takes place more or less on its own.

There was the occasional naive gasp over the first "air pictures", but what is far more surprising, in retrospect, is the farsightedness and imagination characterizing discussions on the young medium at the time. One is amazed by early remarks already taking into consideration the medium's potential range of applications. Jules Janin, for example, foresaw the birth of architectural and landscape photography, although he did not use these terms. He also spoke of the possibility of art reproductions, and referred to portraiture. Dominique Arago, physicist, politician and one of the medium's most outspoken advocates at the time, saw the photograph as a tool of archaeology, astronomy and photometry. Schorn/Kollof, correspondents to the "Morgenblatt für gebildete Stände" (Morning Paper for the Learned), gave consideration to the possibility of doing instantaneous shots. And no less than the widely travelled Alexander von Humboldt reflected on the usefulness of a camera on journeys.

Not a single allusion to nudes is to be found. The concept of linking photography with erotic imagery remained unexpressed, which comes as no surprise in view of the repressive sexual code of ethics

reigning during the nineteenth century. Yet the idea of representing the human body photographically was in the air nonetheless, as an early picture by Daguerre makes quite clear. The 1839 work, entitled "Still Life with Sculptures" and which is a small-scale study of an imitation of the three graces in plaster, definitely can be considered as an hors'd'oeuvre, as a vague and yet to be redeemed erotic promise. In any case, it was but a short step from that daguerreotype of nudes disguised as an art reproduction to the first real-life photographic depictions of the body.

Exactly when a first, presumably female, model actually posed before a camera is not known. Rudolf Brettschneider ("Die Erotik in der Photographie" – Eroticism in Photography –, 1931) mentions the year 1849, while Joseph Maria Eder ("Die Geschichte der Photographie" – The History of Photography – 1932) would have a nude photograph appear in 1844. Other sources allude to a picture of the human body dating 1841. In any case, we can be certain that when the daguerreotype process began to be adopted, the long exposure times required left the achievement of portraits, together with that of the secretly longed for nudes, in the realm of the utopic. For example, after a first visit to Daguerre in February of 1839, Humboldt mentions exposure times lasting 10 minutes. The discoverer of the technique himself declared that he did not need "any more than a brief period of from three to at the most thirty minutes, depending on the season". Even in 1841/42, after the introduction of improved lenses and increasingly sensitive photographic plates, exposure times were rarely less than 30 seconds.

Powder or white makeup was applied to faces. Bodies were forced into tortuous stances and left exposed to the blazing sun for minutes at a time. The pioneers of photography displayed great inventiveness in their efforts to achieve the desired result when taking a portrait. One may safely assume that they also applied their creative talents to nude photographs, which were no doubt just as lucrative, if not more. The latter seem to have first made their appearance in Paris around 1845 at opticians, instrument makers and art dealers, in the form of artistically coloured and finely conceived, palm-sized daguerreotypes. How, one wonders, did the petit bourgeois of the mid-nineteenth century react to the sight of a totally unknown, remote yet altogether real, more or less undressed woman? Were

they fascinated? Irritated? One would expect it came as a shock. Although copper etchings with erotic motifs had already been in existence for some time (with names the likes of Gavelot, Picard, Borel and Elluin, Paris had also played a leading role), there was a fundamental difference between traditional graphic arts and the new medium. "An extraordinarily realistic technique" was Willi Warstat's (1929) description of photography, by which he referred to the almost "fairy-tale" (Janin) effect of a photograph's "pictorial sharpness", "true-to-life detail" and "delicate tonal nuances" (Daguerre) on the medium's early public, especially. But a more far-reaching effect, in fact decisive when it comes to nudes, arose from the phenomenological aspect of the new technique, its link with the object.

While painters could always draw on their mental imagery, photographers were dependent on reality, be it in whatever form. In creating his famous "Maja Unclothed", the Spanish painter Francisco Goya copied – as the British art historian John Berger has rather conclusively proven – from his already painted portrait of the Duchess of Alba, unclothing her garment by garment in the process: first in his imagination and then on canvas.

In contrast to this, those looking upon an erotic daguerreotype image around 1850/60 could be altogether sure that a real nude had posed for the picture. The anonymous beauty pictured unclothed really existed somewhere: a corner prostitute on some boulevard, a dancer in a more or less prominent vaudeville show, a faceless Betty or Sue living in whatever brand-new housing section the city of Paris had just put up. The contemporary viewer therefore found himself slipping into the role of voyeur, as if perched above a skylight, looking down on a lovely, unknown and "real" naked female body. This was the main attraction of early photographs of nudes, giving them a considerable edge over all graphic endeavors, no matter how artistically accomplished. Photos of nudes stirred the viewer's imagination in a particular manner and the authorities into action.

An overview of photographic output in the early days, with respect to known erotic daguerreotypes, mainly of French origin, reveals an impressively wide range of motifs right from the start, as well as a great variety of stagings and stances. In his "Geschichte der erotischen Kunst"(History of Erotic Art, 1928), Eduard Fuchs already

could affirm: not a single erotic motif can be labelled "a new invention". And indeed, even the first daguerreotype artists took recourse to familiar pictorial motifs with which to translate man's most hidden erotic dreams and fantasies. The works ranged from nudes seen altogether decently from the back, in the manner of classical "academy figures", all the way through to brazen displays of genitalia, from love between lesbians to heterosexual coitus. The photographers for the most part chose to remain anonymous; those as dared sign their works risked a fine and imprisonment. In 1851, a lawsuit was brought against the photographer Felix Jacques-Antoine Moulin, who had been working in Paris between 1840 and 1850. The court decision maintained that "a great number of the pictures confiscated" at his studio and his dealer Malacrida's place were so obscene ... that even the enunciation of their titles (...) would represent an offense under the law against the dissemination of lewd literature". Malacrida was sentenced to one year of imprisonment and a fine of 500 francs, "the widow René, responsible for producing the daguerreotypes (...) to two months' imprisonment and a fine of 200 francs. Mr. Jacques Moulin, the author of the daguerreotypes, to one month's imprisonment and a fine of 100 francs."

An estimated 5,000 daguerreotypes had been created – mostly in Paris – by around 1860. Daguerreotypes are direct positives, hence one-of-a-kind, and as such they were quite expensive. A single nude represented an investment of a week's average salary. Therefore photographic erotica at first remained restricted to the upper echelons, to customers in the habit of engaging in intimate dialogue with the sultry pictures at the gentleman's club or in the privacy of their study. To publishers, distributors and consumers, undoubtedly confronted as they were by certain problematic aspects of the question – given a still far from liberal social context in matters sexual – that restriction came as a blessing. Steep prices kept the number of customers within manageable limits; moreover, they attracted a clientele stemming from social classes respected for their moral integrity and ethical stability. It was only when the improved negative/positive process enabled mass editions of reasonably priced prints to hit the market that matters became "problematic" in the pleasure-dampening and prudish Victorian sense. This turn of events put "obscene" representations within reach of those layers of

society whose ethical integrity avowedly left room for doubt. The danger, as for instance Willi Warstat ("Der schöne Akt" – The Lovely Nude) put it as late as in 1929, "of a nude photograph having a sensuous effect, since it depicts a scene so faithfully that an almost total illusion of reality is achieved, is all the greater in such times and with respect to such people as are unaccustomed to the unabashed contemplation of human nudity".

Of course, skeptical remarks of the sort had as little effect on slowing down the triumphant advance of nude photography and erotic depictions of the human body as did any laws or harsher prosecutions in the matter. The latter, however, spurred ever more refined sales outlets and commercial strategies. And although up until well into the twentieth century anything "not offered for purposes of artistic and scientific instruction" remained prohibited, the trade in erotica continued to blossom, and had no trouble defying any and all state intervention. A state of affairs which, moreover, reveals the remarkable degree of schizophrenia, or shall we say hypocrisy, characteristic of the middle class of those early modern times: their discovery of the body as something that lends itself to erotic staging and can thus be merchandized, only to then immediately slap a prohibition on the coveted goods, thus rendering it all the more appealing while, at the same time, thrusting it out of official circulation. Commenting in that connection, Horkheimer/Adorno ("Dialektik der Aufklärung" – The Dialectics of the Enlightenment) noted: "Such a love-hate relationship with the body (...) is characteristic of every new culture. The human body is derided and disowned for being inferior and enslaved, while at the same time desired for being prohibited, objectified, alienated". According to the authors, it is only civilisation which views the body as a thing to be possessed: an "object of attraction and repugnance".

From a technical point of view, it was Henry Fox Talbot (1800–1877) who laid the cornerstone for the popularization of photography and, following on from this, the industrialization of its erotic potential. Both in theory and in practice, negatives affording countless positives was a winning formula. Even if, at the start, Talbot's brown-spotted "calotypes" could hardly measure up to the finely lined, steel-gray and sharply defined daguerreotypes of the day. Even stiffer competition was afforded by the coloured motifs in

stereoscopic daguerreotypes which so enthused the public and even now remain astounding. But steady improvements in the technique from approximately 1840 onwards soon made its basic superiority apparent. In 1847 glass was used for the first time as an emulsion support, while albumen paper, which was long appreciated for its sheen, was put on the market in 1850. And the arrival of the collodion wet-plate process in 1851 at last made available photographic material combining a high level of light-sensitivity with sharp definition. By the middle of the nineteenth century, the main steps had been taken with respect to both the practical aspects of the medium and the ever-widening scope of its subject matter.

In addition to the various chemical/technical improvements, and to the new discoveries and refinements of optical features and the cameras themselves, a whole new array of innovative presentation and distribution forms appeared on the scene. Those novelties did not necessarily contribute to the development of photography as an artistic medium, but they did considerably hasten its popularization, including works featuring nudes. From around 1850, stereoscopic photographs, whether daguerreotypes or paper prints, enjoyed great popularity. The "carte-de-visite" format (5,7 x 9 cm) introduced in 1853 by the Frenchman Adolphe-Eugène Disdéri revolutionized the practice, indebted to photography in the first place, of speedily produced and reasonably priced portraits. And as of the 1870s, the picture postcard – in no time a popular collector's item – could be added to the list. In France alone, between 1919 and 1939, statistics have it that over 20 million nude postcards were produced. Nor can we fail to mention the advent of halftone (c. 1880), which for the first time allowed photographs to be reproduced (screened and printed) without detouring via woodcuts. Since then the spread of nude photography has taken place for the most part in the form of printed reproductions: be it in books on the topic, in advertisements and publicity campaigns seeking – since the sixties – to reinforce their message with ever stronger erotic overtones, or in specialized magazines showing vivaciously frivolous pin-ups who have less to fear from state censorship than from the competition afforded by today's electronic picture media.

The earliest nude photographers – Belloc, Berthier, Braquehais, Olivier and Vallou de Villeneuve – were painters or lithographers

who turned to photography because of the lack of demand for painted (portrait) miniatures or, in Delacroix's case, because the new pictorial medium held such fascination. Their nude studies ally the joys of experimentation with a feeling marked for pictorial effects, for natural poses and decors, for composition and lighting, which was also based on an intellectual interest. The ingenuous charm and dainty elegance of a series of photographs produced jointly by Delacroix and Durieu in 1853 still come through over 100 years later. Second generation photographers had of course grown up with the medium: they were interested not so much in its pictorial possibilities as in its economic potential. The so-called age of publicity and the subsequently widely decried artistic decline, the standardization of various formats, stagings and poses, all combined to turn what once belonged in the realm of exclusivity into an event addressing the public at large. Photography took an upturn as a mass phenomenon, both with respect to portraits and to nudes. A police report from the 1850s records that exactly 60 photographs had been seized. Ten years later, thousands of stereo cards had been confiscated. And in 1875 over 130,000 photographs with "lewd" motifs, as well as 5,000 negatives, are said to have fallen into the hands of the London police. The more professional the medium became, the more erotic views came on the market.

The history of nude photography is the history of people's fascination with the topic. Indeed, the photographic depiction of the human body is the only subject that has enthralled photographers, theoreticians and consumers over such a long period – more than 150 years. No other motif is as prevalent as this one during all the phases of development comprising the history of photography, no other is present, whatever the technique, and is a subject of discussion within the context of nearly all aesthetic movements. Nor has any other pictorial topic produced such a variety of specialities as the nude: from the ethnological interpretation of the body to the glamour shot, from nudist photography to the pin-up of today. No other photographic field of application has inspired as much desire as it has awakened official wrath. Nude photography reflects the schizoid relationship that Western culture harbours with respect to the body.

In the early 1930s, in the tracks of the gradually emerging science of

sexology, a first serious attempt was made to come to terms intellectually with the topic of nude photography. In 1931 a work appeared that has continued to serve as reference up until our times: "Die Erotik in der Photographie. Die geschichtliche Entwicklung des Aktphotos und des erotischen Lichtbildes und seine Beziehung zur Psychopathia sexualis" (Eroticism in Photography. The Historical Development of Nudes and Erotic Motifs in Photography in Connection with 'psychopathia sexualis'), edited by, among others, Erich Stenger of the Wiener Verlag für Kulturforschung (Vienna Cultural Research Publications). The Hitler years, World War II and the blatantly priggish postwar era put a temporary close to fruitful endeavors of the sort. It was not until the 1980s that more deeply scientific and publicity-oriented studies were again carried out with respect to the "seamy side of bourgeois consciousness" (Christoph Stölzl). For the first time since the thirties, that renewed interest once again situated nude photography in its full context both culturally and historically, encompassing the many commonplace forms of presentation and distribution, nudist and sport photography, and the photography of male nudes, which, reflecting as it does homosexual aesthetic tastes with respect to art and the human body, has been surrounded by taboo for decades.

The basic idea involved in all the exhibitions and printed matter on the subject was that of categorising the boundless production of photographic representations of the body over a period of 150 years. The various social roles which nude photography had been called upon to play served as basis for delimiting what came down to five main realms of endeavour: artistic nudes, erotic to pornographic interpretations of the body, works to do with science and those to do with sports (including nudism, dance and bodybuilding). It goes without saying that the boundaries between such categories are blurred and their contents tend to overlap. Thus the scientifically intended ethnographic nudes of the nineteenth and early twentieth centuries definitely had the wherewithal to satisfy erotic criteria as well. Today, the reverse is likely to be true – we are altogether prepared to bestow the seal of artistic approval on certain erotic pictorial inventions, past or present. Furthermore, studies in movement that fall somewhere between the realms of science and sport (cf. from Muybridge to Marey) now tend to be discussed within the fine

arts context. Admittedly, classification into categories is often problematic, subject, as it is, to the vagaries of cultural change. Nonetheless, certain core criteria do exist to define boundaries and thus enable serious discourse in the style of the author Stölzl's "Archäologie der Moral im bürgerlichen und postbürgerlichen Zeitalter" (An Archaeology of Morality in Bourgeois and Post-Bourgeois Times). Otto Steinert wrote: "Pictorial representation of the naked human body has been a concern of many important cultural eras. Classical antiquity elevated man to make of him the measure of his environment, using him as the dominant topic of all pictorial endeavors: the portrayal of human beauty represents the crowning artistic experience of that era. The body with which man has been endowed by nature is ennobled, divested of its individuality in order to conform with established standards of perfection, to achieve the effect of regularity through proportion and harmony, creating ideal human figures that even today considerably influence our pictorial consciousness" (cf. "Akt International" – International Nudes – 1954). He further elaborated with respect to photography: "In recognition of the great danger photographic nudes represent, formal elements are kept to a bare minimum. Nudes are reduced to their characteristic basic forms, making them into totally depersonalised symbols of the female body, until it represents nothing more than the pictorial composition's material subject, one of its elements. The cropped figures, forgoing representation of the model's head and facial expression in the manner of modern sculpture's torso motifs, distance these photographs still further from any personal and erotic realms of representation."

The Steinert quotation is, primarily, an expression of the aversion to carnal pleasures characterizing the fifties. It does, however, lead to a somewhat serviceable definition of various artistic endeavors in the field of nude photography, in addition to what we have come to recognize as "subjective photography". If a titillating photograph seeks to lend wings to erotic fantasy by resorting to a whole panoply of strategies, a nude photograph conceived in an artistic vein strives, by "the elimination of erotic/carnal effects" (Warstat), to elevate the human body, in line with classical ideals. Elaborating on the theme, Michael Köhler writes that "while the artistic study dictates complete nudity ... the essence of erotic photography lies in the

charm of the strategically veiled". Shoes and stockings, veils and garter belts, feather and fans therefore number among the indispensable props of the erotic. Settings and props moreover enhance the overall effect, turning the erotic photo into a cheap and portable alternative to peering through the keyhole into the boudoir, and one which is always available. Distance is what defines the artistic nude, closeness defines the erotic photo, as well as, of course, the encouraging smile and a come-hither flash of the eyes. Nudes aspiring to artistic status seek to comply with the law of "less is more", whereas the erotic photo is characterized by "the more the merrier". Artistic nudes make no promises, erotic nudes make a few, and obscene or pornographic works so completely fulfill them all that many viewers find them offensive, rather than exciting. The current volume presents a wealth of material covering the full range of ambitions in the field of photographic nudes. 1000 nudes: admittedly but a sample of a hundred years' output, and far from the whole of the Uwe Scheid Collection. But it appears to be enough to create a small monument to love, in the form of a book, a "garden of desires" entirely in the spirit of Charles Baudelaire who, it must be said, preferred panel painting to the (all too realistic) photograph as a source of inspiration for his fantasies. The period of time spanned by this work is from 1839 to roughly 1939, from the medium's infancy to the end of the classic modernist period. Content-wise, the book pays tribute to the full range of pictorial approaches, from the manually elaborated artistic nudes of the turn of the century, enveloped in layers of theory, to the "obscene" postcard motifs which had not the slightest artistic pretension and were intended to exert a maximum effect on the buyer's wallet. The most meaningful turning point during the period covered has turned out to be 1939: during the first post-war years, the medium suffered considerable criticism with respect to its technical, social and aesthetic inadequacies, creating a drive for improvement and an impulse to widen its subject matter. From 1945 onwards, therefore, colour became more prominent, the snapshot became an important means of artistic expression (for nudes as well) and, in the wake of the women's liberation movement, the discovery of the female self became a central theme – to name but three aspects. Today's nude photography inspires the label "new imperspicuity": it is no longer harmony but dichotomy that seems to be the

main goal. Taboos are being forcibly broken (Jeff Koons), while at the opposite end of the spectrum very nuanced metaphors are taking shape (Helen Chadwick, Dieter Appelt). The ideal of the hardened and intact body beautiful (Robert Mapplethorpe, Bruce Weber) is contraposed to its mutilated, violated and flabby opposite (George Dureau, Joel Peter Witkin, Gundula Schulze). Elaborately staged erotic work (Bettina Rheims) contrasts with a tendency towards fragmentation. The human body is taken apart and put on display like so many transplant organs (Rainer Leitzgen). Or else it is cut into pieces which are then duplicated, remixed and rearranged (Thomas Florschuetz). A look at one's own aging body (John Coplans) is followed by the dream of eternal youth and earthly joy (Jim Long). And, finally, should the natural body inadequately convey the information the artist wishes to share, artists resort to anatomical dummies (cf. the recent work of Cindy Sherman) to give graphic expression to their apocalyptic vision of the present. In short, the body has become "the battlefield for much debate", in the words of Peter Weiermair, commenting on a 1993 exhibition of recent trends in nude photography. "The list of topics ranges from questions concerning sexual identity, mainly with a feminist or homosexual slant to them, to the boundary between public and private, the question of bodily beauty in an age of genetic engineering and bodybuilding, cosmetic surgery and an increasingly dominating industry of the cult of the body. Artists are reacting to taboos dictating what can or cannot be depicted. They are seeking to redefine pornography and to come up with new ways of representing matters sexual, at times in the sense of a holistic utopia." At this point, it is anyone's guess what all this is leading to, especially in an age of new media, digital imagery and processing, video and cyber-sex. But one thing is certain, in any case: the human body remains an – if not *the* – object of our "passion to see and to render (what we see) in the form of an image" (Weiermair). In other words: the battle goes on.

Michael Koetzle

1000 Akte

Anmerkungen zur Kunst- und Sozialgeschichte der fotografischen
Körperdarstellung 1839–1939

Die Erfindung der Fotografie im ersten Drittel des 19. Jahrhunderts
war die Antwort des technischen Zeitalters auf die Bildwünsche
eines ökonomisch erstarkten Bürgertums. Wo Dampfmaschinen ihre
Kraft im Dienst der kapitalistischen Produktionsweise entfalteten,
mechanische Webstühle zunehmend die menschliche Arbeitskraft
ersetzten, die Eisenbahn sich anschickte, entlegene Gegenden mit-
einander zu verbinden und damit die Menschheit mobiler zu machen,
mußten manuelle Bildverfahren wie Zeichnung, Kupferstich und
Lithographie einigermaßen antiquiert erscheinen. Vor allem entspra-
chen diese manuellen und damit weitgehend subjektiven Darstel-
lungsformen kaum mehr dem rationalen, nach objektiver Betrach-
tung von Welt und Umwelt strebenden positivistischen Zeitalter.
Die Grundprinzipien der Fotografie waren genaugenommen längst
bekannt. Sie brauchten nur noch kombiniert und um ein – allerdings
wesentliches – Bindeglied ergänzt zu werden. So war die Camera
obscura in ihrer Funktionsweise eigentlich seit der Antike geläufig
und diente seit der Renaissance als Hilfsmittel einer an perspekti-
visch genauer Darstellung interessierten Kunstpraxis. Ebenso wußte
man spätestens seit Johann Heinrich Schulze (1727) um die Licht-
empfindlichkeit der Silbersalze. Was bis zum Ende des 18. Jahr-
hunderts fehlte, war ein gesellschaftlich fundiertes Interesse an ei-
ner mechanischen Bildgewinnung sowie – technisch gesehen – ein
Mittel, die durch die Camera obscura erzeugten »Sonnenbilder« dau-
erhaft zu machen.
Obwohl dem Franzosen Nicéphore Niepce bereits 1826 mittels einer
asphaltbeschichteten Zinnplatte der fotografische Blick aus dem
Fenster seines Arbeitszimmers gelungen war, der Engländer Henry
Fox Talbot seit 1834 erfolgreich mit sensibilisierten Papiernegativen
experimentierte und Louis Jacques Mandé Daguerre ab 1837 mit
ersten Bildproben im Sinne der nach ihm benannten Daguerreotypie
aufwarten konnte, gilt als Beginn des fotografischen Zeitalters das
Jahr 1839, genauer: der 19. August 1839. An jenem Hochsommertag
traten in Paris die Akademien der Wissenschaften und der Künste zu-

sammen, erörterten noch einmal das Verfahren nach Daguerre und machten es, nachdem der französische Staat dem Erfinder sein Patent auf der Basis einer Leibrente abgekauft hatte, der Weltöffentlichkeit zum Geschenk.

Die ebenso prompte wie heftige internationale Reaktion auf die Veröffentlichung bewies, daß die westliche Industriegesellschaft auf ein technisches Bildmittel wie dieses nur gewartet hatte. Allgemein gelobt wurde die gegenüber allen Bilddetails gleichermaßen vorurteilsfreie Präzision sowie die »Geschwindigkeit der Methode« (Arago). Enttäuscht zeigten sich nicht wenige Rezensenten über das Fehlen der Farbe. Was hingegen faszinierte und letztlich überzeugte, war das Mechanische, quasi Selbsttätige des Verfahrens. Diesmal, so der Kunstkritiker Jules Janin (1839), sei es nicht mehr »der unsichere Blick des Menschen, der aus der Ferne Schatten und Licht wahrnimmt, es ist nicht mehr seine zitternde Hand, die auf vergängliches Papier die wechselhafte Gestalt der Welt bannt...«. Hier tat das »Wunderwerk« (Janin) gewissermaßen seine Arbeit selbst. Neben dem bisweilen naiven Staunen über die ersten »Luftbilder« überraschen – von heute aus gesehen – der Weitblick und die Phantasie, mit welchen bereits frühe Kommentatoren das Bildprogramm des jungen Mediums absteckten bzw. seine potentiellen Anwendungsformen diskutierten. So stellte der bereits zitierte Jules Janin – wenn auch mit anderen Worten – die Architektur- und Landschaftsfotografie in Aussicht, er erörterte die Möglichkeit der Kunstreproduktion und verwies auf das Porträt. Dominique Arago, Physiker, Politiker und der für die Frühzeit vielleicht bedeutendste Propagandist des Mediums, sah das Lichtbild im Dienste der Archäologie, der Astronomie und Photometrie. Schorn/Kolloff, die Korrespondenten von Cottas »Morgenblatt für gebildete Stände«, überdachten die Möglichkeit der Momentaufnahme. Und kein geringerer als der weitgereiste Alexander von Humboldt reflektierte die Nützlichkeit einer Kamera unterwegs.

An keiner Stelle findet sich ein Hinweis auf den Akt. Unausgesprochen blieb die Imagination einer Verbindung von Lichtbild und Erotik, was angesichts der repressiven Sexualmoral des 19. Jahrhunderts kaum verwundern dürfte. Daß die Möglichkeit des fotografischen Körperbildes immerhin mitgedacht wurde, legt eine frühe Aufnahme von Daguerre nahe. Sein »Stilleben mit Skulpturen« von

1839, eine kleinformatige Studie antikisierender Grazien in Gips, läßt sich ohne weiteres als Platzhalter verstehen – als vages und noch einzulösendes erotisches Versprechen. Von dieser als Kunstreproduktion getarnten Akt-Daguerreotypie bis zum ersten wirklichen fotografischen Körperbild war es jedenfalls nicht mehr weit.

Wann zum ersten Mal ein – vermutlich weibliches – Modell vor der Kamera posierte, wissen wir nicht. Rudolf Brettschneider (»Die Erotik in der Photographie«, 1931) spricht vom Jahr 1849. Joseph Maria Eder (»Die Geschichte der Photographie«, 1932) will eine Aktaufnahme von 1844 kennen. Andere Quellen verweisen auf ein Körperbild aus dem Jahr 1841. Unmittelbar nach Bekanntgabe der Daguerreotypie, soviel ist sicher, mußte auf Grund der enormen Expositionszeiten das erstrebte Porträt zunächst ebenso Utopie bleiben wie der heimlich herbeigesehnte Akt. Humboldt etwa spricht nach einem ersten Besuch bei Daguerre im Februar 1839 von Belichtungszeiten um 10 Minuten. Der Erfinder selbst will »nicht mehr als den kurzen Zeitraum von drei bis höchstens dreißig Minuten« benötigt haben, »je nach Jahreszeit«. Und wohl noch 1841/42, nach Einführung verbesserter Objektive und lichtempfindlicherer Platten, dürfte die Belichtungszeit selten unter 30 Sekunden gelegen haben.

Gesichter wurden gepudert oder weiß geschminkt. Körper in folterartige Halterungen gezwängt und minutenlang der prallen Sonne ausgesetzt. Der Erfindungsreichtum der Bildpioniere auf dem Weg zum angestrebten Porträt war groß. Ebenso zügig dürfte man sich auf das nicht weniger Gewinn versprechende Aktbild zubewegt haben, dessen erste Manifestationen in Gestalt kunstvoll kolorierter, edel gefaßter, kaum mehr als handtellergroßer Daguerreotypien um 1845 erstmals bei Pariser Optikern, Instrumentenbauern und Kunsthändlern aufgetaucht sein dürften. Wie reagierte nun ein Mensch des Biedermeier auf die Ansicht einer ihm fremden, fernen und gleichwohl sehr realen, mehr oder minder vollständig entblößten Frau? Fasziniert? Irritiert? Vermuten wir, es war ein Schock.

Zwar gab es erotische Bildkupfer schon lange, und mit Namen wie Gravelot, Picard, Borel und Elluin war Paris auch hier führend. Aber zwischen den traditionellen Bildkünsten und dem neuen Medium bestand doch ein wesentlicher Unterschied. »Eine Technik von hervorragender Wirklichkeitstreue« nannte etwa Willi Warstat (1929) das

Lichtbild und verwies damit auf die vor allem für die ersten Betrachter »ans Märchenhafte« (Janin) grenzende »Schärfe des Bildes«, seine »Detailtreue« und »feine Abstufung der Töne« (Daguerre). Wesentlicher jedoch und – mit Blick auf den Akt entscheidend – war die Phänomenologie der neuen Technik, ihre Bindung an den Gegenstand.

Während ein Maler immer noch aus dem Geist schöpfen konnte, war der Fotograf auf die Wirklichkeit – in welcher Form auch immer – angewiesen. Der spanische Maler Francisco Goya schuf seine berühmte »Nackte Maja«, indem er, wie der britische Kunsthistoriker John Berger einigermaßen schlüssig nachgewiesen hat, sein bereits fertiggestelltes Porträt der Herzogin von Alba kopierte und dabei Stück für Stück entkleidete: zunächst in der Phantasie, dann auf der Leinwand.

Wer um 1850/60 eine erotische Daguerreotypie betrachtete, durfte hingegen sicher sein: Hier hatte wirklich eine Akt-Sitzung stattgefunden. Die anonyme nackte Schöne, es gab sie wirklich. Als kleine Prostituierte irgendwo auf dem Boulevard. Als Tänzerin in einem der mehr oder minder prominenten Varietés. Als eine jener namenlosen Loretten, die für geringe Miete die Pariser Neubauviertel trockenwohnten. Entsprechend schlüpfte der zeitgenössische Betrachter in die Rolle des Voyeurs und blickte wie durch eine Luke auf einen schönen, fremden und »wirklich« nackten Frauenkörper. Das machte den Reiz der frühen fotografischen Körperbilder aus. Dies vor allem erhob sie über alle noch so künstlerischen graphischen Versuche. Es mobilisierte in besonderer Weise die Phantasie der Klientel und rief – nicht zuletzt – die Behörden auf den Plan.

Überblickt man die Bildproduktion der Frühzeit in Gestalt der bekannten erotischen Daguerreotypien hauptsächlich französischer Provenienz, so fällt das von Anfang an breit angelegte Motivspektrum auf, die Vielfalt an Inszenierungen und Posen. Von keinem einzigen erotischen Motiv, hatte schon Eduard Fuchs in seiner »Geschichte der erotischen Kunst« (1928) konstatiert, könne man sagen, »daß es eine neuere Erfindung sei«. Tatsächlich wußten bereits die ersten Daguerreotypisten unter Rückgriff auf bekannte Bildmuster die entlegensten erotischen Träume und Phantasien zu visualisieren. So spannt sich der Bogen vom dezenten Rückenakt im Sinne der klassischen »Akademien« bis hin zum drastischen Herzeigen des

Geschlechtsteils, von der lesbischen Liebe bis zum heterosexuellen Koitus. Die Bildautoren blieben in der Regel anonym. Wer gleichwohl mit seinem Namen zeichnete, riskierte Geldstrafe und Gefängnis. 1851 etwa kam es zum Prozeß gegen den zwischen 1840 und 1850 in Paris wirkenden Lichtbildner Felix Jacques-Antoine Moulin. Bei ihm bzw. seinem Händler Malacrida war, wie es im Urteil hieß, »eine große Anzahl so obszöner Bilder beschlagnahmt« worden, daß »sogar die Verkündigung der Titel (...) unter das Vergehen der Verbreitung unzüchtiger Schriften fallen würde«. Zu einem Jahr Gefängnis und 500 Francs Geldstrafe wurde Malacrida verurteilt. »Die Witwe René, Herstellerin der Daguerreotypien, (...) zu zwei Monaten Gefängnis und 200 Francs Strafe. Herr Jacques-Antoine Moulin, Autor der Daguerreotypien, zu einem Monat Gefängnis und 100 Francs Strafe.«

Etwa 5000 Daguerreotypien erotischen Gehalts dürften bis ca. 1860 insbesondere in Paris entstanden sein. Daguerreotypien sind Direkt-Positive, also Unikate, und waren entsprechend teuer. Ein Aktmotiv konnte sich allenfalls der leisten, der bereit war, einen mittleren Wochenlohn zu investieren. Fotoerotica blieben folglich zunächst einem gehobenen bürgerlichen Publikum vorbehalten, das im abendlichen Herrenzimmer den intimen Dialog mit den schwülen Bildern pflegte. Was Herstellern, Vertreibern, Konsumenten fraglos als Crux erscheinen mußte, erwies sich für eine in Fragen der Sexualität immer noch restriktive Gesellschaft als Segen: Der hohe Preis der Bilder nämlich garantierte einen überschaubaren Kundenkreis, der sich zudem aus Schichten rekrutierte, die man als moralisch integer und sittlich stabil einstufen durfte. Problematisch im Sinne viktorianischer Lustfeindlichkeit und Prüderie wurde es freilich, als das verbesserte Negativ-Positiv-Verfahren preiswerte Abzüge in Massenauflage möglich machte und nun auch jene in den Genuß »obszöner« Darstellungen gelangten, um deren sittliche Integrität man eingestandenermaßen fürchtete. Die Gefahr, konnte etwa Willi Warstat (»Der schöne Akt«) noch 1929 schreiben, »daß eine Aktfotografie sinnlich wirkt, weil sie durch ihre wirklichkeitsnahe Darstellung die nahezu vollständige Illusion der Wirklichkeit gibt, ist natürlich in solchen Zeiten und bei solchen Menschen größer, die an die unbefangene Betrachtung menschlicher Nacktheit in der Wirklichkeit nicht gewöhnt sind.« Skeptische Stimmen wie diese konnten den Sieges-

zug des Aktfotos und der erotischen Körperdarstellung so wenig aufhalten wie entsprechende Gesetze oder eine verschärfte Strafverfolgung. Allenfalls provozierte dergleichen immer raffiniertere Vertriebszweige und Handelsstrategien. Obwohl bis weit in unser Jahrhundert hinein verboten war, was »nicht zu Zwecken der künstlerischen und wissenschaftlichen Belehrung dargeboten« wurde, blühte der Handel mit Erotica und überstand problemlos alle Eingriffe des Staates. Hier zeigte sich im übrigen jene bemerkenswerte Bewußtseinsspaltung bzw. Scheinmoral der bürgerlichen Neuzeit, die in Gestalt erotischer Inszenierungen den Körper als Handelsware entdeckte, um das begehrte Gut umgehend mit dem Bann des Verbots zu belegen und aus dem öffentlichen Diskurs zu drängen. »Die Haßliebe gegen den Körper« hatten in diesem Sinne bereits Horkheimer/Adorno in ihrer »Dialektik der Aufklärung« formuliert, »färbt alle neuere Kultur. Der Körper wird als Unterlegenes, Versklavtes noch einmal verhöhnt und gestoßen und zugleich als das Verbotene, Verdinglichte, Entfremdete begehrt.« Erst Kultur, so die Autoren, kenne den Körper als Ding, das man besitzen kann: ein »Gegenstand von Anziehung und Widerwillen«.

Technisch gesehen hatte der bereits zitierte Henry Fox Talbot (1800–1877) den Grundstein für die Popularisierung der Fotografie und damit – nicht zuletzt – der Industrialisierung des erotischen Blicks gelegt. Ein Negativ, von dem im Prinzip unendlich viele Positive gezogen werden können, dies war gedanklich wie praktisch der richtige Weg. Zwar konnten Talbots bräunlich-fleckige »Kalotypien« zunächst kaum mit den fein ziselierten, stahlgrauen, gestochen scharfen Daguerreotypien konkurrieren, die insbesondere in Gestalt kolorierter Stereomotive begeisterten und noch heute Staunen machen. Aber mit der ca. 1840 einsetzenden zügigen Verbesserung des Verfahrens zeigte sich schnell dessen prinzipielle Überlegenheit. 1847 wurde Glas als Schichtträger entdeckt. 1850 kam das ob seiner Brillanz lange Zeit geschätzte Albuminpapier auf den Markt. Und mit der Einführung des nassen Kollodiumverfahrens (1851) stand endlich ein ebenso lichtempfindliches wie scharf zeichnendes Aufnahmematerial zur Verfügung. Mitte des 19. Jahrhunderts waren die wichtigsten Schritte auf dem Weg zu einer anwendungsorientierten, motivisch breit sich auffächernden Fotografie getan.

Zu den chemo-technischen, optischen und apparativen Erfindungen

und Verfeinerungen kamen schon bald neuartige Darbietungs- und Distributionsformen, die der künstlerischen Entwicklung der Fotographie nicht unbedingt förderlich waren, aber doch die Popularisierung des Lichtbildes – einschließlich der Aktaufnahme – maßgeblich beschleunigten. Seit etwa 1850 erfreuten sich Stereoaufnahmen – in Form von Daguerreotypien und Papierabzügen – großer Beliebtheit. 1853 machte der Franzose Adolphe-Eugene Disdéri erste Aufnahmen in dem von ihm entwickelten Carte-de-visite-Format (5,7 x 9 cm) und revolutionierte mit diesem der schnellen und preiswerten Bildherstellung verpflichteten Verfahren (nicht nur) das Porträt. Ab den siebziger Jahren des vorigen Jahrhunderts kam als beliebtes Sammelobjekt die Bildpostkarte hinzu. Allein im Frankreich der Zeit zwischen 1919 und 1939 sollen jährlich über 20 Millionen Akt-Postkarten produziert worden sein. Nicht zu vergessen die Autotypie, durch die (ab ca. 1880) erstmals Fotografien ohne den Umweg des Holzstichs gerastert und gedruckt werden konnten. Seitdem ist es vor allem die gedruckte Form, in der das Aktmotiv Verbreitung fand und findet. Sei es in Büchern, die sich dem Thema widmen. Sei es im Rahmen der Anzeigenreklame, die sich seit den sechziger Jahren unseres Jahrhunderts zunehmend erotischer Appelle für ihre werblichen Botschaften bedient. Sei es in Gestalt einschlägiger Magazine, deren Pin-ups heute weniger die staatliche Zensur als die Konkurrenz der elektronischen Bildmedien zu fürchten haben.

Die Aktfotografen der ersten Stunde – Belloc, Berthier, Braquehais, Olivier oder Vallou de Villeneuve – waren Maler oder Lithographen, die das Ende der gemalten (Bildnis-) Miniatur bzw. – wie im Falle Delacroix – die Faszination des neuen Bildmittels zur Fotografie gebracht hatte. In ihren Aktstudien verbinden sich die Freude am Experimentieren mit einem (akademisch fundierten) ausgeprägten Sinn für Bildwirkung, für Schlichtheit in Pose und Dekor, für Bildaufbau und Lichtführung. Die 1853 von Delacroix und Durieu gemeinsam realisierte Serie von Aktaufnahmen etwa überzeugt noch rund hundert Jahre später durch schlichte Anmut und zarte Eleganz. Die Fotografen der zweiten Generation waren bereits mit dem Lichtbild aufgewachsen. Nicht mehr die bildnerischen Möglichkeiten des neuen Mediums standen für sie im Vordergrund des Interesses, sondern eher ökonomische Perspektiven. Die sogenannte Gewerbezeit mit ihrem später vielbeklagten künstlerischen Nieder-

gang, der Standardisierung der Formate, der Inszenierungen und Posen, machte aus einer exklusiven eine Veranstaltung für alle. Die Fotografie erlebte ihren Aufschwung zu einem wahren Massenphänomen. Dies galt für die Porträtaufnahme, aber auch für den Akt. Gerade 60 beschlagnahmte Bilder meldete ein Polizeibericht aus den fünfziger Jahren des 19. Jahrhunderts. Zehn Jahre später wurden bereits Tausende von Stereokarten konfisziert. Und 1875 sollen der Londoner Polizei mehr als 130 000 Aufnahmen mit »unzüchtigen« Motiven sowie 5000 Negative in die Hände gefallen sein. Die Professionalisierung des Mediums ging Hand in Hand mit einer Kommerzialisierung des erotischen Blicks.

Die Geschichte des Aktfotos ist die Geschichte einer Faszination. Kein anderes Motiv hat über 150 Jahre Bildpraktiker, Theoretiker und Rezipienten so sehr in Atem gehalten wie die fotografische Körperdarstellung. Kein anderes Motiv ist in gleicher Weise präsent durch sämtliche Epochen der Fotografiegeschichte, kommt vor in allen technischen Verfahren, ist Diskussionsgegenstand annähernd sämtlicher ästhetischer Programme. Keine andere Bildaufgabe hat so viele Sonderformen provoziert wie der Akt: von der ethnologischen Körperinterpretation bis zum Glamourfoto, von der FKK-Fotografie bis zum Pin-up unserer Tage. Keine fotografische Anwendungsform war in gleicher Weise Objekt der Begierde wie Gegenstand der Strafverfolgung. Im Aktfoto findet das gespaltene Verhältnis der abendländischen Kultur zum Körper seinen bildhaften Beleg. Anfang der dreißiger Jahre, im Zuge der sich etablierenden Sexualwissenschaft, gab es einen ersten ernsthaften Versuch, sich wissenschaftlich mit dem Gegenstand auseinanderzusetzen. 1931 erschien, herausgegeben u.a. von Erich Stenger, im Wiener Verlag für Kulturforschung das bis heute vielzitierte Werk »Die Erotik in der Fotographie. Die geschichtliche Entwicklung des Aktphotos und des erotischen Lichtbildes und seine Beziehung zur Psychopathia sexualis«. Hitlerjahre, Krieg und eine ausgesprochen prüde Nachkriegszeit setzten den fruchtbaren Forschungsansätzen ein vorläufiges Ende. Erst in den achtziger Jahren kam es erneut zu einer intensiven wissenschaftlich-publizistischen Auseinandersetzung mit dieser »Nachtseite des bürgerlichen Bewußtseins« (Christoph Stölzl), wobei der Akt erstmals seit den dreißiger Jahren wieder in seiner ganzen kulturgeschichtlichen Dimension Beachtung fand, ein-

schließlich aller trivialen Darbietungs- und Distributionsformen, einschließlich FKK- und Sportfotografie, einschließlich jenes über Jahrzehnte tabuisierten Bereichs der Männer-Aktfotografie bzw. homosexueller Sehweisen in der Kunst rund um den Körper. Grundlage aller Ausstellungen und gedruckten Diskussionsbeiträge war der Versuch, die praktisch uferlose Produktion fotografischer Körpervisionen über 150 Jahre zu kategorisieren. Dabei haben sich, vor dem Hintergrund der sozialen Gebrauchsformen der Aktfotografie, im wesentlichen fünf zentrale Bereiche herauskristallisiert: das künstlerische Aktfoto, die erotische bis pornografische Körperinterpretation, das wissenschaftliche Lichtbild sowie die Sportfotografie (einschließlich FKK, Tanz und Bodybuilding). Daß die Kategorien an den Rändern verwischen bzw. häufig ineinander übergehen, ist evident. So hatten die wissenschaftlich gemeinten Ethno-Akte des 19. und frühen 20. Jahrhunderts zweifellos auch erotische Bildbedürfnisse zu befriedigen. Umgekehrt sind wir heute durchaus bereit, bestimmten erotischen Bildfindungen der Vergangenheit und Gegenwart künstlerische Qualitäten zuzubilligen. Auch die zwischen Wissenschaft und Sport angesiedelten Bewegungsstudien (von Muybridge bis Marey) werden heute eher im Kunstkontext diskutiert. Die Zuordnung ist – eingestandenermaßen – oftmals schwierig bzw. dem kulturellen Wandel unterworfen. Gleichwohl gibt es im Kern Kriterien, die eine Einordnung gestatten und somit den ernsthaften Diskurs, eine »Archäologie der Moral im bürgerlichen und postbürgerlichen Zeitalter« (Stölzl) möglich machen.

»Die bildhafte Darstellung des nackten menschlichen Körpers ist Anliegen vieler großer Kulturepochen. Die klassische Antike erhebt den Menschen zum Maßstab seiner Umwelt, er wird dominierendes Motiv allen bildhaften Schaffens; die Schilderung der menschlichen Schönheit ist das große künstlerische Erlebnis jener Zeit. Der naturgegebene Körper wird veredelt, man entindividualisiert ihn nach dem Muster vollkommener Maße, der Gesetzmäßigkeit von Proportion und Harmonie und schafft menschliche Idealgestalten, die noch heute unser Bildbewußtsein maßgeblich beeinflussen«, schrieb Otto Steinert (in »Akt international«, 1954) und führte mit Blick auf das Lichtbild weiter aus: »In Erkenntnis der starken Gefährdung der fotografischen Aktdarstellung werden die formalen Mittel mit äußerster Sparsamkeit verwendet. Man reduziert den Akt auf cha-

rakteristische Grundformen, zu entindividualisierten Symbolen des weiblichen Körpers, bis er nur noch den materiellen Vorwurf, ein Bauelement der Bildkomposition, darstellt. Der knappe Bildschnitt mit Verzicht auf die Abbildung des Kopfes und Gesichtsausdrucks des Modells, entsprechend dem Torso-Motiv der modernen Plastik, entrücken diese Aufnahmen weiter der Sphäre aller persönlichen und erotischen Vorstellungen.«

Das Steinert-Zitat, nicht zuletzt auch Ausdruck der Körper- und Lustfeindlichkeit der fünfziger Jahre, weist den Weg zu einer einigermaßen brauchbaren Eingrenzung künstlerischen Akt-Bemühens auch außerhalb dessen, was man als »subjektive Fotografie« zu bezeichnen sich angewöhnt hat. Sucht das pikante Lichtbild unter Aufbietung unterschiedlichster Strategien erotische Phantasien freizusetzen, so strebt die künstlerische Aktaufnahme nach einer an klassischen Idealen geschulten Überhöhung des menschlichen Körpers unter »Ausschaltung erotisch-triebhafter Wirkungen« (Warstat). »Schreibt die Künstlerstudie völlige Nacktheit vor«, definiert Michael Köhler, »so lebt die fotografische Pikanterie gerade vom Reiz des strategisch Verhüllten.« Schuhe und Strümpfe, Schleier und Strapse, Federn und Fächer zählen folglich zu den unabdingbaren Attributen der Erotik. Dekor und Requisiten steigern überdies die Bildwirkung und machen die Pikanterie zum wohlfeilen, transportablen und stets verfügbaren Blick durchs Schlüsselloch ins Boudoir. Der künstlerische Akt definiert sich durch Distanz, das erotische Lichtbild durch Nähe. Dazu gehört auch das aufmunternde Lächeln, der einladende Blick. Die künstlerisch ambitionierte Aktaufnahme argumentiert nach dem Motto »weniger ist mehr«, das pikante Foto findet »mehr ist lustiger«. Der Künstlerakt verspricht nichts, das erotische Lichtbild manches, die obszöne oder pornographische Darstellung löst alle Versprechungen ein und wirkt dadurch auf viele Betrachter eher verstörend als anregend.

Aus all diesen Kategorien bietet der vorliegende Band reichlich Bildmaterial. 1000 Akte – das ist, zugegeben, nur ein Ausschnitt aus rund 100 Jahren Bildproduktion und längst nicht alles aus der Uwe Scheid Collection. Aber es scheint genug, um ein (kleines gedrucktes) Liebesmuseum einzurichten, einen »Garten der Lüste«, ganz im Sinne Charles Baudelaires, der in seinen Phantasien freilich dem Tafelbild den Vorzug vor der (allzu realistischen) Fotografie gab.

Zeitlich spannt sich der Bogen von 1839 bis etwa 1939, von den Anfängen bis zum Ende der klassischen Moderne. Inhaltlich erweist die Auswahl allen Bildstrategien ihre Reverenz, vom handwerklich elaborierten, theoretisch unterfütterten Künstlerakt der Jahrhundertwende bis zum »obszönen« Postkartenmotiv, das ohne jeden Kunstanspruch allein nach der Brieftasche des Bürgers schielt. Als sinnvoll erwiesen hat sich die Zäsur um 1939. Mit der Nachkriegszeit erlebte das Aktfoto – technisch, gesellschaftlich, ästhetisch – erhebliche Verwerfungen, die eine eigene, ausgreifende Darstellung fordern würden. So tritt nach 1945 verstärkt die Farbe auf den Plan, wird das Sofortbild zum wichtigen künstlerischen Ausdrucksmittel (auch im Akt), avanciert im Zuge der Emanzipationsbewegung die weibliche Selbsterkundung zu einem der zentralen Themen – um nur drei Aspekte herauszugreifen. Von einer »neuen Unübersichtlichkeit« könnte man mit Blick auf die Gegenwart der Aktfotografie sprechen. Nicht mehr Harmonie scheint das Ziel, sondern Dichotomie. Da werden mit Macht Tabus aufgebrochen (Jeff Koons), während andererseits an subtilen Metaphern gefeilt wird (Helen Chadwick, Dieter Appelt). Dem Ideal des schönen, unversehrten und gestählten Body (Robert Mapplethorpe, Bruce Weber) steht der verstümmelte, verletzte, welke Körper gegenüber (George Dureau, Joel Peter Witkin, Gundula Schulze). Der erotisch aufgeladenen Inszenierung (Bettina Rheims) widerspricht der Hang zum Splitter, zum Fragment. Der Körper wird zerlegt und nach den Regeln der Organtransplantation präsentiert (Rainer Leitzgen). Oder er wird tranchiert, verdoppelt, neu aufgemischt und arrangiert (Thomas Florschuetz). Dem Traum von ewiger Jugend und irdischem Glück (Jim Long) folgt der Blick auf den eigenen, alternden Körper (John Coplans). Und wo der natürliche Körper als Auskunft gebender Referent versagt, greifen Künstler (wie neuerdings Cindy Sherman) auf medizinische Puppen zurück, um ihre apokalyptische Sicht der Dinge zu visualisieren. Der Körper, so Peter Weiermair 1993 angesichts einer Schau jüngster Trends in der Aktfotografie, sei zum »Schlachtfeld vieler Debatten« geworden. »Der Themenkatalog reicht von Fragen der sexuellen Identität, die vor allem von feministischer und homosexueller Seite pointiert gestellt werden, bis zum Verhältnis öffentlich/privat, der Frage nach Normen der Körperschönheit im Zeitalter von Gentechnik und Bodybuilding, kosmeti-

scher Eingriffe und einer immer dominanter werdenden Industrie des Körperkultes. Die Künstler reagieren auf die Tabus der Darstellbarkeit, diskutieren den Pornographiebegriff und bieten neue Möglichkeiten der Darstellung von Sexualität an, auch im Sinne einer ganzheitlichen Utopie.« Wohin dies alles führt, zumal im Zeitalter der neuen Medien, der digitalen Bilderzeugung und -verarbeitung, von Video und Cyber-Sex, ist gegenwärtig kaum vorherzusagen. Fest steht allenfalls: Der menschliche Körper bleibt ein, wenn nicht *der* Gegenstand einer »Leidenschaft des Schauens und ihrer Materialisierung im Bild« (Weiermair). Mit anderen Worten: The battle goes on.

Michael Koetzle

1000 nus

Remarques sur l'évolution artistique et sociale de la photographie de nu entre 1839 et 1939.

Avec l'invention de la photographie, au cours du premier tiers du 19ème siècle, l'ère technique combla l'envie d'images d'une bourgeoisie dont le pouvoir économique s'était renforcé. A une époque où la machine à vapeur mettait sa force au service de la production capitaliste, où les métiers à tisser mécaniques remplaçaient de plus en plus la main-d'œuvre humaine et où le chemin de fer se préparait à relier des régions éloignées, offrant à l'homme une plus grande mobilité, les procédés manuels comme le dessin, la gravure ou la lithographie devaient paraître quelque peu dépassés. De plus, ces techniques manuelles, et donc largement subjectives, ne correspondaient plus tellement à l'esprit de ce siècle rationaliste et positiviste qui aspirait à une vision du monde objective.

A vrai dire, les principes de base de la photographie étaient depuis longtemps connus. Il ne restait plus qu'à les combiner et à les assembler autour d'un élément néanmoins essentiel. La chambre noire, dont le principe était déjà connu dans l'Antiquité, était employée par les artistes depuis la Renaissance pour contrôler l'exactitude de la perspective. De même, on savait au moins depuis Johann Heinrich Schulze (1727) que les sels d'argent étaient sensibles à la lumière. Mais il fallut attendre la fin du 18ème siècle pour que quelqu'un s'intéresse à la fabrication industrielle des images, et que, du point de vue technique, on trouve un moyen de fixer les «images solaires» obtenues avec la chambre noire.

Bien que le Français Nicéphore Niepce, dès 1826, ait obtenu une vue de la fenêtre de son atelier au moyen d'une plaque en étain recouverte de bitume de Judée, que l'Anglais Henry Fox Talbot, dès 1834, ait mis au point un négatif papier sensible et que Louis Jacques Mandé Daguerre, dès 1837, ait présenté ses premières épreuves obtenues grâce au procédé qui porte son nom, la daguerréotypie, on considère que l'ère de la photographie commença en 1839, plus précisément le 19 août. En ce jour d'été, les Académies des Sciences et des Arts se réunirent à Paris, discutèrent une nouvelle fois du procédé de Daguerre et en firent don au monde après que l'Etat

français ait acquis le brevet en accordant une rente viagère à son inventeur.

Les réactions internationales déclenchées par sa publication furent aussi rapides que passionnées, et elles montrèrent à quel point la société industrielle occidentale attendait un procédé de ce genre.

Partout, il fut encensé pour la précision qui s'appliquait de la même façon, sans préjugés, à tous les détails, et pour la «rapidité de la méthode» (Arago). Si de nombreux critiques se montrèrent déçus de l'absence de couleurs, beaucoup furent fascinés et finalement conquis par l'aspect mécanique, presque automatique du procédé.

Cette fois, écrivait le critique d'art Jules Janin (1839), ce n'est plus «le regard incertain de l'homme qui perçoit de loin les ombres et la lumière, ce n'est plus sa main tremblante qui trace sur le papier éphémère la forme changeante du monde...» Désormais, c'est la «merveille» (Janin) qui agit pratiquement toute seule.

Si on peut s'étonner aujourd'hui de leur ébahissement parfois naïf devant les premières «vues aériennes», on l'est plus encore par la clairvoyance et l'imagination dont les premiers commentateurs firent preuve pour cerner les perspectives qu'offrait ce nouveau mode d'expression et pour discuter de ses applications possibles. Ainsi, Jules Janin envisageait déjà, bien qu'en d'autres termes, la photographie d'architecture et de paysage, discutait de la possibilité de reproduire des œuvres d'art, et annonçait le portrait. Le physicien et politicien Dominique Arago, qui fut peut-être à l'époque le plus important défenseur du nouveau moyen d'expression, imagina les services que pouvait rendre la photographie dans les domaines de l'archéologie, de l'astronomie et de la photométrie. Schorn/Kolloff, des correspondants du journal de Cotta «Morgenblatt für gebildete Stände», envisagèrent la photo instantanée. Et le grand voyageur Alexander von Humboldt lui-même reconnaissait l'utilité de la chambre noire en voyage.

Nulle part, il n'est fait mention de la photo de nu. Personne n'exprima l'idée d'un rapprochement entre la photographie et l'érotisme, ce qui n'est guère surprenant dans le contexte moral du 19ème siècle où la sexualité était réprimée. Néanmoins, un des premiers clichés de Daguerre montre qu'il avait déjà caressé l'idée de photographier le corps humain. Sa «Nature morte avec sculptures» de 1839, une étude de petit format représentant des statues an-

tiques en plâtre, peut s'interpréter comme un précédent riche en promesses érotiques. D'ailleurs, il ne faudra plus attendre long-temps après ce daguerréotype de nu dissimulé en reproduction d'art pour que soit réalisée la première véritable photographie de nu. Nous ne savons pas quand un modèle – sûrement féminin – posa pour la première fois devant la chambre noire. Rudolf Brettschneider («Die Erotik in der Photographie», 1931) suggère l'année 1849. Joseph Maria Eder («Die Geschichte der Photographie», 1932) pré-tend connaître une photo de nu datant de 1844. D'autres sources parlent d'une image de nu datant de 1841. Ce qui est certain, c'est qu'au moment où le procédé du daguerréotype fut rendu public, le temps d'exposition était tellement long qu'il reléguait au rang d'utopie aussi bien le portrait que le nu, tous deux objets d'ardentes recherches. Ainsi, à la suite de sa première visite chez Daguerre, en février 1839, Humboldt parle d'un temps d'exposition d'environ dix minutes. L'inventeur prétend lui-même ne pas dépasser «le court espace de temps de trois à trente minutes au maximum, en fonction de la saison». Et en 1841/42, après l'apparition d'objectifs plus per-fectionnés et de plaques plus sensibles, le temps d'exposition tom-bait encore rarement en dessous de 30 secondes.

Les visages étaient poudrés ou maquillés en blanc. Les corps étaient maintenus par des accessoires de soutien frisant la torture et ex-posés pendant plusieurs minutes en plein soleil. Les pionniers de la photographie déployèrent des trésors d'imagination pour se rappro-cher de leur objectif : le portrait. Ils ne durent pas déployer moins d'efforts dans le domaine du nu, qui promettait d'être lui aussi des plus rentables, et dont les premiers clichés apparurent à Paris vers 1845 – dirons-nous – chez des opticiens, des fabricants d'instru-ments optiques ou des marchands d'art, sous la forme de daguerréo-types de la taille d'une main, joliment coloriés et magnifiquement encadrés. Comment réagirent les spectateurs du début du 19ème siècle devant l'image d'une femme plus ou moins dénudée qui leur semblait si inconnue, si lointaine et pourtant tellement réelle? Eprouvèrent-ils de la fascination, de l'excitation? Imaginons que ce fut pour eux un choc.

Bien sûr, il existait depuis longtemps des gravures érotiques, dont Paris s'était fait une spécialité avec des noms comme Gravelot, Picard, Borel ou Elluin. Mais une différence essentielle séparait les

arts traditionnels du nouveau moyen d'expression. Willi Warstat définissait en 1929 la photographie comme «une technique extraordinairement fidèle à la réalité», faisant référence à la «netteté de l'image» – qui pour Janin était proche du «fabuleux» –, à la «précision des détails» et au «fin dégradé des tons» (Daguerre). Cependant, le processus mental et le rapport à l'objet qu'impliquait cette technique nouvelle se révélèrent plus importants encore, et décisifs dans le domaine du nu.

Alors qu'un peintre pouvait toujours créer à partir de son imagination, le photographe travaillait toujours à partir de la réalité, peu importe sa forme. Comme l'a montré de façon assez ingénieuse l'historien de l'art anglais John Berger, le peintre espagnol Francisco Goya réalisa sa célèbre «Maja nue» en effectuant une série de copies d'un portrait qu'il avait réalisé de la duchesse d'Albe, et en la déshabillant un peu plus à chaque copie : d'abord en imagination, puis sur la toile. En revanche, quiconque regardait vers 1850/60 un daguerréotype érotique pouvait être sûr qu'un modèle avait réellement posé : cette anonyme beauté dénudée existait bel et bien. Elle pouvait être une petite prostituée de boulevard, une danseuse d'un théâtre de variétés plus ou moins célèbre ou une jeune femme sans grands revenus. Ainsi, le spectateur de l'époque endossait le rôle du voyeur et regardait comme à travers une lucarne un beau et inaccessible corps de femme «réellement» nu. C'est ce qui fit le charme des premières images de nu, et surtout, ce qui les plaça au-dessus de toutes les autres tentatives encore très graphiques et artistiques. Cette façon particulière de capter l'imagination de la clientèle entraîna d'ailleurs l'intervention rapide des autorités.

En regardant les célèbres daguerréotypes érotiques des débuts de la photographie, principalement réalisés en France, on est surpris de la diversité des sujets, des décors et des poses. Dans «Geschichte der erotischen Kunst» (1928), Eduard Fuchs constatait déjà qu'il était impossible de trouver un seul sujet érotique «qui constitue une nouveauté». En effet, déjà les premiers daguerréotypistes surent, en recourant à des motifs connus, visualiser les fantasmes et les rêves les plus insolites. Ainsi, l'éventail s'étend du nu de dos décent dans le style de l'«académie» classique à la représentation crue du sexe, des amours entre lesbiennes au coït hétérosexuel. Les auteurs de ces photos gardaient en général l'anonymat. Celui qui signait de son

nom encourait amendes et peines de prisons. En 1851, par exemple, eut lieu le procès du photographe Félix Jacques-Antoine Moulin qui exerça à Paris entre 1840 et 1850. On avait saisi chez lui et chez le commerçant Malacrida, dit le jugement, «un grand nombre d'images si obscènes que l'énonciation même des titres (…) serait un délit d'outrage à la morale publique». Malacrida fut condamné à un an de prison et à 500 francs d'amende. «La dame veuve René, fabricante de daguerréotypes, à deux mois d'emprisonnement et à 200 francs d'amende. Le sieur Jacques-Antoine Moulin, daguerréotypeur, à un mois de prison et à 100 francs d'amende.»

Quelque 5 000 daguerréotypes à caractère érotique furent réalisés jusque vers 1860, principalement à Paris. Obtenus par un procédé directement positif, et donc en exemplaire unique, leur prix était élevé. Pour acquérir une image de nu, il fallait être prêt à y investir la moitié d'un salaire hebdomadaire moyen. La photo érotique fut donc tout d'abord réservée à une haute bourgeoisie, dont les messieurs se réservaient ces images voluptueuses à usage très privé dans les fumoirs occidentaux. Ce qui auprès des fabricants, représentants et acheteurs devait incontestablement passer pour un handicap se révéla finalement un atout dans une société qui réprouvait tant la sexualité : en effet, en raison de leur prix élevé, ces images se cantonnèrent à un public restreint issu de couches sociales réputées pour leur moralité irréprochable et leurs bonnes mœurs. Les choses se compliquèrent, dans le contexte de pruderie et de refus du plaisir de l'époque, lorsque les perfectionnements apportés au procédé négatif-positif permirent de tirer des épreuves bon marché et en grande quantité, offrant les images «obscènes» à la contemplation de ceux dont on craignait qu'elle ne compromette la moralité.

Ce qui faisait dire, en 1929, à Willi Warstat («Der schöne Akt»): le danger «qu'une photo de nu agisse sur les sens parce qu'elle constitue, du fait de sa fidélité, une illusion presque parfaite de la réalité, est naturellement supérieur à cette époque, et sur des personnes qui ne sont pas habituées à contempler la nudité humaine».

Néanmoins, ce scepticisme ne put entamer le succès de la photo de nu et de l'image érotique, pas plus d'ailleurs que le vote de lois répressives ni le renforcement des poursuites pénales. Cela eut même plutôt pour effet d'encourager la création de réseaux et de stratégies de ventes de plus en plus sophistiquées. En dépit de l'interdic-

tion qui frappa, jusqu'au début du 20ème siècle, toutes les images qui ne présentaient pas un caractère artistique ou scientifique, le commerce de l'érotisme continua à prospérer, évitant sans problème tous les assauts de l'Etat. D'ailleurs, ce fut l'occasion de voir se révéler la remarquable schizophrénie et l'hypocrisie de cette nouvelle ère bourgeoise qui, découvrant la valeur marchande du corps à travers la photo érotique, en interdit aussitôt le commerce et empêcha qu'on en parle publiquement. Comme l'avaient déjà formulé Horkheimer/Adorno («La dialectique de la raison»), «l'amour-haine à l'égard du corps est caractéristique de toutes les civilisations nouvelles. Le corps est désiré à la fois comme quelque chose d'inférieur, d'asservi, une fois de plus raillé et mis à mal, et conjointement comme quelque chose d'interdit, de concret, d'éloigné». Pour ces auteurs, seule la civilisation pose le corps en tant que chose qu'il est possible de posséder: un «objet de séduction et de répulsion». Du point de vue technique, c'est Henry Fox Talbot (1800–1877) qui est à l'origine de la popularisation de la photographie et de l'industrialisation de l'image érotique. L'idée à retenir était celle d'un négatif, à partir duquel on pourrait tirer, en principe, un nombre illimité d'épreuves. Les «calotypes» à taches brunâtres de Talbot ne furent pas immédiatement en mesure de supplanter les daguerréotypes gris acier, finement ciselés et extrêmement nets, dont les images stéréoscopiques coloriées connurent un vif succès et provoquent encore aujourd'hui notre admiration. Mais les perfectionnements apportés au procédé vers 1840 démontrèrent rapidement sa supériorité. En 1847, on découvrit que la plaque de verre pouvait servir de négatif. En 1850 fut commercialisé le papier albuminé, dont la brillance lui garantit un succès durable. Enfin, l'introduction du procédé au collodion humide (1851) fournit un système de prise de vue aussi sensible que précis. Telles furent les principales étapes qui firent de la photographie, au milieu du 19ème siècle, une technique maniable et riche en applications.

Aux perfectionnements chimiques, optiques et de construction s'ajoutèrent bientôt de nouveaux formats qui ne favorisèrent pas nécessairement le développement artistique de la photographie, mais contribuèrent largement à la populariser, et donc aussi, indirectement, le nu. Depuis 1850 environ, les vues stéréoscopiques – sur daguerréotype ou sur tirage papier – jouissaient d'une grande popula-

rité. En 1853, le Français Adolphe-Eugène Disdéri réalisa les premiè-
res images dans le format carte de visite (5,7 / 9 cm) qu'il avait lui-
même mis au point. Ce format, qui permettait d'obtenir des images
rapidement et à bon marché, révolutionna (entre autres) le genre du
portrait. Dans les années 1870 apparut ensuite la carte postale illus-
trée, très appréciée des collectionneurs. Rien qu'en France, entre
1919 et 1939, plus de 20 millions de cartes postales de nu furent pro-
duites chaque année. N'oublions pas non plus la phototypie qui, à
partir de 1880 environ, permit de tramer et d'imprimer pour la pre-
mière fois des photographies sans passer par la gravure sur bois. Dès
lors, le nu sera surtout diffusé sous une forme imprimée, que ce soit
dans les livres, dans la publicité, qui, à partir des années 1960, re-
court de plus en plus souvent à des thèmes érotiques, ou encore dans
les magazines spécialisés dont les pin up joyeusement désinvoltes
sont aujourd'hui plus menacées par les médias électroniques que par
la censure de l'Etat.

Les pionniers de la photo de nu – Belloc, Berthier, Braquehais,
Olivier ou Vallou de Villeneuve – étaient des peintres ou des litho-
graphes que la disparition des (portraits) miniatures ou – dans le cas
de Delacroix – la fascination pour le nouveau moyen d'expression
poussèrent vers la photographie. Dans leurs études de nu, le plaisir
d'expérimenter s'allie à un sens aigu de l'image (venant d'une forma-
tion académique) qui se manifeste par le choix de la pose, du décor,
de la composition et de l'éclairage. Ainsi, la série de nus réalisés en
1853 par Delacroix et Durieu force un siècle plus tard notre admira-
tion par sa grâce simple et sa délicate élégance. Les photographes
de la deuxième génération, eux, grandirent avec la photo. Ce qui les
intéressait, ce n'était plus les possibilités artistiques qu'offrait le
nouveau mode d'expression, mais ses implications économiques. Le
passage au professionnalisme – qui se caractérise par un déclin artis-
tique qui lui sera plus tard reproché, et par une standardisation des
formats, des décors et des poses – popularisa néanmoins la photo-
graphie, jusqu'alors réservée aux riches. Elle devint un véritable phé-
nomène de masse, aussi bien dans le domaine du portrait que du nu.
Un rapport de police des années 1850 mentionne une saisie de 60
images. Dix ans plus tard, plusieurs milliers de cartes stéréoscopi-
ques étaient confisquées. Et en 1875, la police londonienne mettait
la main sur plus de 130 000 photos «licencieuses» et sur 5 000 néga-

tifs. La professionnalisation de la photo alla de pair avec la commercialisation de l'image érotique.

L'histoire de la photo de nu est celle d'une fascination. Aucun autre genre ne passionna autant, pendant 150 ans, photographes, théoriciens et amateurs. Aucun autre genre ne fut autant traité à toutes les époques de l'histoire de la photographie et avec tous les procédés techniques, ni autant discuté au sein de la plupart des courants esthétiques. Aucun autre genre n'engendra autant de formes particulières : nu ethnologique, photo glamour, photo naturiste ou de pin up. Aucun autre genre ne fut à ce point objet de convoitise et en même temps de répression. Dans la photo de nu, la culture occidentale exprima par l'image son rapport conflictuel avec le corps.

Au début des années 30, alors que naissait la sexologie, on tenta pour la première fois d'aborder scientifiquement le sujet. En 1931, Erich Stenger publia à Vienne un ouvrage abondamment cité jusqu'à aujourd'hui : «Die Erotik in der Photographie. Die geschichtliche Entwicklung des Aktphotos und des erotischen Lichtbildes und seine Beziehung zur Psychopathia sexualis.» Ces recherches fécondes furent prématurément interrompues par la période hitlérienne, la guerre et un après-guerre très prude. Il fallut attendre les années 80 pour que la science aborde à nouveau le sujet avec «Nachtseite des bürgerlichen Bewußtseins» (Christoph Stölzl), qui, pour la première fois depuis les années 30, s'intéressait à toutes les implications culturelles du nu, même dans ces formes les plus banales, et prenait aussi bien en compte la photo naturiste et de sport qu'un genre resté tabou pendant des dizaines d'années : le nu masculin et la manière de voir homosexuelle.

Expositions et écrits tentèrent alors de classifier une production photographique très vaste qui s'était consacrée pendant 150 ans à la représentation du corps. Cinq catégories principales furent définies sur la base des différentes fonctions de la photo de nu dans la société : le nu artistique, la photo érotique, la photo pornographique, la photo scientifique et la photo de sport (comprenant la photo naturiste, de danse ou de body-building). Bien sûr, entre ces catégories, les limites restent floues et se chevauchent fréquemment. Ainsi, les nus ethnologiques à vocation scientifique du 19ème et du début du 20ème siècle témoignent également d'une forte inspiration érotique. A l'inverse, nous sommes prêts aujourd'hui à trouver des qua-

lités artistiques à certains clichés érotiques anciens ou récents. Quant à certaines études de mouvements relevant de la science ou du sport (comme celles de Muybridge et de Marey), elles sont aujourd'hui plutôt intégrée à l'histoire de l'art. Cette classification reste souvent délicate et soumise aux changements culturels. Certains critères permettent pourtant de procéder à une classification et de construire une analyse sérieuse, une «archéologie de la morale à l'époque bourgeoise et post-bourgeoise» (Stölzl).

«La représentation du corps nu est au centre de beaucoup de grandes époques culturelles. Dans l'Antiquité classique, l'homme devient la mesure du monde, le sujet dominant de toute la production iconographique. La représentation de la beauté humaine est le grand événement artistique de cette époque. Le corps est magnifié. Il y perd son individualité mais y gagne des proportions parfaites. Les types humains idéaux créés à cette époque influencent aujourd'hui encore notre perception iconographique», écrivait Otto Steinert («Akt international», 1954), poursuivant à propos de la photographie : «Prenant conscience de la menace que constitue la photo de nu, on recourt avec la plus extrême parcimonie aux moyens formels. On réduit le nu à ses formes de base caractéristiques, à des symboles désincarnés du corps féminin, jusqu'à ce qu'il ne représente plus que l'esquisse matérielle, un élément de la composition iconographique. Le cadrage serré, qui supprime la tête et les expressions du visage du modèle, ce qui correspond dans la sculpture moderne au motif du torse, soustrait davantage encore ces images à la sphère des représentations personnelles et érotiques.»

Cette citation de Steinert, qui reflète aussi un refus du corps et du plaisir caractéristique des années 50, donne une définition assez utile du nu artistique, et ce également en dehors de ce qu'on considère habituellement comme la «photographie subjective». Alors que la photo grivoise déploie les stratégies les plus diverses pour créer l'érotisme, le nu artistique aspire à une idéalisation du corps nourrie des idéaux classiques en «supprimant tout effet érotique» (Warstat). «Tandis que l'étude d'artiste impose la nudité totale», décrit Michael Köhler, «la photo grivoise se nourrit du charme de ce qui est habilement dissimulé.» Chaussures, bas, voiles, jarretelles, plumes et éventails sont à ce titre les attributs indispensables de l'érotisme. Décor et accessoires renforcent en outre l'effet de l'image grivoise :

la vue à travers le trou de la serrure du boudoir devient un objet bon marché que l'on peut emmener partout avec soi. Le nu artistique instaure une distance, alors que la photo érotique crée une intimité, entre autres à travers un sourire aguicheur ou un regard suggestif. Si le nu à ambition artistique opte pour la sobriété, la photo grivoise se réalise dans l'exubérance. Le nu artistique ne fait aucune promesse, la photo érotique en suggère certaines, et la photo pornographique les comble toutes, exerçant sur beaucoup de spectateurs un effet plus dérangeant qu'excitant.

Ce livre présente de nombreux exemples illustrant chaque catégorie. 1 000 nus – cela ne correspond, il est vrai, qu'à une partie infime de ces quelque 100 ans de photographie et ne constitue pas, et de loin, la totalité de la collection Uwe Scheid. Cela suffit néanmoins à constituer un musée de l'amour (imprimé et de petit format), un «jardin des plaisirs» tout à fait dans l'esprit de Charles Baudelaire qui, à vrai dire, préférait la peinture à la photographie. Cette sélection couvre la période de 1839 à 1939 environ, des débuts jusqu'à la fin de la période moderne classique. Elle rend hommage à toutes les stratégies de l'image, du nu artistique du début du siècle réalisé artisanalement et théoriquement fondé, jusqu'à la carte postale «obscène» qui, sans la moindre prétention artistique, vise uniquement le porte-monnaie de la clientèle. L'année 1939 marque un tournant. Au cours de l'après-guerre, la photo de nu fut l'objet de nombreux questionnements – techniques, sociaux, esthétiques – qui pourraient faire l'objet d'un autre ouvrage. Ainsi, après 1945 – pour ne citer que trois aspects – la couleur occupe une place de plus en plus importante, l'instantané devient un mode d'expression artistique essentiel (également pour le nu), et l'introspection féminine, dans le sillage du mouvement d'émancipation, se révèle un thème majeur. Quant à la photographie de nu contemporaine, on pourrait la caractériser de «nouvelle incertitude». Elle ne semble plus tendre vers l'harmonie mais l'antinomie. Certains transgressent violemment les tabous (Jeff Koons), alors que d'autres filent de subtiles métaphores (Helen Chadwick, Dieter Appelt). A l'idéal du corps beau, intact et vigoureux (Robert Mapplethorpe, Bruce Weber) répondent des corps mutilés, blessés, avachis (George Dureau, Joel Peter Witkin, Gundula Schulze). A la composante érotique (Bettina Rheims) s'oppose une propension à l'éclatement, à la fragmentation. Le corps est dépecé

et présenté sur le mode de la transplantation d'organes (Rainer Leitzgen). Il est aussi découpé, dédoublé, mélangé et recomposé (Thomas Florschuetz). Au rêve d'éternelle jeunesse et de bonheur terrestre (Jim Long) succède la vision de son propre corps en train de vieillir (John Coplans). Et quand le corps se refuse à transmettre l'information, les artistes (comme récemment Cindy Sherman) recourent, pour matérialiser leur vision apocalyptique des choses, à des mannequins. Peter Weiermair écrivait en 1993, à l'occasion d'une exposition des nouvelles tendances, que le corps était devenu le «champ de bataille de nombreux débats». «Parmi les thèmes traités, on trouve aussi bien la question de l'identité sexuelle, posée de façon particulièrement aiguë par les féministes et les homosexuels, que le rapport public-privé et la question des normes de beauté physique à l'ère de la technique génétique et du bodybuilding, de la chirugie esthétique et d'une industrie du culte du corps de plus en plus puissante. Les artistes se rebellent contre les tabous de ce qui est montrable, s'interrogent sur la notion de pornographique et proposent de nouvelles façons de représenter la sexualité, également dans le sens d'une utopie globale.» Il est difficile de prédire où tout cela conduira, surtout en cette époque de nouveaux médias, de production et de traitement numérique de l'image, de vidéo et de minitel rose. Quoi qu'il en soit, si une chose est sûre, c'est que le corps humain reste un, sinon le seul objet capable de susciter une telle «passion de regarder et sa matérialisation en image» (Weiermair). Autrement dit : la bataille continue.

Michael Koetzle

1
Daguerreotypes: the first photographs of nudes

Die Daguerreotypie: Die ersten Lichtbilder des nackten Menschen

Les daguerréotypes: les premiers nus photographiques

By the start of the nineteenth century, the time was ripe for a technical pictorial process, at once in keeping with the positivist outlook of the day and capable of satisfying the growing middle-class demand for portraits bearing witness to their new-found prosperity. And indeed, France's Louis Jacques Mandé Daguerre (1787–1851) was only one among several who, around 1800, were seeking the practical means by which to turn fleeting camera pictures into lasting images. Yet he was the first to go public with his results. His country purchased the process from him in August of 1839, proclaiming his technique a gift to the world at a spectacular Academy session held specially for the occasion. This meant that anyone (except the English) could produce daguerreotypes without a license, a practice that finally overcame the technique's considerable inherent flaws and made an international success of it. The process produces images in black-and-white, most of which are laterally inverted; they are direct positives (in other words, one-offs) in standard formats between 54 x 72 mm and 162 x 216 mm. The photograph is taken on a silver-coated copper plate which is sensitized with iodine vapor and then exposed inside a camera obscura; the image is developed by being exposed to mercury vapor and, finally, is fixed in a solution of sodium thiosulphate. Until mid-nineteenth century, the technique was used mainly to produce portraits, but there were also some still lifes, landscapes, cityscapes as well as photos of nudes. The latter were often submitted to crafted miniaturists for artistic enhancement in soft shades of colour. In order to protect the daguerreotypes from oxidation or mechanical damage to their very fragile surface, they were sealed airtight under glass and stored in shockproof little boxes. It is said that 5000 daguerreotypes of an erotic nature were produced between 1840 and roughly 1860, for the most part in Paris. An estimated 1200 have survived until now. And about 700 are famous worldwide.

Mit Beginn des 19. Jahrhunderts schien die Zeit reif für ein technisches Bildverfahren, das gleichermaßen den Ansprüchen des positivistischen Zeitalters wie den Wünschen eines ökonomisch erstarkten Bürgertums nach repräsentativen Bildnissen genügte. Tatsächlich war der Franzose Louis Jacques Mandé Daguerre (1787–1851) nicht der einzige, der um 1800 nach einem brauchbaren Prozeß zur dauerhaften Fixierung flüchtiger Kamerabilder suchte. Aber er war der erste, der mit seinem Verfahren an die Öffentlichkeit drängte. Im August 1839 kaufte der französische Staat seine Erfindung an und machte sie im Rahmen einer spektakulären Akademiesitzung der Weltöffentlichkeit zum Geschenk. Damit konnte jedermann (Ausnahme England) lizenzfrei »daguerreotypieren«, was dem mit erheblichen Nachteilen behafteten Verfahren letztlich zu seinem raschen internationalen Siegeszug verhalf. Technisch handelt es sich bei Daguerreotypien um schwarzweiße, meist spiegelverkehrte Direkt-Positive (also Unikate), deren standardisierte Formate sich zwischen 54 x 72 mm und 162 x 216 mm bewegten. Bei der Aufnahme wurde eine silberbedampfte Kupferplatte über Joddämpfen sensibilisiert, dann in der Camera obscura belichtet, über Quecksilberdämpfen entwickelt und schließlich in einer Lösung aus Natriumthiosulfat fixiert. Bis in die fünfziger Jahre des 19. Jahrhunderts entstanden so vorwiegend Porträts, aber auch Stilleben, Landschaften, Stadtansichten sowie Aktaufnahmen, deren Bildwirkung geübte Miniaturmaler durch zarte Kolorierung kunstvoll zu steigern wußten. Um eine Oxydation bzw. mechanische Verletzung der empfindlichen Oberfläche zu verhindern, wurden die Aufnahmen hinter Glas luftdicht verkittet und in repräsentativen Kästchen stoßsicher aufbewahrt. 5000 Daguerreotypien erotischen Gehalts sollen zwischen 1840 und etwa 1860 vor allem in Paris entstanden sein. 1200, schätzt man, haben sich erhalten. Rund 700 davon sind weltweit bekannt.

Le début du 19ème siècle vit la naissance d'un procédé photographique qui répondait aussi bien à l'esprit positiviste de l'époque qu'à l'envie d'images d'une bourgeoisie dont le pouvoir économique s'était renforcé. Aux alentours de 1800, le Français Louis Jacques Mandé Daguerre (1787–1851) ne fut pas le seul à rechercher un procédé capable de fixer durablement les images photographiques, mais fut le premier à rendre son procédé public. Au mois d'août 1839, l'Etat français acquit son invention et en fit don à l'humanité lors d'une séance historique de l'Académie. Ainsi, le monde entier (à l'exception de l'Angleterre) put réaliser des daguerréotypes sans payer de droits, ce qui permit au procédé, en dépit de certaines faiblesses, d'acquérir rapidement une renommée internationale. La technique du daguerréotype repose sur un procédé directement positif noir et blanc, donnant une image unique et souvent miroitante. Les formats normalisés allaient de 54 × 72 mm à 162 × 216 mm. Pour obtenir une image, il fallait sensibiliser une plaque de cuivre argentée en la soumettant aux vapeurs d'iode, l'exposer ensuite dans une chambre noire, la révéler par des vapeurs de mercure, et enfin la fixer dans une solution de thiosulfate de sodium. Ce procédé permit de réaliser, jusqu'au milieu du 19ème siècle, d'innombrables portraits, mais aussi des natures mortes, des paysages, des vues urbaines et des nus, dont l'effet était renforcé par une douce colorisation due aux talents des miniaturistes. Afin de protéger la surface sensible de l'oxydation et des accidents, les daguerréotypes étaient placés sous un verre étanche et conservés dans une boîte à l'abri des chocs. Entre 1840 et 1860 furent réalisés, principalement à Paris, quelque 5 000 daguerréotypes à caractère érotique. Environ 1 200 exemplaires sont conservés, dont 700 sont connus dans le monde entier.

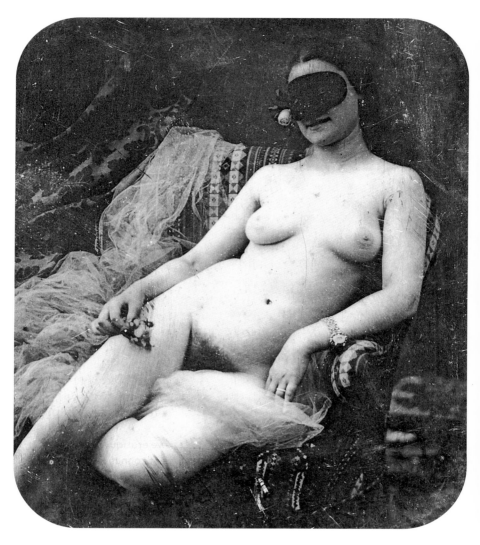

Anonymous
c. 1855

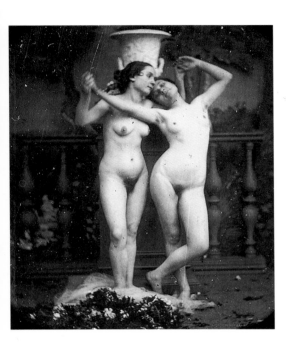

Anonymous
c. 1855

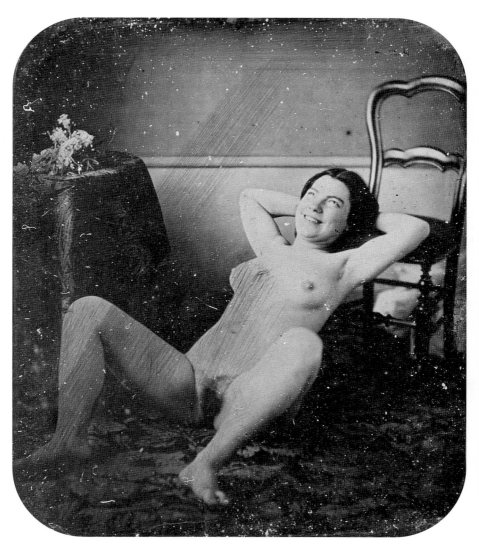

Anonymous
c. 1855

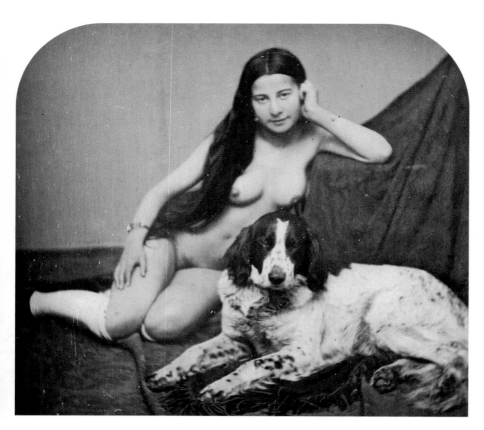

Anonymous
c. 1855
Detail

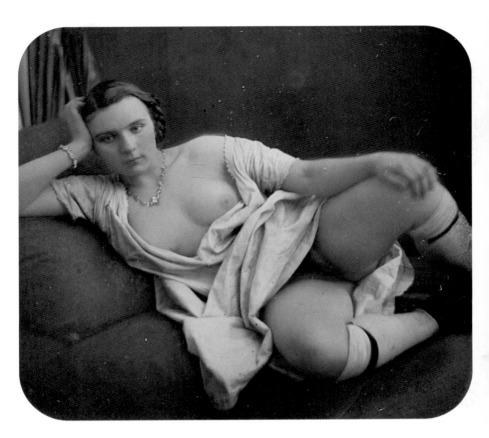

Anonymous
c. 1855
Detail

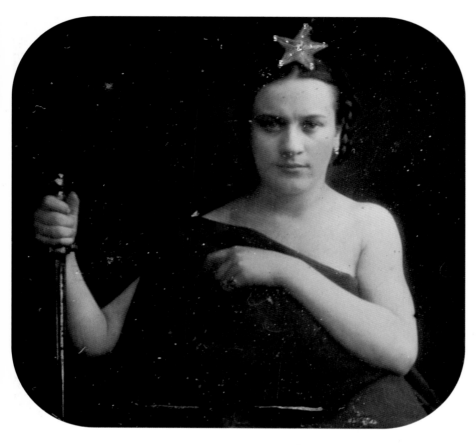

Anonymous
c. 1855
Detail

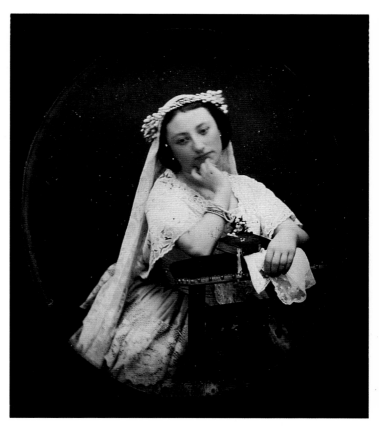

Anonymous
c. 1855

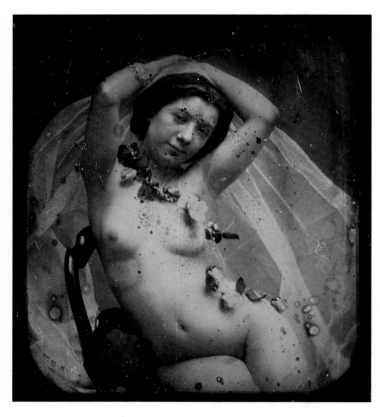

Anonymous
c. 1855

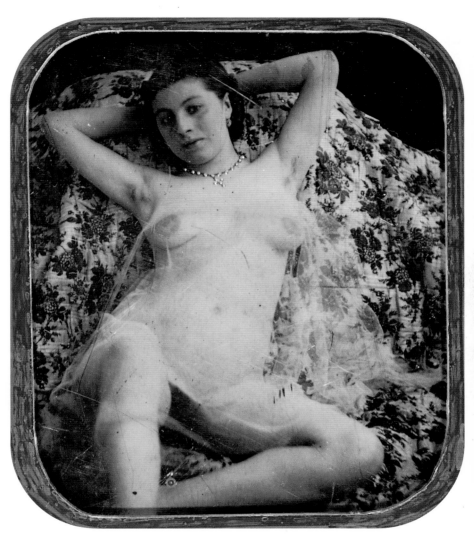

Anonymous
c. 1855

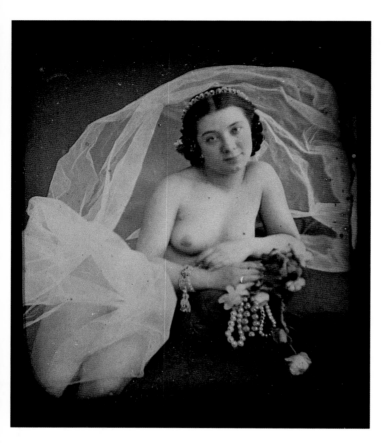

Anonymous
c. 1855

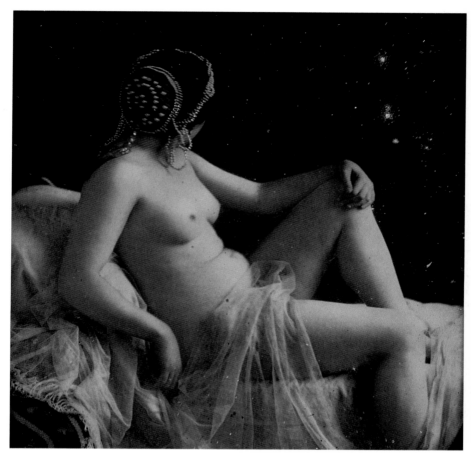

Anonymous
c. 1855

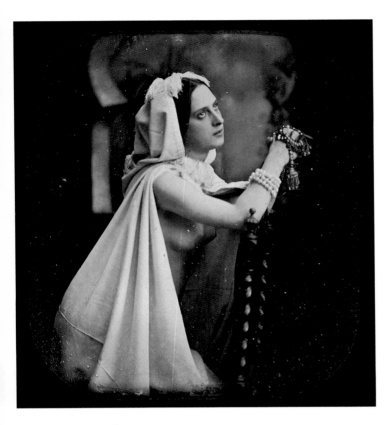

Anonymous
C. 1855

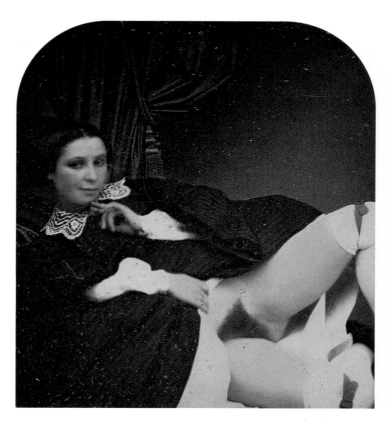

Anonymous
c. 1855

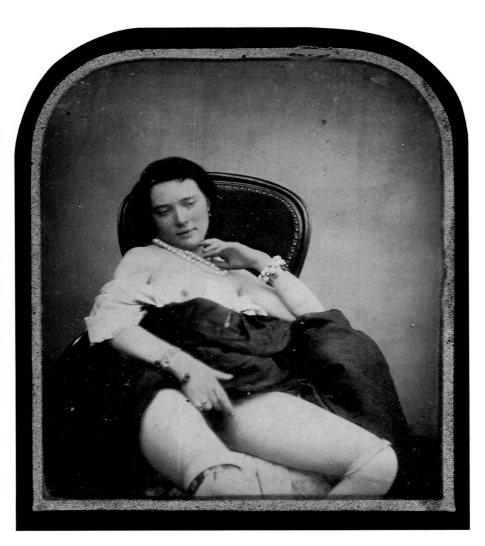

Anonymous
c. 1855

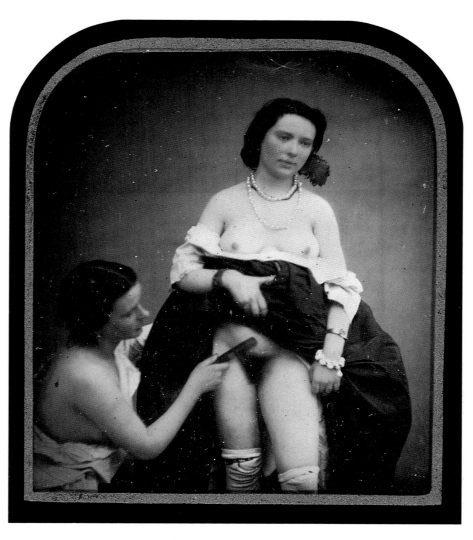

Anonymous
c. 1855

►
Anonymous
c. 1855
►►
Anonymous
c. 1855

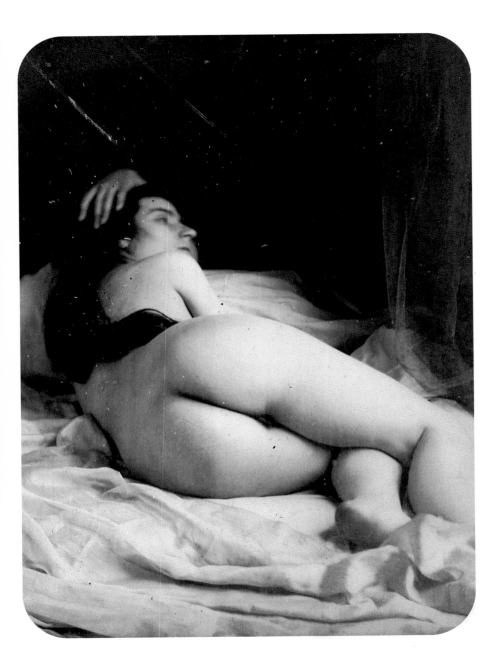

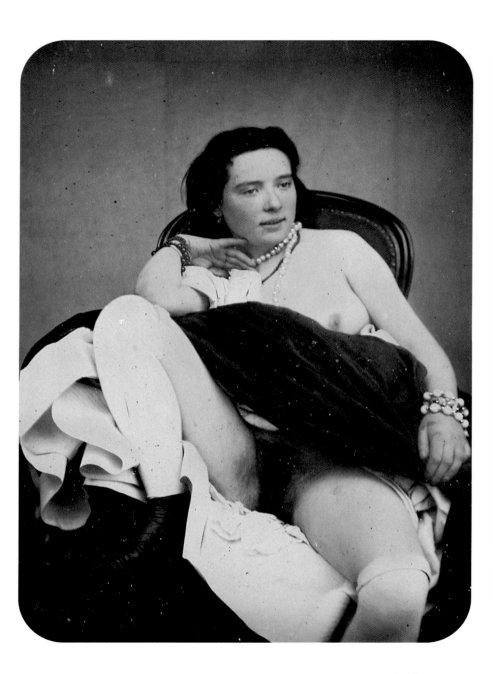

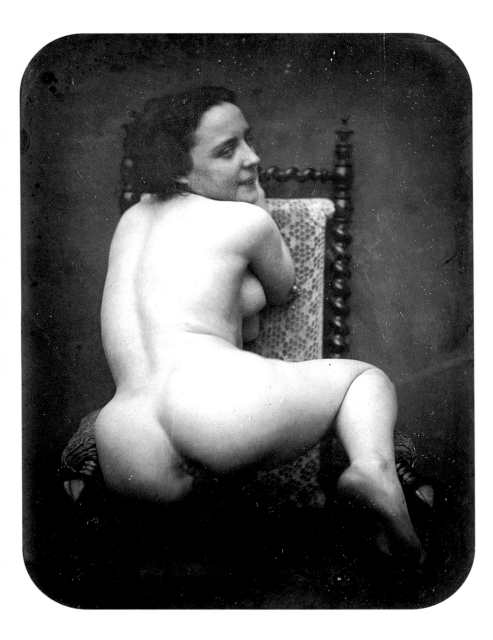

Anonymous
C. 1850

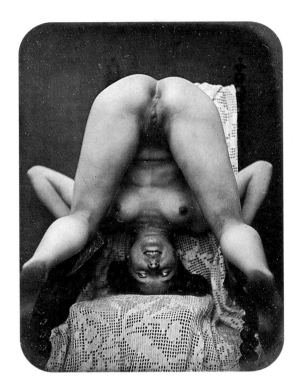

Anonymous
C. 1850

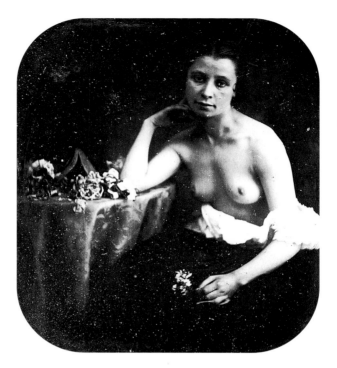

Anonymous
c. 1855

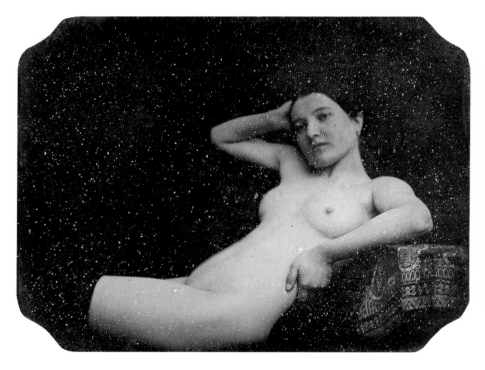

Anonymous
c. 1850

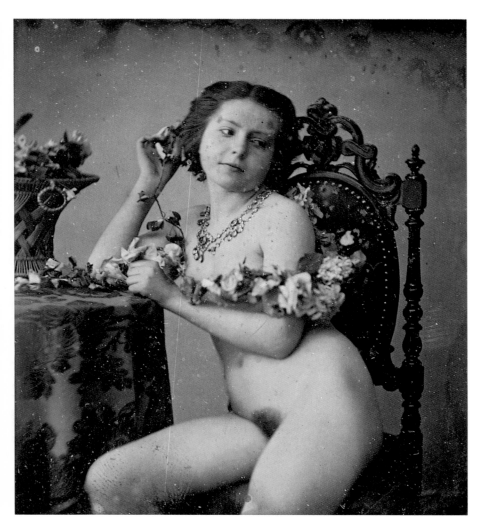

Anonymous
c. 1855

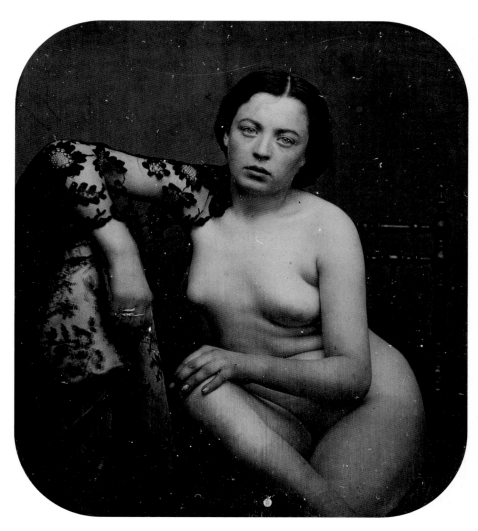

Anonymous
c. 1855

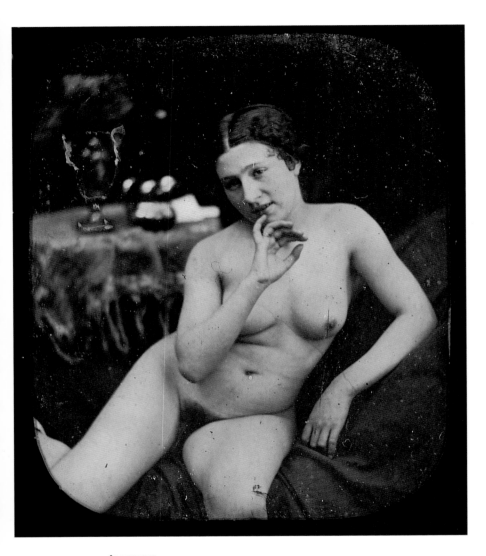

Anonymous
c. 1855

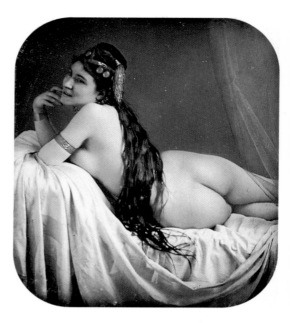

Anonymous
C. 1855

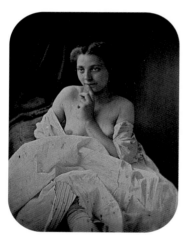

Anonymous
C. 1855

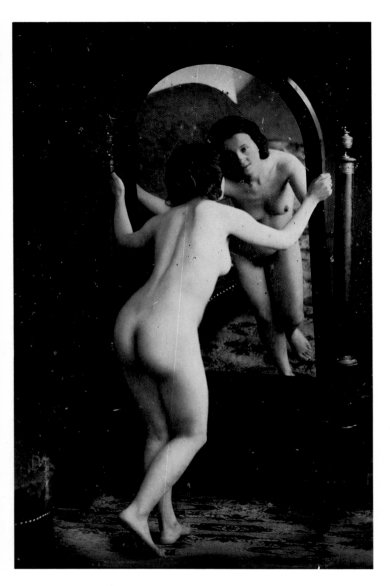

Anonymous
c. 1855
Detail

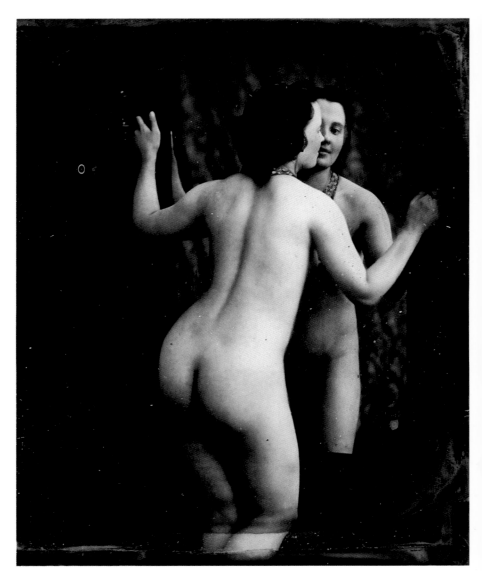

Anonymous
c. 1855

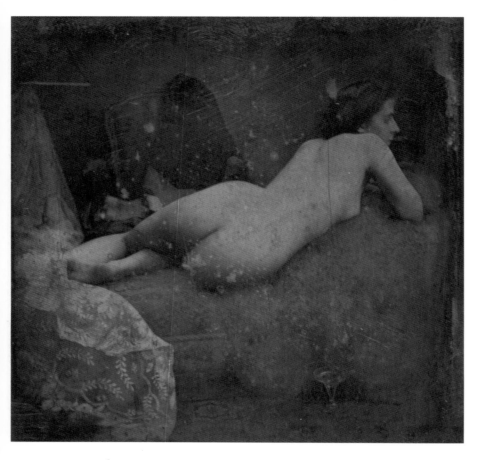

Anonymous
c. 1855

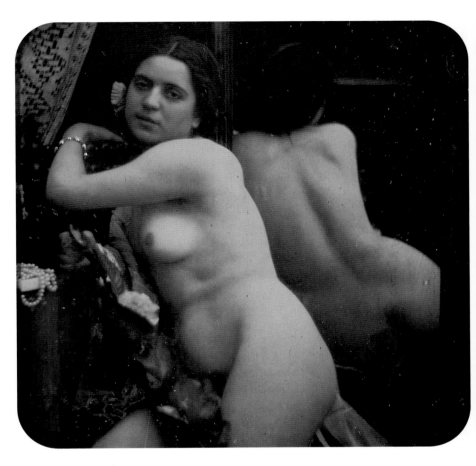

Anonymous
c. 1855
Detail

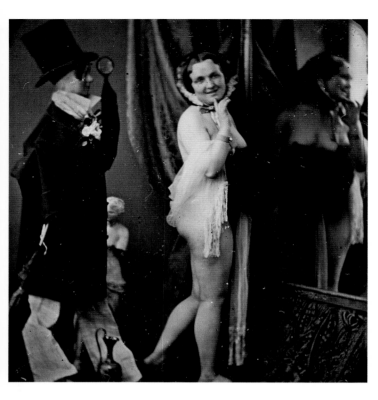

Anonymous
c. 1855

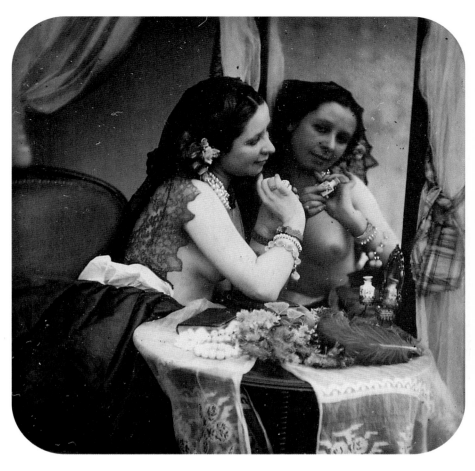

Anonymous
c. 1855

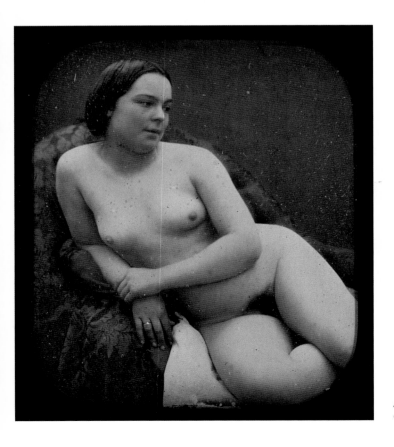

Anonymous
c. 1855

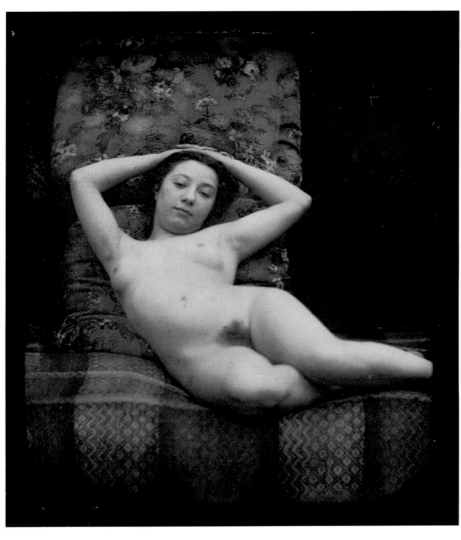

Anonymous
c. 1855

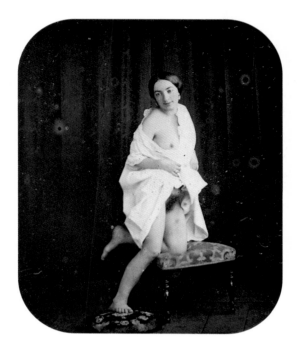

Anonymous
C. 1855

Anonymous
C. 1855

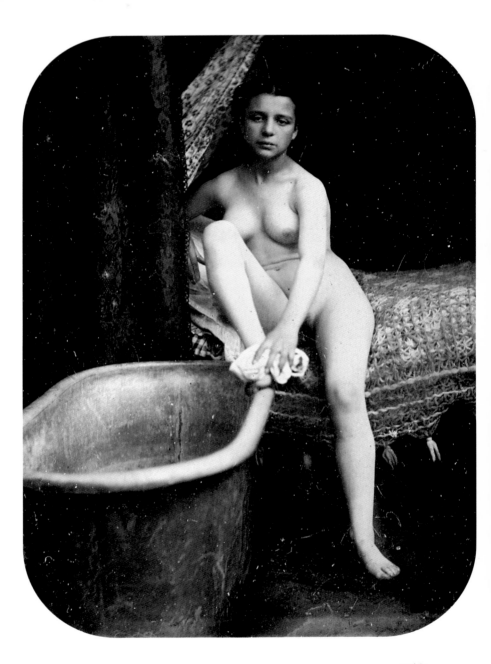

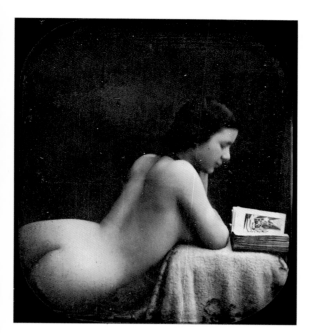

Anonymous
c. 1855

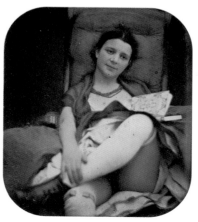

Anonymous
c. 1855

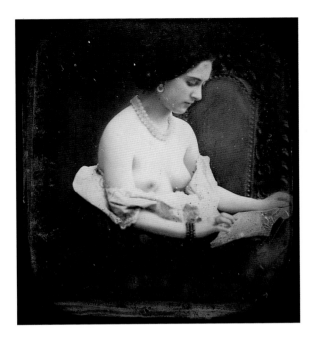

Anonymous
c. 1855

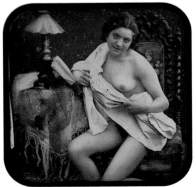

Anonymous
c. 1855

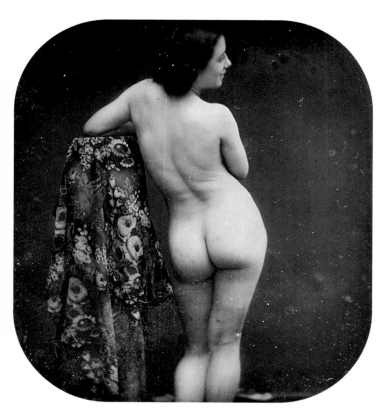

Anonymous
c. 1855

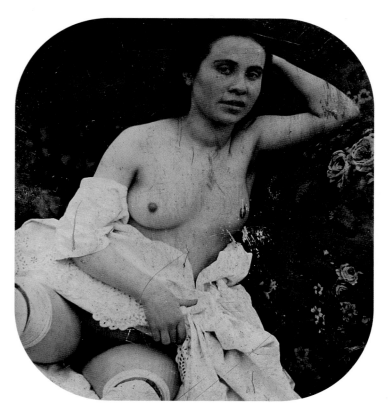

Anonymous
c. 1855

Anonymous
c. 1855

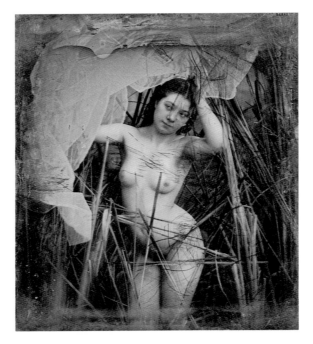

Anonymous
c. 1855

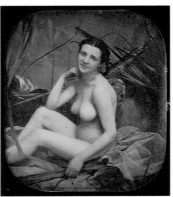

Anonymous
c. 1855

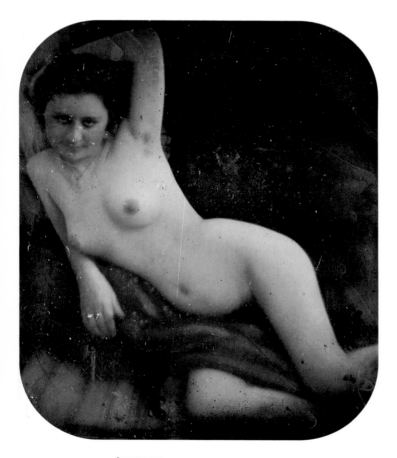

Anonymous
c. 1855

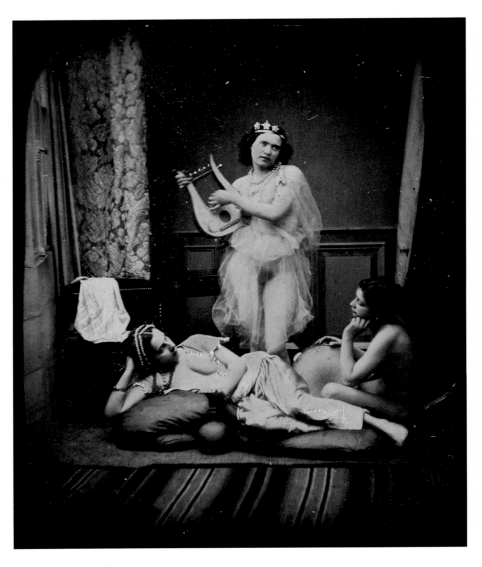

Anonymous
c. 1855

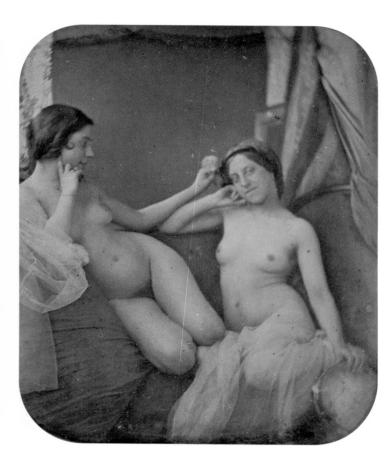

Anonymous
c. 1855

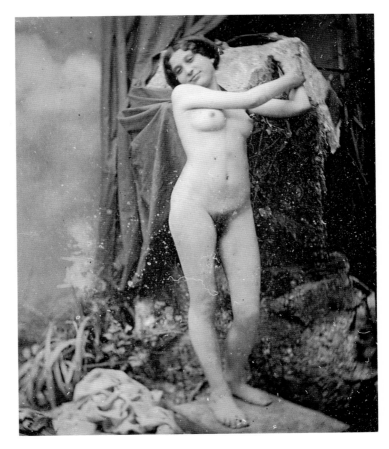

Anonymous
c. 1855

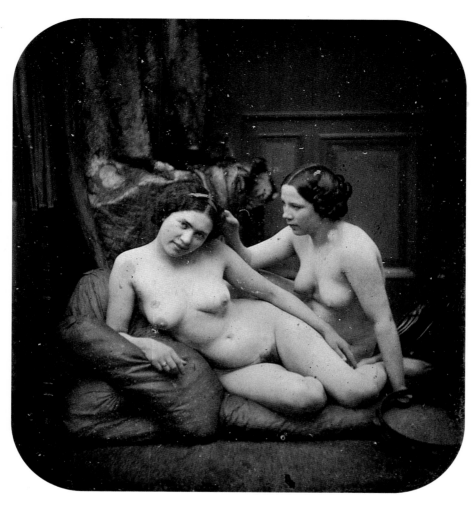

Anonymous
c. 1855

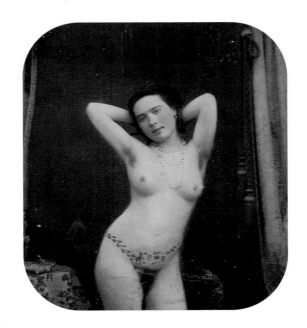

Anonymous
c. 1855

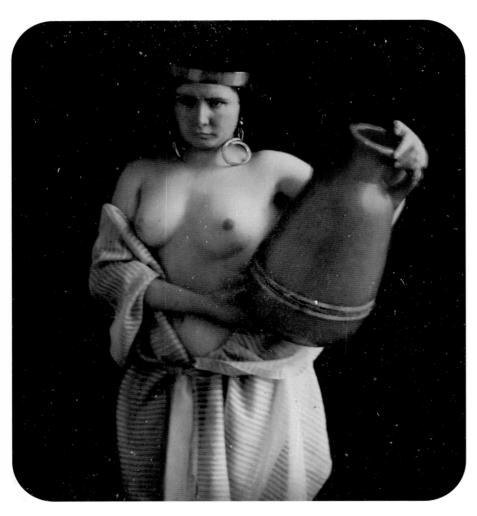

Anonymous
c. 1855

Anonymous
c. 1855
Detail

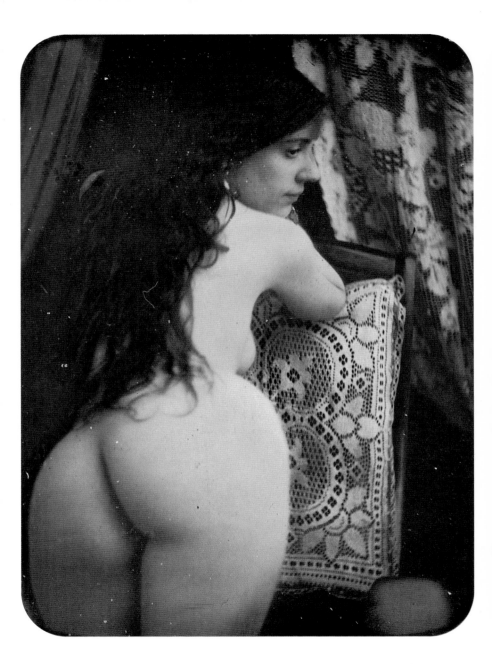

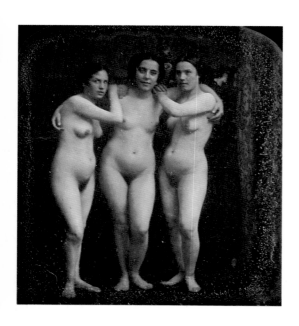

Anonymous
c. 1855

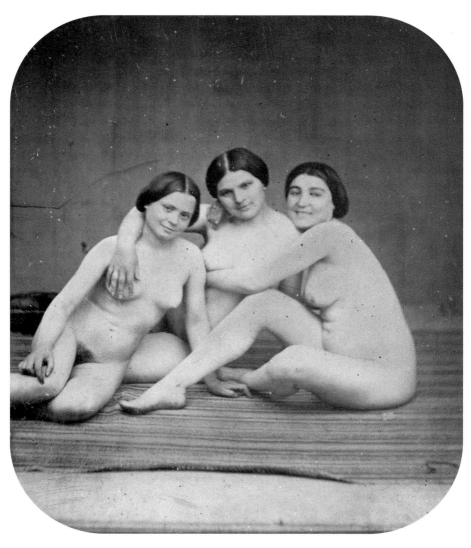

Anonymous
c. 1855

2
Academy figures: early pictures of nudes

Akademien: Die Frühzeit der Aktdarstellung

Les académies: les débuts du nu

Since the Renaissance, the naked human figure had been used by artists for study purposes, but with the advent of photography that practice took a new turn. Live models, plaster casts and copper engravings were no longer the indispensable rule: relatively fast and cheap photographic representations became available for the same purpose. The first photographs for study purposes, the so-called "academy figures", were probably taken around 1850. However, it was not the smaller and more detailed daguerreotypes but rather the tinted albumen prints that met with the artists' approval: as the result of a negative/positive process, albumen prints were cheaper to print and quite up to par with daguerreotypes as far as sheen and tonal rendering were concerned. Pioneers in this type of work include the painter Eugène Delacroix (1798–1863), who not only highly recommended the study of photographs, but also (together with the photographer Eugène Durieu) did a series of quite noteworthy "academy figures" himself. Early artistic photographs of nudes – by the likes of Vallou de Villeneuve, Berthier, Moulin and d'Olivier – owe their impact to natural poses and spare settings. Later, more extravagantly staged pictures of the nude body resorted to the art context as a pretext, using the label "academy figure" to dodge censorship. And it can be said that, generally speaking, the portfolios put out by the (for the most part) Parisian publishers specializing in the field contained figures posed more appropriately to satisfy erotic rather than academic interest. This explains the demand – lasting as it did far into the twentieth century – for "Artistic Photographs of Nudes", long after Impressionism, Expressionism and the first hintings of a break with representationalism had rendered "academy figures" meaningless. And several painters themselves – such as Munch, Bonnard or Eakins – increasingly resorted to taking pictures, using the spontaneity of snapshots as reference supports for their artistic output.

Das seit der Renaissance im Rahmen des Kunstunterrichts prakti-
zierte Studium des nackten menschlichen Körpers mündete mit
Erfindung der Fotografie in eine neue Phase. Nicht mehr unbedingt
nach lebenden Modellen, Gipsabgüssen oder Kupferstichen mußte
nun gearbeitet werden. Die vergleichsweise rasch und billig zu ver-
fertigende fotografische Körperdarstellung bot sich jetzt als brauch-
bare Vorlage für Künstler an. Erste Aufnahmen dieser Art, soge-
nannte Akademien, dürften um 1850 entstanden sein, allerdings
nicht in Gestalt kleinformatiger und spiegelnder Daguerreotypien.
Als geeigneter für Akademien erwiesen sich vielmehr getonte
Albuminabzüge, die (im Negativ-Positiv-Verfahren) preiswert herzu-
stellen waren und in Brillianz und Tonwertreichtum bereits an die
Daguerreotypie heranreichten. Zu den Pionieren der Bildgattung
zählte der Maler Eugène Delacroix (1798–1863), der nicht nur
grundsätzlich das Studium von Lichtbildern empfahl, sondern auch
(zusammen mit dem Fotografen Eugène Durieu) eine Serie bemer-
kenswerter Akademien realisierte. Frühe Künstlerakte – etwa von
Vallou de Villeneuve, Berthier, Moulin und d'Olivier – überzeugen
durch schlichte Posen und sparsames Dekor. Spätere, aufwendig ins-
zenierte Körperbilder nutzten den Kunst-Kontext, sprich: das Etikett
Akademie, um die Zensur zu unterlaufen. Tatsächlich dürfte das Gros
der meist von Pariser Spezialverlagen edierten Mappen mit entspre-
chenden Studienposen weniger akademischen als erotischen
Interessen entgegengekommen sein. Nur so erklärt sich auch der bis
weit ins 20. Jahrhundert hinein anhaltende Bedarf an »Künstlerakt-
Lichtbildern«, nachdem die eigentliche »Akademie« im Zuge von
Impressionismus, Expressionismus sowie einer sich anbahnenden
Abkehr vom Gegenständlichen ihre Bedeutung verloren hatte bzw.
Maler wie Munch, Bonnard oder Eakins vermehrt selbst zur Kamera
griffen, um ihrem Kunstverständnis gemäße Momentaufnahmen her-
zustellen.

L'étude du corps humain, qui se pratiquait depuis la Renaissance dans les ateliers d'artistes, connut un développement nouveau à partir de l'invention de la photographie. Désormais, il n'était plus indispensable de travailler d'après des modèles vivants, des moulages en plâtre ou des gravures : les nus photographiques, réalisés rapidement et à peu de frais, servirent de modèles aux artistes. Les premières «académies» apparurent vers 1850. Le petit format et l'image miroitante des daguerréotypes convenant mal à ce genre d'images, les académies furent réalisées en tirages sur papier albuminé obtenus à peu de frais par un procédé négatif-positif qui présentait une brillance et une richesse de couleurs équivalentes à celles des daguerréotypes. Le peintre Eugène Delacroix (1798-1863), un des premiers adeptes de la photographie, en recommanda l'étude et réalisa, en association avec le photographe Eugène Durieu, une remarquable série d'académies. Les premiers nus, comme ceux de Vallou de Villeneuve, Berthier, Moulin et Olivier, nous touchent par la sobriété des poses et des décors. Par la suite, le titre d'«académie» n'eut souvent plus qu'un rôle d'alibi artistique destiné à protéger de la censure des photos mettant en scène des corps nus dans un décor exubérant. En effet, si la plupart des cartes éditées par les maisons spécialisées de Paris reprenaient ce type de poses, c'était plus pour leur aspect érotique qu'académique. Voilà pourquoi les «photos de nu» exercèrent un attrait aussi durable jusqu'au 20ème siècle, tandis que les véritables «académies» perdaient toute faveur dès l'arrivée de l'impressionnisme, de l'expressionnisme et d'un certain refus du figuratif, et que des peintres comme Munch, Bonnard ou Eakins recouraient souvent à l'appareil photo pour réaliser des instantanés correspondant à leur esthétique.

Anonymous
c. 1875

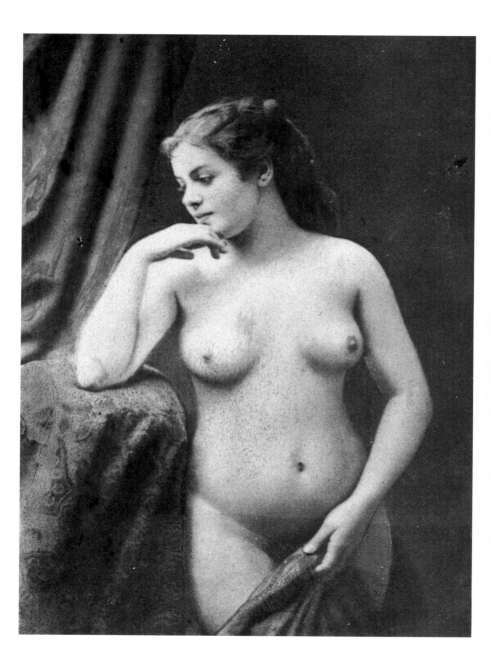

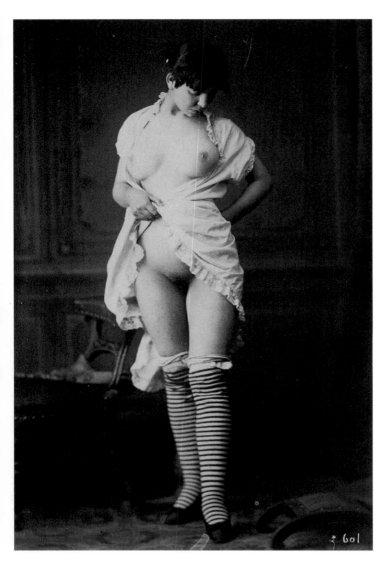

Anonymous
c. 1880

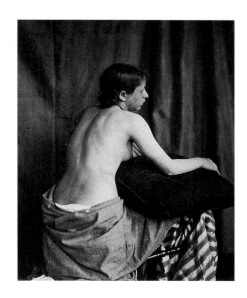

Eugène Durieu
C. 1855

Eugène Durieu
C. 1855

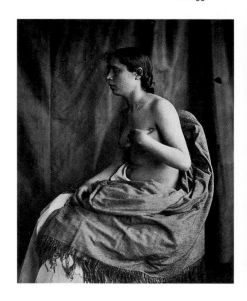

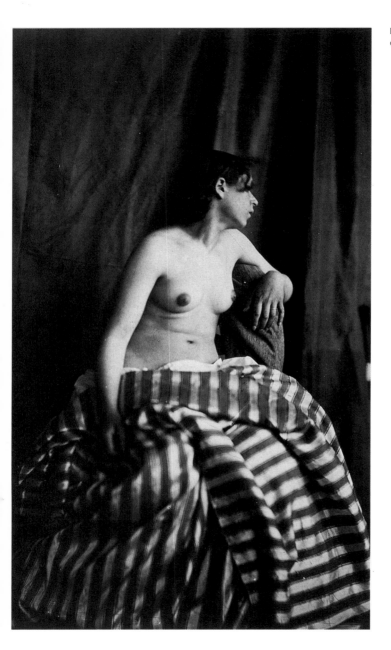

Eugène Durieu
c. 1855

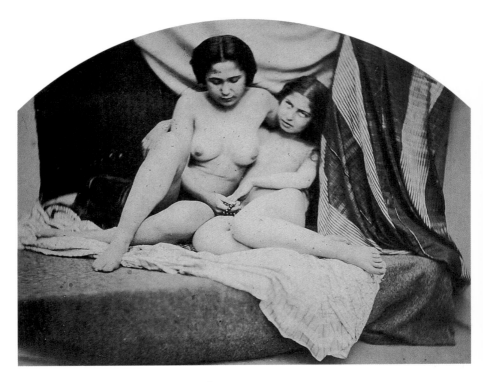

Anonymous
c. 1853

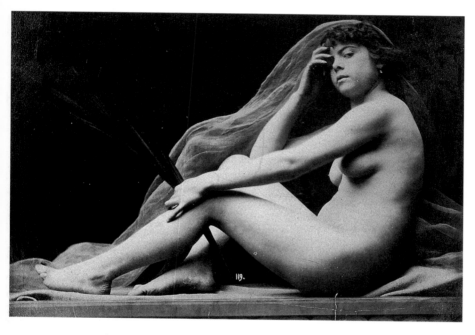

Anonymous
c. 1875

Anonymous
c. 1860

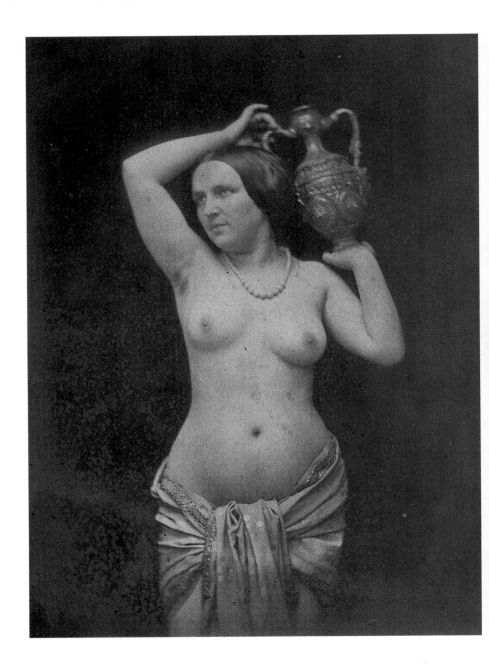

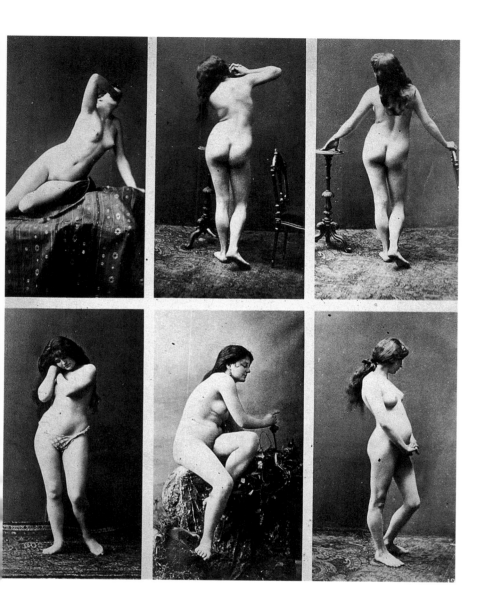

A. Calavas

c. 1895

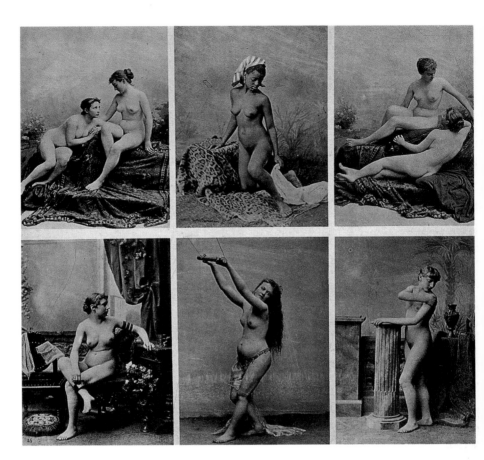

Anonymous
C. 1900

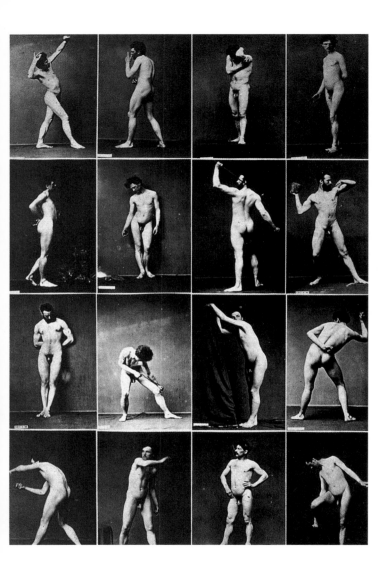

A. Calavas
c. 1895

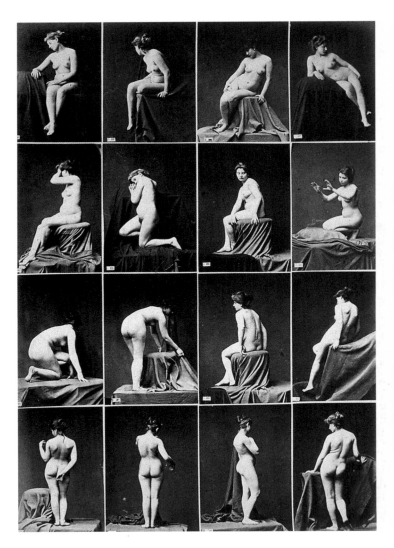

A. Calavas
c. 1895

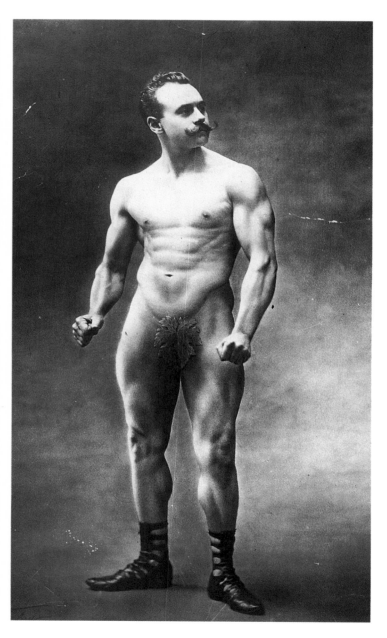

Anonymous
Collection Athlétique
c. 1890

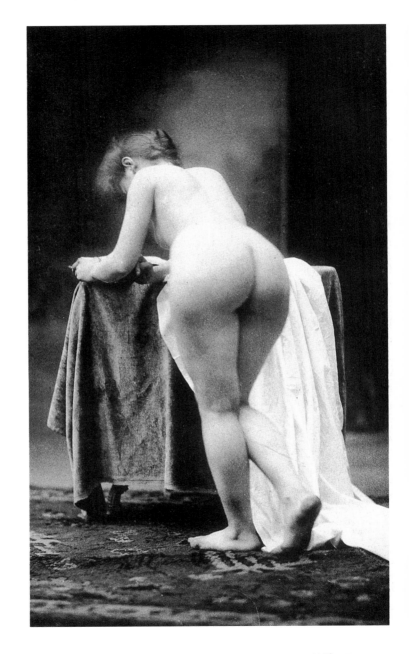

Anonymous
c. 1890

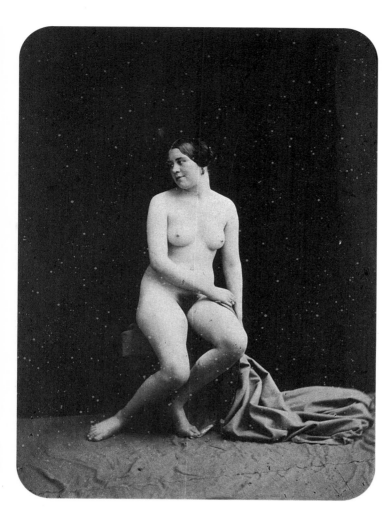

Louis Camille d'Olivier
C. 1855

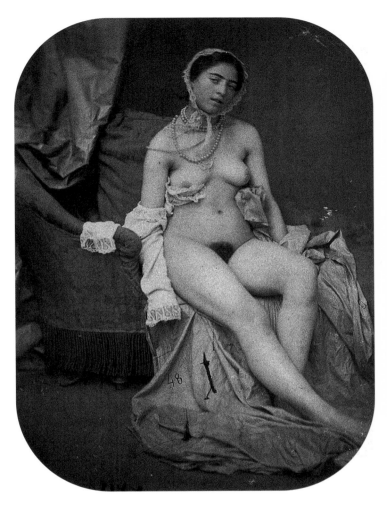

Auguste Belloc
C. 1854

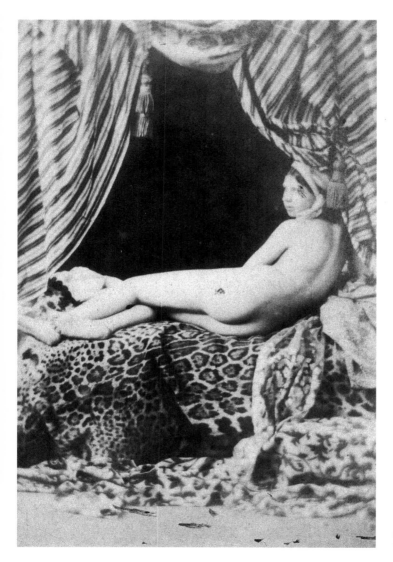

Anonymous
c. 1860

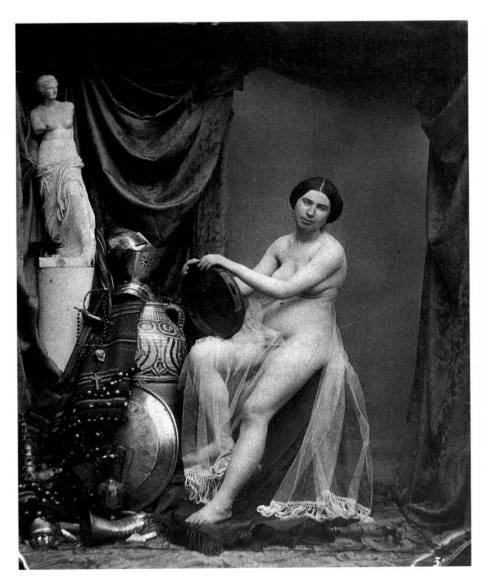

B. Braquehais
Academy Study
c. 1858

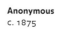

Anonymous
c. 1875

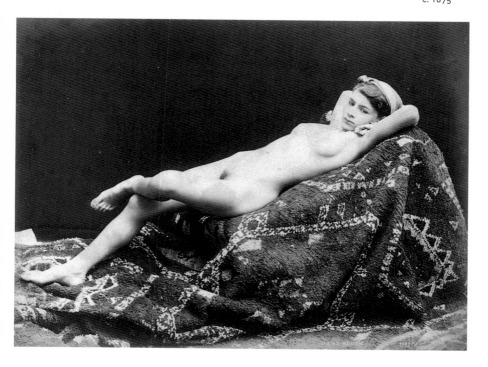

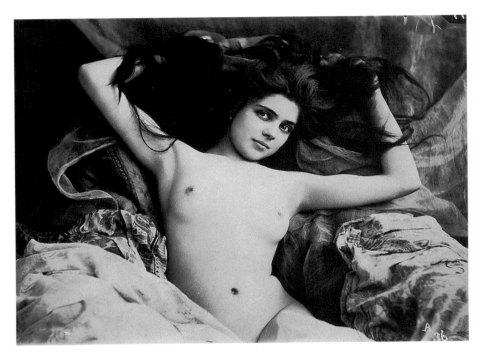

Léopold Reutlinger
c. 1890

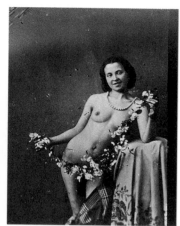

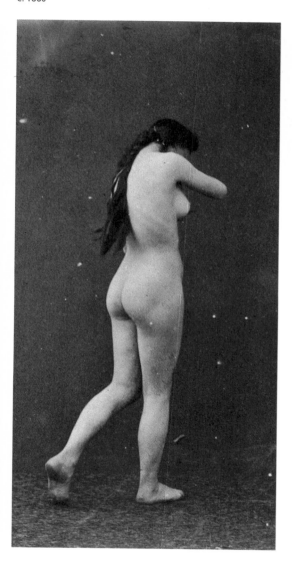

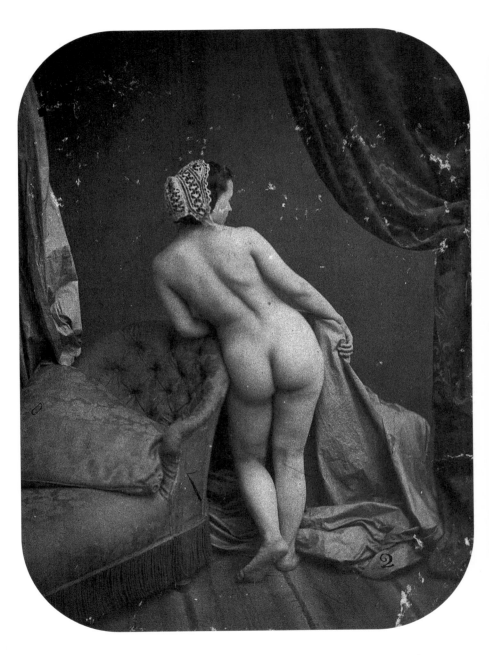

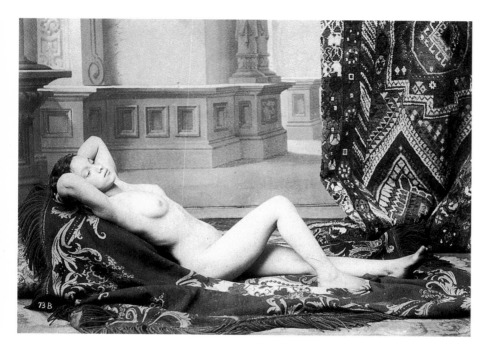

Anonymous
C. 1870

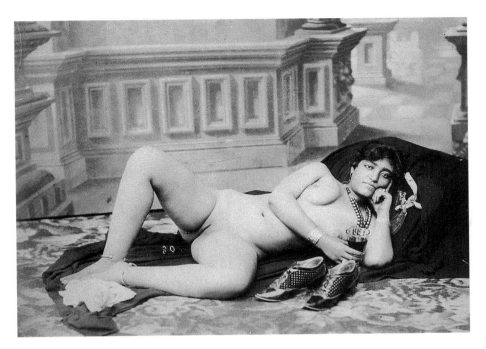

Anonymous
c. 1875

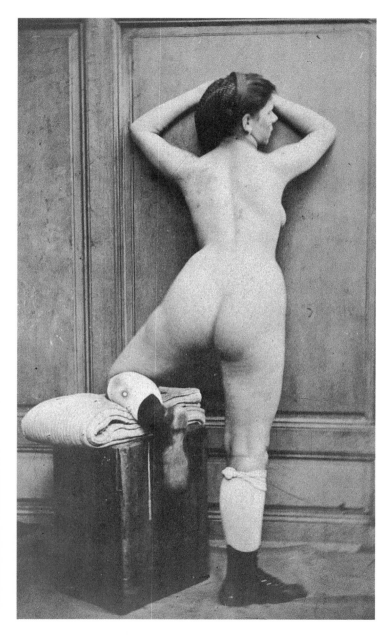

Anonymous
c. 1865

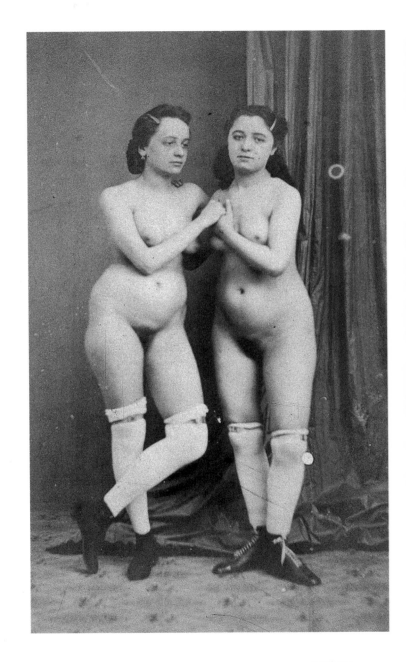

Anonymous
c. 1865

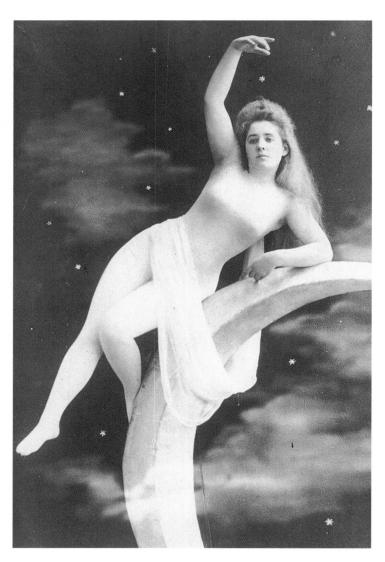

Léopold Reutlinger
Duvernoy Casino Paris
c. 1890

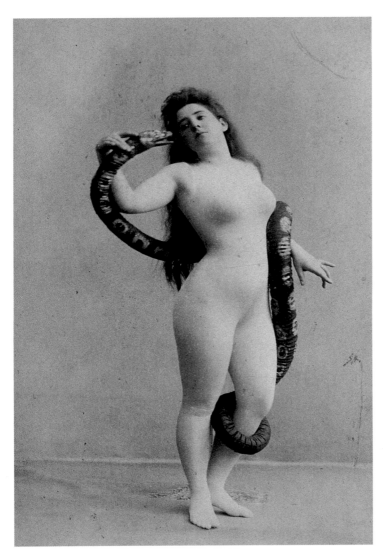

Léopold Reutlinger
Duvernoy Casino Paris
c. 1890

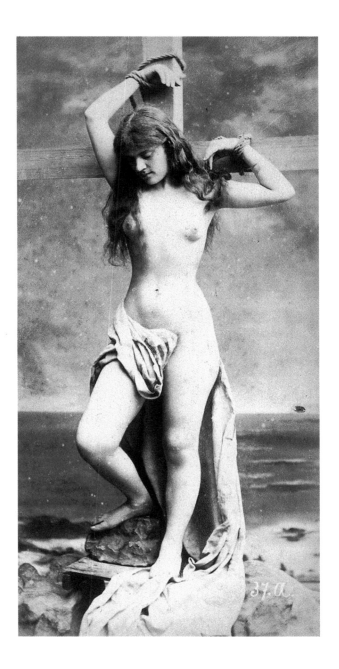

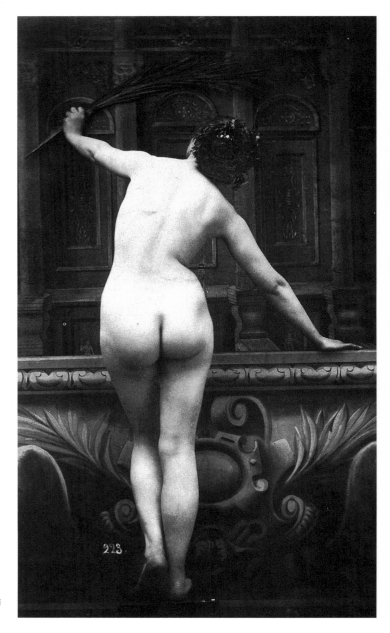

Guglielmo Marconi
c. 1870

Laborie
c. 1895

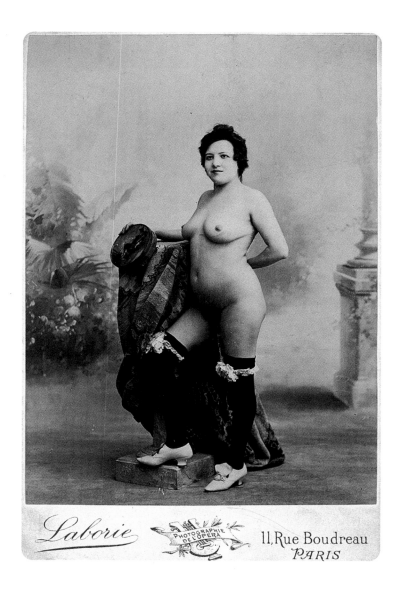

Anonymous
Study
c. 1880

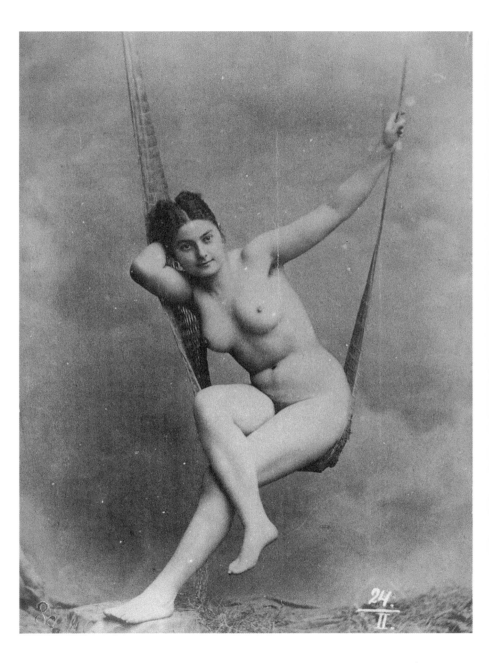

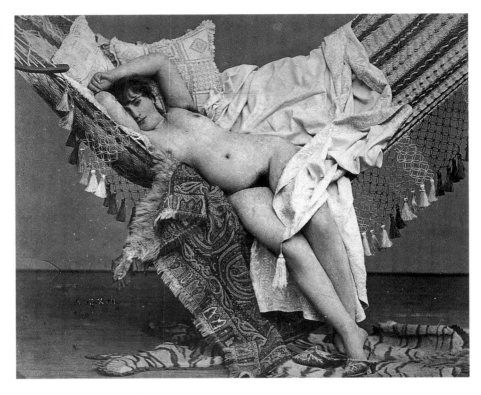

Anonymous
c. 1870

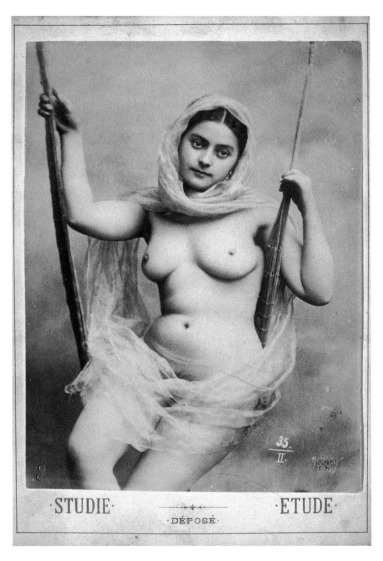

STUDIE· ·ETUDE·

·DÉPOSÉ·

Anonymous
Study
c. 1885

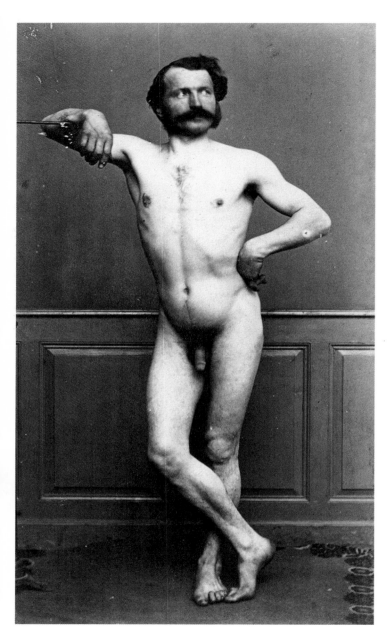

Anonymous
c. 1865

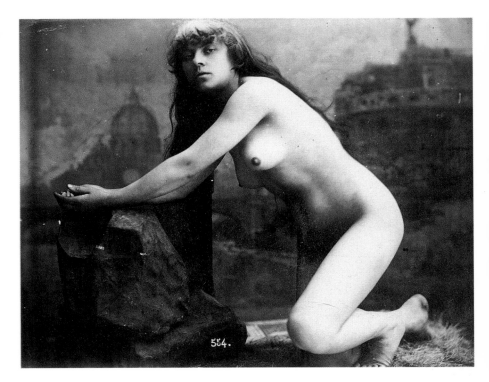

Guglielmo Marconi
c. 1870

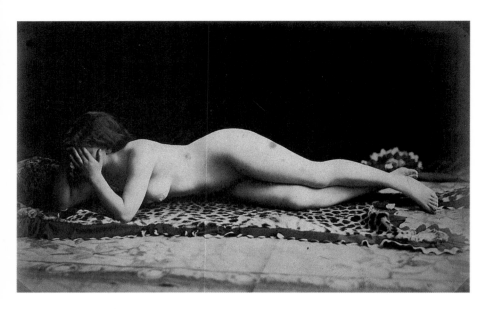

G.L. Arlaud
C. 1900

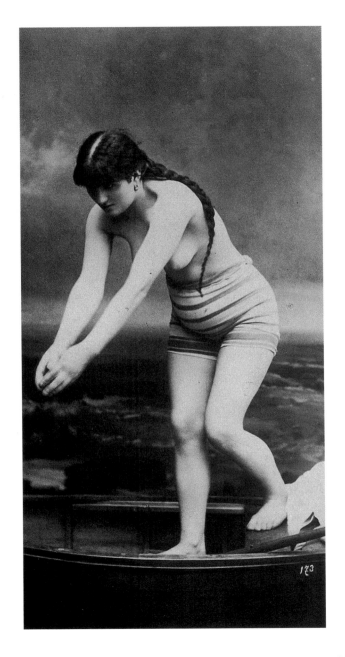

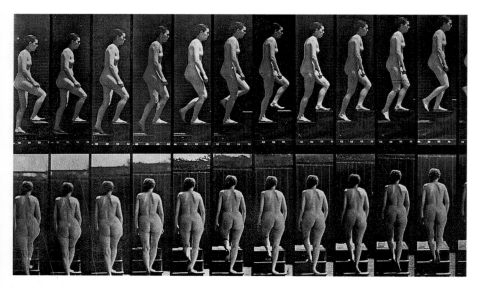

Eadweard Muybridge
Animal Locomotion
(plate 92)
1887

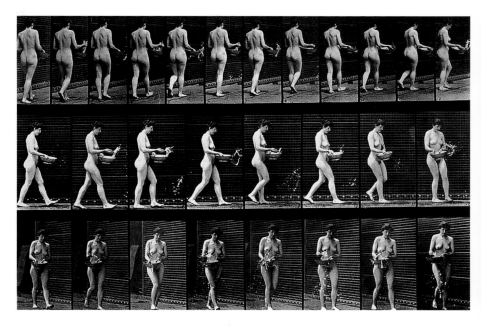

Eadweard Muybridge
Animal Locomotion
(plate 43)
1887

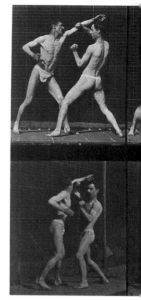

Eadweard Muybridge
Animal Locomotion
(plate 406)
1887

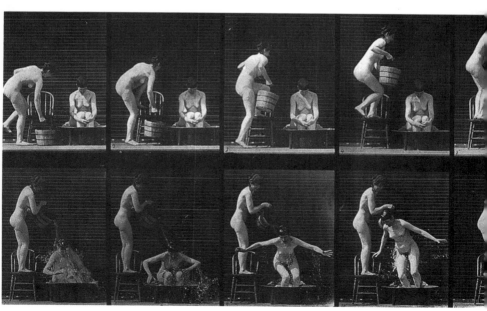

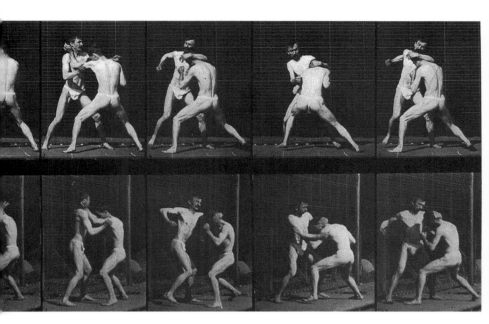

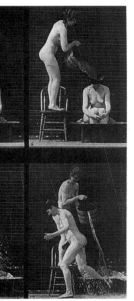

Eadweard Muybridge
Animal Locomotion
(plate 342)
1887

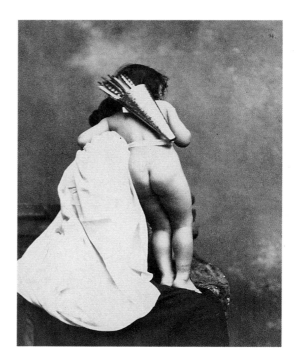

Anonymous
1891

Anonymous
1891

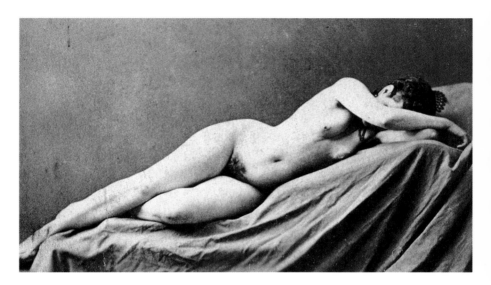

Anonymous
c. 1865

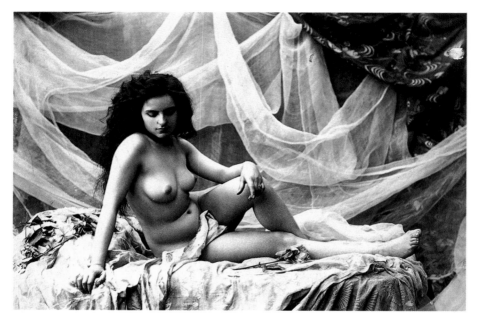

Anonymous
c. 1890

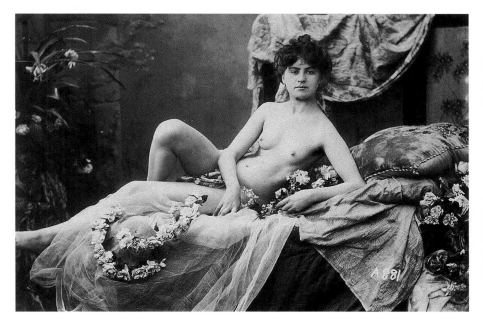

Anonymous
c. 1890

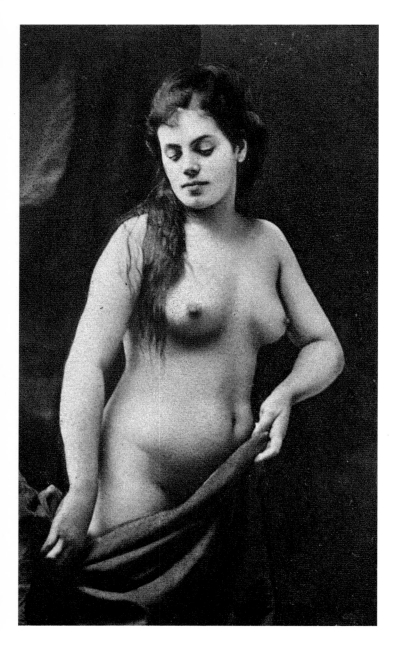

Anonymous
c. 1875

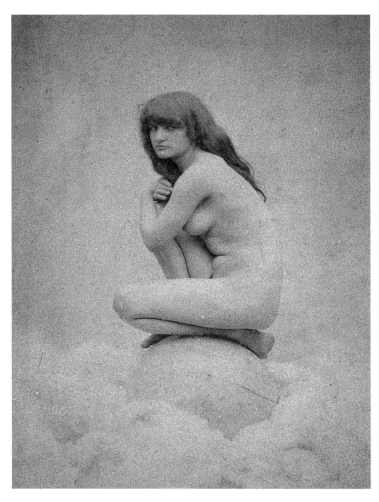

J.E. Lecadre
C. 1890

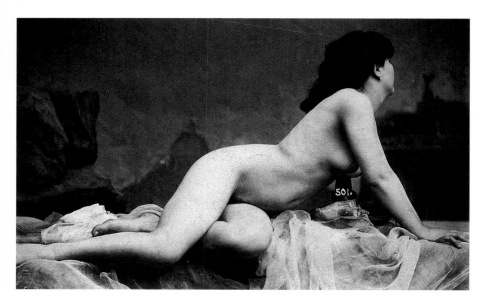

Guglielmo Marconi
c. 1870

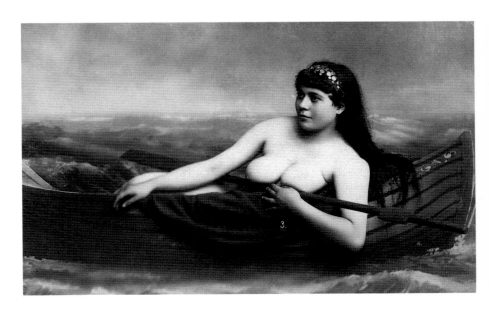

Anonymous
c. 1890

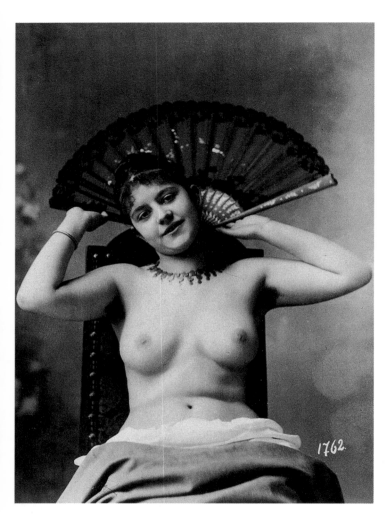

Anonymous
c. 1890

Anonymous
Exposition 1889 -
Beauty Contest No. 3
1889

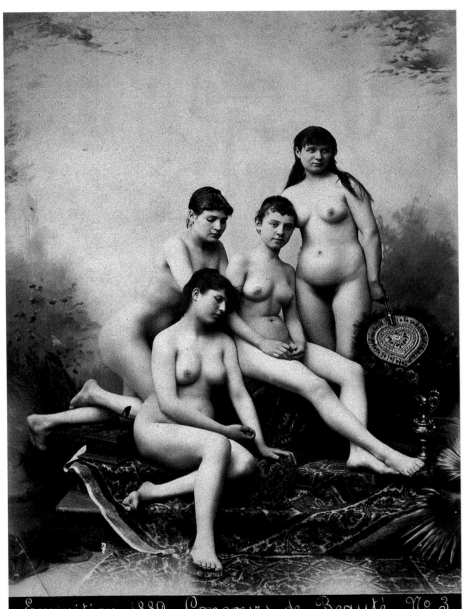

Exposition 1889. Concours de Beauté. N° 3
Déposé.

3
Saucy scenes

Pikantes und Galantes

Les scènes grivoises

While the term "daguerreotype" refers to a technical pictorial process, "postcard" to a specific means of distribution and the term "art photography" refers to aesthetic tenets that can be defined by period, "saucy scenes" are works in which the human body is staged solely with an eye to arousing the erotic interest of the paying customer. They are intended neither to impart knowledge (scientific), nor to cater to good taste (artistic). Of course, what is considered erotic, sexually stimulating, varies from person to person, from era to era and from culture to culture. There are nonetheless certain norms governing the "mise-en-scène", elements of which, much like erotic icons, can be spotted in works going from the early daguerreotypes right through to the lascivious pictorial inventions of today. If purely artistically intentioned nudes are generally shown totally unclothed, works meant to pique erotic fancy resort to the play of the now-hidden, now-revealed, in which shoes, stockings, suspender, scarves and veils, fabrics and fans are indispensable accessories. Pieces of furniture and all sorts of props were used to convey the intimacy of a boudoir, even in early images of this genre, thinly disguised as "academy figures". And the "come hither" gaze, straight at the camera, represents one of the "timeless" constants of erotic photography's resources. During the heyday of the daguerreotype, erotic motifs were comparatively rare (due to the technical limitations of the process) and hence rather costly for the average purse. But with the advent of the negative/positive process, of stereoscopic and visiting cards (as of 1850), and of postcards (as of 1870), what could be termed as the industrialization of the erotic gaze soon took place. The world capital in matters of output and distribution was (until the end of World War II) Paris, which explains why erotic photography was, more often than not, publicized as "Parisian photos".

Während der Begriff Daguerreotypie auf ein technisches Bildverfahren, die Postkarte auf eine spezifische Distributionsform und der Terminus Kunstfotografie auf ein zeitlich eingrenzbares ästhetisches Programm verweisen, steht die »Pikanterie« oder »Galanterie« für eine besondere Form der Körperinszenierung, die sich weder an das Erkenntnisinteresse (Stichwort Wissenschaft) noch an den guten Geschmack (Stichwort Kunst), sondern allein an die erotischen Interessen des zahlenden Kunden wendet. Was als erotisch, also sexuell stimulierend empfunden wird, ist zwar von Mensch zu Mensch, von Epoche zu Epoche und von Kultur zu Kultur verschieden. Gleichwohl gibt es aber Standards der »mise-enscène«, die sich als Elemente einer Ikonographie des Erotischen von den frühen Daguerreotypien bis hin zu den lasziven Bildfindungen der Gegenwart nachweisen lassen. Gehorcht der künstlerisch ambitionierte Akt in der Regel dem Gebot vollständiger Nacktheit, so baut die Pikanterie auf den Reiz des Verhüllens und Enthüllens. Schuhe, Strümpfe, Strapse, Schals und Schleier, Tücher und Fächer gehören folglich zu den unabdingbaren Requisiten erotischer Inszenierungskunst. Möbel und allerhand Requisiten sorgten bereits auf frühen, als »Akademien« getarnten Galanterien für intime Boudoir-Atmosphäre. Auch der aufmunternde Blick ins Objektiv zählt zu den »überzeitlichen« Konstanten im Fundus erotischer Fotografie. Waren erotische Motive im Zeitalter der Daguerreotypie (aufgrund der technischen Eigenheiten des Verfahrens) noch vergleichsweise rar und somit für einen durchschnittlichen Geldbeutel kaum erschwinglich, so setzte mit Einführung des Negativ-Positiv-Prozesses, der Stereo- und Visitkarte (nach 1850) sowie der Postkarte (nach 1870) das ein, was man als Industrialisierung des erotischen Blicks bezeichnen könnte. Welthauptstadt in Sachen Produktion und Distribution war (bis Ende des Zweiten Weltkriegs) Paris, weshalb Fotoerotica nicht selten als »Pariser Foto« angeboten wurden.

Alors que le daguerréotype renvoie à un procédé photographique, la carte postale à un support spécifique, et la notion de «pictorialisme» à un courant artistique précisément délimité dans le temps, la scène grivoise est une façon particulière de mettre en scène le corps, qui ne repose ni sur l'intérêt documentaire (aspect scientifique), ni sur le bon goût (aspect artistique), mais uniquement sur les attentes érotiques d'une clientèle prête à payer. Certes, la notion d'érotique, c'est-à-dire de ce qui est ressenti comme une stimulation sexuelle, varie en fonction des individus, des époque et des cultures. En revanche, certains éléments de mise en scène sont de véritables constantes de l'iconographie érotique, depuis les premiers daguerréotypes jusqu'aux images scabreuses d'aujourd'hui. Alors que le nu à ambition artistique obéit en général à la loi de la nudité totale, les images grivoises, elles, reposent sur le charme du corps qu'on voile et qu'on dévoile. Chaussures, bas, jarretelles, foulards et voiles, étoffes et éventails, sont ainsi des accessoires indispensables de la mise en scène érotique. Dès les premières scènes grivoises, dissimulées sous le titre d'«académies», meubles et accessoires servaient à recréer l'atmosphère intime du boudoir. Le regard aguicheur face à l'objectif est une autre constante de la photographie érotique. Alors qu'à l'époque du daguerréotype, du fait des caractéristiques techniques du procédé, les scènes érotiques étaient encore relativement rares et beaucoup trop chères pour des budgets moyens, l'apparition du procédé négatif-positif, de la carte stéréoscopique et de visite (après 1850), puis de la carte postale (après 1870), fut le point de départ d'une véritable industrie de l'image érotique. Jusqu'à la fin de la Deuxième Guerre, Paris fut la capitale mondiale en matière de production et de diffusion d'images érotiques, ce qui explique qu'elles étaient souvent désignées à l'étranger sous le nom de «photos de Paris».

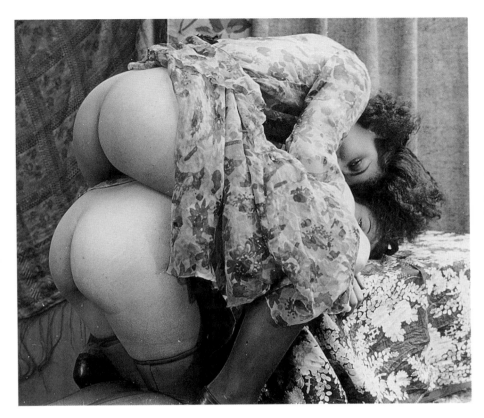

Anonymous
C. 1920

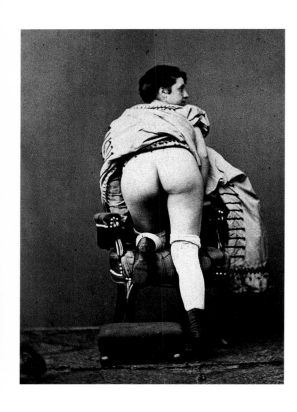

Anonymous
c. 1865

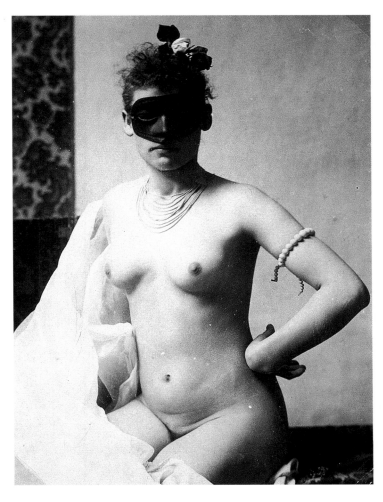

Anonymous
c. 1890

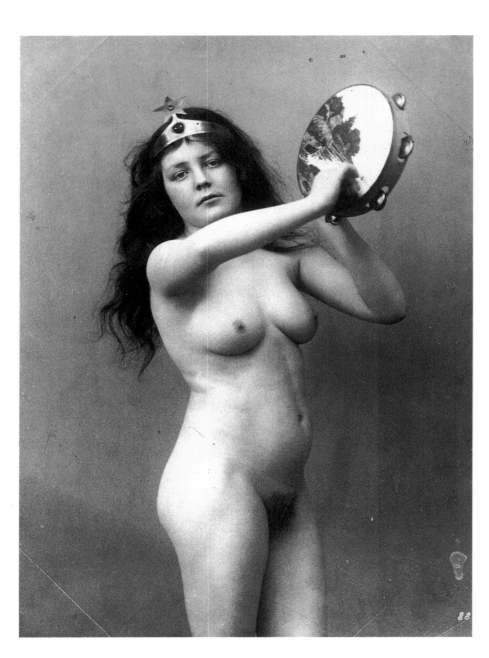

Guglielmo Marconi
c. 1870

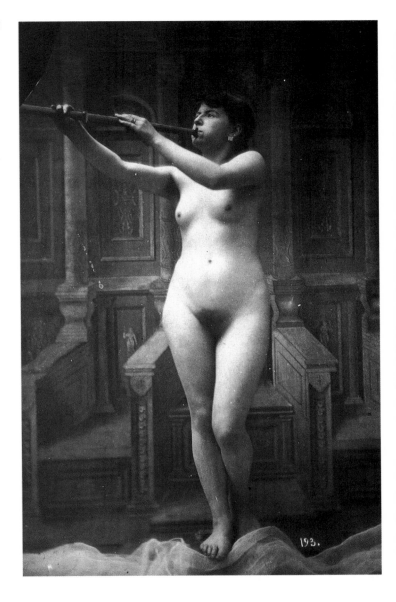

Anonymous
c. 1890

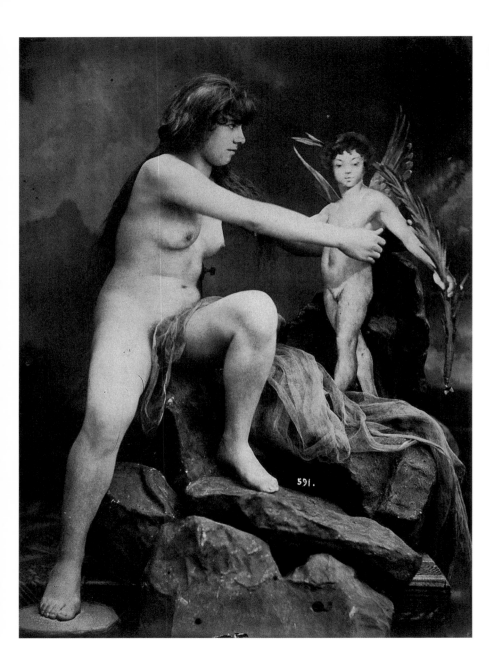

591.

Guglielmo Marconi
c. 1870

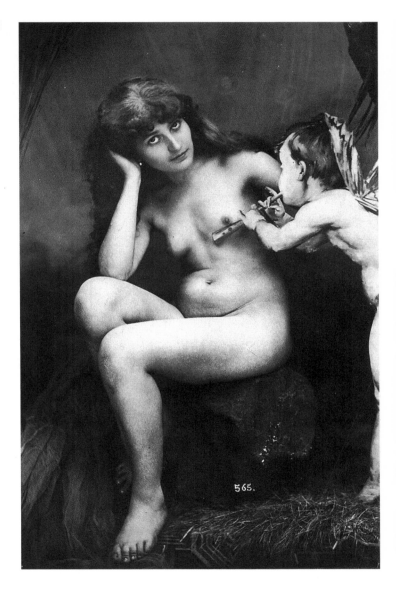

Guglielmo Marconi
c. 1870

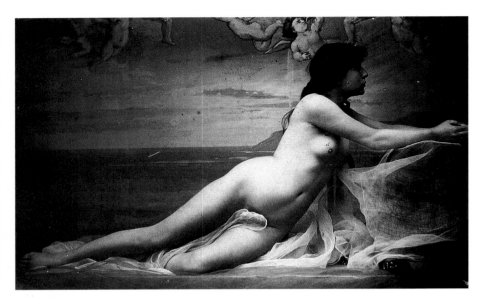

Guglielmo Marconi
c. 1870

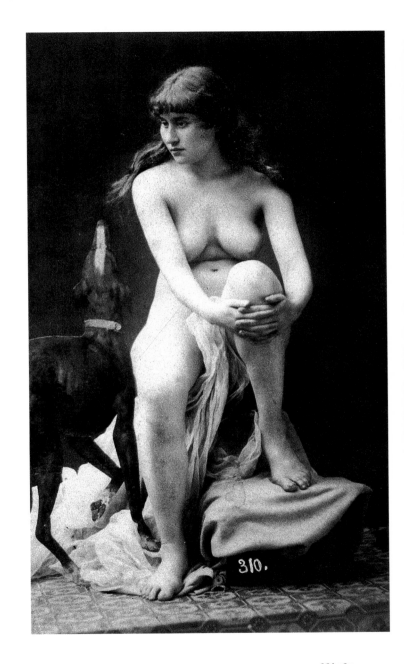

Anonymous
c. 1875

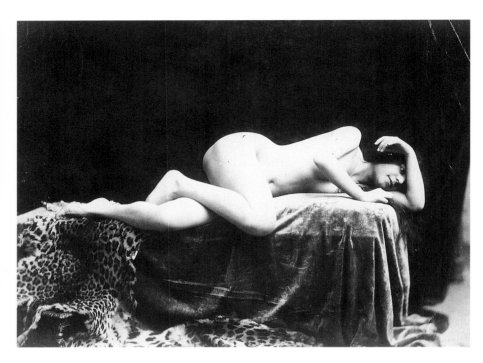

Anonymous
c. 1890

Anonymous
c. 1890

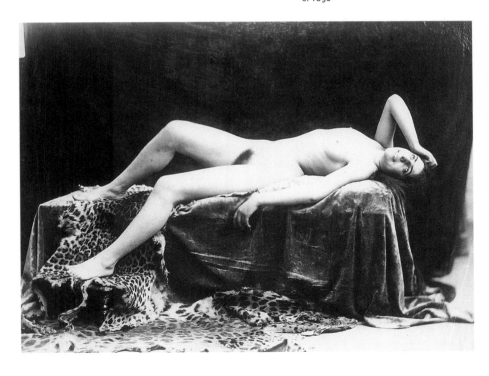

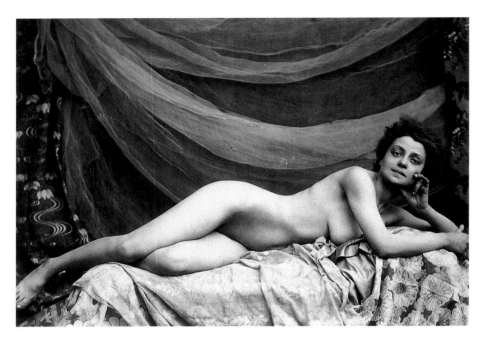

Anonymous
c. 1890

Anonymous
c. 1890

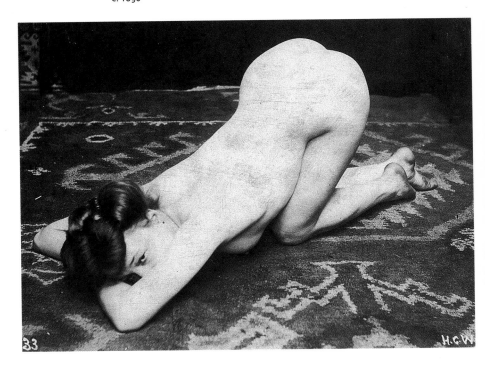

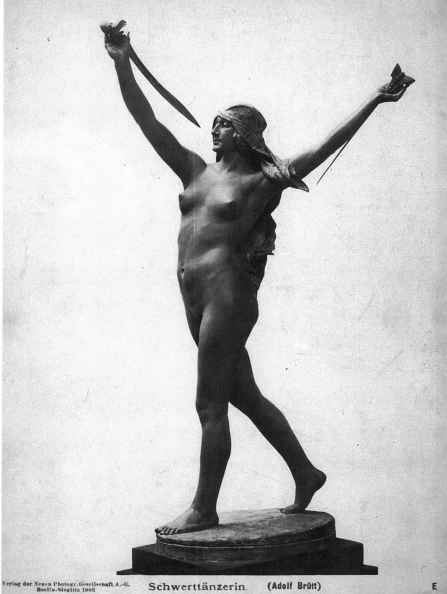

Verlag der Neuen Photogr. Gesellschaft A.-G.
Berlin-Steglitz 1903

Schwerttänzerin. (Adolf Brütt)

E 3

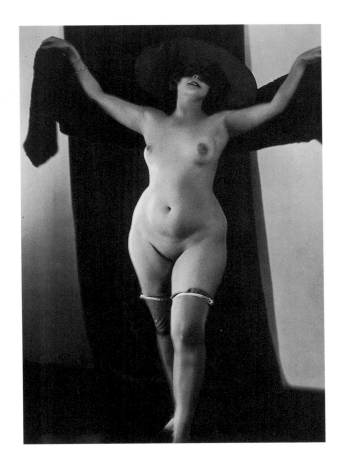

Albert Wyndham
c. 1900

Adolf Brütt
Sword Dancer
c. 1890

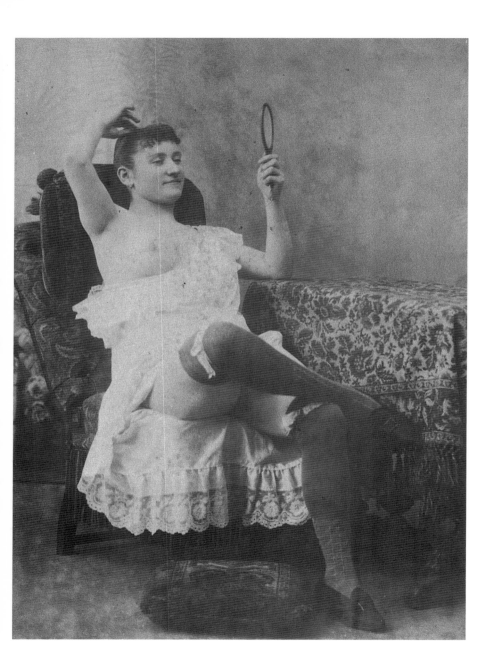

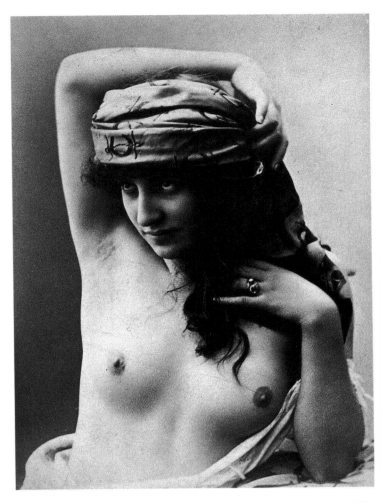

S.B. Farren and Son
c. 1890

Anonymous
c. 1890

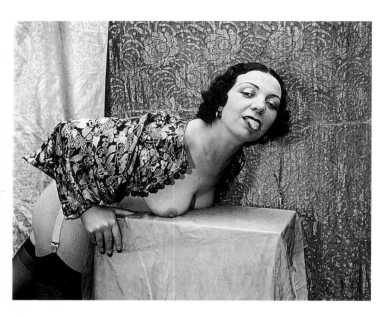

Anonymous
C. 1920

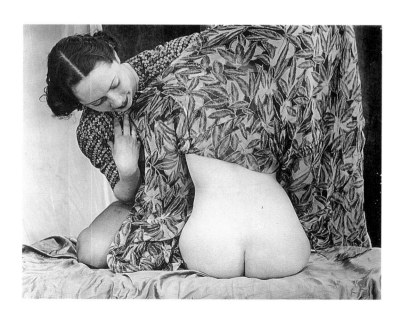

Anonymous
C. 1920

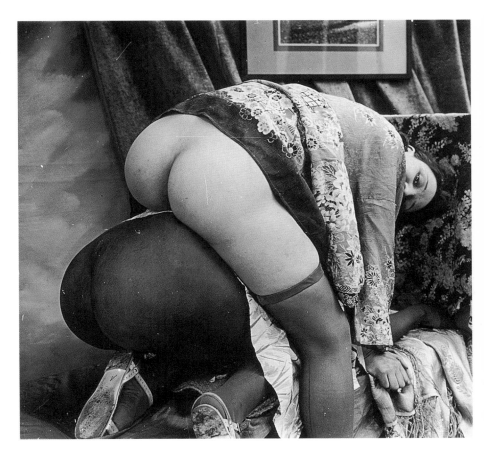

Anonymous
C. 1920

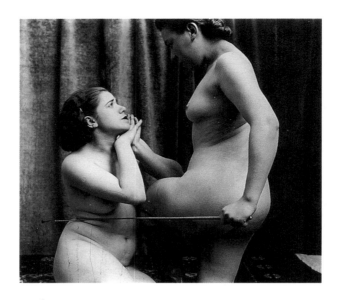

Anonymous
C. 1920

Anonymous
C. 1920

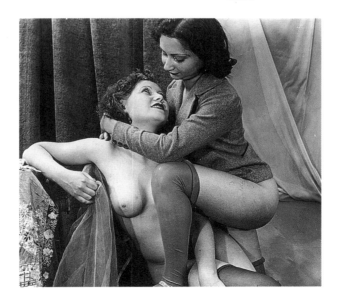

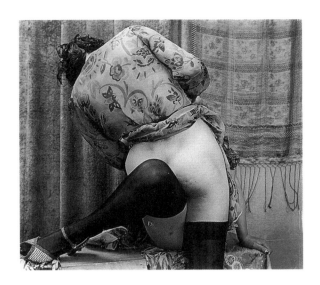

Anonymous
C. 1920

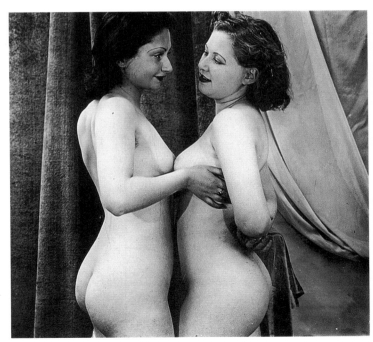

Anonymous
C. 1920

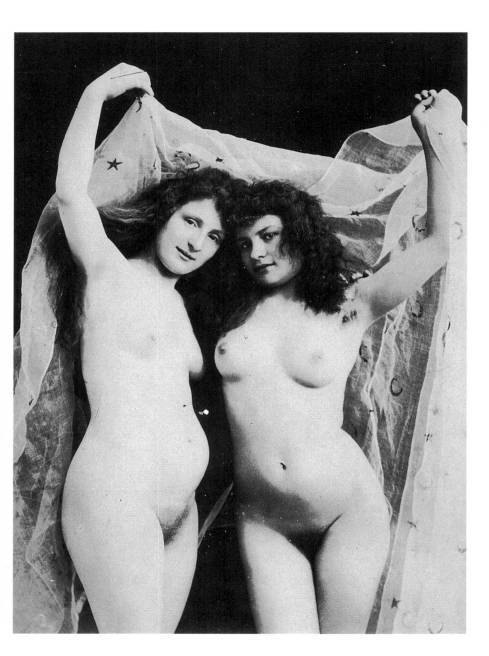

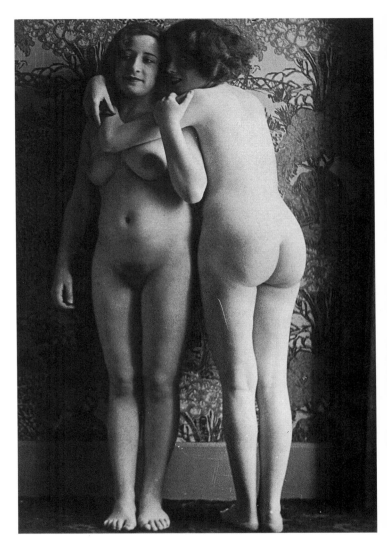

Anonymous
c. 1920

Anonymous
c. 1885

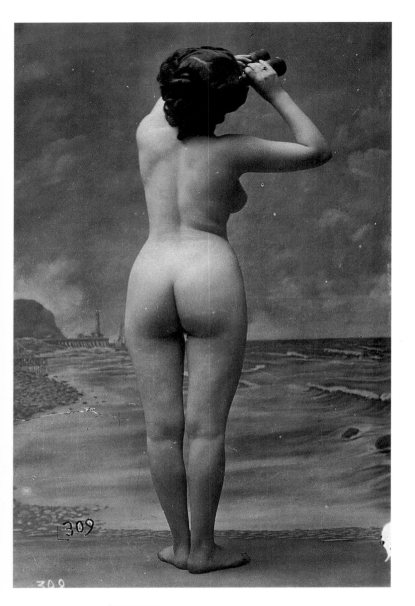

Anonymous
c. 1890

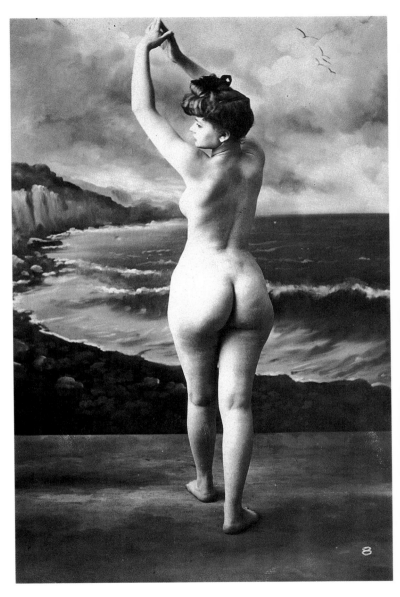

Anonymous
c. 1890

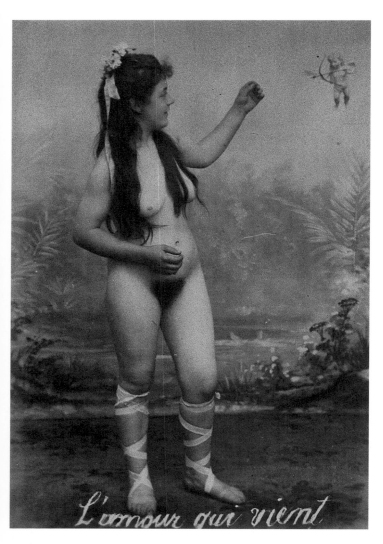

L'amour qui vient

Anonymous
Love comes
c. 1890

Anonymous
Buy the apples!
c. 1890

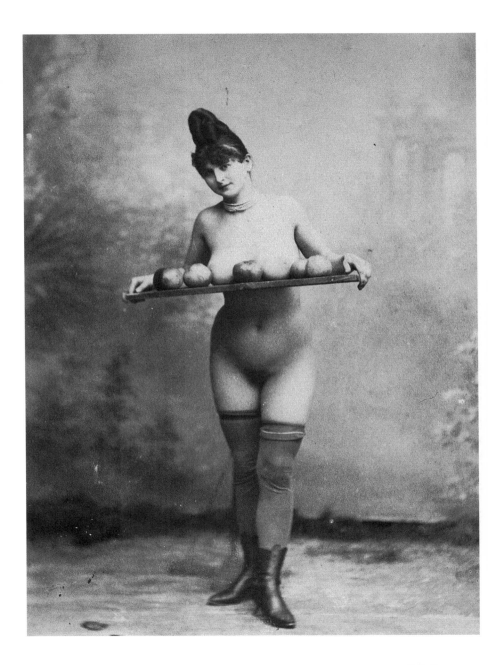

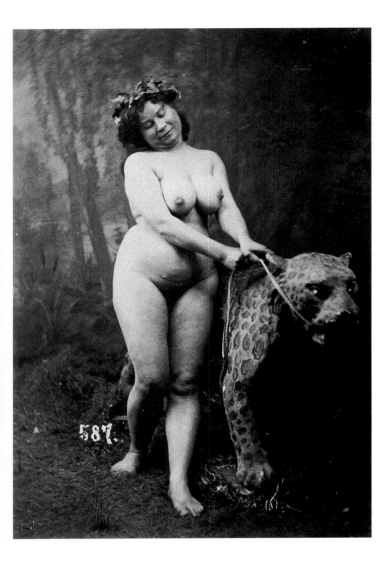

Anonymous
c. 1890

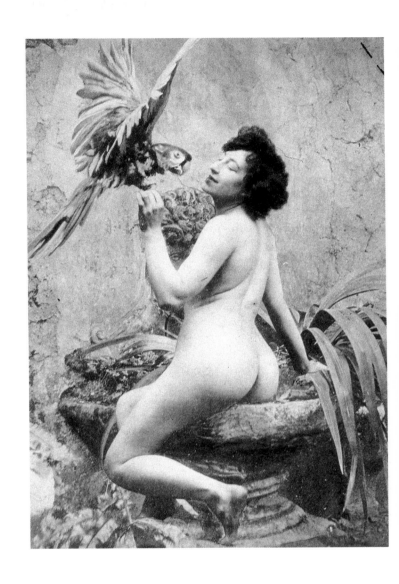

Anonymous
c. 1890

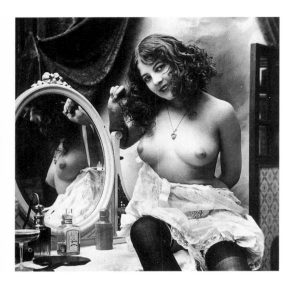

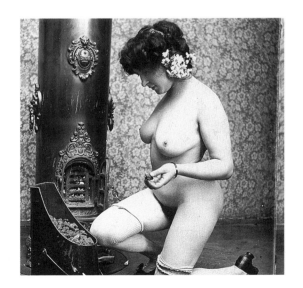

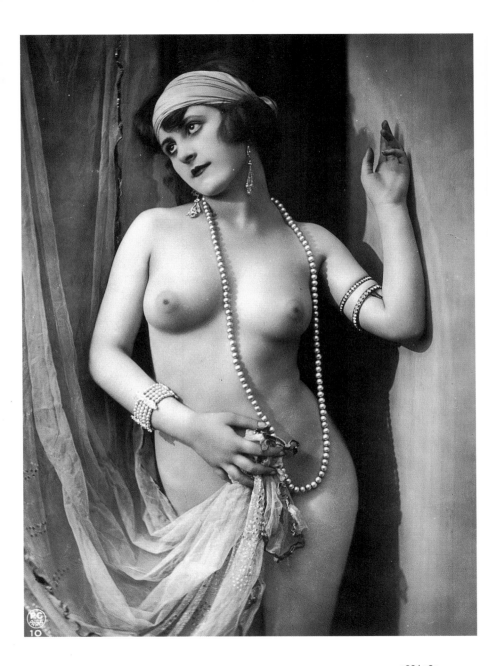

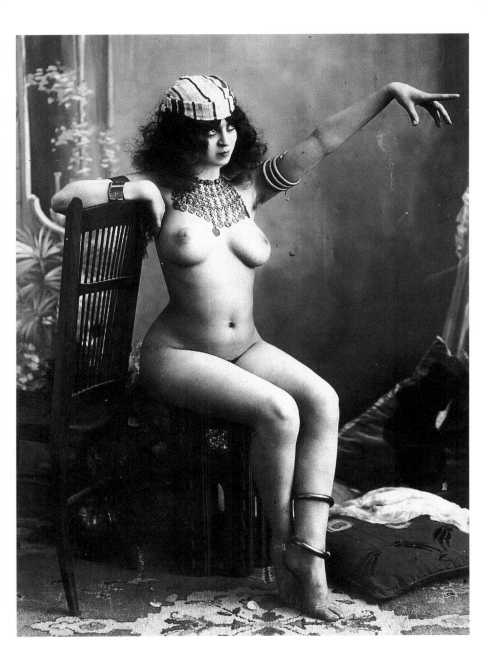

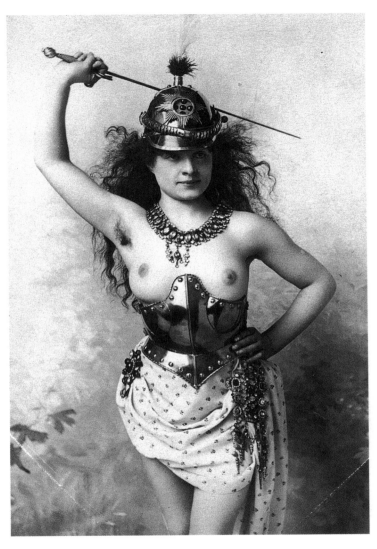

Anonymous
c. 1900

Anonymous
c. 1900

Anonymous
C. 1920

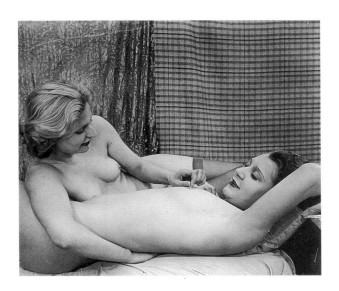

Anonymous
C. 1920

Anonymous
C. 1920

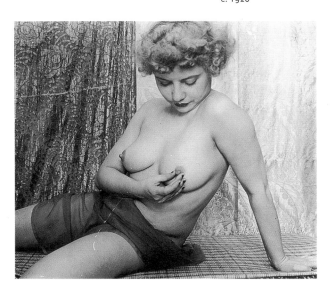

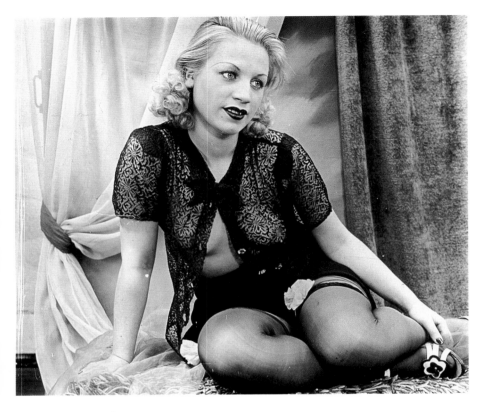

Anonymous
C. 1920

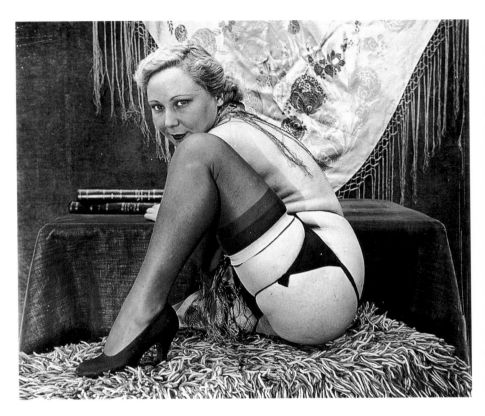

Anonymous
C. 1920

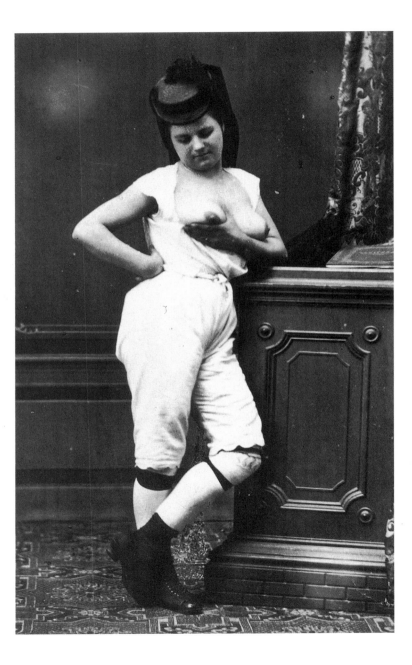

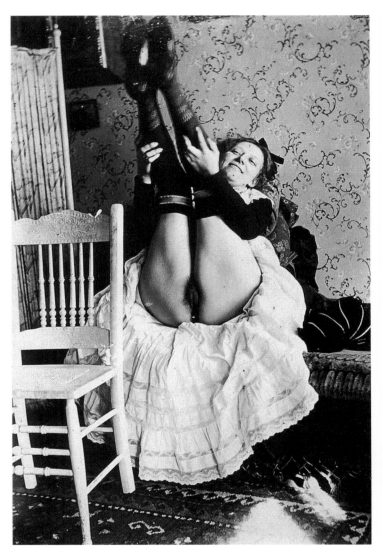

Anonymous
c. 1890

Anonymous
c. 1870

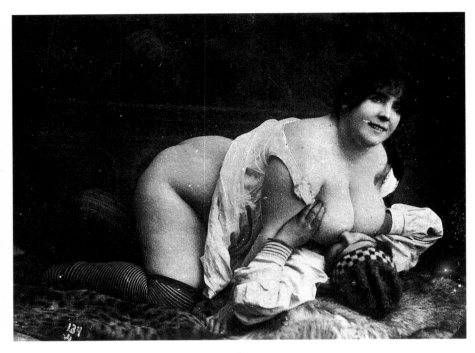

Anonymous
c. 1890

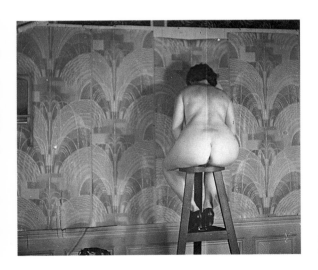

Anonymous
c. 1920

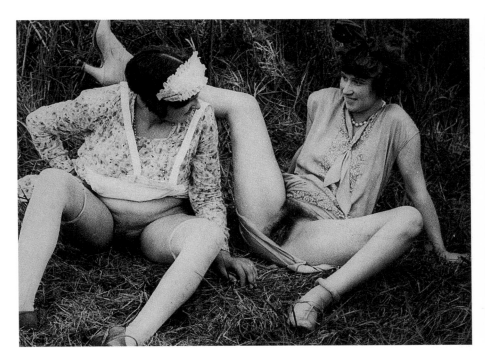

Anonymous
C. 1920

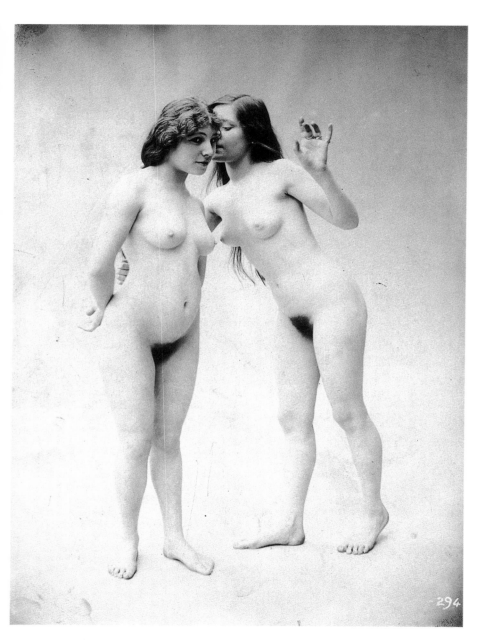

294

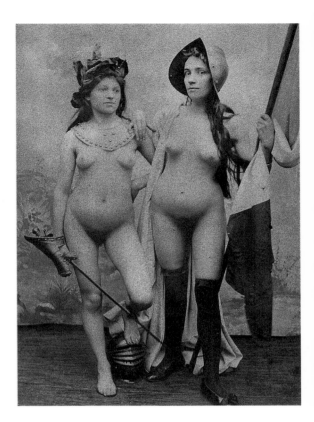

Anonymous
c. 1890

Anonymous
c. 1900

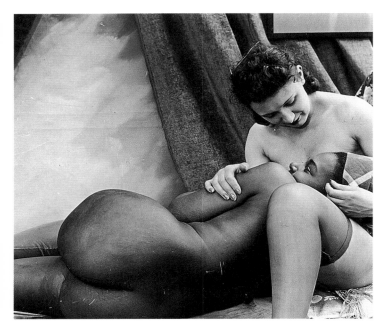

Anonymous
C. 1920

Anonymous
C. 1920

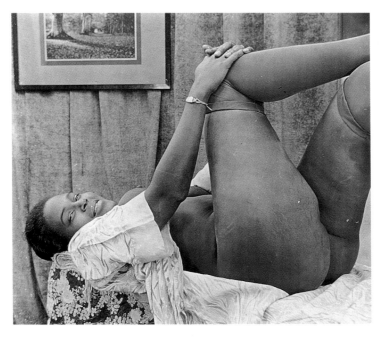

Anonymous
C. 1920

Anonymous
C. 1920

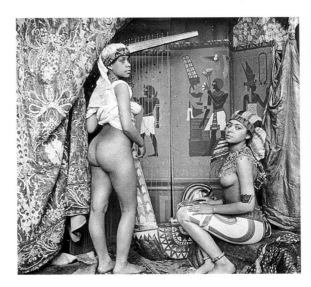

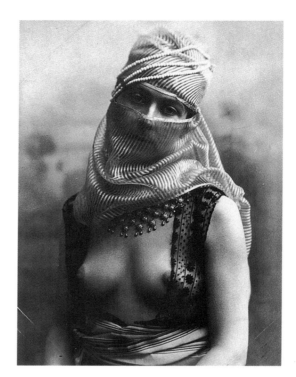

Anonymous
c. 1890

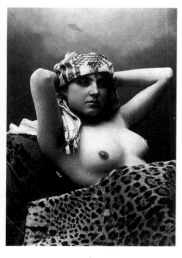

Anonymous
c. 1890

Anonymous
c. 1890

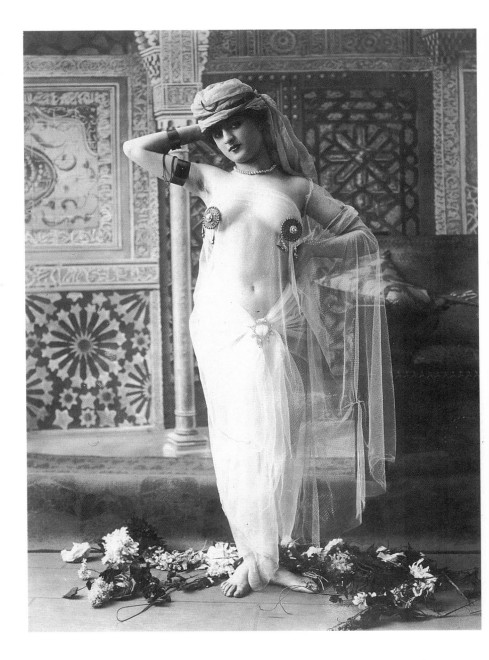

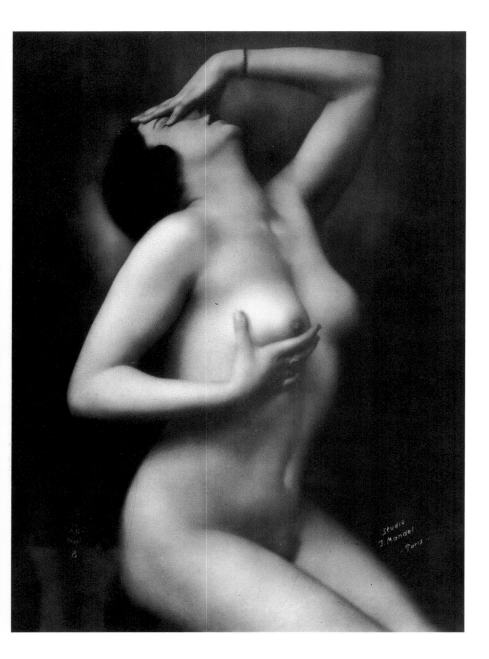

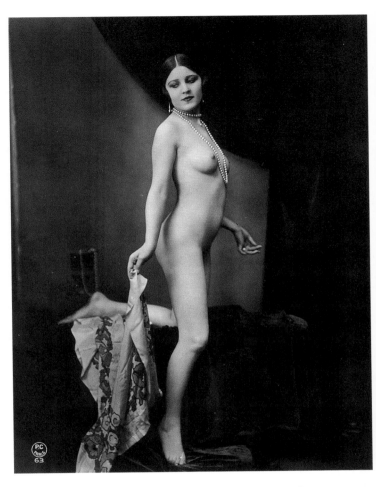

Anonymous
c. 1920

Studio J. Mandel
c. 1925

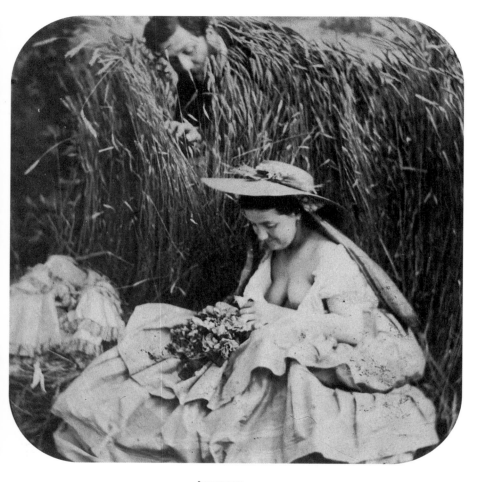

Anonymous
c. 1860

Hans Hildenbrand
Humbly Research
C. 1905

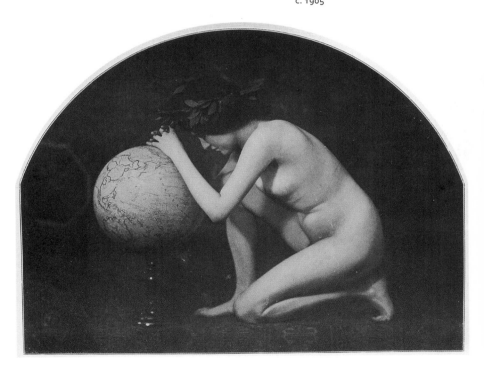

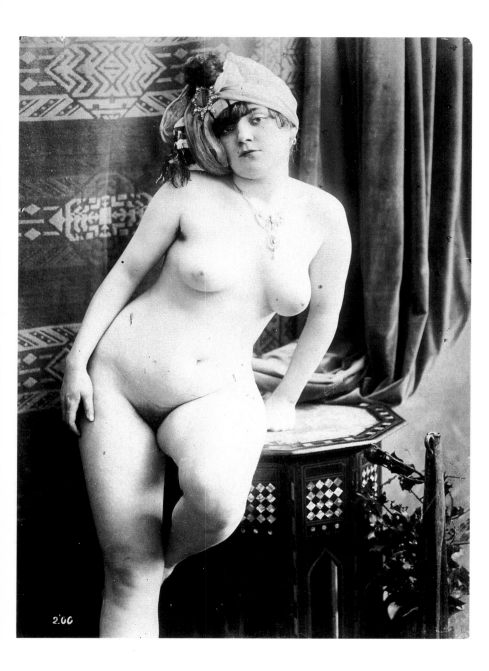

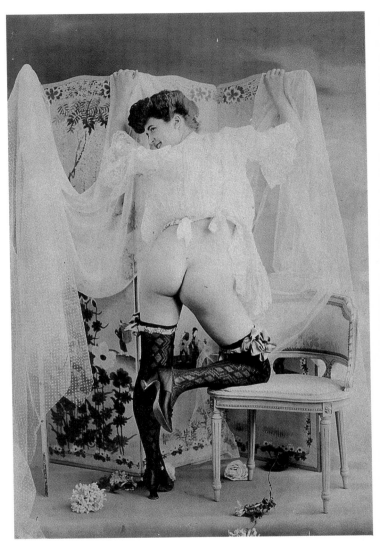

Anonymous
c. 1890

Anonymous
c. 1890

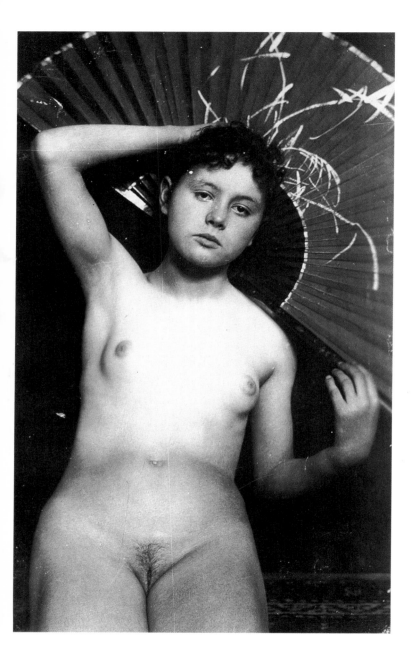

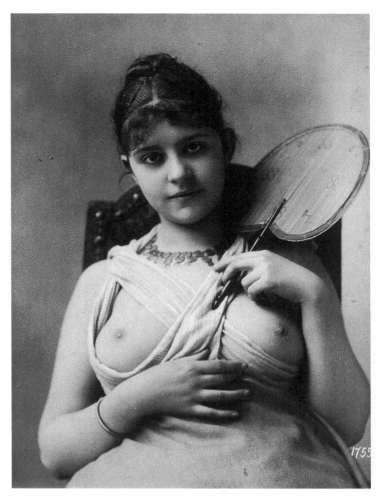

Anonymous
c. 1890

Anonymous
c. 1890

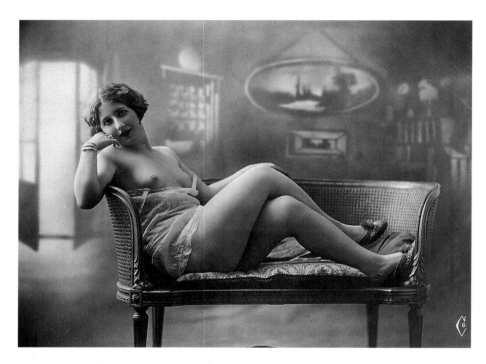

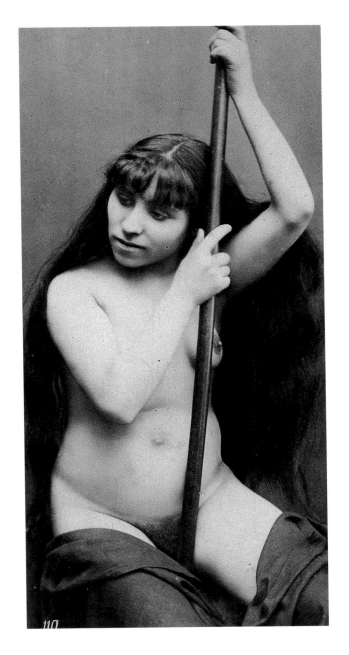

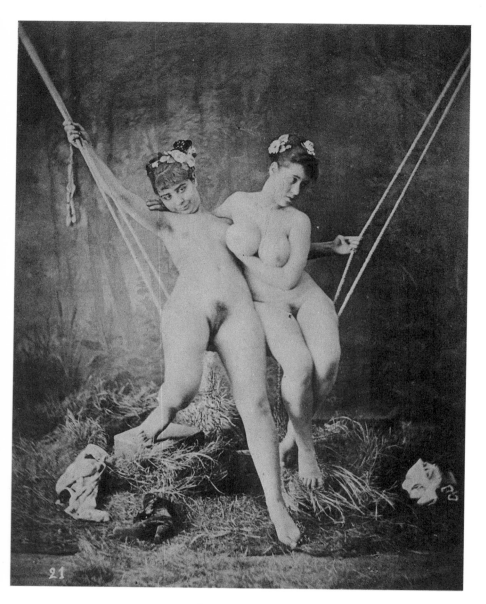

Anonymous
c. 1865

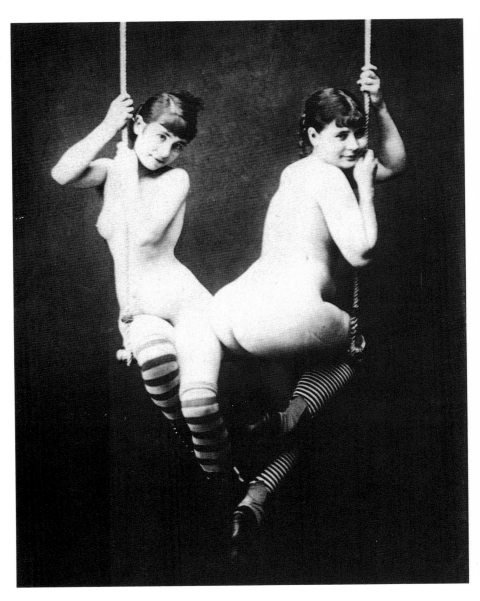

Anonymous
c. 1885

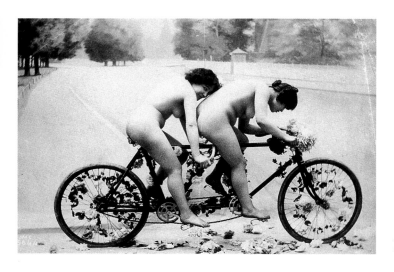

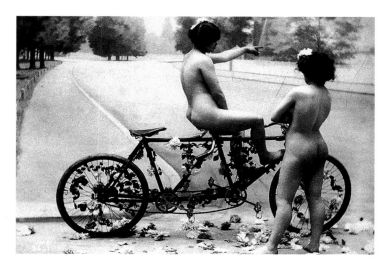

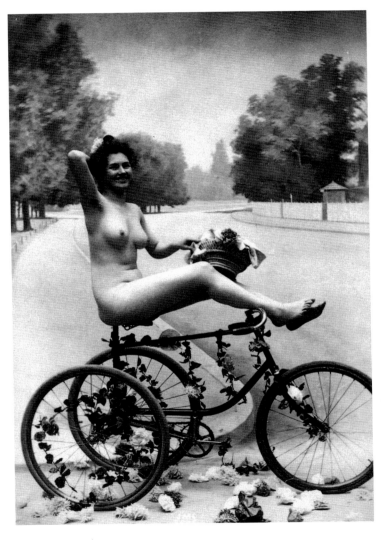

Anonymous
c. 1895

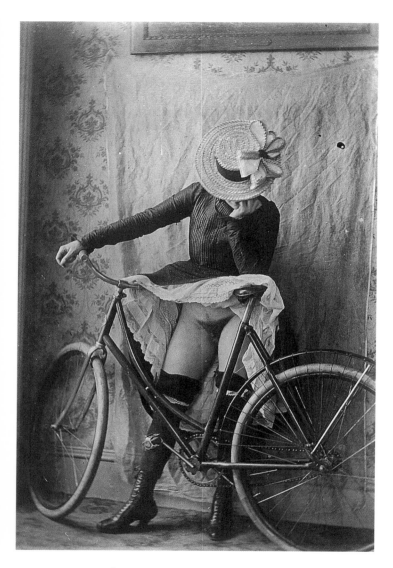

Anonymous
C. 1910

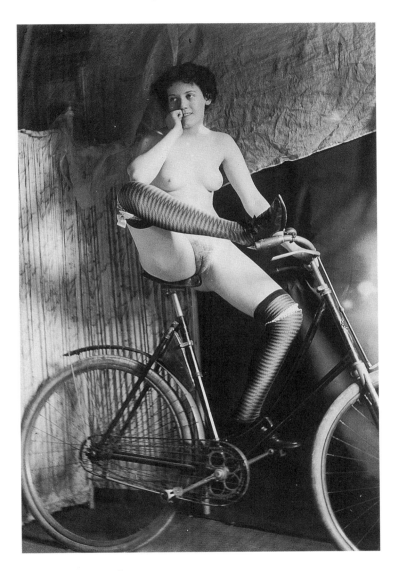

Anonymous
C. 1910

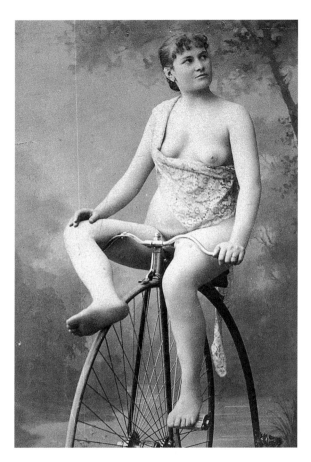

Anonymous
c. 1890

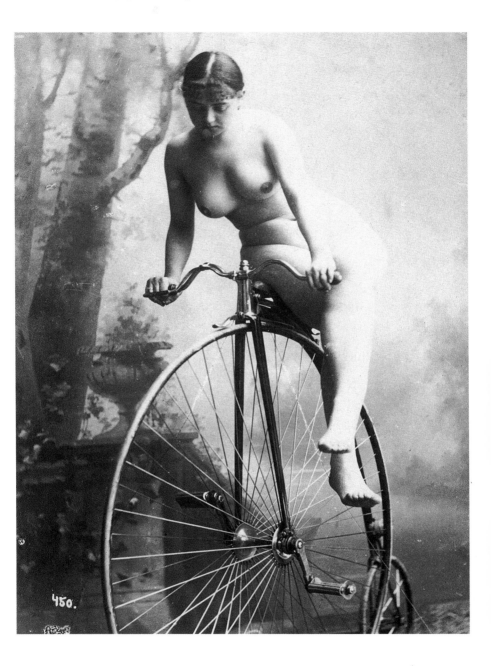

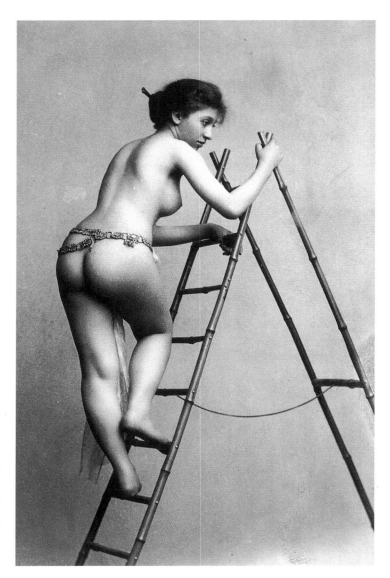

Anonymous
c. 1890

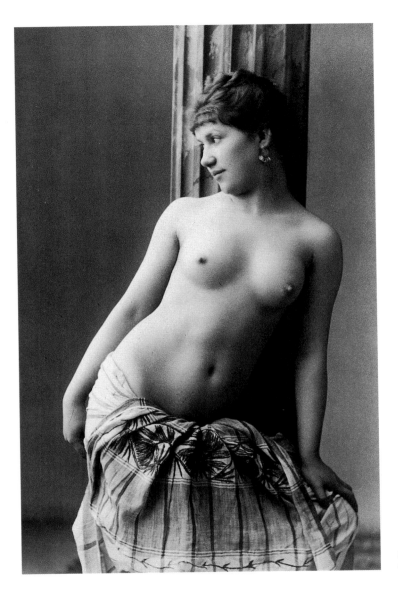

Anonymous
c. 1890

4
Obscene photography

Die obszöne Fotografie

La photographie pornographique

Terms such as "obscene" or "lewd" reflect the sexually repressive attitudes which became more widespread, interestingly enough, at the very time photography was being discovered and adopted. The first lawsuit concerning a "lewd" novel in England was in 1727, but it was the laws passed in 1824 and 1853 that provided a legal context for prosecutions targeting the display and importation of lewd books and pictures (most of which stemmed from France). From then on and throughout Europe, protecting the legal rights of the mentally retarded and the morally vulnerable served as grounds for prosecuting the output and distribution of lewd representations. This implied that any photographic nude unable to lay claim to scientific or artistic intent would be classified as "obscene". As long as manual techniques were involved, a certain degree of control could be exercised but, once the output of erotic imagery became industrialized, restraints of any sort were no longer feasible. Thus, in 1874, a visit by the London police to the shipping department of a certain Henry Hayler yielded 130,248 "lewd" prints, which were confiscated on the spot. The figure highlights both the trade's production capacity and the wealth of public demand for erotica. Pioneers in the field were wont to avail themselves of a full palette of "obscene" staging possibilities, as can be seen, for example, in the Kinsey Collection's 70,000 pictures, which comprise what must be the world's most extensive collection of this genre. Indeed, it was researchers like Kinsey who exposed terms such as "lewd" or "obscene" as hardly rational value judgements, contributing in large measure to the sexual liberalization that developed as of 1945. In this context, those works can be classed as "obscene" or "pornographic" which, above and beyond purely portraying the human body, portray an array of sexual practices, from the act of sexual intercourse to the brazen display of genitalia.

Begriffe wie »obszön« oder »unzüchtig« sind das Ergebnis einer repressiven Sexualmoral, deren Verbreitung interessanterweise mit Bekanntgabe und Rezeption der Fotografie zeitlich in etwa zur Deckung kommt. Einen ersten Prozeß wegen Publikation eines »unzüchtigen« Romans hatte es zwar bereits im England von 1727 gegeben, doch erst die Gesetze von 1824 bzw. 1853 schufen hier eine juristische Handhabe gegen die Zurschaustellung bzw. den Import unzüchtiger Bücher und Bilder (hauptsächlich französischer Provenienz). Europaweit und unter Verweis auf das Schutzbedürfnis der geistig Schwachen und moralisch Labilen wurden seitdem Produktion und Distribution unzüchtiger Darstellungen verfolgt, wobei im Grunde jeder fotografische Akt als »obszön« klassifiziert wurde, der nicht wissenschaftlichen oder künstlerischen Ansprüchen genügte. Was noch zu Zeiten händischer Bildverfahren halbwegs kontrollierbar schien, geriet mit der Industrialisierung des erotischen Blicks im Zeitalter der Fotografie freilich völlig außer Kontrolle. So konnte die Londoner Polizei 1874 im Versandlager eines gewissen Henry Hayler nicht weniger als 130248 »unzüchtige« Aufnahmen konfiszieren, womit die Leistungsfähigkeit des Gewerbes wie auch die erotische Schaulust der Gesellschaft unterstrichen wäre. Daß bereits die Pioniere die gesamte Klaviatur »obszöner« Inszenierungskunst zu nutzen wußten, belegt nicht zuletzt die mit 70 000 einschlägigen Bildern wohl umfangreichste Sammlung des Kinsey Institutes. Sexualforscher wie Kinsey waren es denn auch, die Ausdrücke wie »unzüchtig« oder »obszön« als rational kaum begründbare Werturteile entlarvten und damit zu einer Liberalisierung der Sexualität nach 1945 beitrugen. In diesem Zusammenhang bietet sich an, jene Bildfindungen als »obszön« oder »pornographisch« zu klassifizieren, die über die reine Darstellung des Körpers hinaus sexuelle Praktiken illustrieren: vom Koitus bis zum drastischen Herzeigen des Geschlechts.

Les concepts d'«obscène» ou de «pornographique» sont les fruits d'une morale sexuelle répressive. Il est d'ailleurs intéressant de noter que cette morale commença justement à perdre de son influence à partir de la diffusion de la photographie et de son accueil par le public. Certes, en 1727, un procès avait déjà été intenté en Angleterre contre la publication d'un roman «licencieux». Ce n'est pourtant qu'avec les lois de 1824 et de 1853 que fut créé un cadre juridique contre la publication et l'importation de livres et d'images obscènes, principalement en provenance de France. Sous couvert de protéger les faibles d'esprit et les personnes de moralité fragile, la production et la propagation des images pornographiques furent interdites dans toute l'Europe. Ainsi furent déclarées «obscènes» toutes les images de nus qui ne répondaient à des préoccupations ni scientifiques, ni artistiques. Ce contrôle put être pratiqué tant que dura le procédé de tirage manuel, mais il devint impossible avec l'industrialisation de l'image érotique. Ainsi, la police londonienne confisqua en 1874, dans le hangar d'expédition d'un certain Henry Hayler, pas moins de 130 248 images «pornographiques», ce qui donne une idée de la capacité de production de ce secteur et des attentes érotiques de la société. L'importante collection de l'Institut Kinsey, qui comprend quelque 70 000 images, montre à quel point les pionniers étaient déjà experts dans l'art de la mise en scène «pornographique». Mais ce sont également des sexologues comme Kinsey qui dénoncèrent les notions d'«obscène» ou de «pornographique» comme étant des préjugés sans fondements rationnels, contribuant ainsi à la libération sexuelle qui eut lieu après 1945. Dans notre exposé, nous classerons parmi les images «obscènes» ou «pornographiques» celles qui représentent le corps dans la seule optique des pratiques sexuelles, du coït à l'étalage cru des parties sexuelles.

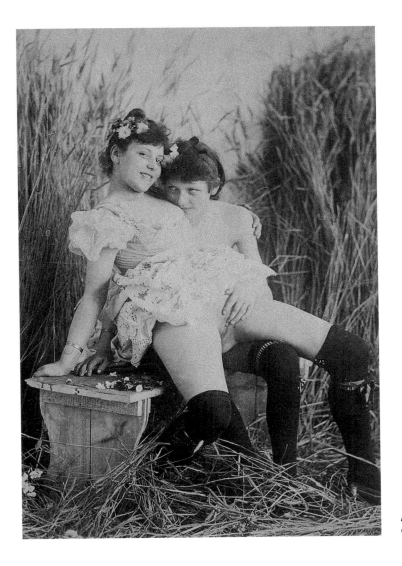

Anonymous
c. 1885

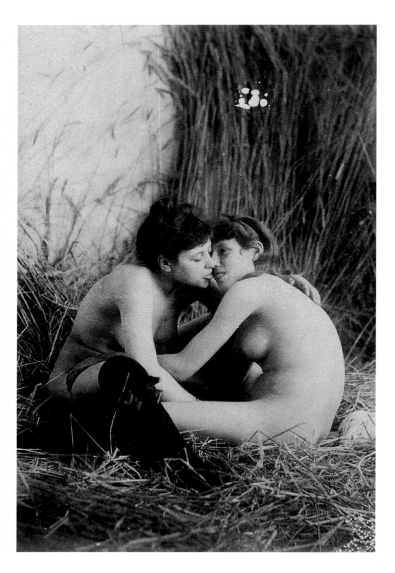

Anonymous
c. 1885

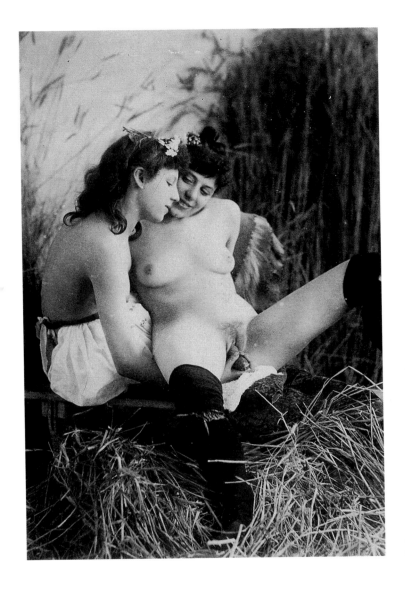

Anonymous
c. 1885

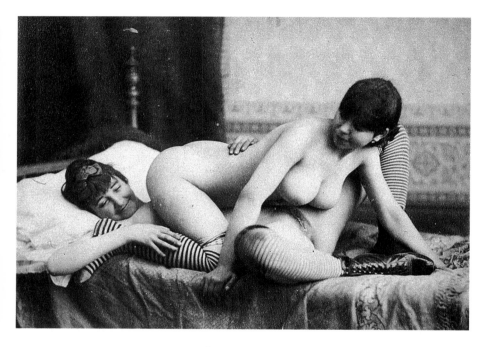

Anonymous
c. 1885

Anonymous
c. 1885

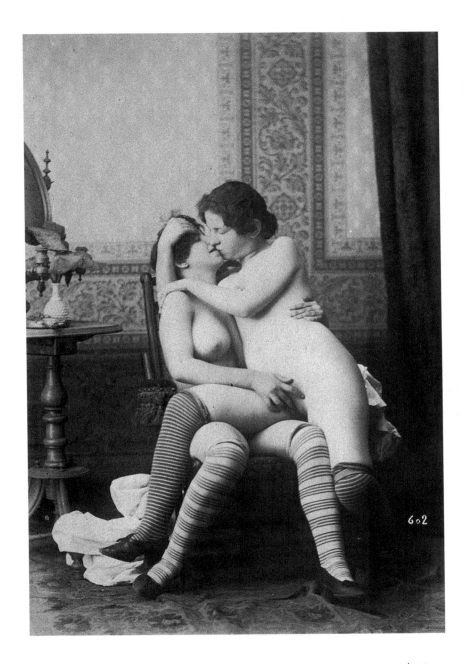

602

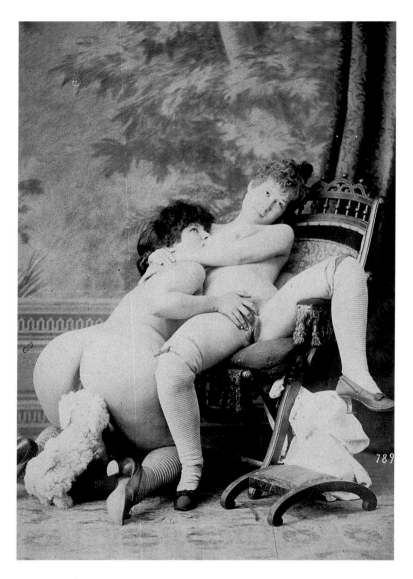

Anonymous
c. 1885

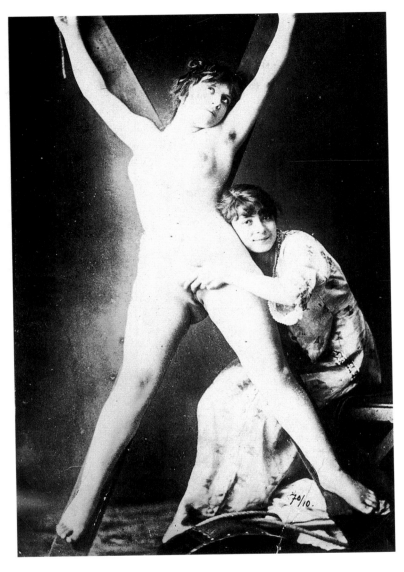

Anonymous
c. 1890

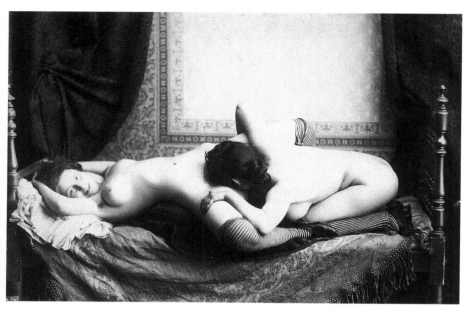

Anonymous
c. 1885

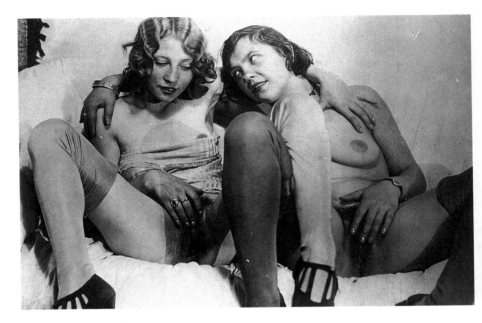

Anonymous
C. 1920

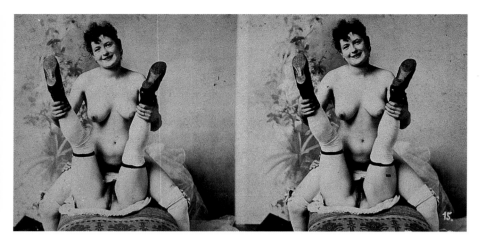

Anonymous
c. 1880

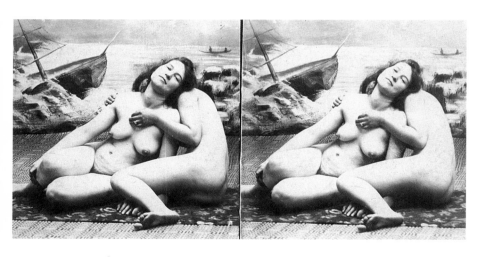

Anonymous
c. 1880

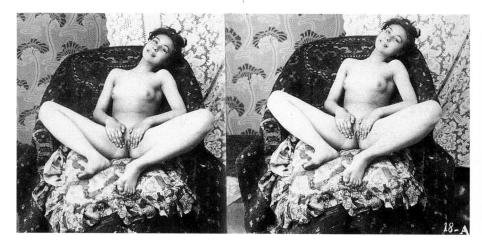

Anonymous
c. 1880

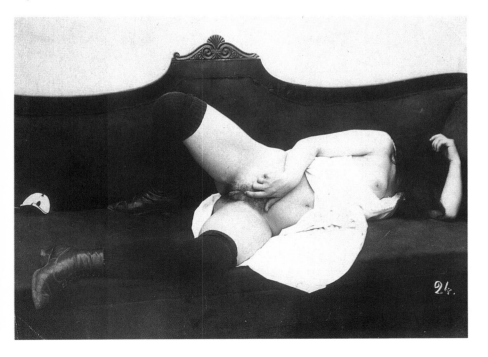

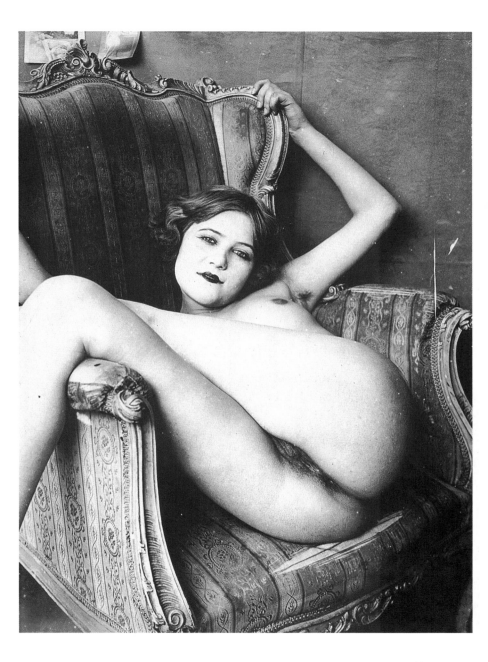

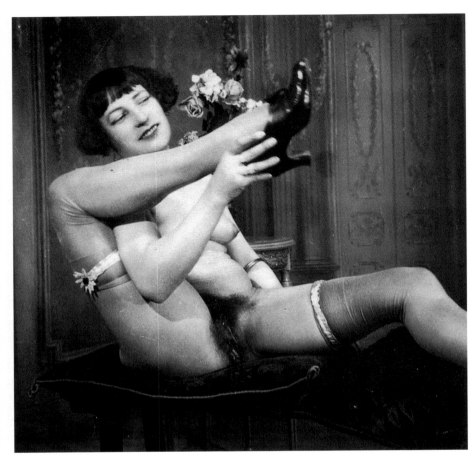

Anonymous
C. 1910

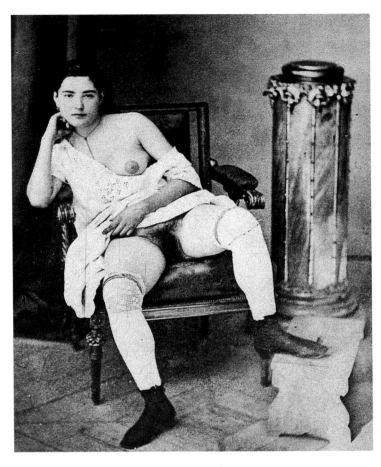

Anonymous
c. 1865

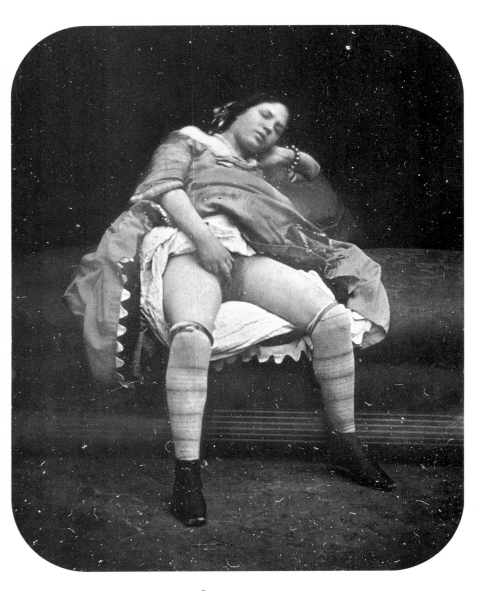

Anonymous
c. 1855
Daguerreotype

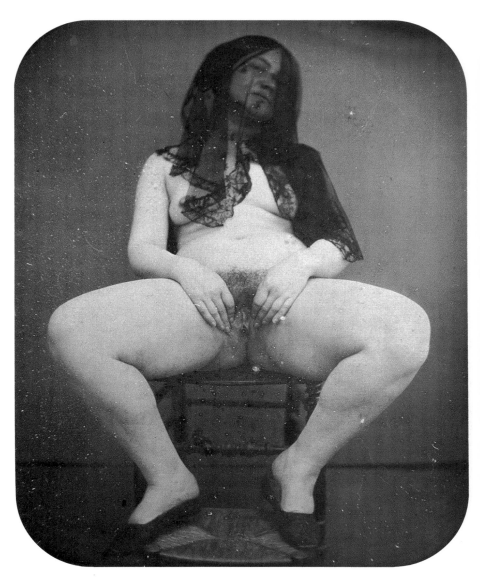

Anonymous
c. 1855
Daguerreotype

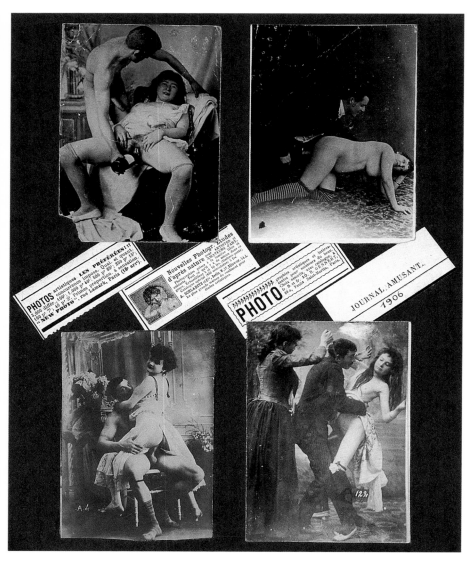

Anonymous
c. 1905

Anonymous
c. 1890

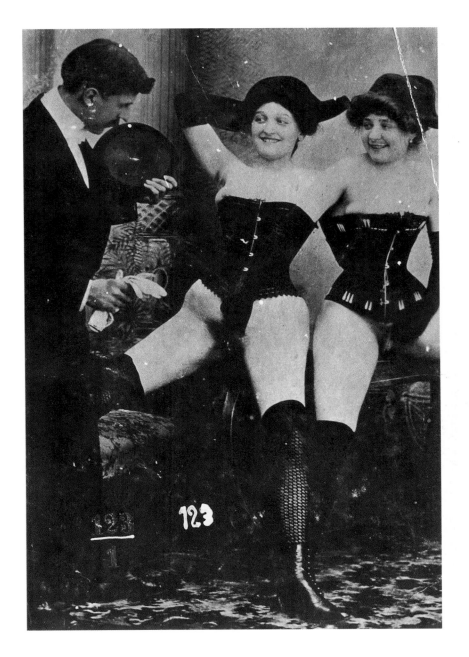

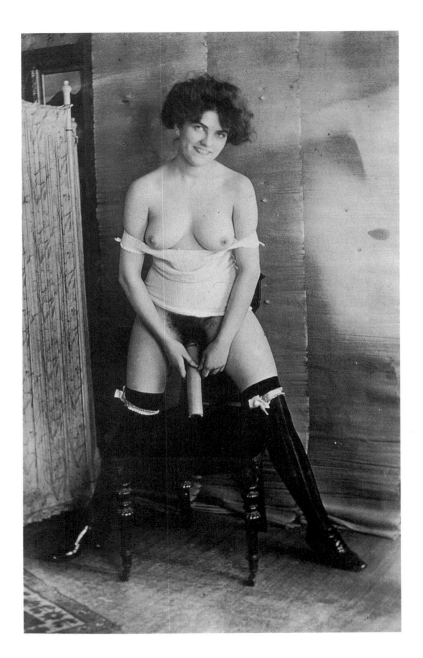

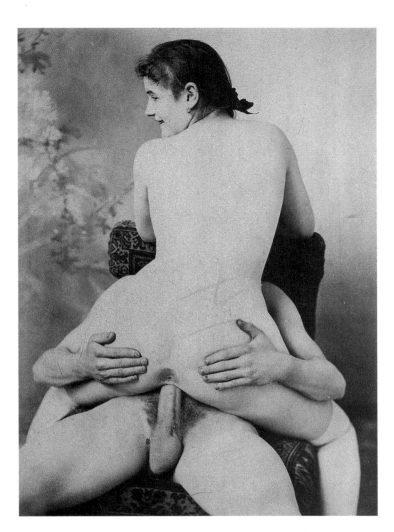

Anonymous
c. 1885

Anonymous
c. 1900

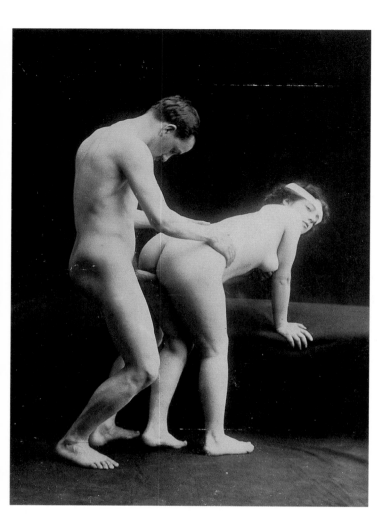

Anonymous
c. 1890

Anonymous
c. 1890

Anonymous
c. 1890

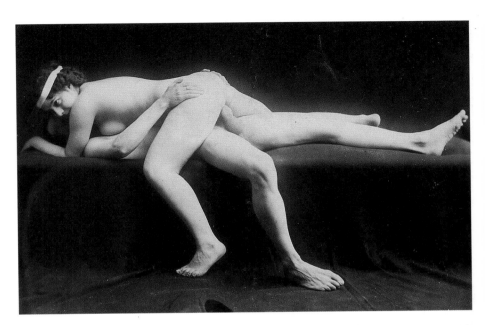

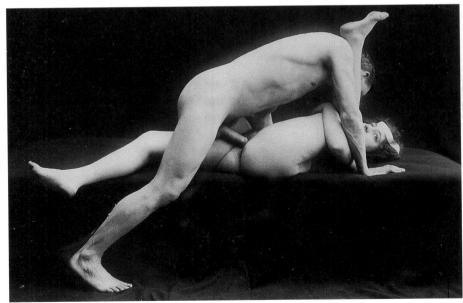

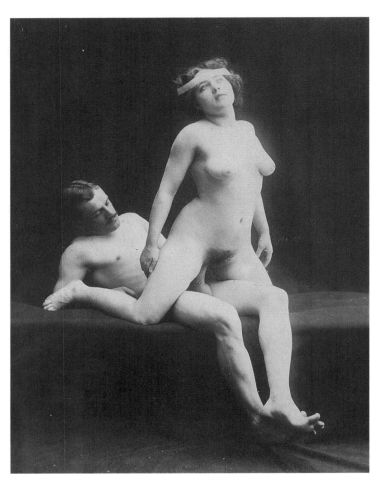

Anonymous
c. 1890

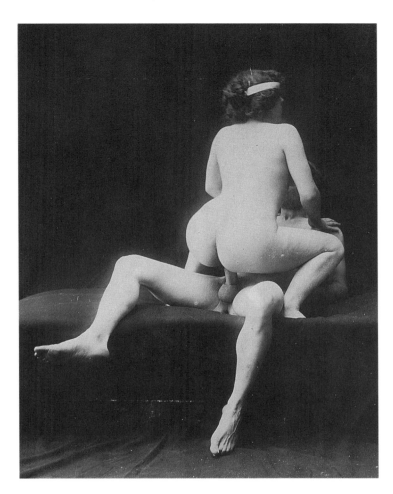

Anonymous
c. 1890

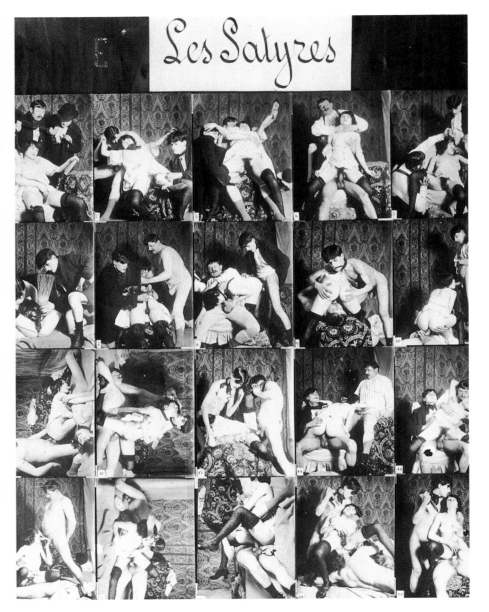

Les Satyres

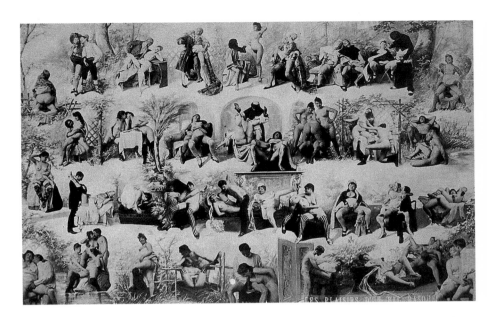

Anonymous
The Pleasures of a Masked Ball
c. 1890

Anonymous
The Satyres
c. 1890

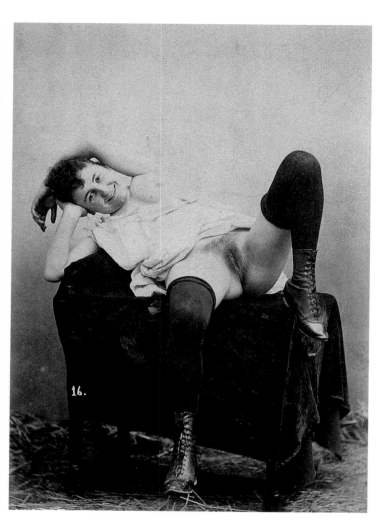

Anonymous
c. 1885

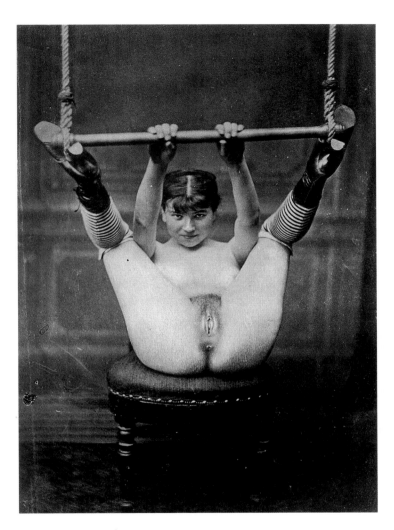

Anonymous
c. 1885

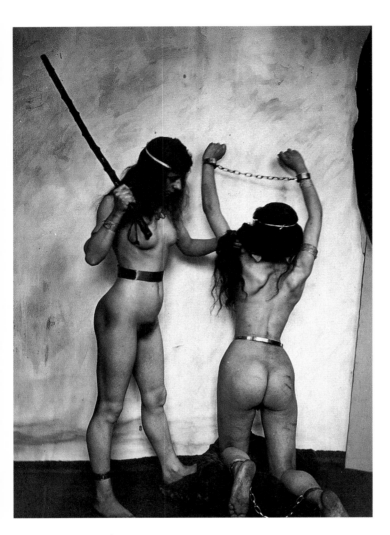

Anonymous
c. 1900

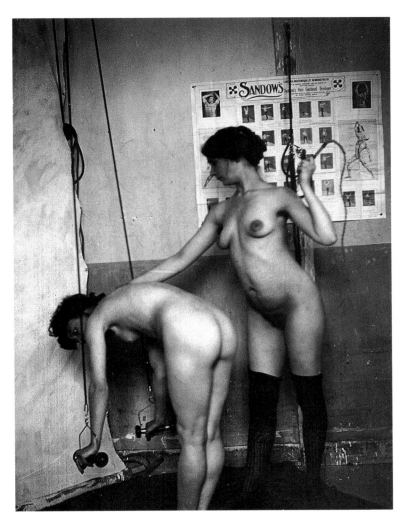

Anonymous
C. 1900

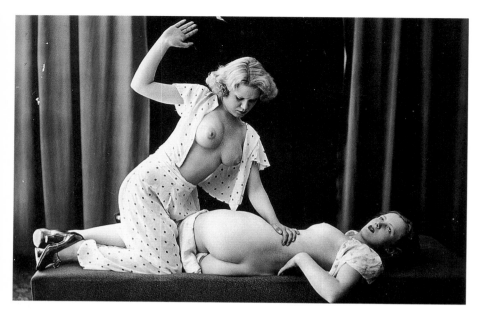

Anonymous
C. 1920

Anonymous
C. 1900

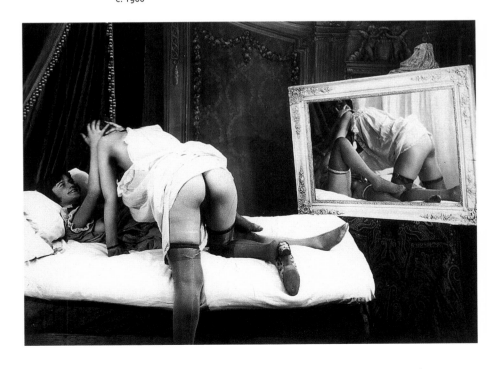

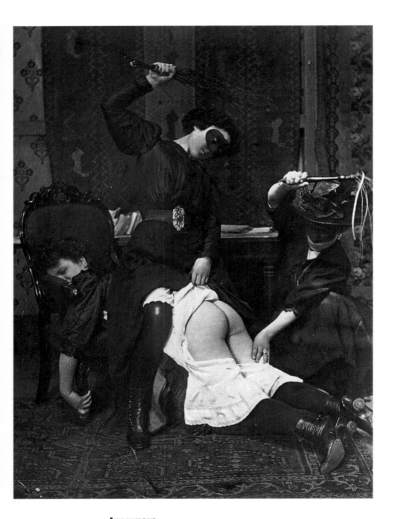

Anonymous
c. 1890

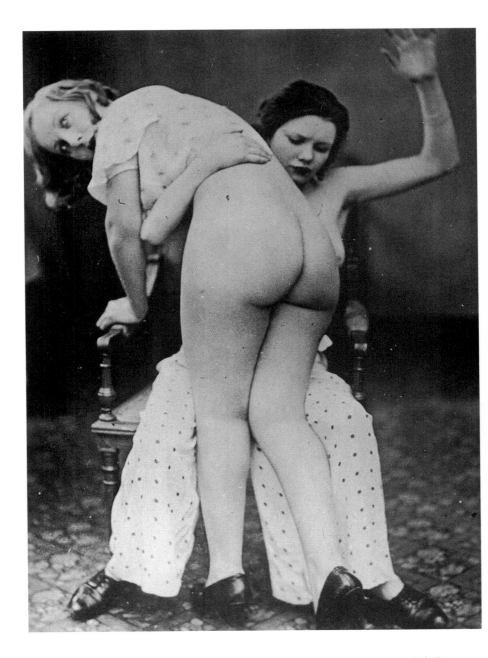

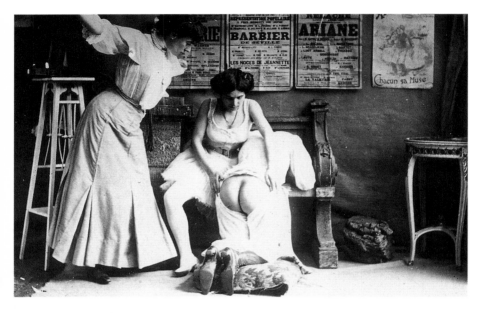

Anonymous
c. 1890

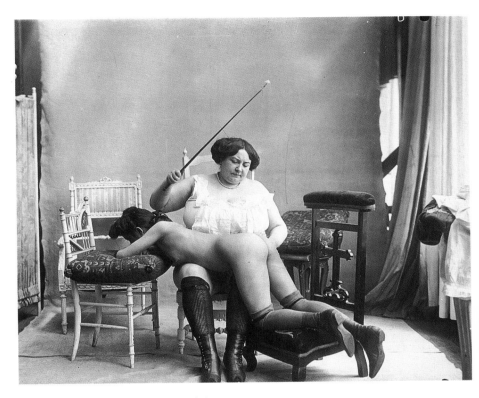

Anonymous
c. 1890

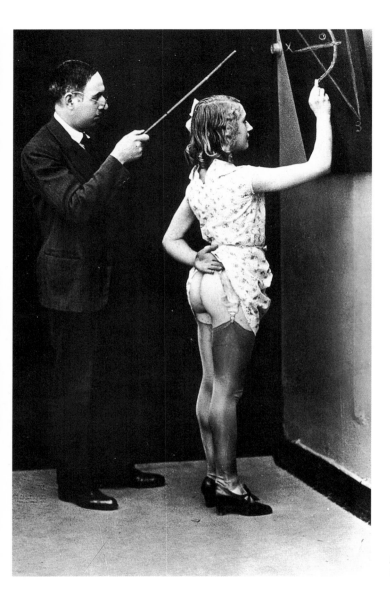

Anonymous
c. 1925

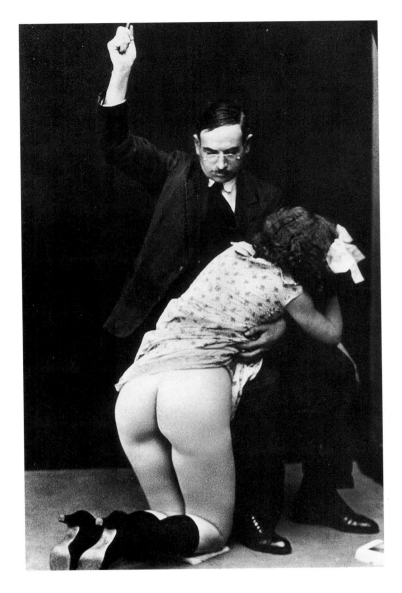

Anonymous
C. 1925

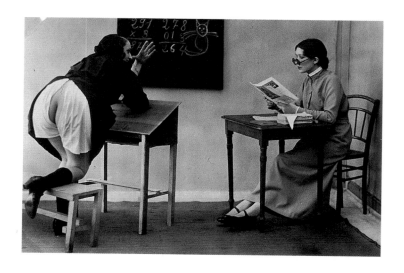

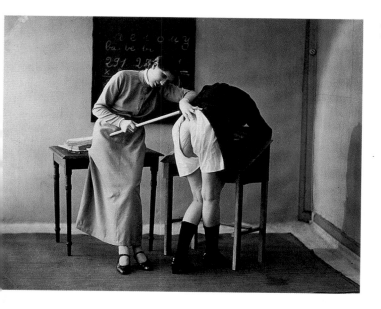

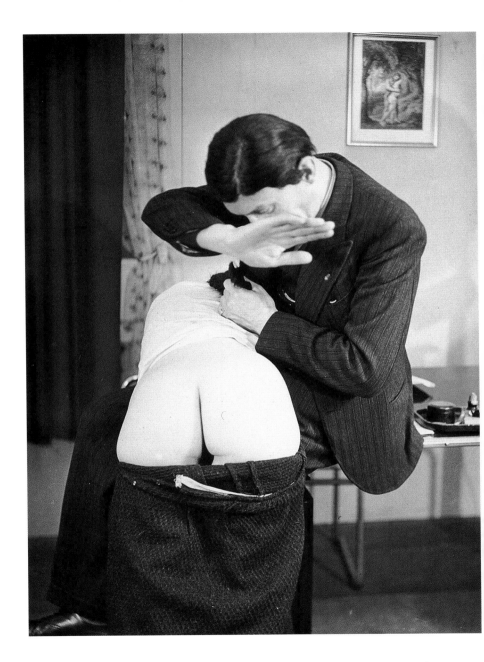

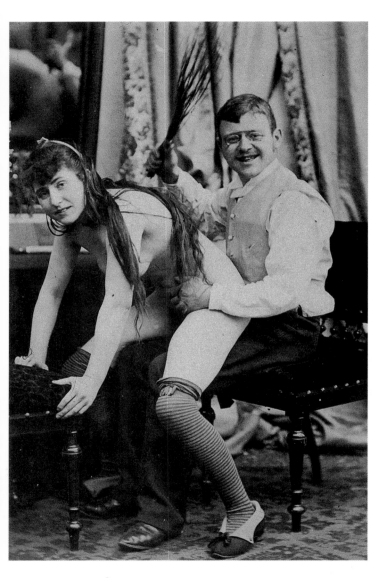

Anonymous
c. 1885

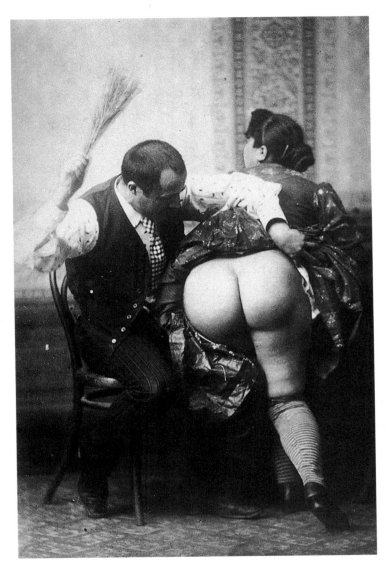

Anonymous
c. 1885

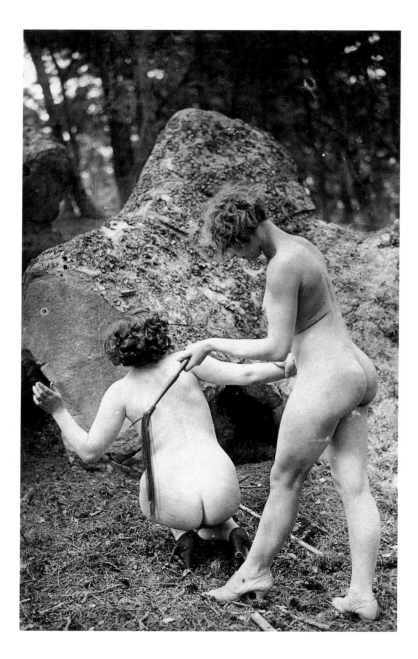

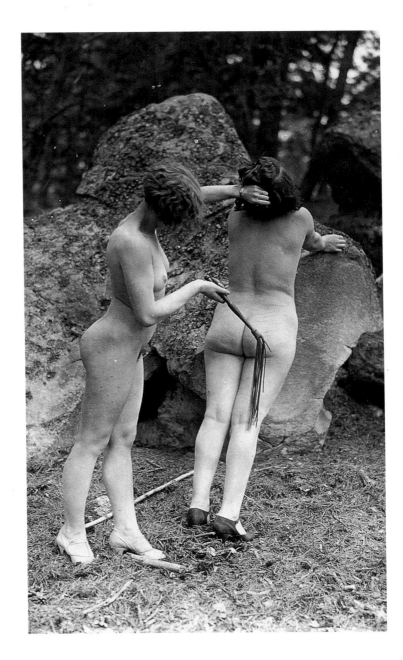

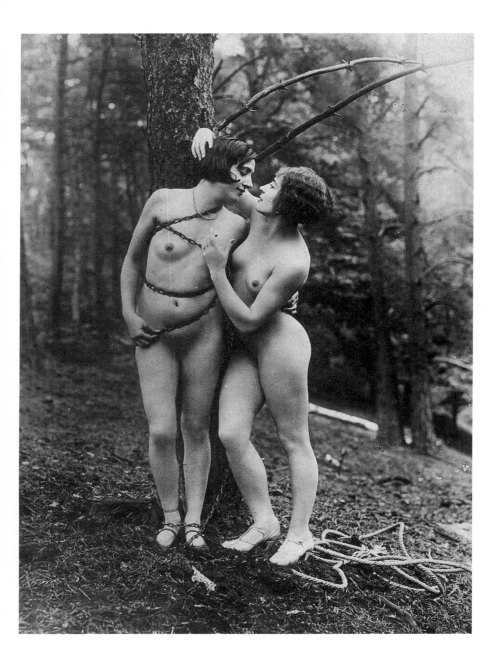

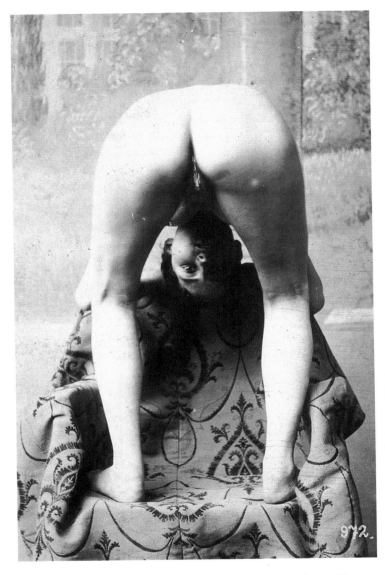

Anonymous
c. 1890

Anonymous
c. 1930

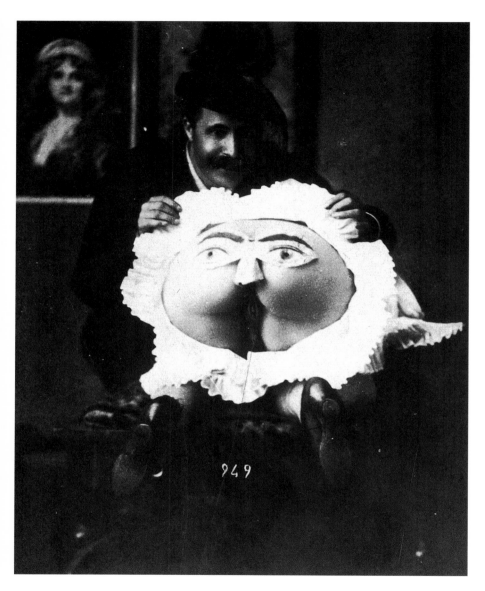

Anonymous
c. 1870

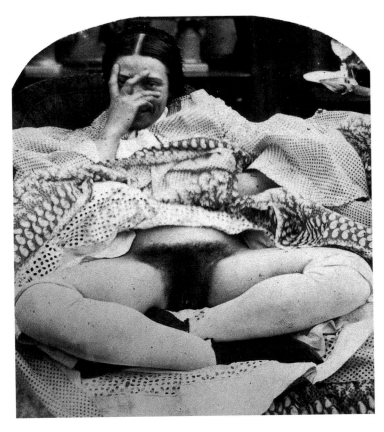

Anonymous
c. 1860

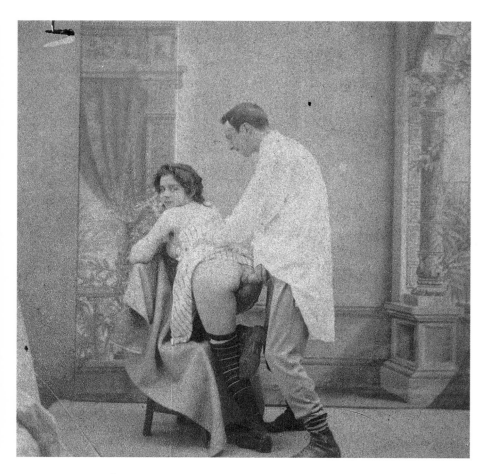

Anonymous
c. 1865

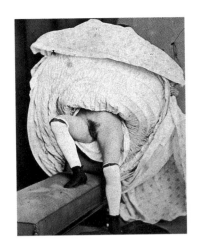

Anonymous
c. 1865

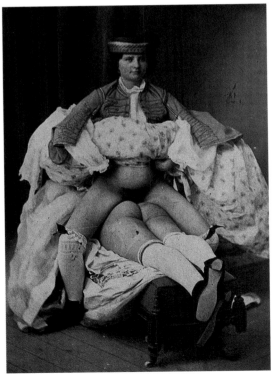

Anonymous
c. 1868

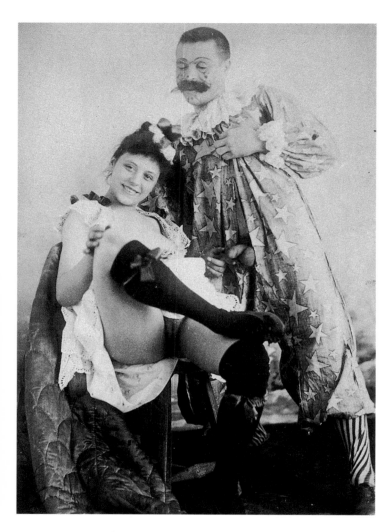

Anonymous
c. 1885

Anonymous
c. 1885

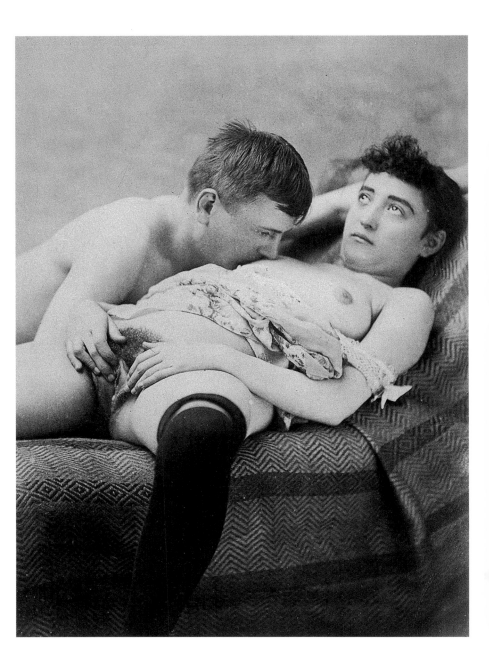

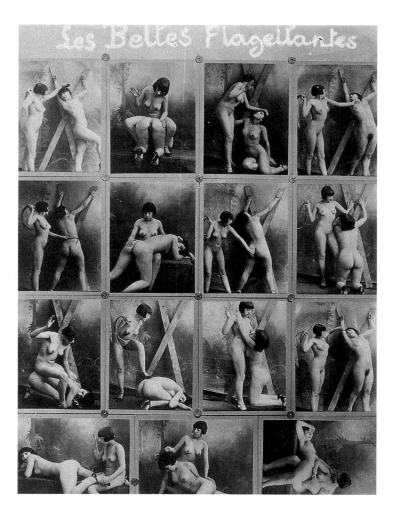

Anonymous
The Lovely Flagellants
c. 1890

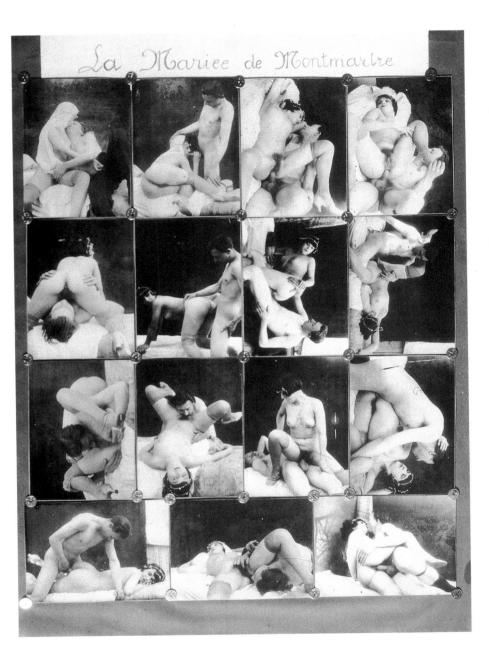

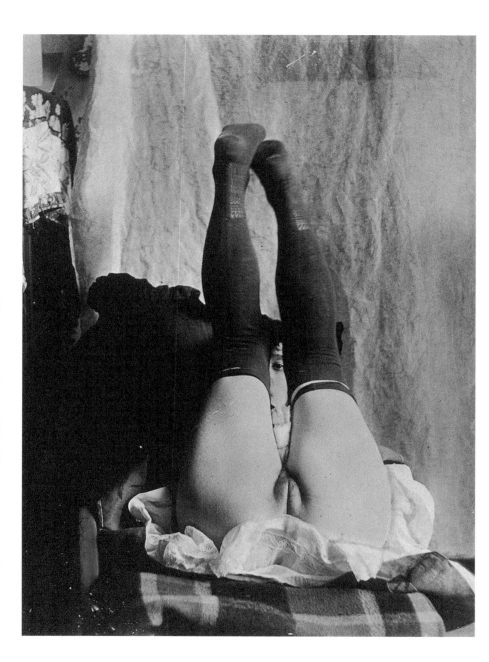

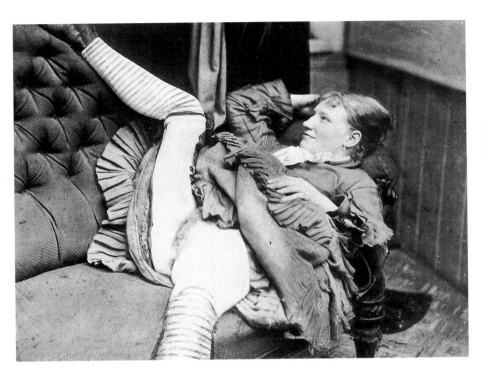

Anonymous
c. 1880

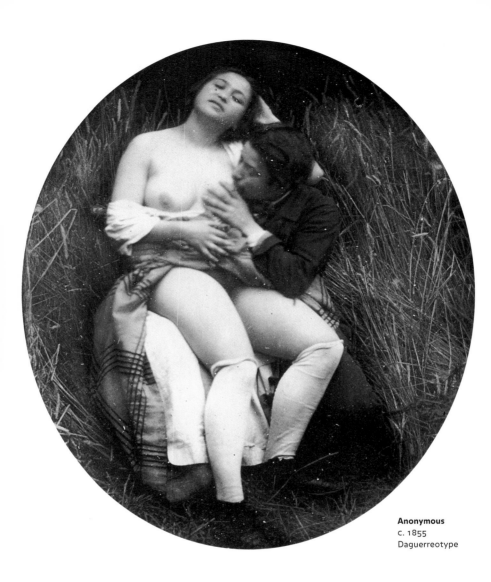

Anonymous
c. 1855
Daguerreotype

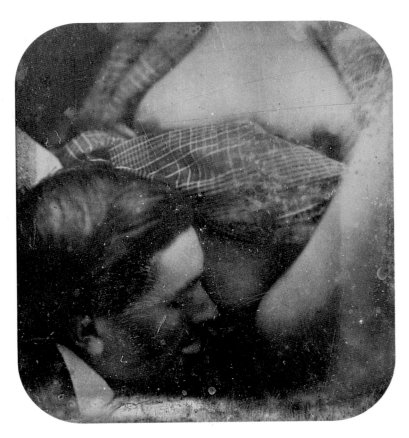

Anonymous
c. 1855
Daguerreotype

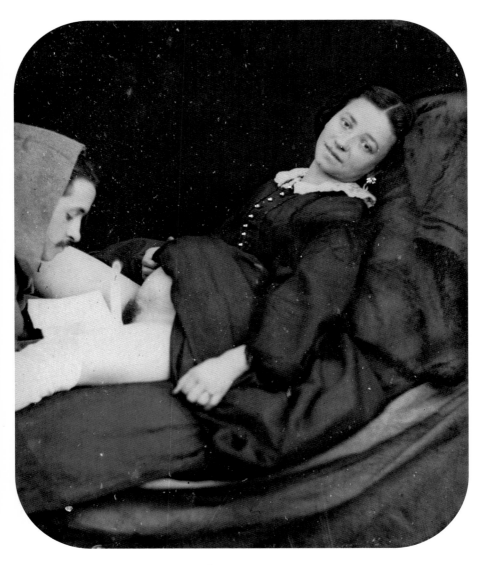

Anonymous
c. 1855
Daguerreotype

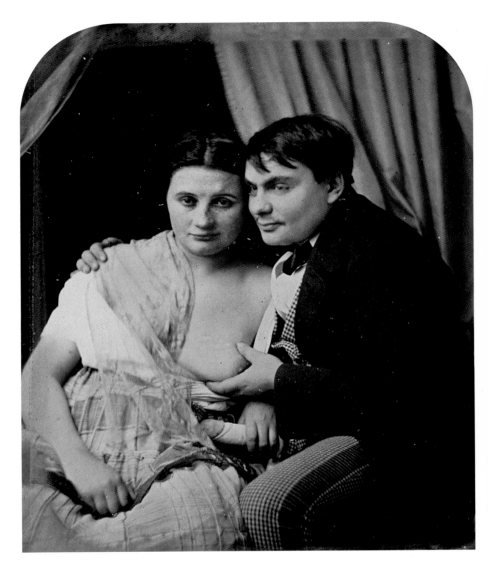

Anonymous
c. 1855
Daguerreotype

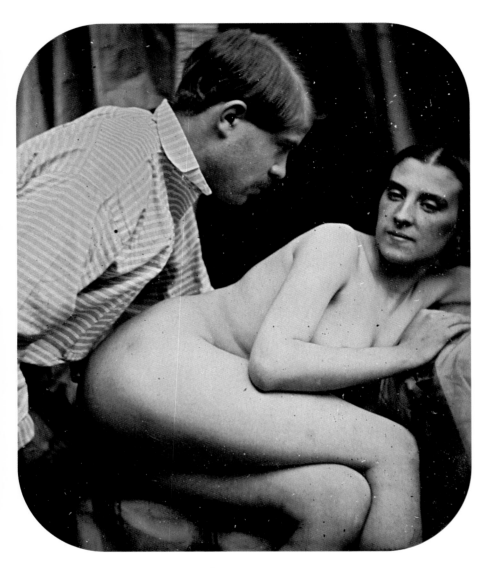

Anonymous
c. 1855
Daguerreotype

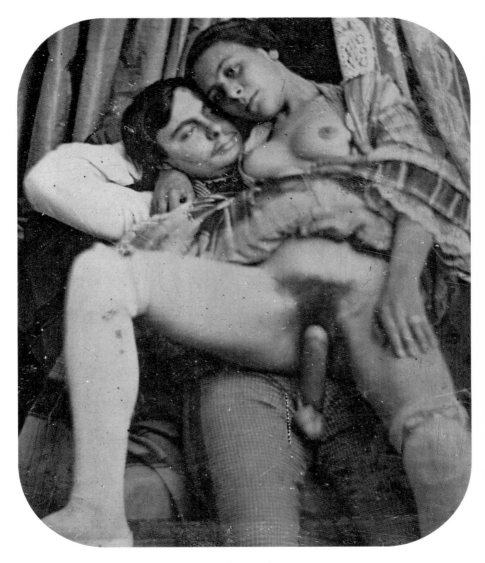

Anonymous
c. 1855
Daguerreotype

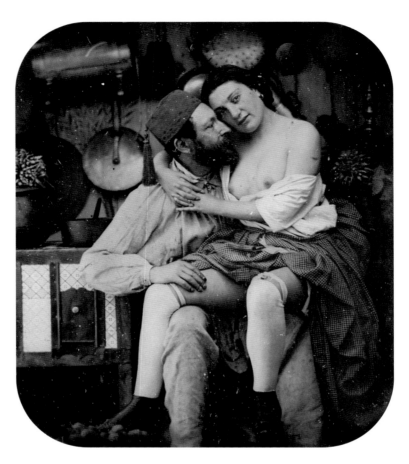

Anonymous
c. 1855
Daguerreotype

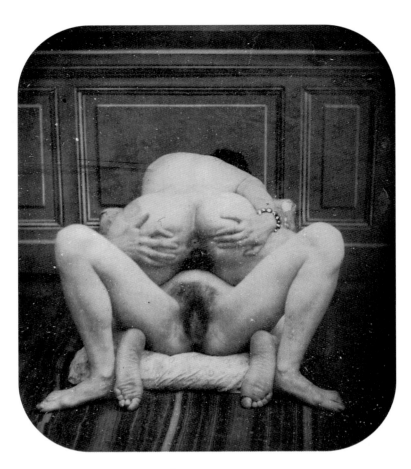

Anonymous
c. 1855
Daguerreotype

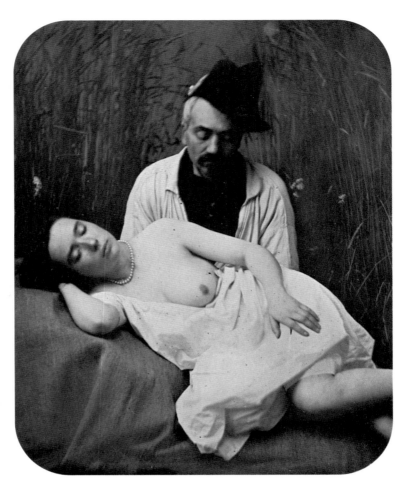

Anonymous
c. 1855
Daguerreotype

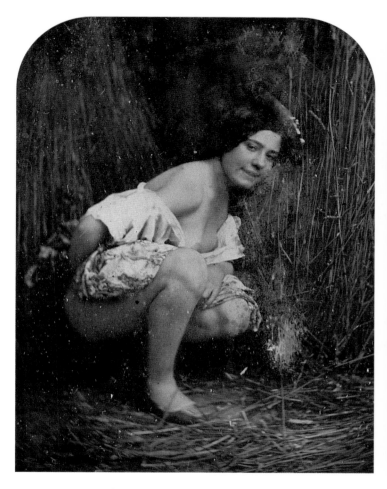

Anonymous
c. 1855
Daguerreotype

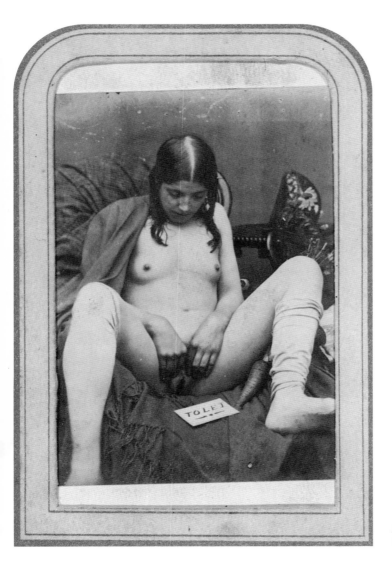

Anonymous
c. 1865

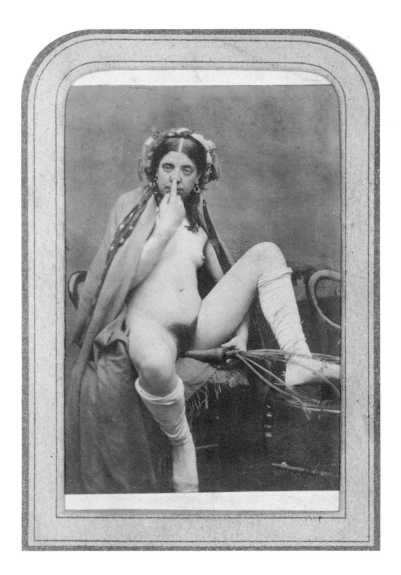

Anonymous
c. 1865

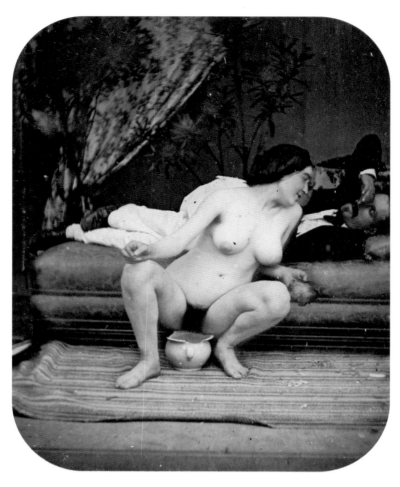

Anonymous
c. 1855
Daguerreotype

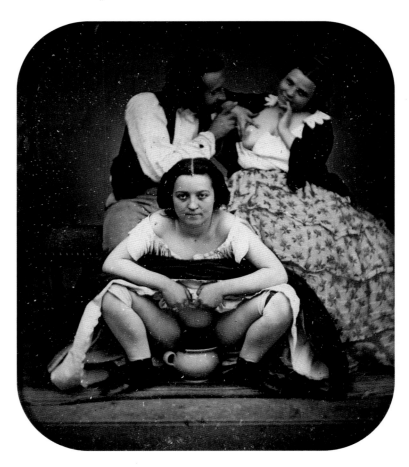

Anonymous
c. 1855
Daguerreotype

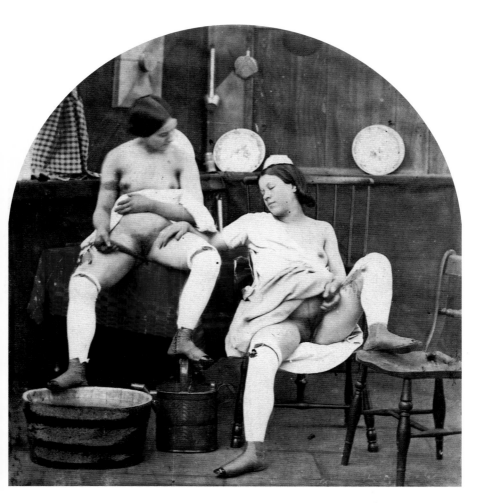

Anonymous
c. 1860

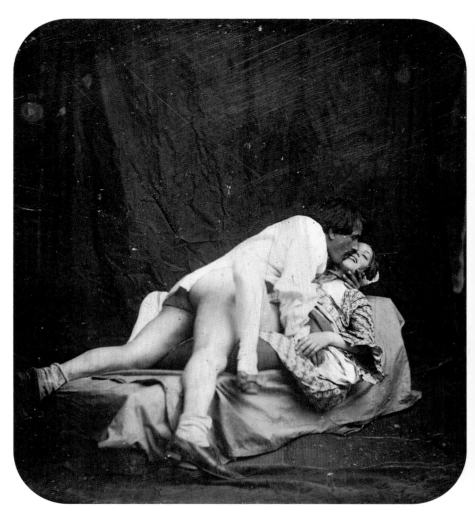

Anonymous
c. 1855
Daguerreotype

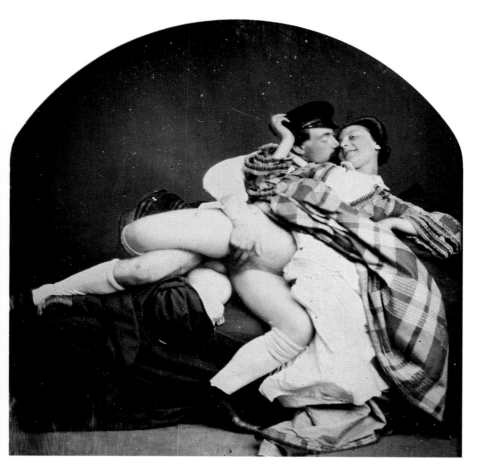

Anonymous
c. 1855
Daguerreotype

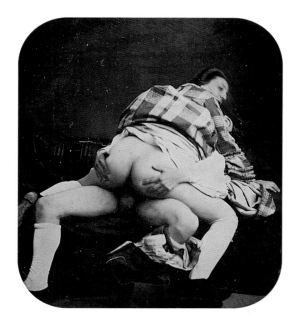

Anonymous
c. 1855
Daguerreotype

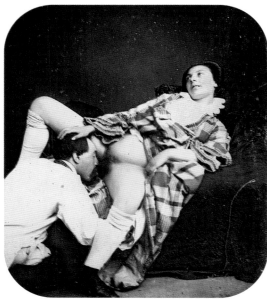

Anonymous
c. 1855
Daguerreotype

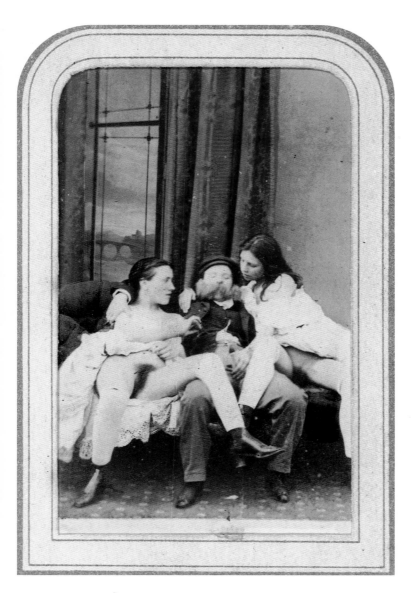

Anonymous
c. 1865

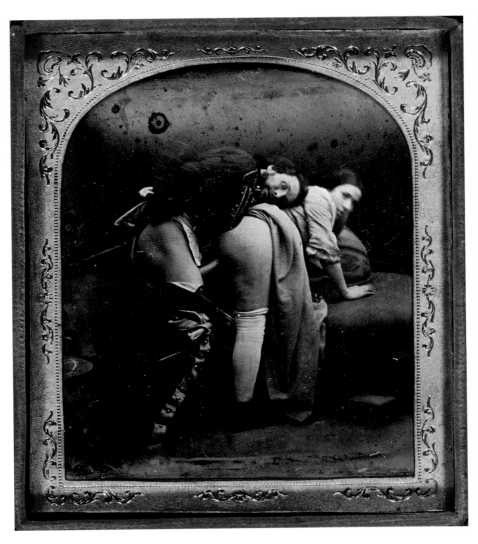

Anonymous
c.1855
Daguerreotype

5
Erotic postcards

Erotische Grüße

Les cartes postales érotiques

Towards the end of the nineteenth century, and in the wake of the popularity of stereoscopic pictures and visiting cards, it was mainly the postcard that served as a cheap mass medium for the communication of erotic fantasies. Postcards were standard in size (A6) and small enough to be traded clandestinely, though larger than stereoscopic pictures or visiting cards, with more space, therefore, for erotic stagings. And yet they were relatively cheap to produce, either in limited editions as silver gelatin prints or in larger print editions. The first person to come up with the idea of an unwritten "postal sheet" was the German Reich's future General Postmaster, Heinrich von Stephan (1831–1897). It was upon his suggestion that "correspondence cards" were introduced in July 1870, first in the German Reich, and shortly thereafter in England, Switzerland, etc… The Oldenburg book dealer, Schwartz (1875), and the Berin lithographer, Miesler (1876), were among the first to recognize the commercial potential of illustrated correspondence cards. And what started out as a very small-scale business, grew in no time at all into a full-fledged industry. Production statistics for 1899 cite 88 million picture postcards issued in the German Reich, 14 million in Great Britain and 12 million in Belgium. France was the country to produce the largest amount of erotic imagery; in the early 1900s, that country alone – so the statistics say – employed some 30,000 people in the branch. Everything, from the merely saucy to the frankly pornographic, from artistic nudes to nudist shots, eventually found its way onto a postcard. One thing all these images of the body had in common was the fact that they were seldom "sent off", meaning that they were collected and exchanged but only rarely posted. With the advent of new forms of visual communication after World War I (especially the illustrated press), the heyday of postcards drew to a close.

Nach Stereo- und Visitkarte war es gegen Ende des 19. Jahrhunderts vor allem die Ansichtskarte, die als preiswertes Massenmedium erotischer Bildphantasien fungierte. Postkarten mit ihrem standardisierten Format (A6) waren klein und konnten somit bequem «sous le manteau» gehandelt werden. Größer als Stereo- oder Visitkarte, boten sie doch mehr Raum für erotische Inszenierungskunst. Gleichwohl waren sie – ob in Kleinauflage als Silbergelatineprint oder in größerer Druckauflage – vergleichsweise billig herzustellen. Die Idee eines offenen »Postblatts« hatte als erster der spätere Generalpostmeister des Deutschen Reiches, Heinrich von Stephan (1831–1897). Sein Vorschlag führte im Juli 1870 zur Einführung der »Correspondenzkarte«, zunächst im Deutschen Reich, wenig später dann in England, der Schweiz etc. Der Oldenburger Buchhändler Schwartz (1875) bzw. der Berliner Lithograph Miesler (1876) dürften mit die ersten gewesen sein, die die kommerziellen Möglichkeiten einer mit Bild versehenen Korrespondenzkarte erkannten. Aus kleingewerblichen Anfängen entwickelte sich jedenfalls rasch eine regelrechte Industrie. 88 Millionen Ansichtskarten verzeichnete die Produktionsstatistik von 1899 für das Deutsche Reich. 14 Millionen waren es in Großbritannien und 12 Millionen in Belgien. Allein in Frankreich, das als Hauptlieferant erotischer Motive gelten darf, sollen nach 1900 über 30 000 Menschen Arbeit in dieser Branche gefunden haben. Von der Galanterie bis zur pornographischen Darstellung, vom Künstler-Akt bis zur FKK-Fotografie – nichts, was in der Folge nicht auch als Postkarte aufgelegt worden wäre. Was alle Körper-Bilder verband, war die Tatsache, daß sie nicht »gelaufen« sind. Das heißt, sie wurden gesammelt und getauscht, aber kaum verschickt. Mit dem Aufkommen neuer Bildkommunikationsmittel nach dem Ersten Weltkrieg (insbesondere der illustrierten Zeitung) war die hohe Zeit der Postkarte zu Ende.

Après les cartes stéréoscopiques et de visite, ce fut la carte postale qui s'imposa, à partir de la fin du 19ème siècle, comme le support privilégié et bon marché des images érotiques. Les cartes postales, grâce à leur format réduit (A6), pouvaient facilement circuler sous le manteau. De plus, ce format, supérieur à celui des cartes stéréoscopiques ou de visite, offrait de nouvelles possibilités de mise en scène érotiques. Leur prix de revient resta très bas, qu'elles aient fait l'objet de gros tirages ou qu'elles aient été produites en petites quantités par gélatinographie. Le premier à avoir eu l'idée d'une «carte-lettre» fut Heinrich von Stephan (1831–1897) qui devint par la suite receveur général des postes de l'Allemagne impériale. Il fut ainsi à l'origine de la «carte de correspondance» qui apparut en juillet 1870 tout d'abord en Allemagne, et peu après en Angleterre, en Suisse, etc... En 1875, un libraire d'Oldenburg, Schwartz, et, en 1876, le lithographe berlinois Miesler, furent les premiers à entrevoir les possibilités commerciales que pouvaient offrir une carte de correspondance agrémentée d'une image. Ces modestes débuts artisanaux se transformèrent rapidement en une véritable industrie. En 1899, les statistiques de production recensèrent en Allemagne 88 millions de cartes postales. En Grande-Bretagne, elles s'élevèrent à 14 millions et en Belgique à 12 millions. Rien qu'en France, qui était le principal fournisseur d'images érotiques, plus de 30 000 personnes trouvèrent un emploi dans ce secteur après 1900. Tous les genres, de la scène grivoise à l'image pornographique, du nu artistique à la photo naturiste, furent imprimés sur carte postale. Néanmoins, leur caractéristique commune est d'avoir peu circulé. Objets de collection et à échanger, elles n'ont en effet guère fait l'objet d'envoi. La vogue de la carte postale fut éclipsée, après la Première Guerre mondiale, par l'arrivée de nouveaux moyens de diffusion de l'image, en particulier les journaux illustrés.

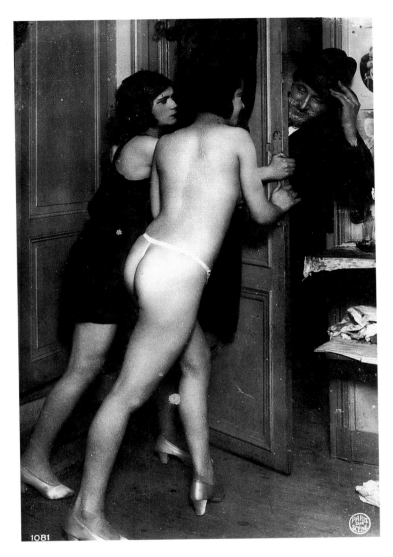

Anonymous
c. 1925

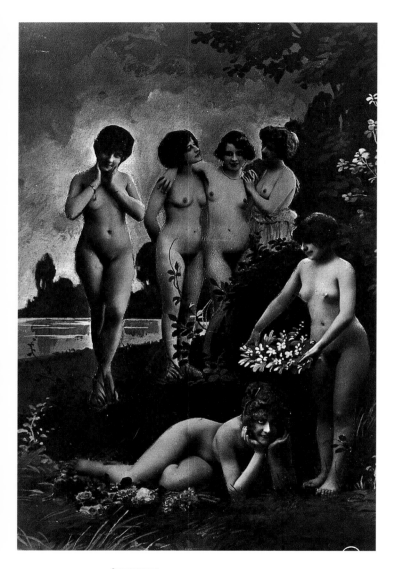

Anonymous
C. 1900

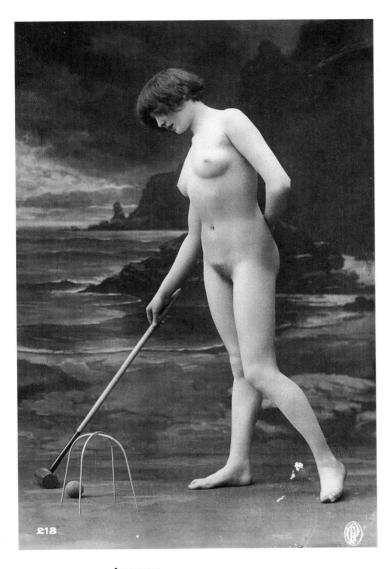

Anonymous
C. 1910

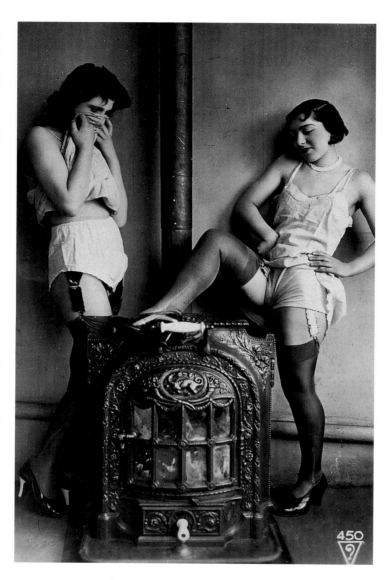

Anonymous
C. 1930

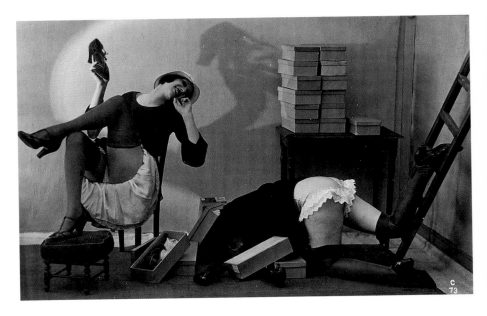

Anonymous
C. 1920

Anonymous
C. 1920

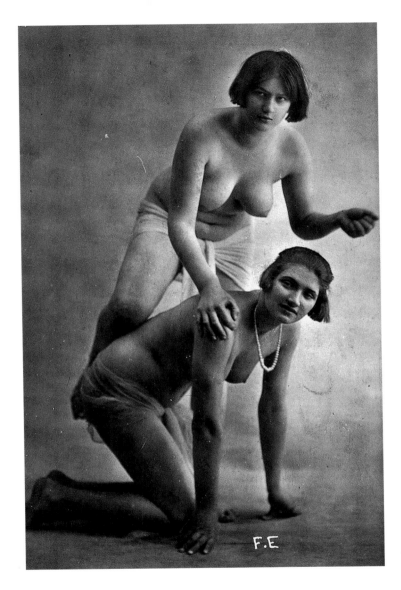

Anonymous
c. 1910

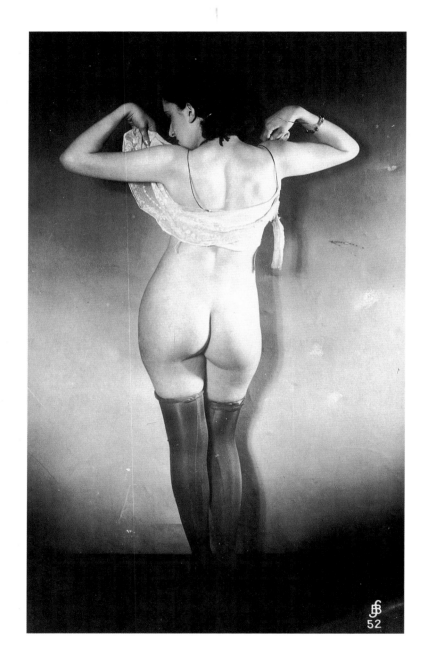

52

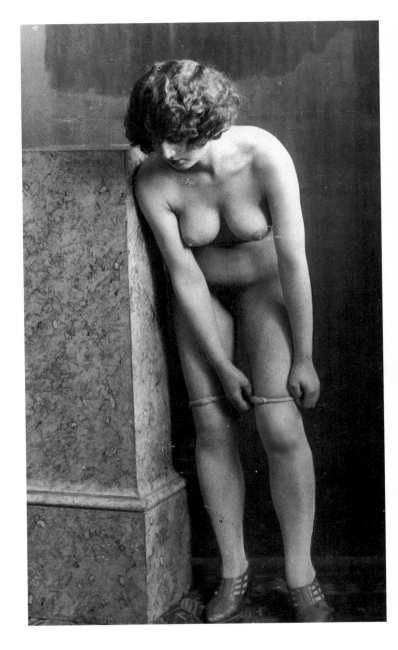

Anonymous
C. 1925

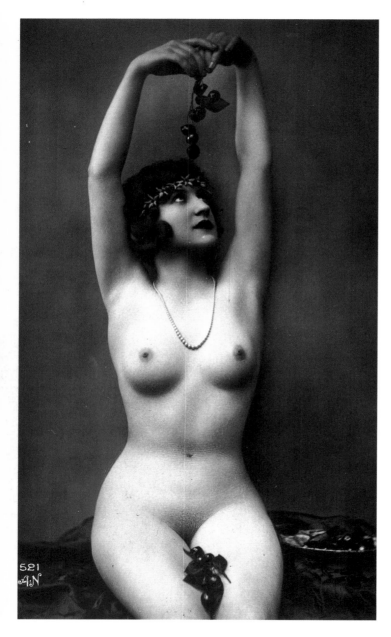

521

Anonymous
C. 1920

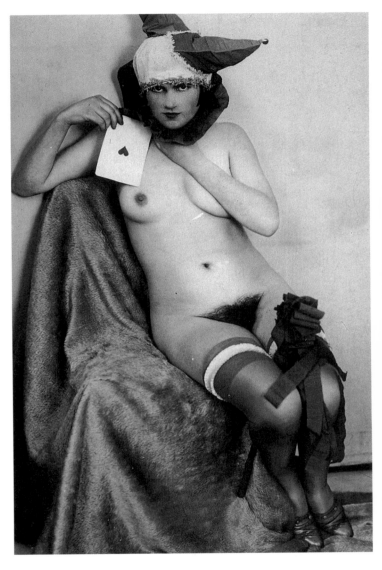

Anonymous
C. 1920

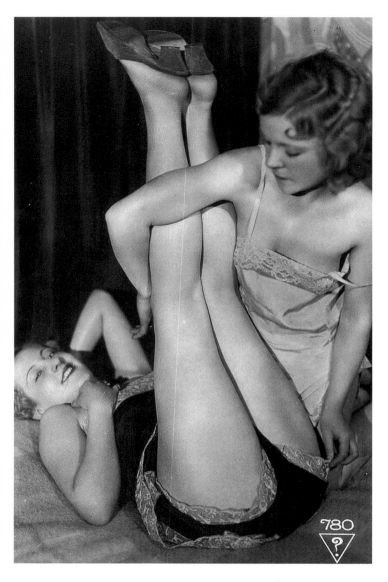

Anonymous
C. 1925

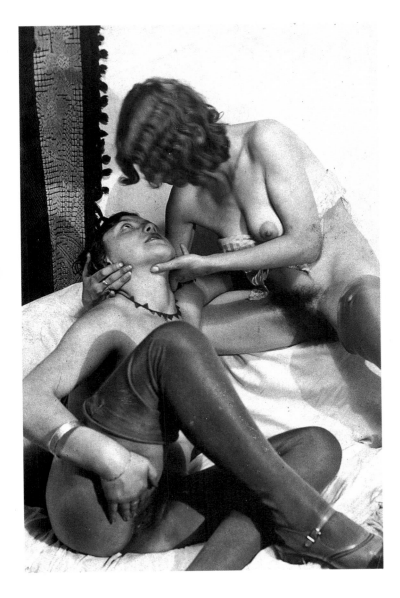

Anonymous
c. 1925

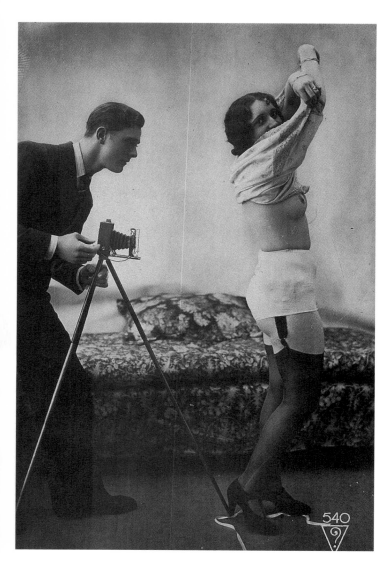

Anonymous
C. 1920

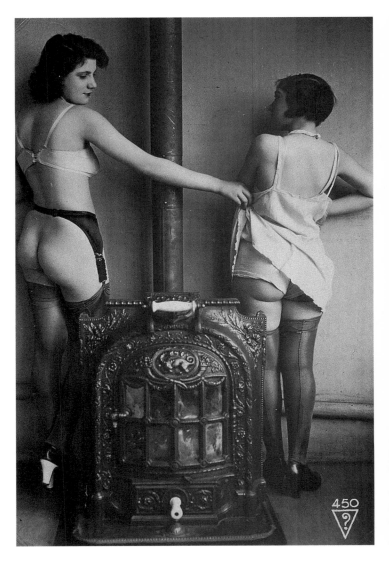

Anonymous
C. 1930

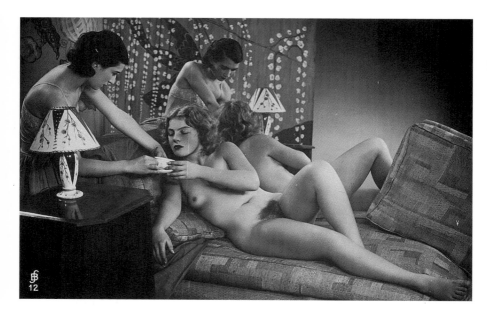

Anonymous
C. 1925

Anonymous
C. 1930

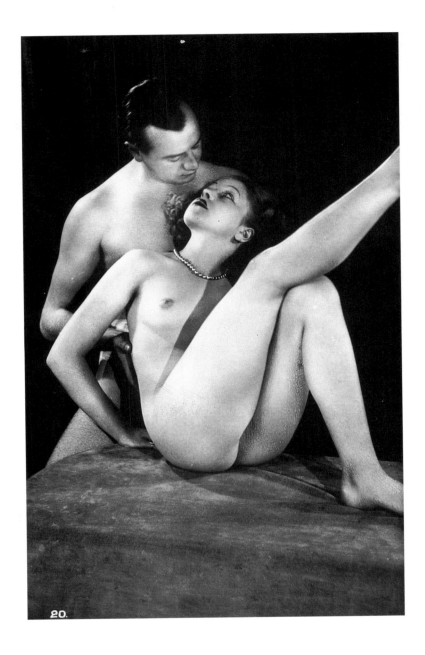

20.

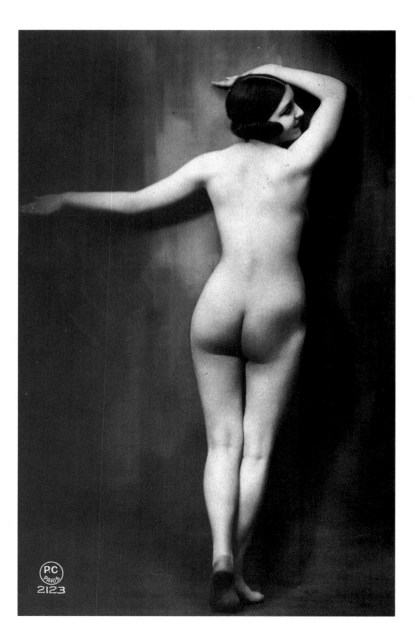

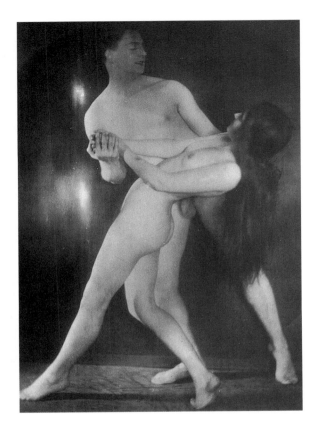

Anonymous
C. 1925

Anonymous
C. 1915

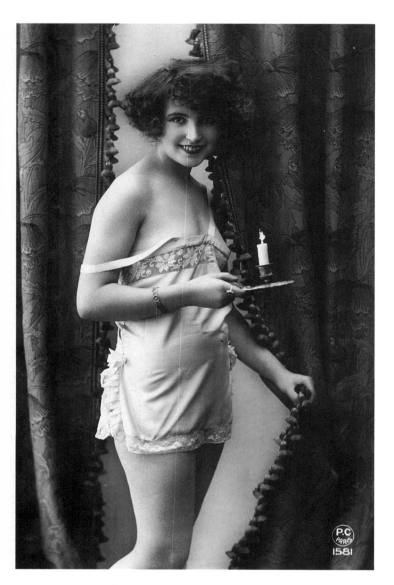

Anonymous
C. 1920

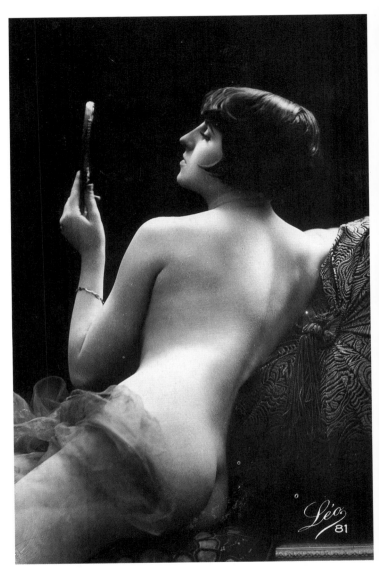

Anonymous
C. 1920

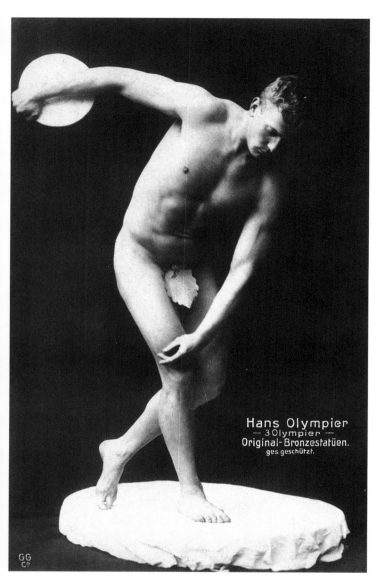

Anonymous
C. 1910

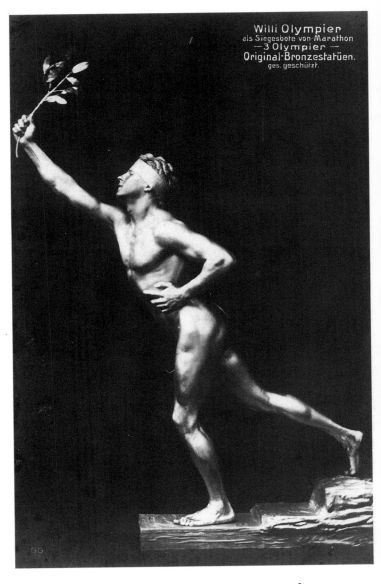

Willi Olympier
als Siegesbote von Marathon
— 3 Olympier —
Original-Bronzestatüen.
ges. geschützt.

Anonymous
c. 1910

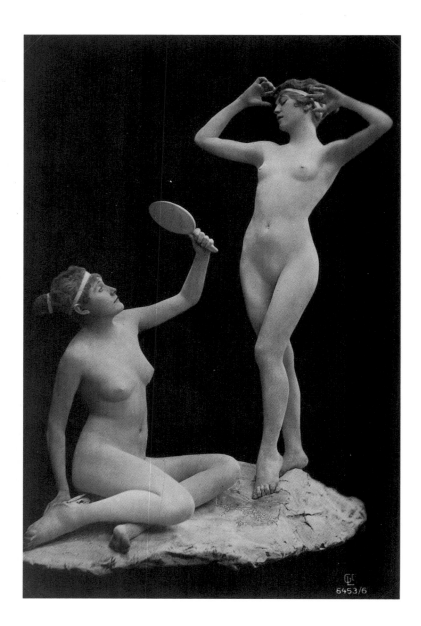

6453/6

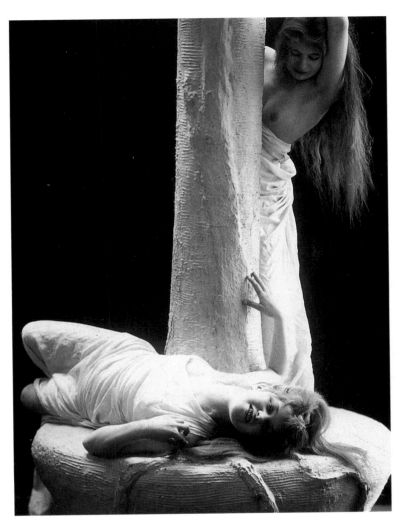

Anonymous
C. 1910

Anonymous
C. 1910

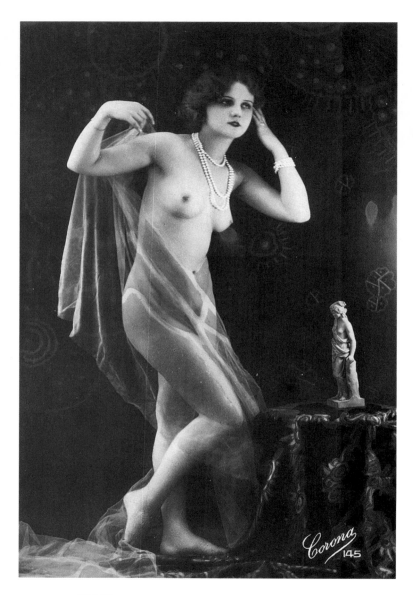

Anonymous
C. 1920

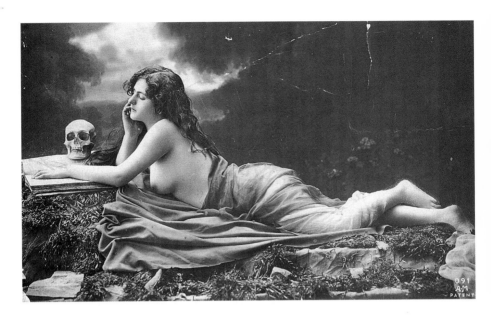

Anonymous
C. 1900

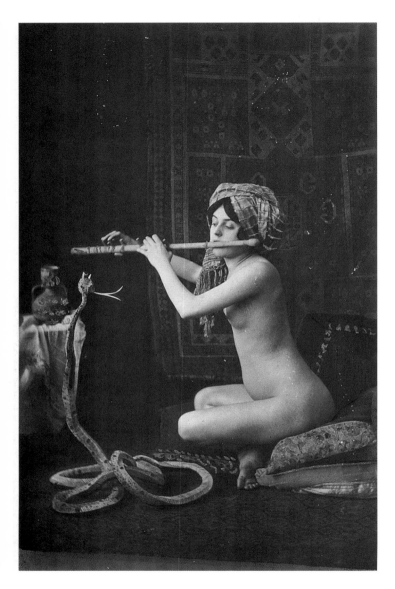

Anonymous
C. 1910

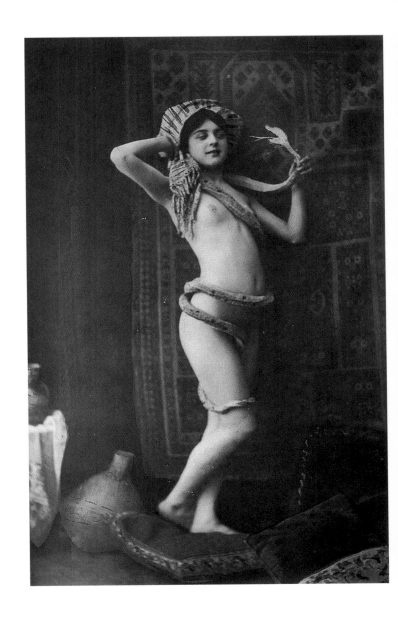

Anonymous
C. 1910

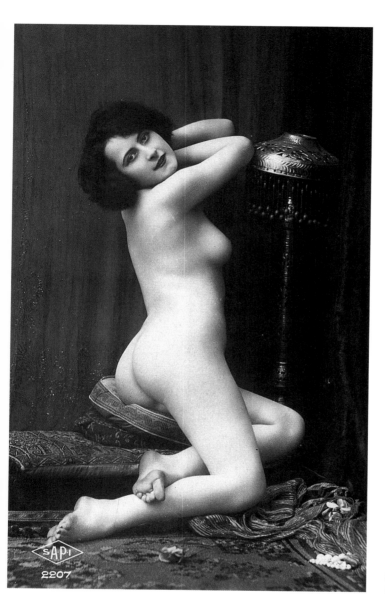

Anonymous
C. 1920

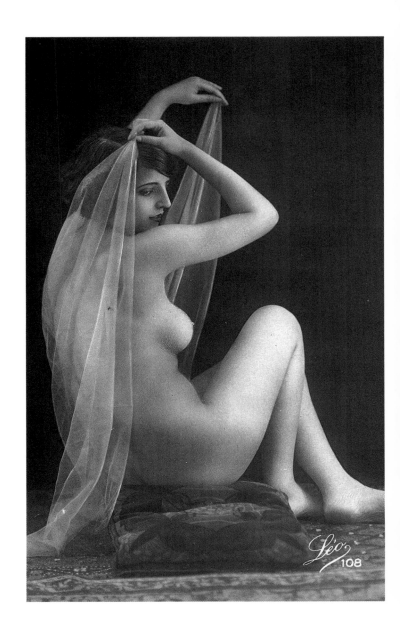

Anonymous
C. 1920

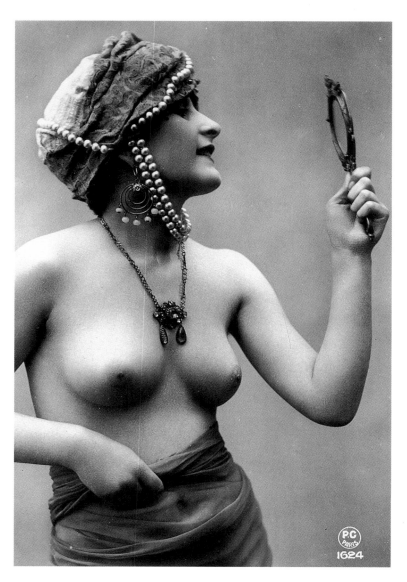

Anonymous
C. 1920

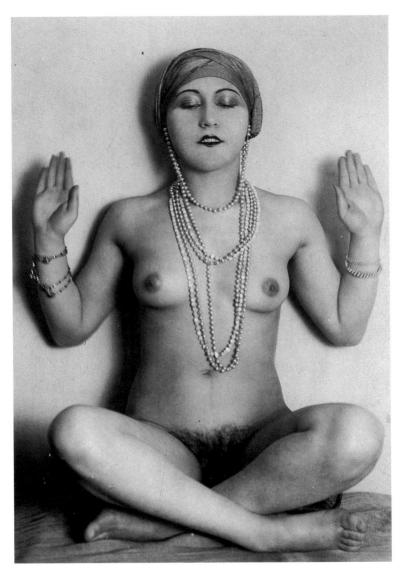

Anonymous
c. 1920

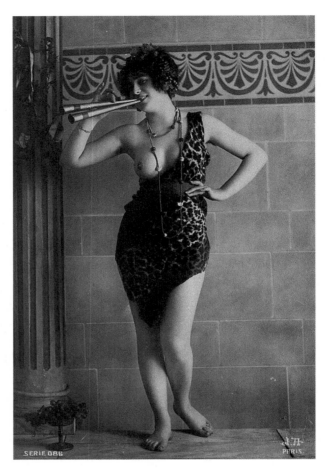

Anonymous
C. 1910

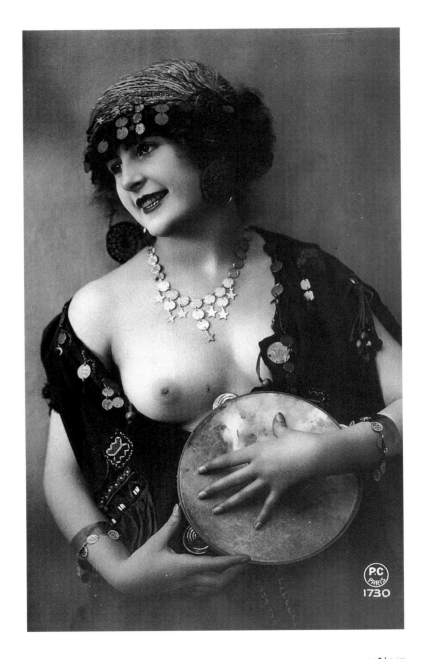

P.C
PARIS
1730

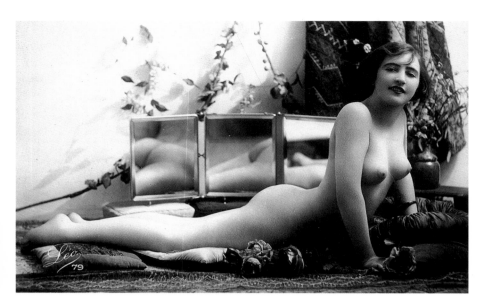

Anonymous
C. 1920

Anonymous
C. 1920

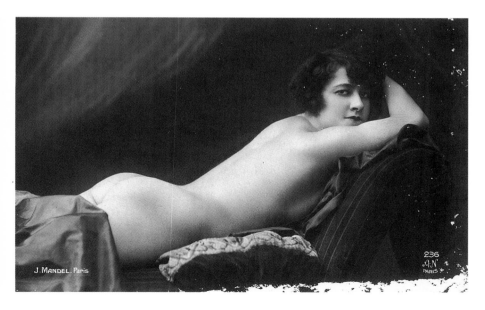

Anonymous

c. 1920

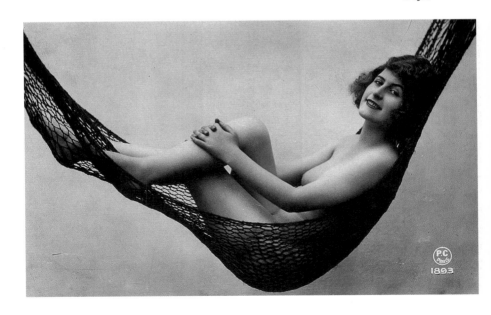

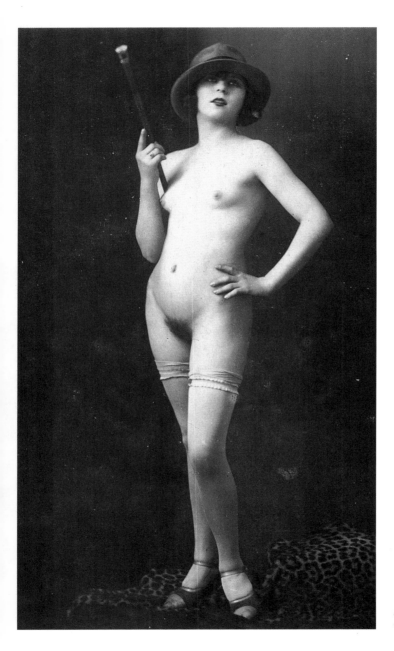

Anonymous
C. 1915

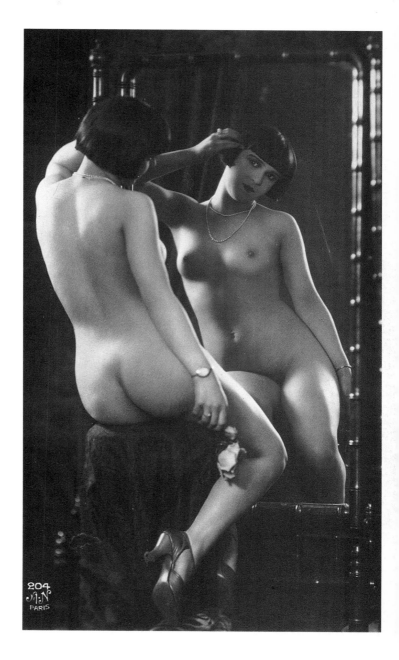

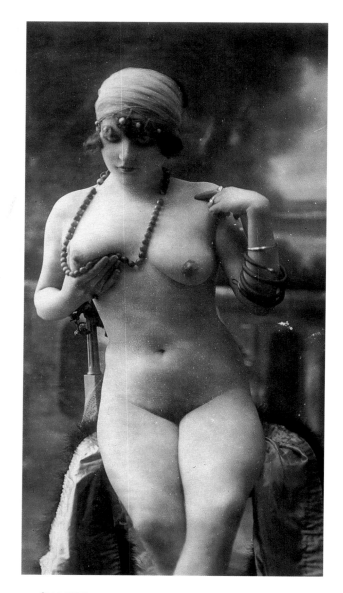

Anonymous
C. 1920

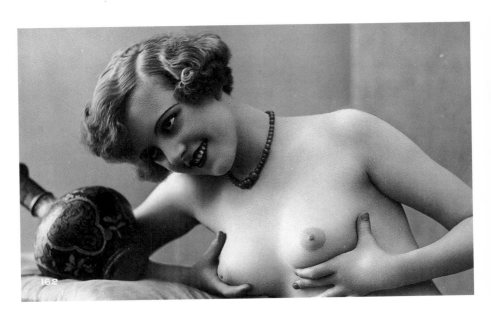

Anonymous
c. 1920

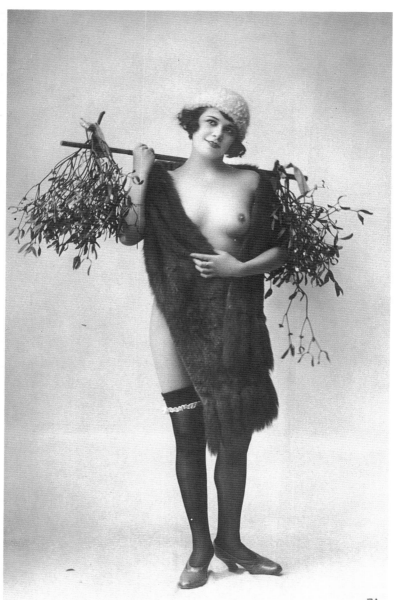

31

Anonymous
c. 1920

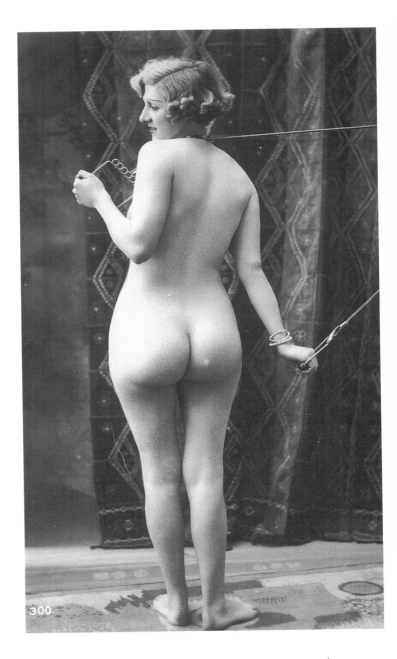

Anonymous
c. 1920

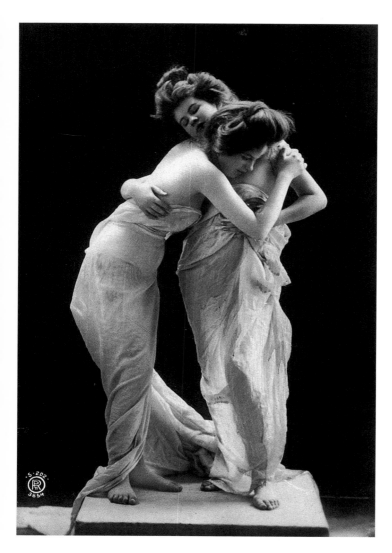

Anonymous
C. 1910

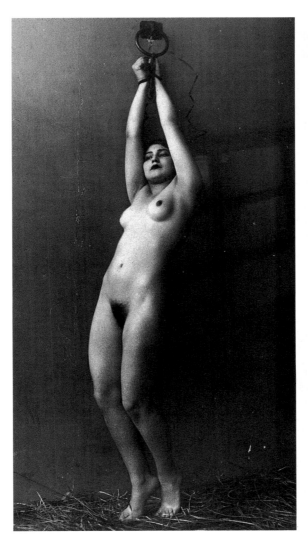

Anonymous
c. 1920

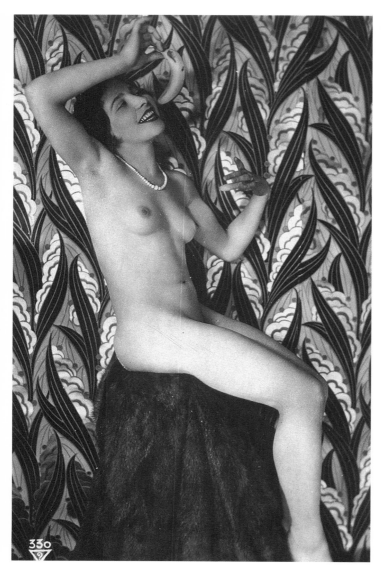

Anonymous
c.1930

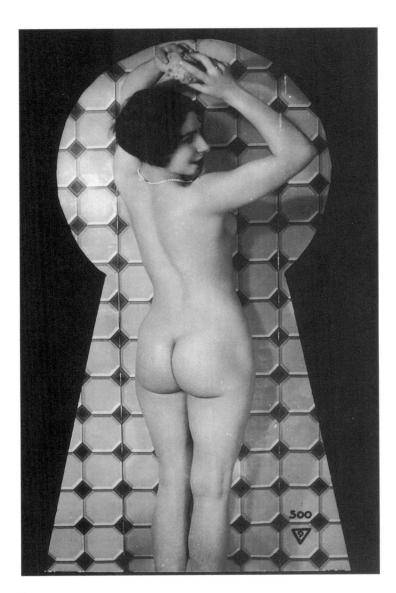

Anonymous
c. 1920

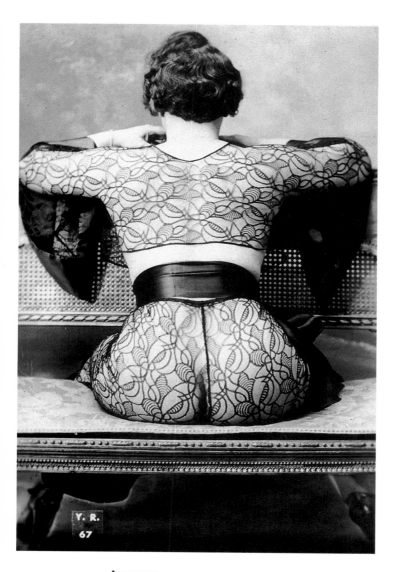

Anonymous
C. 1920

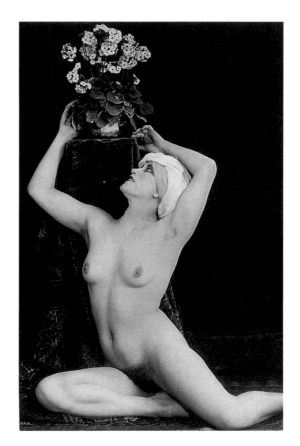

Anonymous
C. 1920

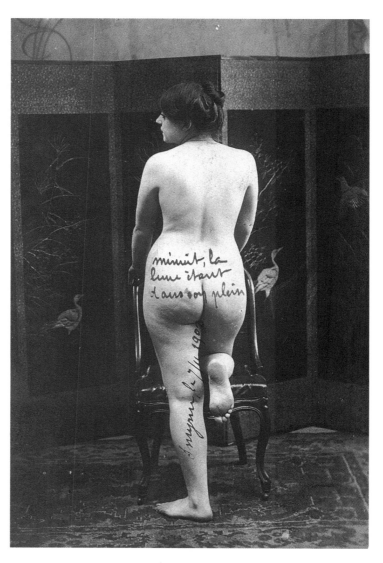

Anonymous
Full Moon at Midnight
1906

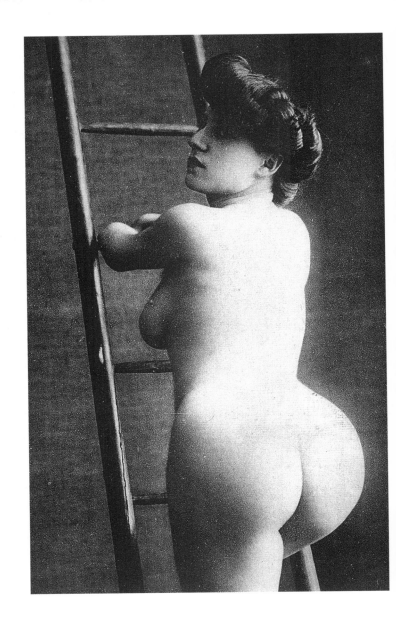

Anonymous
c. 1940

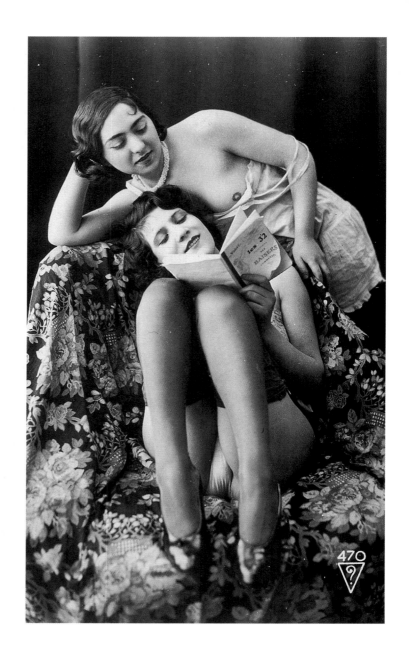

Anonymous
C. 1925

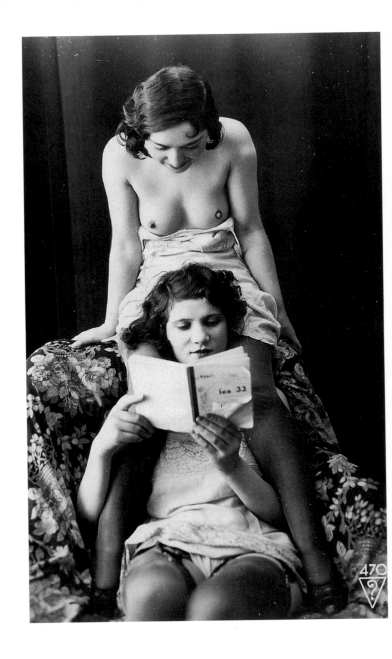

Anonymous
c. 1925

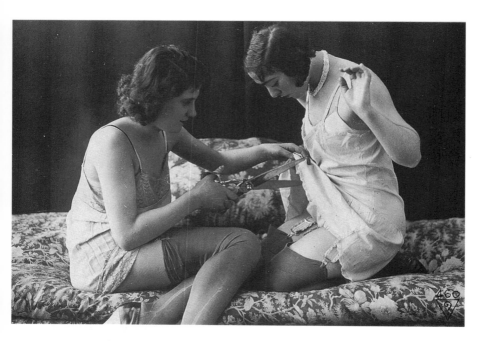

Anonymous
C. 1920

Anonymous
C. 1920

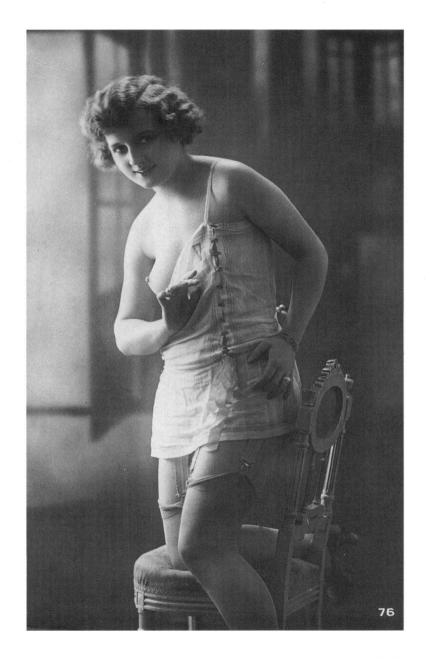

76

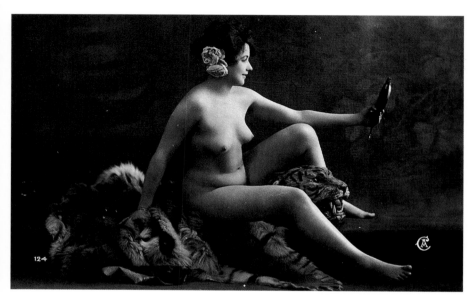

Anonymous
C. 1915

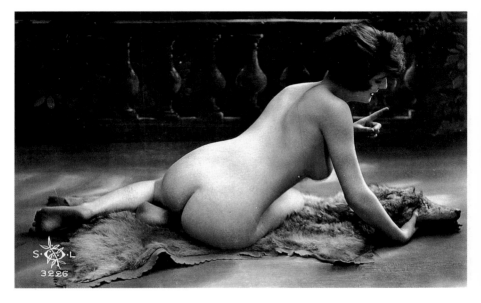

Anonymous
C. 1920

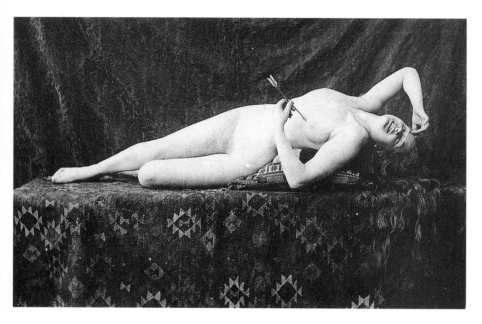

Anonymous
C. 1910

Anonymous
C. 1920

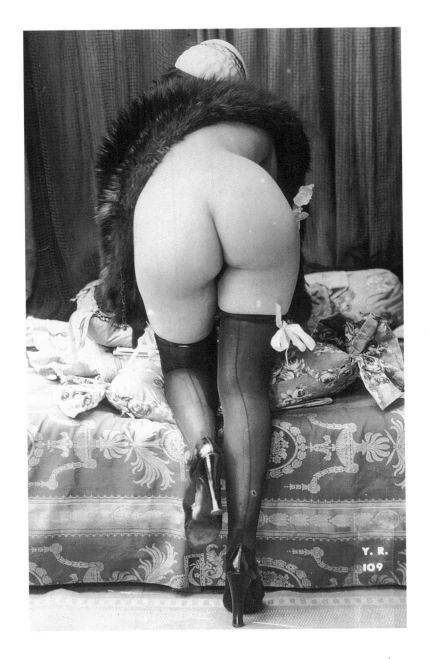

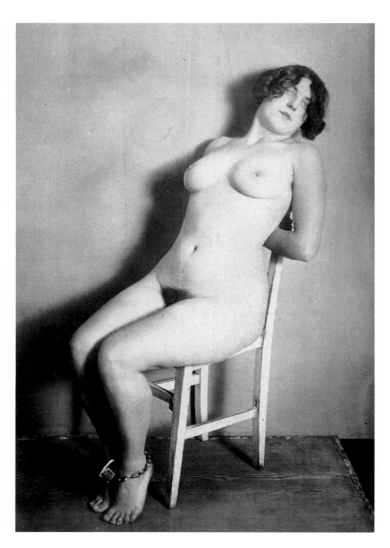

Anonymous
C. 1915

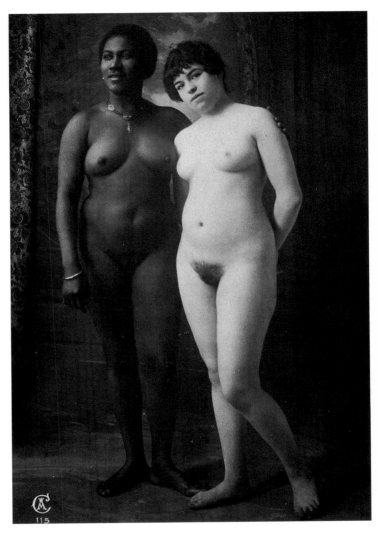

Anonymous
C. 1910

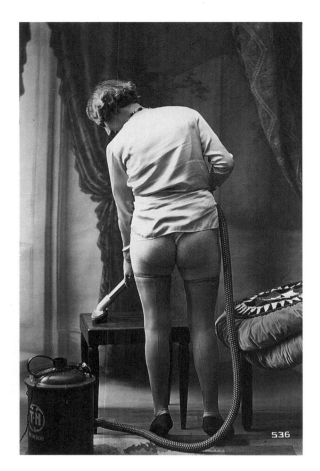

Anonymous
c. 1920

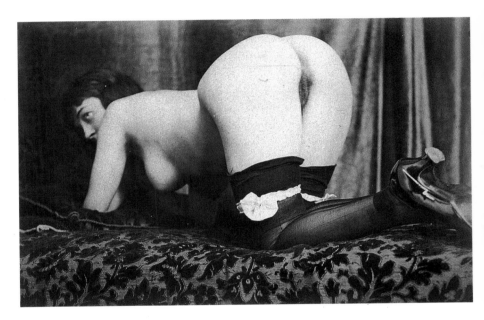

Anonymous
c. 1900

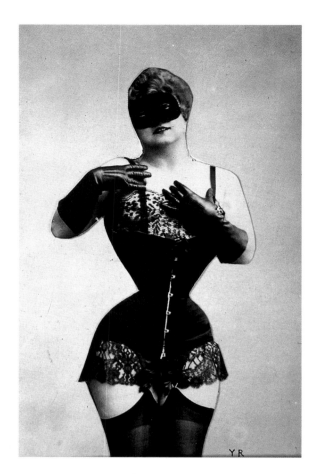

Anonymous
c. 1915

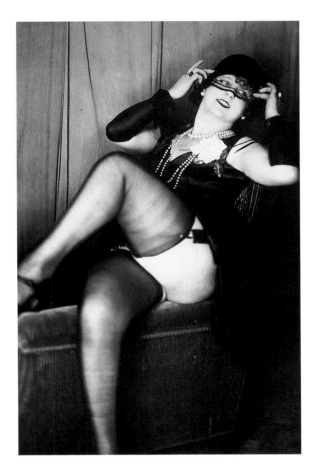

Anonymous
C. 1915

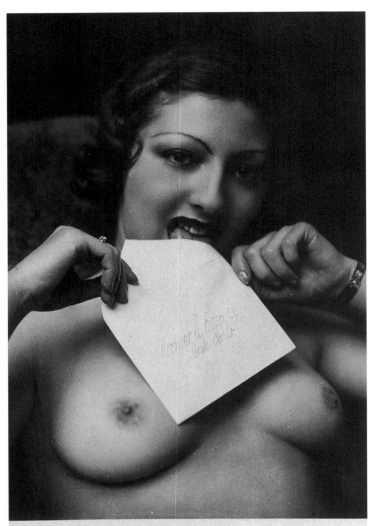

Voilà deux jolis seins
ronds et potelés.

Anonymous
Two lovely breasts, round and full
C. 1910

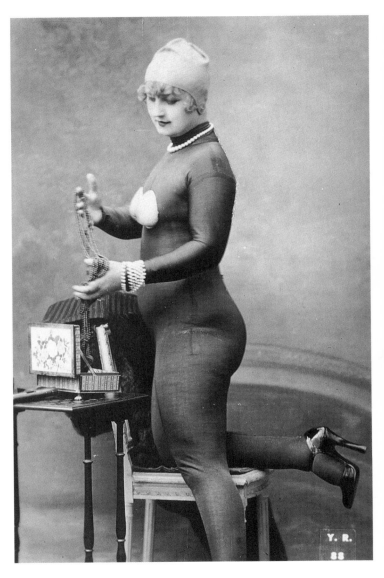

Anonymous
C. 1920

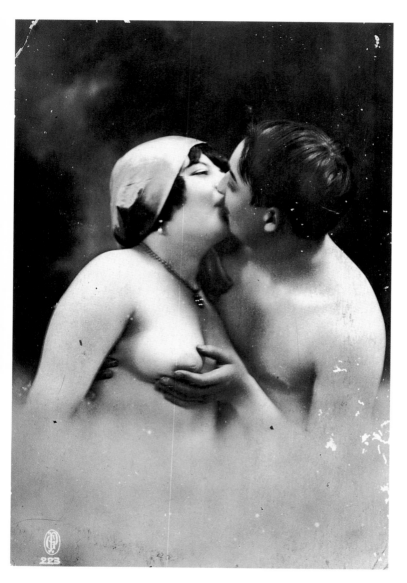

Anonymous
C. 1910

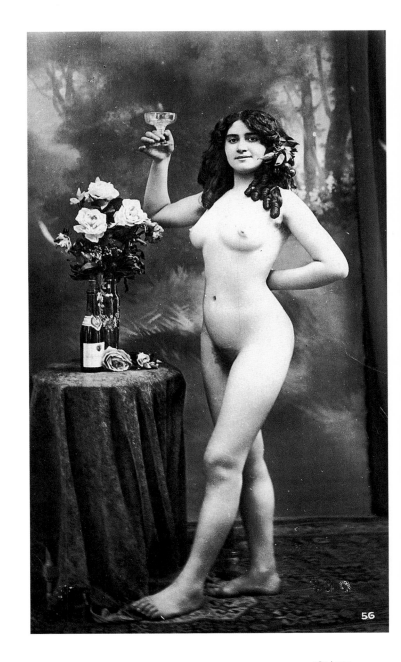

Anonymous
c. 1900

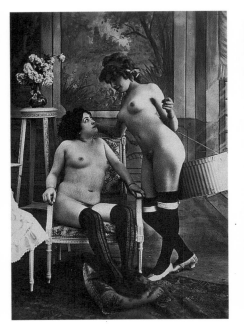

Anonymous
C. 1910

Anonymous
C. 1910

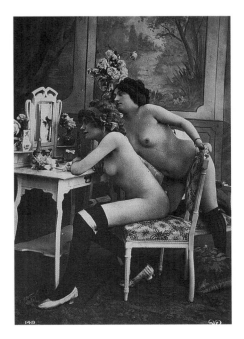

Anonymous
C. 1910

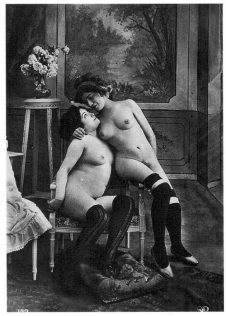

Anonymous
C. 1910

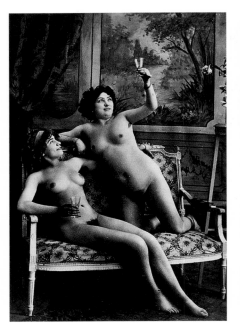

Anonymous
C. 1910

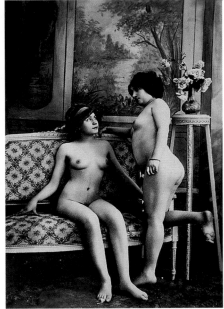

Anonymous
C. 1910

Anonymous
C. 1910

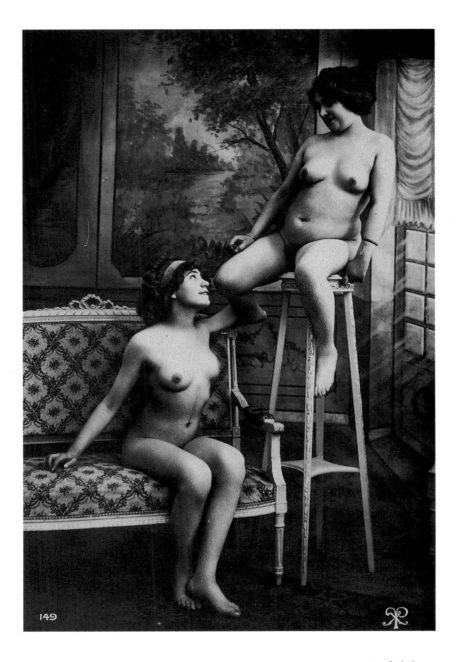

149

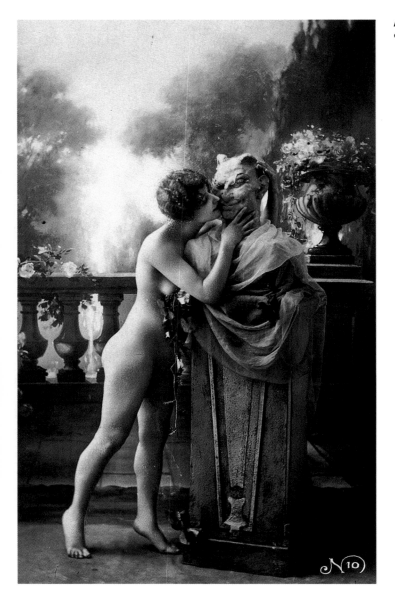

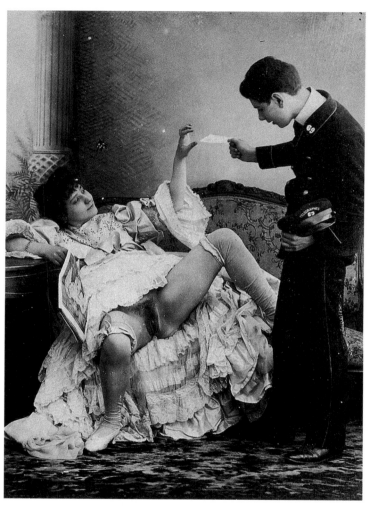

Anonymous
c. 1890

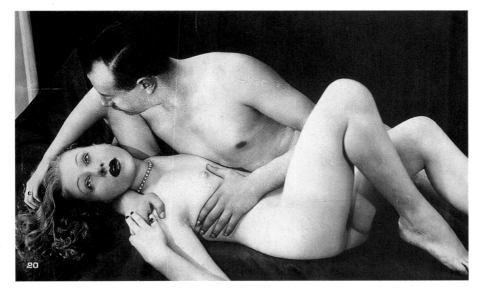

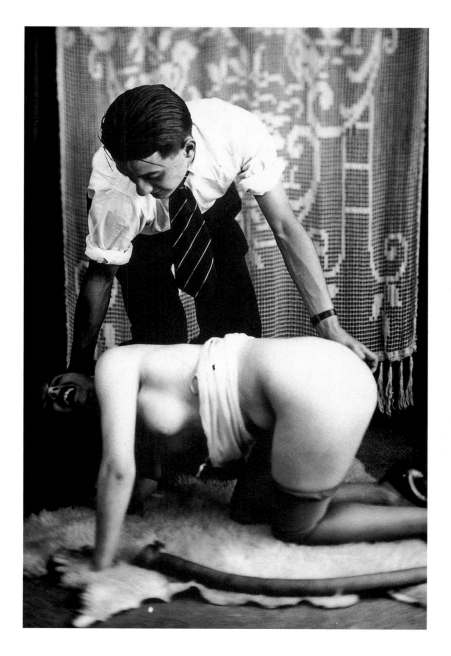

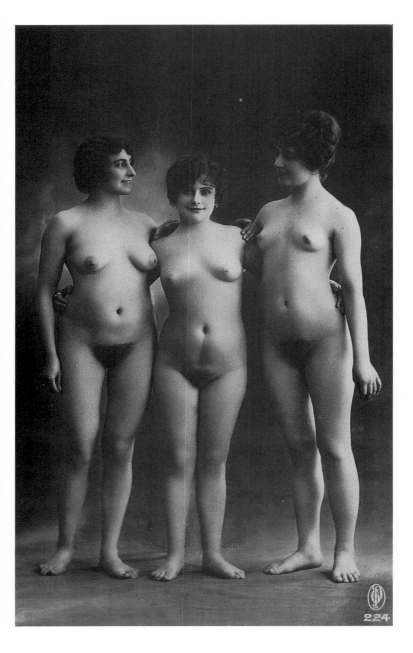

224

Anonymous
c. 1900

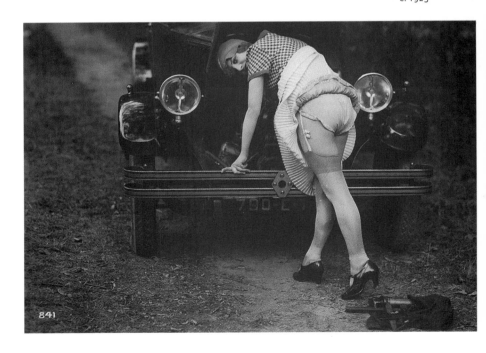

841

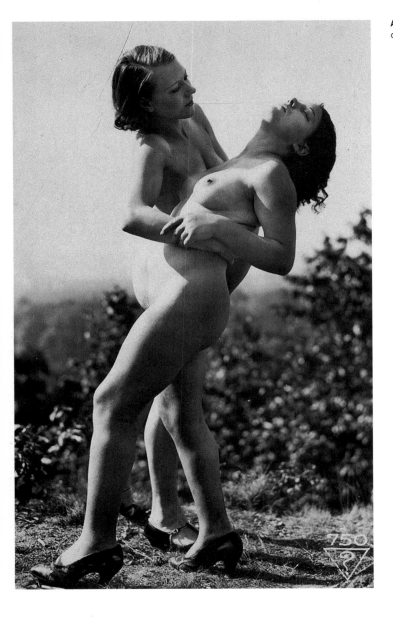

Anonymous
c. 1925

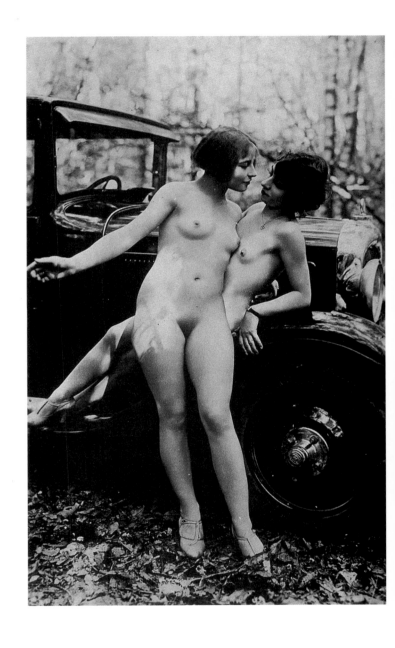

Anonymous
C. 1930

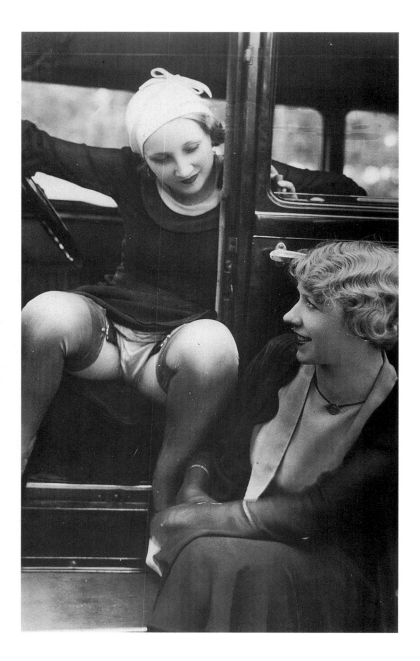

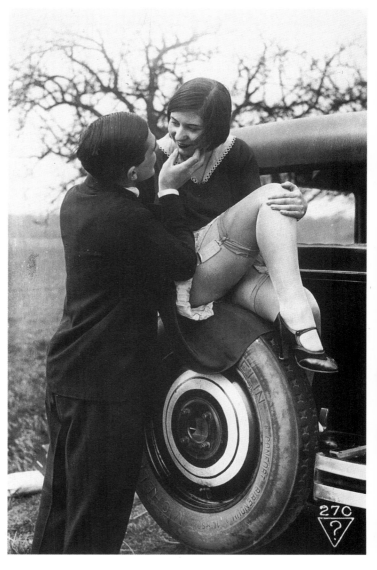

Anonymous
C. 1930

Anonymous
C. 1930

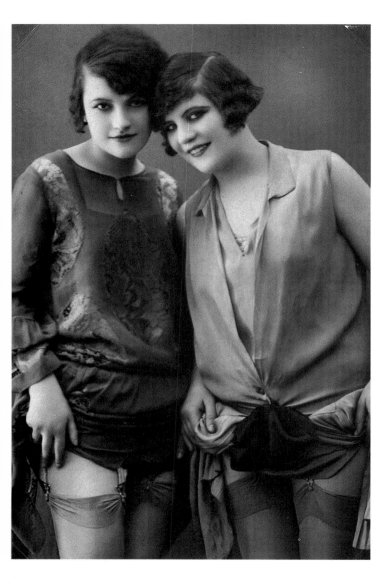

Anonymous
C. 1925

Anonymous
C. 1925

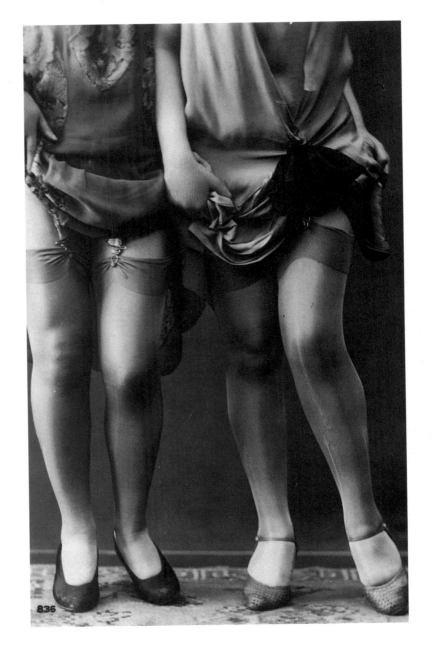

836

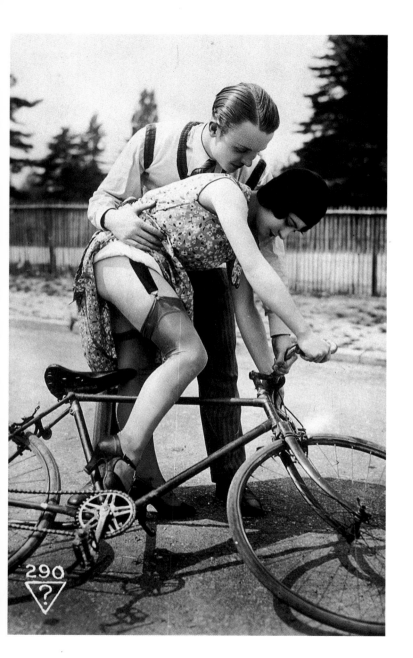

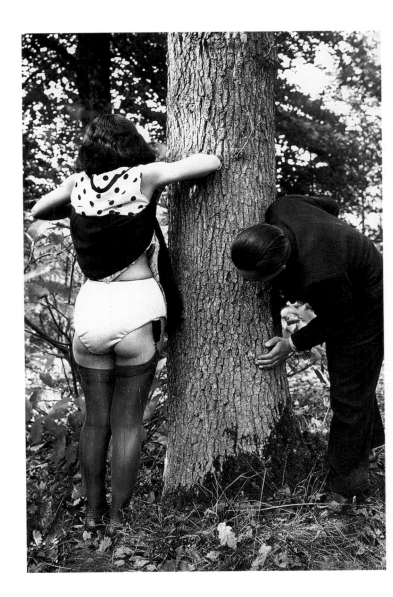

Anonymous
C. 1925

Anonymous
C. 1930

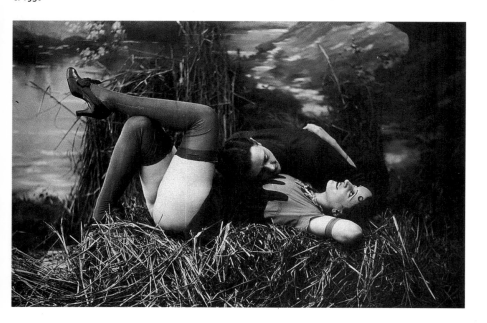

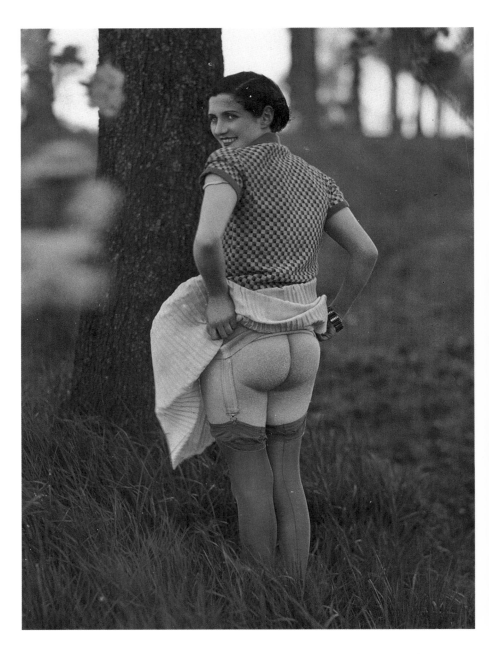

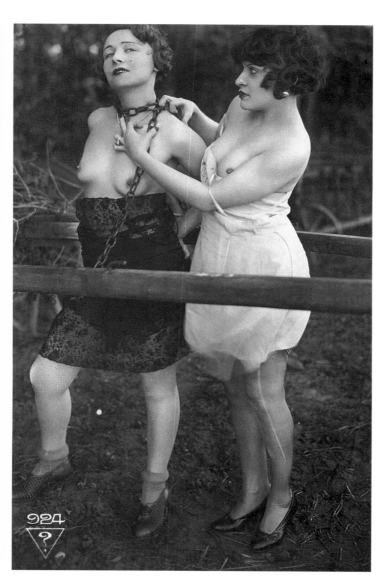

Anonymous
C. 1920

Anonymous
C. 1920

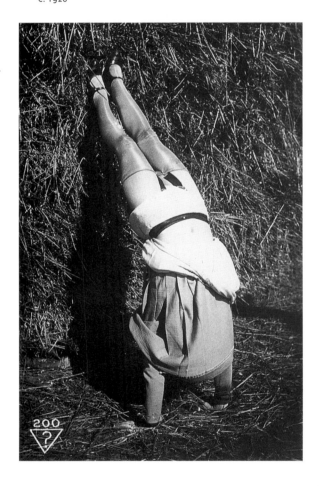

►
Anonymous
C. 1920
►►
Anonymous
C. 1920

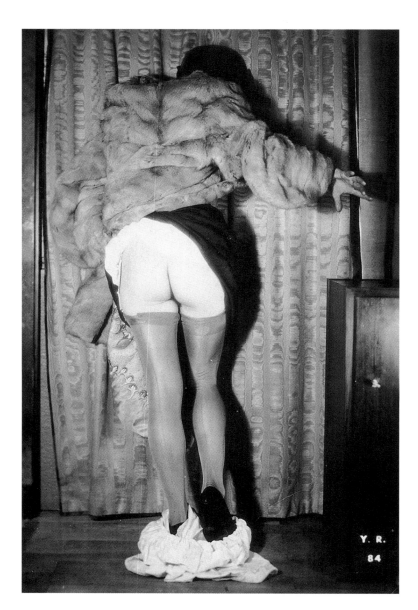

Y. R.
84

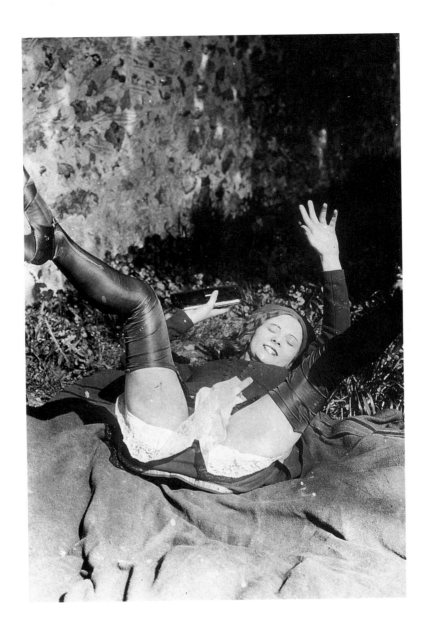

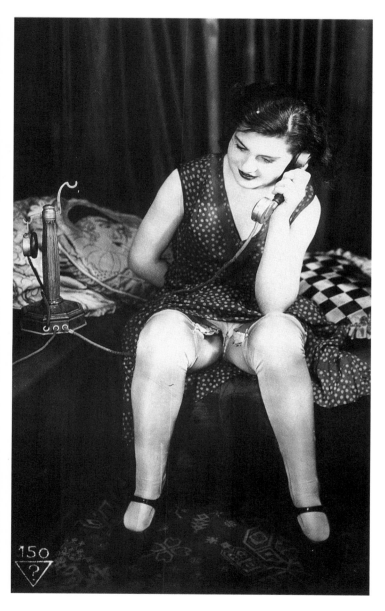

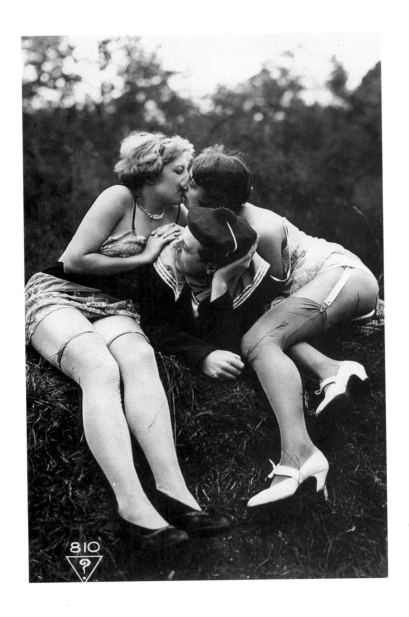

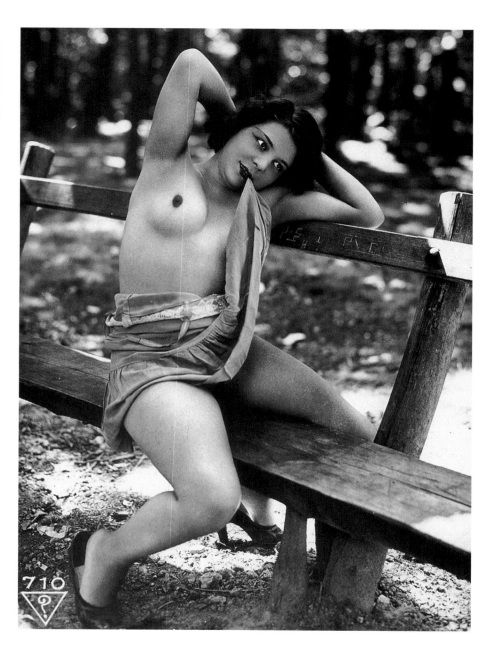

710
?

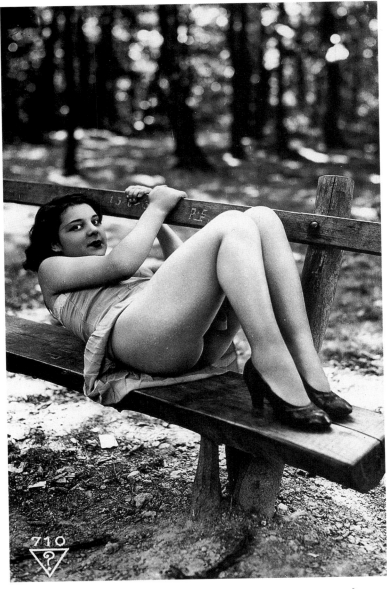

Anonymous
c. 1925

Anonymous
c. 1925

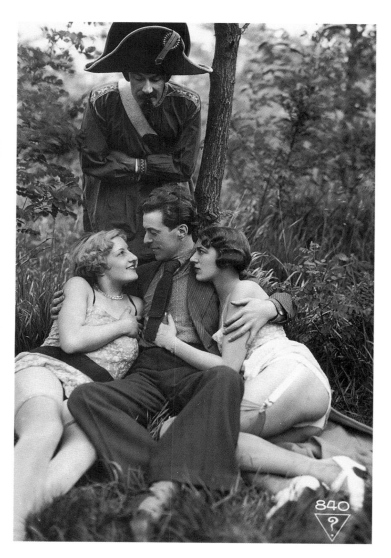

Anonymous
C. 1920

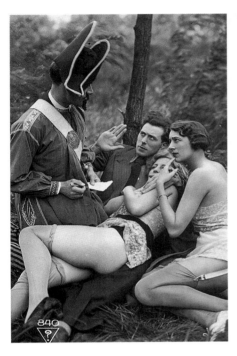

Anonymous
C. 1920

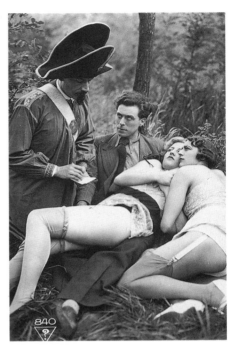

Anonymous
C. 1920

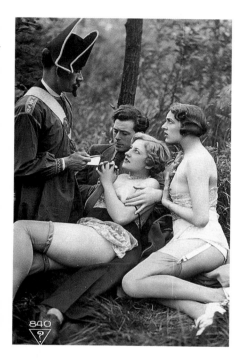

Anonymous
C. 1920

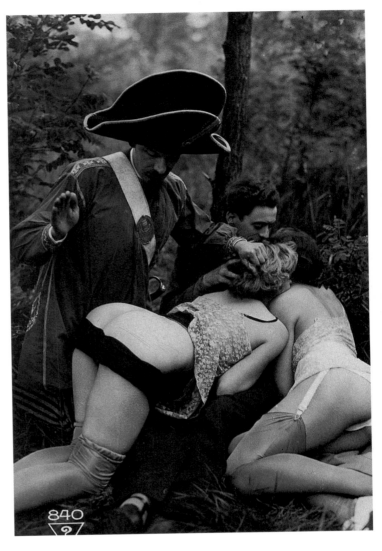

Anonymous
C. 1920

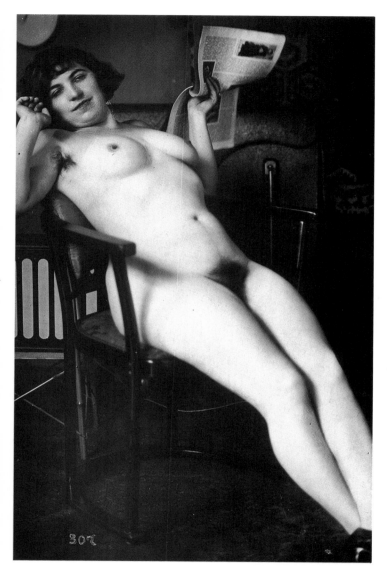

Anonymous
C. 1920

Anonymous
C. 1920

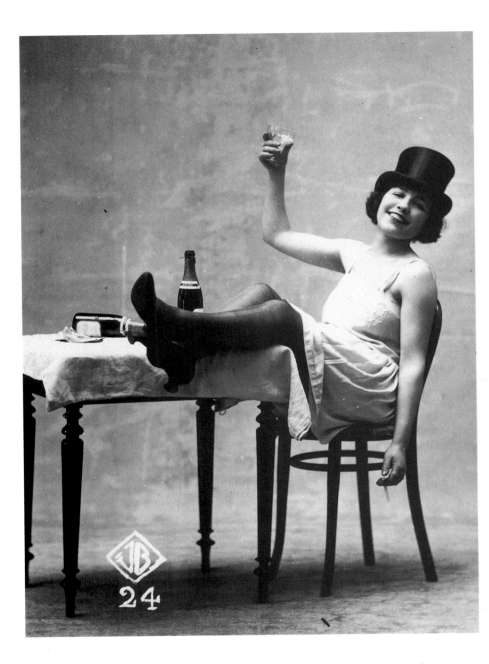

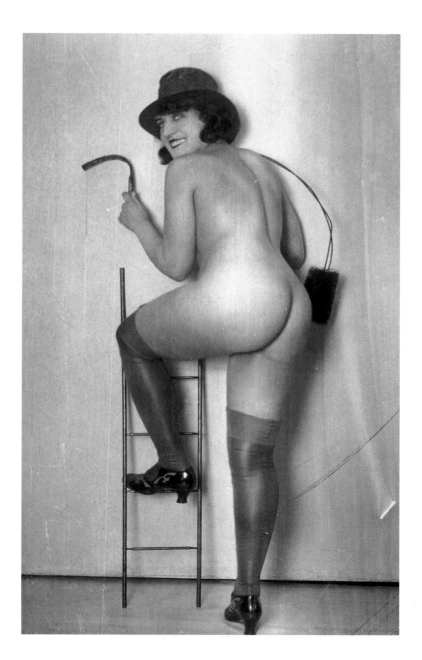

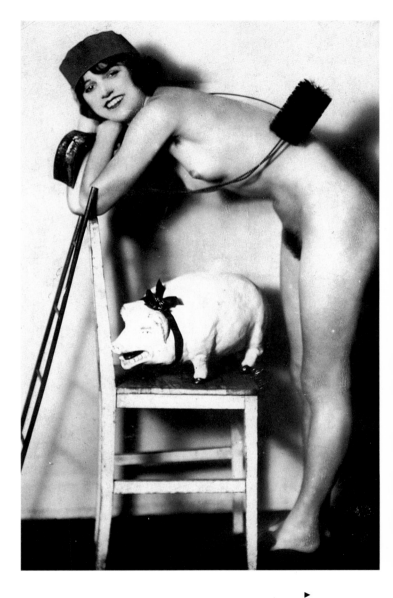

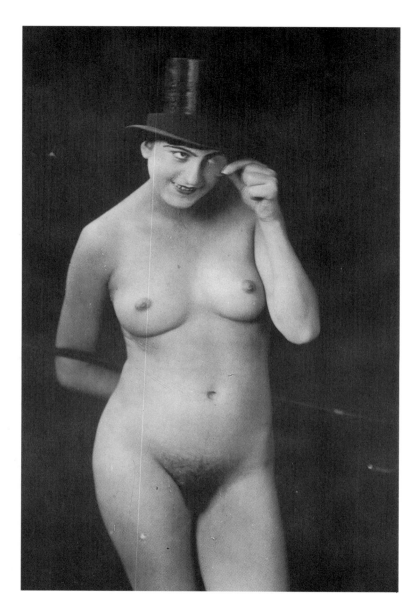

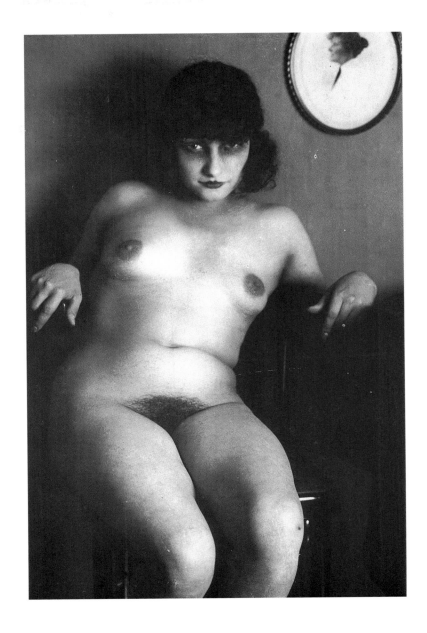

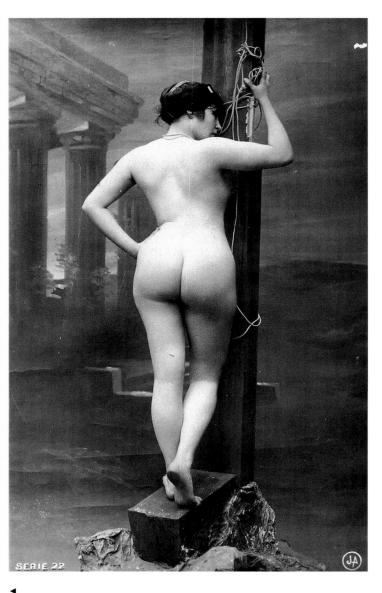

SERIE 22

◄

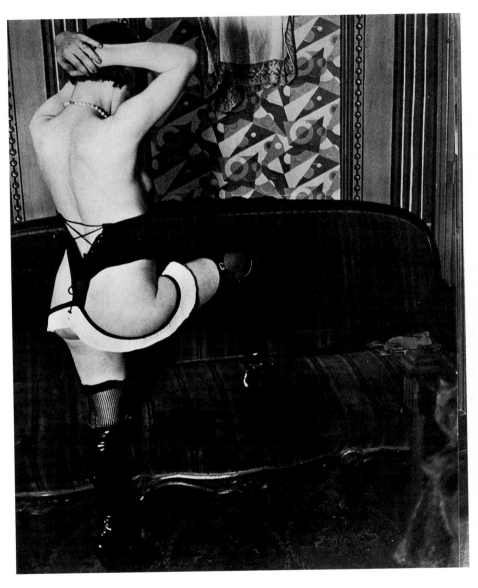

Anonymous
C. 1920

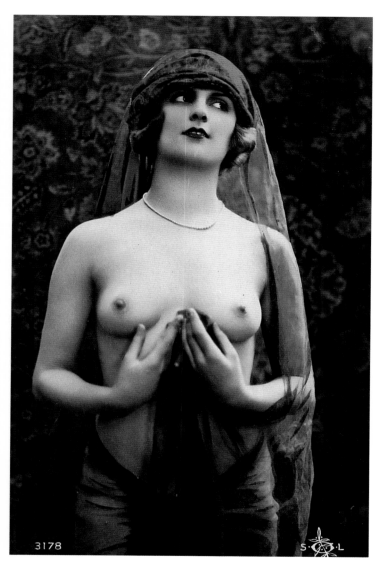

Anonymous
C. 1920

3178

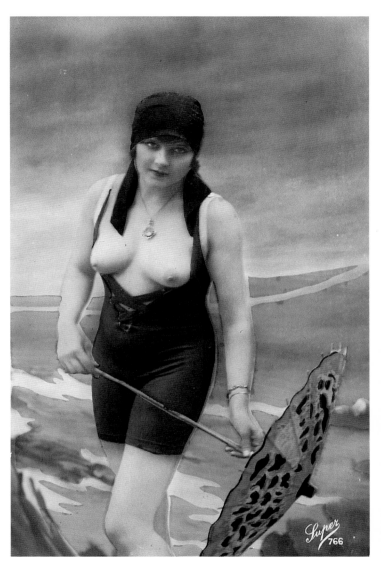

Anonymous
C. 1920

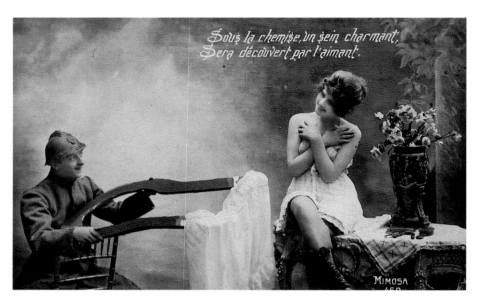

Anonymous
Under the shirt appears a lovely breast
C. 1910

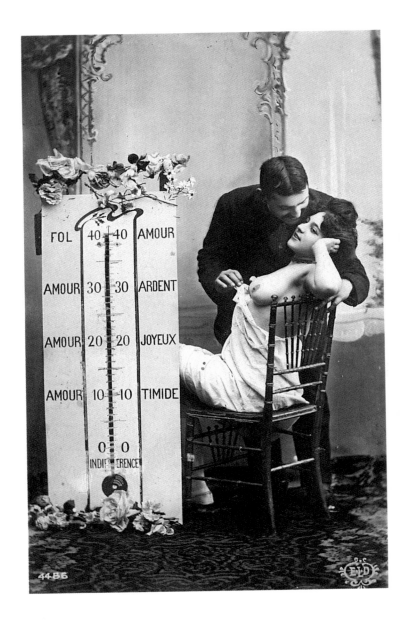

Anonymous
c. 1910

6
Peepshows: the three-dimensional nude

Peepshow: Der drei-dimensionale Akt

Le peep-show: le nu en trois dimensions

Lasting as late as the 1940s, one of the most popular distribution forms for erotic photographic images were stereoscopic nudes. They were first done as daguerreotypes, then as paper prints and finally (around 1900) as slides. In 1832, the principle of creating an illusion of depth had already been described by Britain's Charles Wheatstone. But it was only when the photographs were combined with a handy viewer, invented in 1850 by Sir David Brewster, that a veritable craze for stereoscopic images took hold of the public. The technical feat in stereoscopy is that a pair of slightly dissimilar images can be made to appear as a single three-dimensional picture when viewed through the binocular-like apparatus. The pictures were first taken using two sliding cameras, but later special cameras with jointly-controlled lenses did the job. Soon production in the field became industrialized and fell into the hands of large companies like the "London Stereoscopic Company", founded in 1854 by George Swan Nottage. The company's slogan – "No home without a stereoscope" – testifies to the huge extent of the fad, one which experienced a surge in popularity in the 1880s and another around 1925. During the first two years of its existence, this London company supplied some half a million viewers. Around 1856, an estimated 10,000 different motifs were on the market. By 1858, the figure came to an estimated 100,000, undoubtedly including photos of nudes, whose special attraction, alongside that of the spatial illusion, probably lay in the impression they created of a certain intimacy between the viewer and the model. Many technical improvements in stereoscopy, especially with respect to the viewing apparatus, were made, right up to the onset of World War II. However, once mass media – such as films, and illustrated magazines and newspapers – took over the scene, stereoscopy had obviously outlived its usefulness as a popular form of entertainment.

Zu den besonders populären Distributionsformen erotischer Bildfindungen zählte bis in die vierziger Jahre des 20. Jahrhunderts der Stereo-Akt, zunächst als Daguerreotypie, später als Papierabzug und schließlich (nach ca. 1900) in Gestalt von Glasdiapositiven. Die Prinzipien räumlichen Sehens hatte bereits 1832 der Brite Charles Wheatstone beschrieben. Doch erst die Erfindung bzw. Publikation der Fotografie in Verbindung mit der Entwicklung eines handlichen Betrachtungsgeräts durch Sir David Brewster (1850) führte Mitte des 19. Jahrhunderts zu einer ersten »Stereoskopomanie«. Technisch profitiert das Verfahren von der Tatsache, daß ein Paar geringfügig unterschiedlicher Bilder, durch ein brillenartiges Gerät betrachtet, dreidimensional aufscheint. Die Aufnahmen selbst wurden zunächst mit verschiebbaren Kameras, später mit Spezialkameras mit parallel geschalteten Objektiven aufgenommen. Den Vertrieb der industriell gefertigten Stereobilder übernahmen Großunternehmen wie die 1854 durch George Swan Nottage gegründete »London Stereoscopic Company«. Ihr Slogan – »Kein Heim ohne Stereoskop« – verweist auf den Massencharakter der Stereoskopie, die Ende der achtziger Jahre des 19. Jahrhunderts sowie um 1925 noch einmal einen Popularitätsschub erfuhr. Das Londoner Unternehmen selbst konnte bereits in den ersten beiden Jahren seines Bestehens rund eine halbe Million Betrachter absetzen. 10 000 verschiedene Motive hielt man um 1856 vor. 100 000 sollen es um 1858 gewesen sein, darunter zweifellos auch Aktaufnahmen, deren besonderer Reiz neben der räumlichen Vision im Gefühl intimer Zweisamkeit von Betrachter und Modell gelegen haben dürfte. Bis in die Zeit vor dem Zweiten Weltkrieg erlebte die Stereoskopie allerhand technische Verbesserungen insbesondere im apparativen Bereich. Mit dem Aufkommen neuer Bildkommunikationsmittel – wie illustrierte Massenpresse und Film – hatte sie sich als Unterhaltungsmedium freilich überlebt.

Jusque dans les années 40, l'un des supports les plus populaires de l'image érotique fut le nu stéréoscopique, qui apparut tout d'abord sous forme de daguerréotypes, puis de tirages papier et enfin, vers 1900, sous forme de diapositives. Dès 1832, le Britannique Charles Wheatstone avait décrit les principes de la vision dans l'espace. Mais, alors que la photographie était inventée et rendue publique, il fallut encore attendre que Sir David Brewster mette au point un instrument de vue manuel (1850) pour que se propage, au milieu du siècle dernier, une première mode de la stéréoscopie. Techniquement, ce procédé repose sur le fait que deux images légèrement différentes, observées à travers un instrument ressemblant à une paire de lunettes, apparaisse comme une image en trois dimensions. Au départ, les images étaient prises avec deux appareils différents, et plus tard avec des appareils spéciaux dotés d'objectifs actionnés simultanément. Ces images stéréoscopiques produites industriellement furent commercialisées par de grandes sociétés, comme la «London Stereoscopic Company», créée en 1854 par George Swan Nottage. Son slogan «Un stéréoscope pour chaque foyer» témoigne du succès public de la stéréoscopie qui connut une grande vogue vers 1890, puis à nouveau vers 1925. En deux ans, l'entreprise londonienne réussit à vendre un demi-million de visionneuses. En 1856, le catalogue comprenait quelque 10 000 vues différentes. Elles étaient passées à 100 000 en 1858. Parmi ces images figuraient sans doute des nus, dont le principal attrait, outre la vision spatiale, résidait dans l'impression d'intimité qui s'instaurait entre le spectateur et le modèle. Jusqu'à la Deuxième Guerre mondiale, la stéréoscopie connut d'innombrables perfectionnements, surtout au niveau technique. Avec l'avènement de nouvelles formes de diffusion de l'image, comme la presse illustrée et le cinéma, la stéréoscopie disparut en tant que source de divertissement.

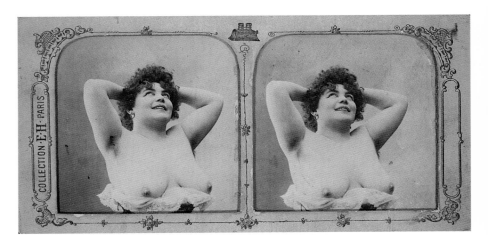

Collection E.H. Paris
c. 1870

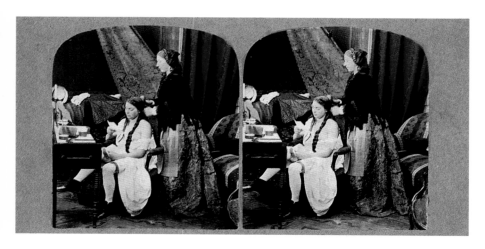

Anonymous
c. 1865

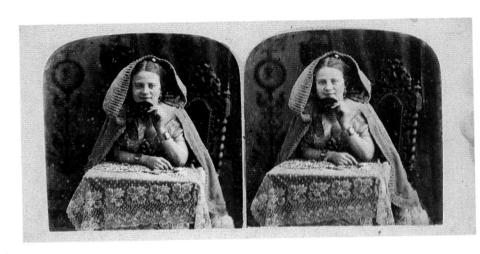

Anonymous
c. 1865

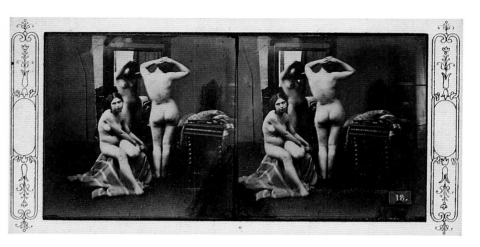

Anonymous
c. 1858

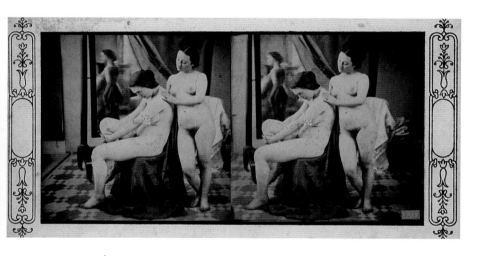

Anonymous
c. 1858

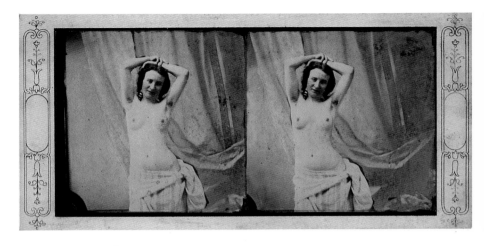

Anonymous
c. 1858

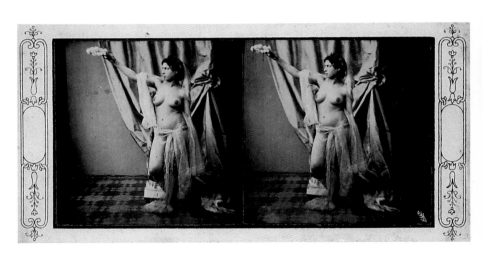

Anonymous
c. 1858

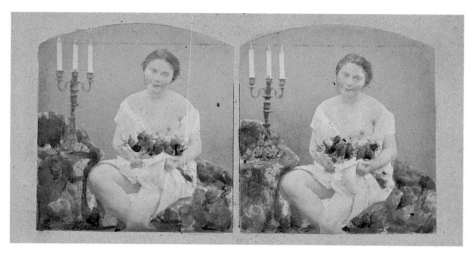

Anonymous
c. 1860

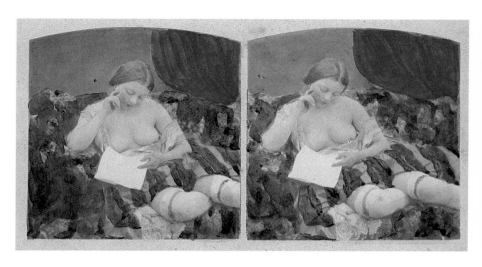

Anonymous
c. 1860

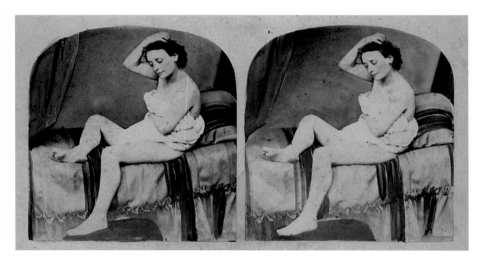

Anonymous
c. 1860

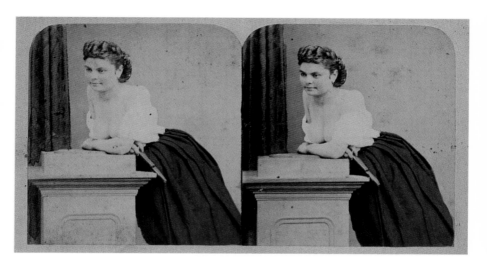

Anonymous
c. 1860

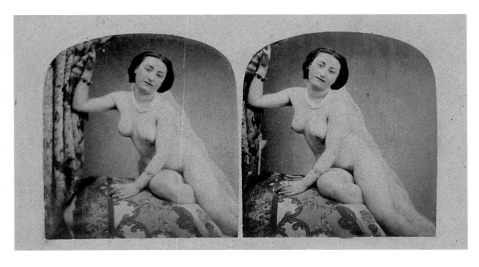

Anonymous
c. 1858

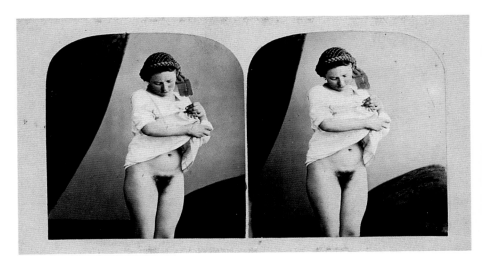

Anonymous
c. 1860

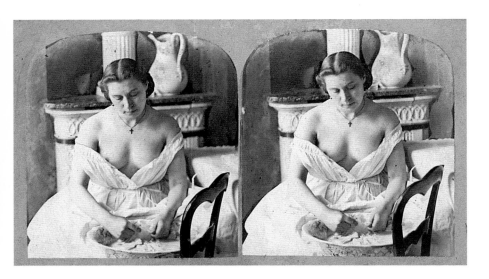

Anonymous
c. 1860

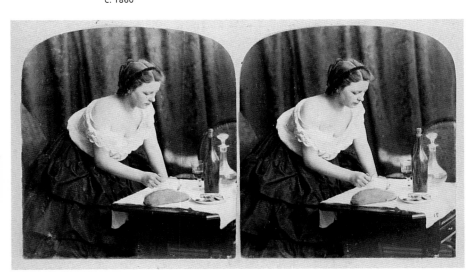

Anonymous
c. 1860

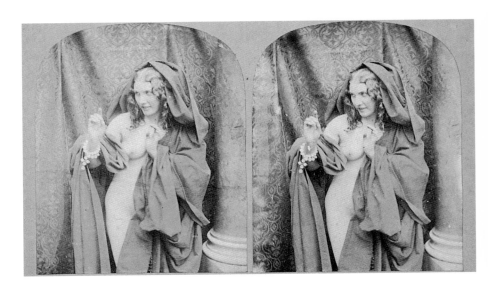

Anonymous
c. 1860

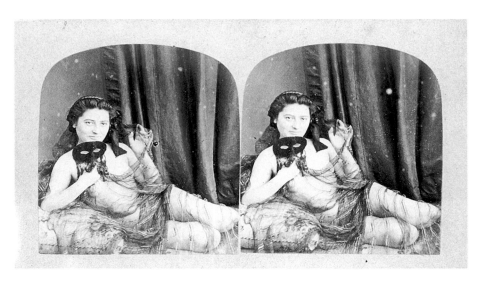

Anonymous
c. 1865

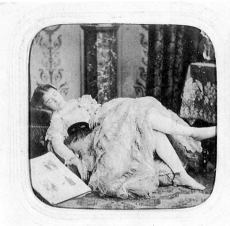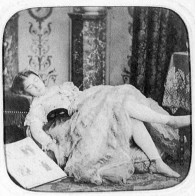

Anonymous
c. 1870

Anonymous
c. 1860

Anonymous
c. 1860

Anonymous
c. 1860

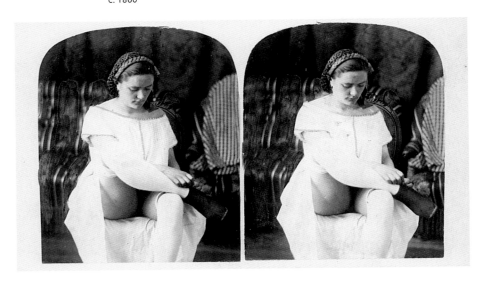

Anonymous
c. 1860

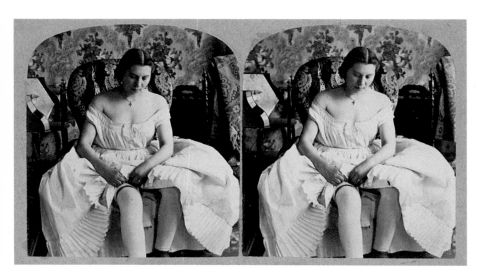

Anonymous
c. 1860

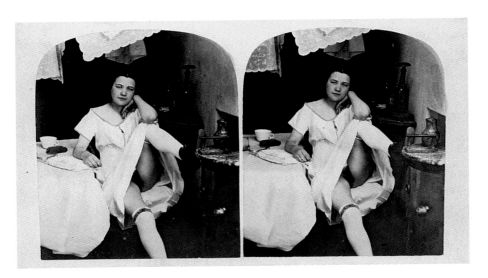

Anonymous
c. 1860

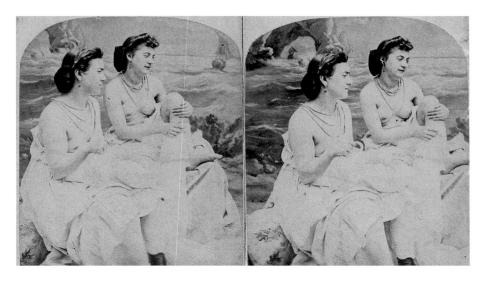

Anonymous
c. 1860

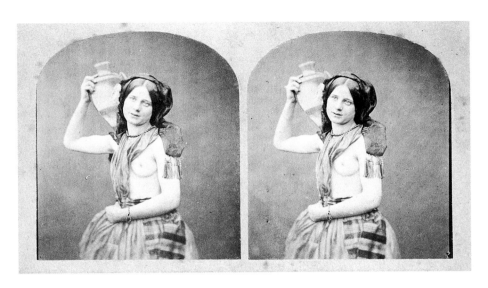

Anonymous
c. 1858

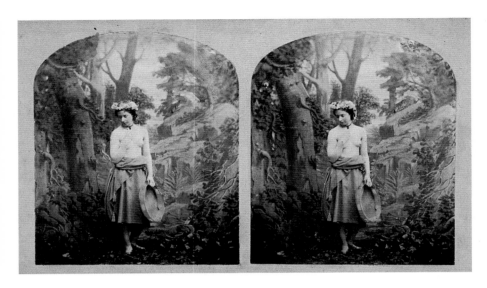

Anonymous
c. 1860

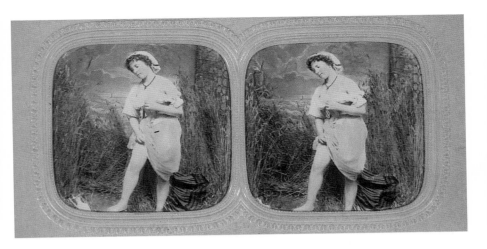

Anonymous
C. 1860

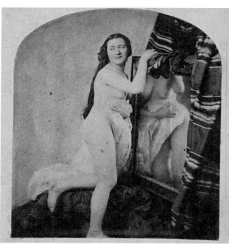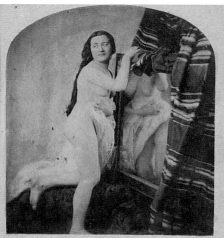

Anonymous
c. 1860

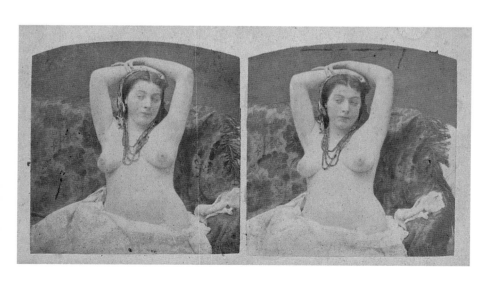

Anonymous
c. 1860

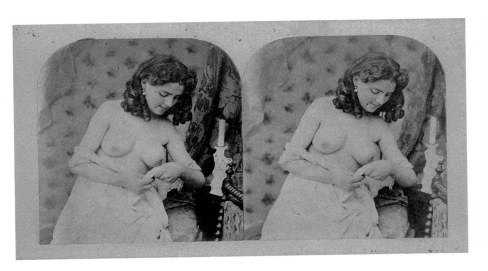

Anonymous
c. 1860

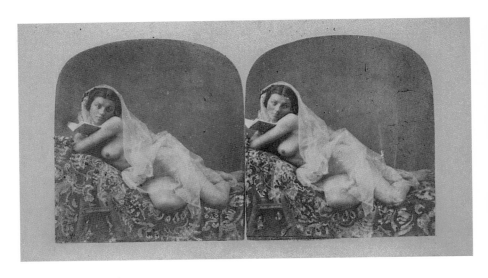

Anonymous
c. 1860

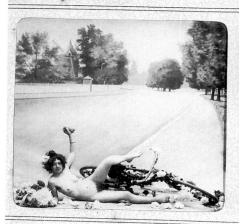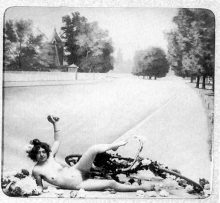

Anonymous
C. 1900

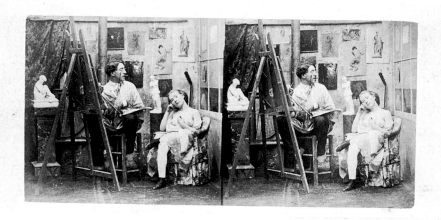

Anonymous
C. 1865

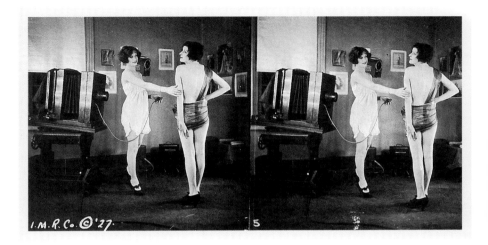

I.M.R. Co.
1927

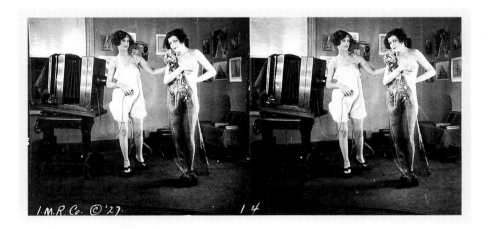

I.M.R. Co.
1927

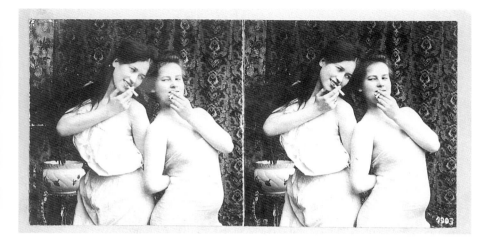

Anonymous
C. 1900

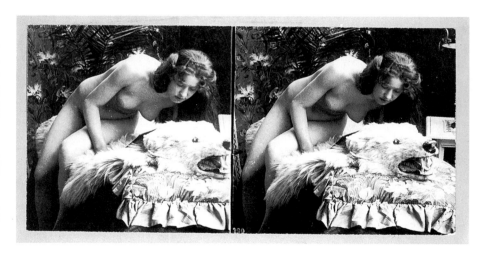

Anonymous
C. 1900

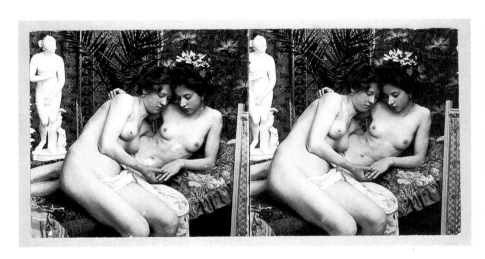

Anonymous
C. 1900

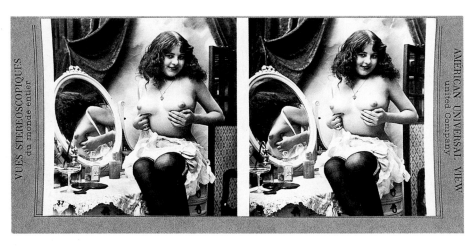

E. Agelou
C. 1900

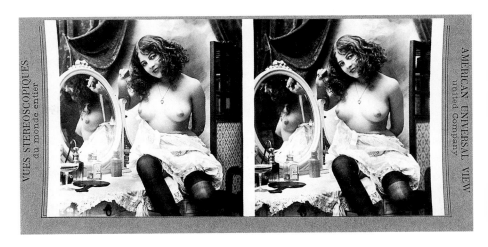

E. Agelou,
C. 1900

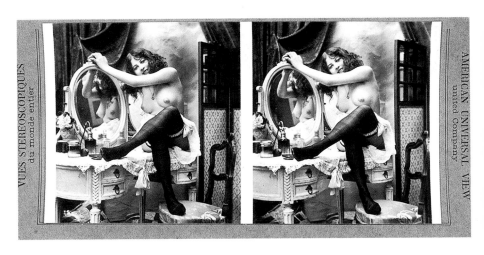

E. Agelou
C. 1900

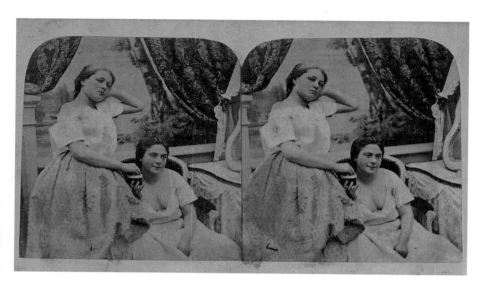

Anonymous
c. 1865

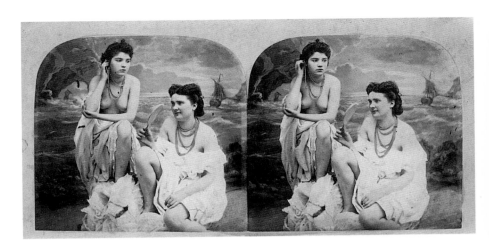

Anonymous
c. 1858

7
The ethnological nude

Der ethnographische Akt

Le nu ethnologique

As early as in 1839, a certain François Dominique Arago, fervent apologist of the new medium, referred to archaeology as a specific field of application for the daguerreotype process. But other branches of science were also quick to avail themselves of a medium so "unerring" and "objective" as photography. One of these, developing in the wake of colonial expansion, was the comparative study of peoples, or "ethnology". A few daguerreotypes from the early 1840s bear witness as to how rapidly this technique was assimilated as a tool for ethnological research. However, foreign races and types could only really start to be catalogued properly and to the desired extent with the advent of more practical negative/positive processes. By the end of the colonial era, therefore, some hundred thousand ethnographic photos – for the most part taken in Asia and Africa – had been produced. Upon closer inspection, however, these works are exposed as an attempt to lay claim to power using a camera and a photographic plate. Standard fare for those anthropological and ethnological testimonies are the surveyor's staff, the rigid standing-to-attention stance (necessary in the first place due to the long exposure times), frontal and profile shots reminiscent of mug shots... Rare is the photograph bearing witness to any sort of interest in the lives of the "savages". As a result, the majority of photographic images delivered to the newly-founded museums of ethnology speak more eloquently about the mentality of the person producing the picture, about the camera operator's awareness and self-awareness, in short, about all that falls under the umbrella term "the colonial gaze". Those photographs that did not directly contribute to the research of their day found their way into countless popularized works such as Carl Heinrich Stratz's "The Racial Beauty of Women" (1901) or Ploss/ Bartels' "Women in Biology and Ethnology" (1884), which were aimed at satisfying both the curiosity with respect to exotic subjects and the taste for the erotic evinced by the growing middle-class of the times.

Bereits 1839 hatte François Dominique Arago, einer der Apologeten des neuen Mediums, auf den Nutzen der Daguerreotypie speziell für die Archäologie hingewiesen. Aber auch andere Wissenschafts- zweige wußten sich schnell der Hilfe des als »unbestechlich« und »objektiv« erachteten Bildmittels Fotografie zu versichern, wie etwa die sich im 19. Jahrhundert im Zuge kolonialer Ausbreitung konstitu- ierende vergleichende Völkerkunde, die Ethnologie. Vereinzelte Daguerreotypien aus den frühen vierziger Jahren des 19. Jahr- hunderts verweisen auf die rasche Indienstnahme der Technik durch die ethnologische Forschung. Richtig und im angestrebten enzyklo- pädischen Umfang beginnen konnte das Sammeln und Katalogisie- ren fremdländischer Rassen und Typen aber erst nach Einführung praktikabler Negativ-Positiv-Prozesse. So entstanden bis zum Ende der Kolonialära Hunderttausende ethnographische Aufnahmen, vor allem in Asien und Afrika, die sich bei kritischer Betrachtung aller- dings häufig als ein mittels Kamera und Fotoplatte exekutierter Herrschaftsanspruch entlarven. Meßlatte, Strammstehen (schon auf- grund der langen Belichtungszeiten), en-face- und Profilaufnahmen wie beim Polizeifoto gehörten zu den Standards anthropologischer bzw. ethnographischer Aufnahmetechnik. Eher ausnahmsweise scheint man sich für die eigentlichen Lebensumstände der »Wilden« interessiert zu haben, so daß die in großen Mengen bei den neuge- gründeten Völkerkundemuseen eingelieferten Bildergebnisse letzt- lich eher etwas aussagen über das Denken der Bildproduzenten, über Bewußtsein und Selbstbewußtsein der Operateure, über das, was man als »kolonialen Blick« bezeichnen könnte. Wo die Aufnahmen nicht im engeren Sinne der zeitgenössischen Forschung dienten, fan- den sie Eingang in zahllose popularwissenschaftliche Werke – wie etwa Carl Heinrich Stratz' »Die Rasseschönheit des Weibes« (1901) oder Ploss/Bartels »Das Weib in der Natur- und Völkerkunde« (1884) –, die die exotische Neugier ebenso bedienten wie das erotische Interesse eines bürgerlichen Publikums.

Dès 1839, François Dominique Arago, ardent défenseur de ce nouveau mode d'expression, avait souligné l'intérêt que le daguerréotype présentait pour les archéologues. De même, d'autres disciplines scientifiques surent rapidement tirer parti de cette technique réputée «exacte» et «objective». Ce fut le cas, par exemple, de l'ethnologie, l'étude comparée des peuples, qui se développa au 19ème siècle à la suite de l'expansion coloniale. Quelques daguerréotypes datant des années 1840 témoignent du développement rapide de cette technique dans le domaine de la recherche ethnologique. Cependant, ce n'est qu'après l'introduction du procédé plus maniable du négatif-positif, qu'il fut possible de rassembler et de classifier à grande échelle les races et les types étrangers. Des centaines de milliers de clichés ethnologiques furent ainsi réalisés jusqu'à la fin de la période coloniale, principalement en Asie et en Afrique. Cependant, un examen attentif de ces plaques trahit souvent un besoin de domination exercé par le biais de la démarche photographique. Parmi les images anthropologiques et ethnologiques, on retrouve fréquemment la présence d'une règle graduée, la position au garde-à-vous (en partie à cause de la longueur du temps de pause), et des portraits de face et de profil qui rappellent les fiches anthropométriques de police. On ressent tellement rarement un intérêt pour le mode de vie des indigènes, que la plupart de ces images destinées à alimenter les musées ethnologiques tout nouvellement créés, nous renseignent finalement bien plus sur l'état d'esprit des photographes, conscient et inconscient, et sur ce qu'on pourrait appeler le «regard colonial». Si ces images n'ont pas apporté grand chose à la science de l'époque, elles ont en revanche trouvé leur place dans d'innombrables ouvrages de vulgarisation, comme «Die Rassenschönheit des Weibes» de Carl Heinrich Stratz (1901) ou «Das Weib in der Natur- und Völkerkunde» de Ploss/Bartel (1884), qui répondaient autant à l'engouement du public bourgeois pour l'exotisme, qu'à son intérêt pour l'érotisme.

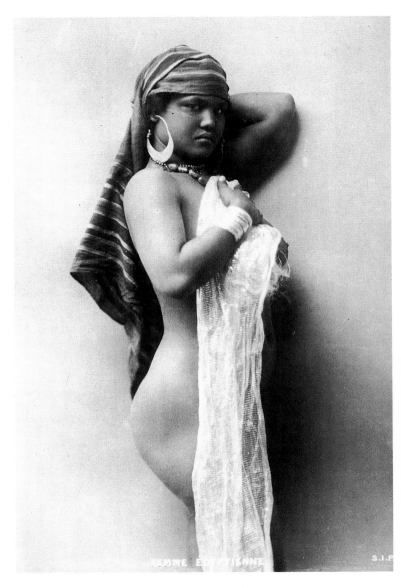

Anonymous
C. 1910

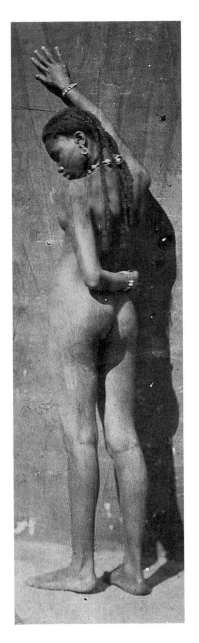

Rudolf C. Huber
c. 1875

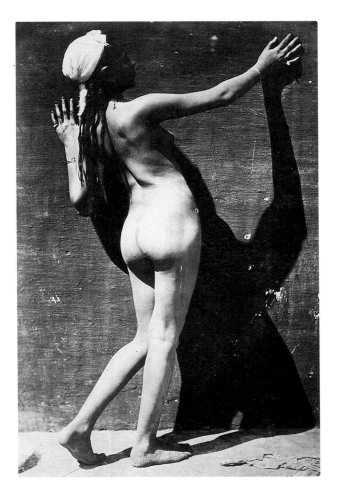

Rudolf C. Huber
C. 1875

►
Anonymous
Woman from Samoa
C. 1920
▶▶
Lehnert & Landrock
Arab from Tunis
C. 1910

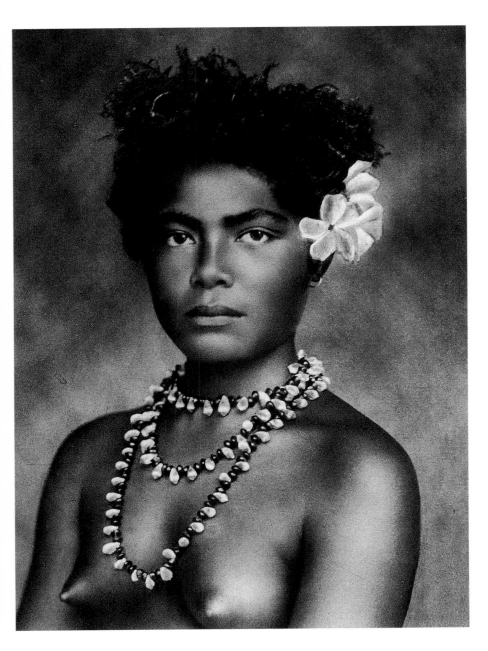

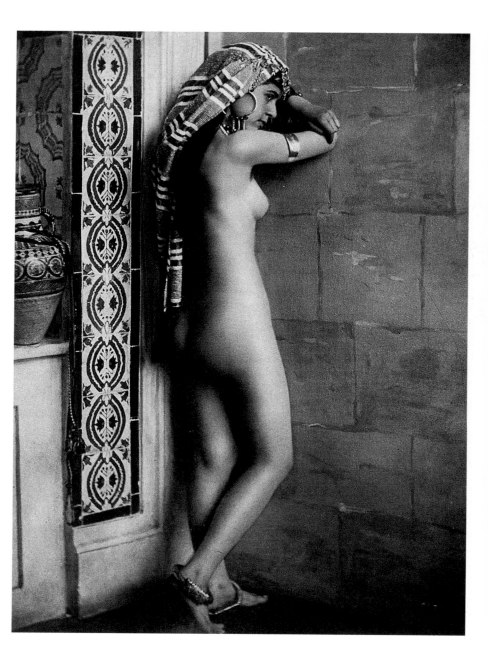

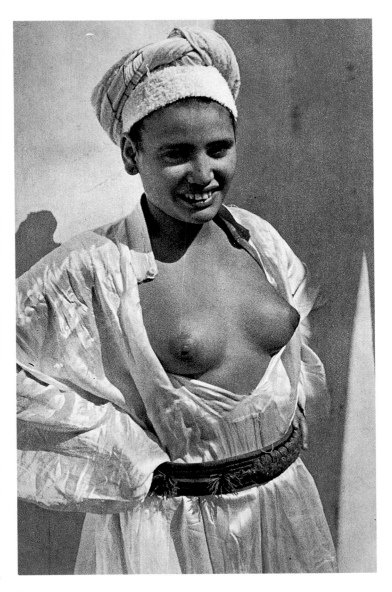

Anonymous
C. 1910

Anonymous
c. 1880

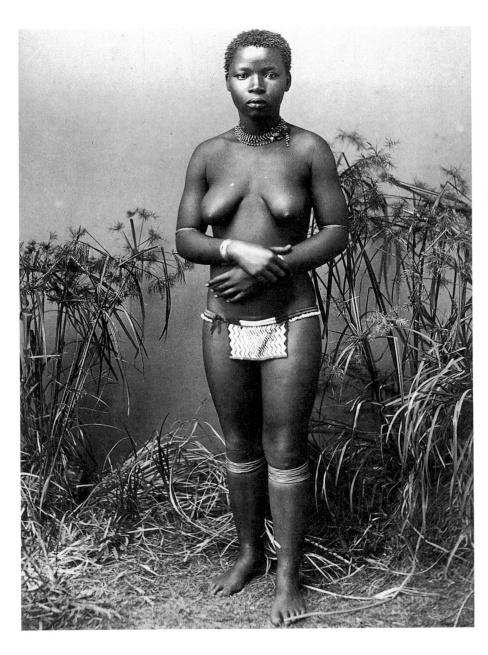

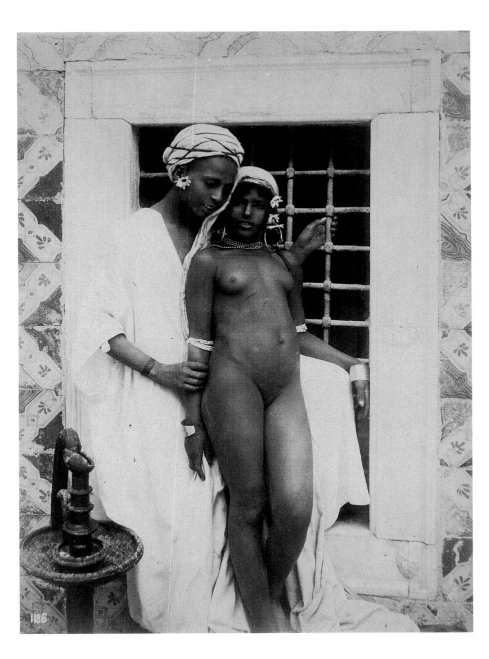

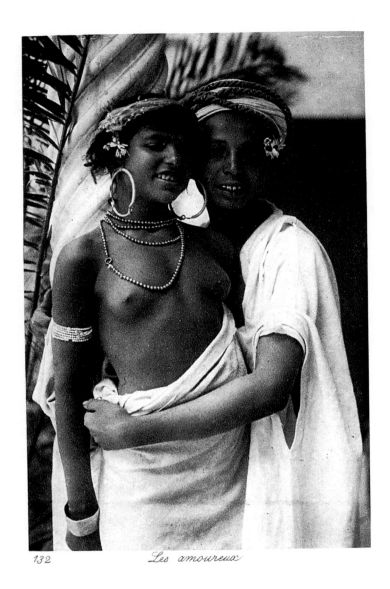

132 *Les amoureux*

Lehnert & Landrock
c. 1910

Lehnert & Landrock
The Lovers
c. 1910

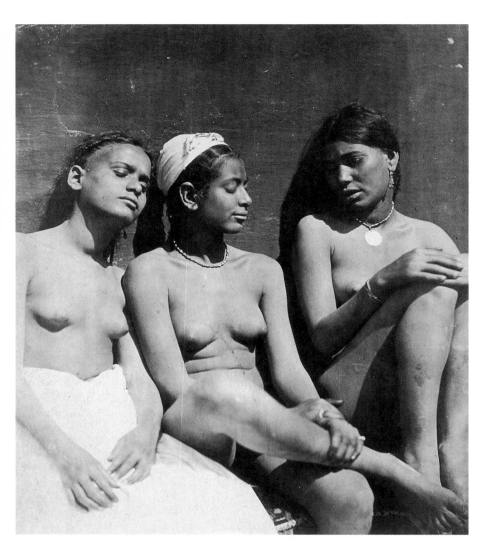

Rudolf C. Huber
c. 1875

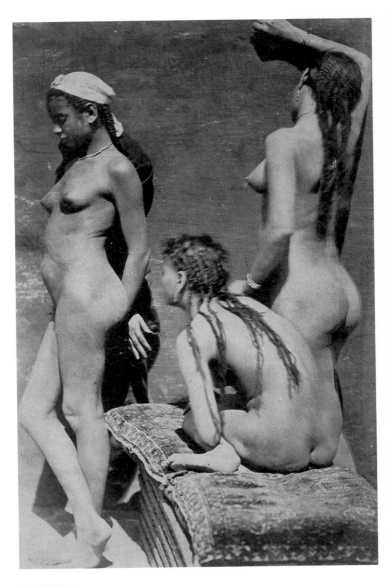

Rudolf C. Huber
c. 1875

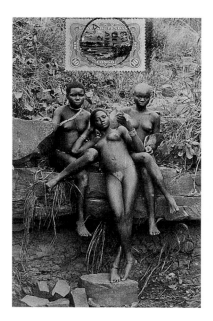

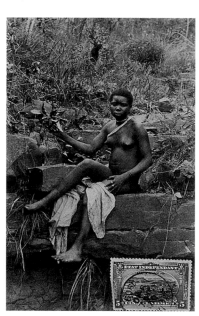

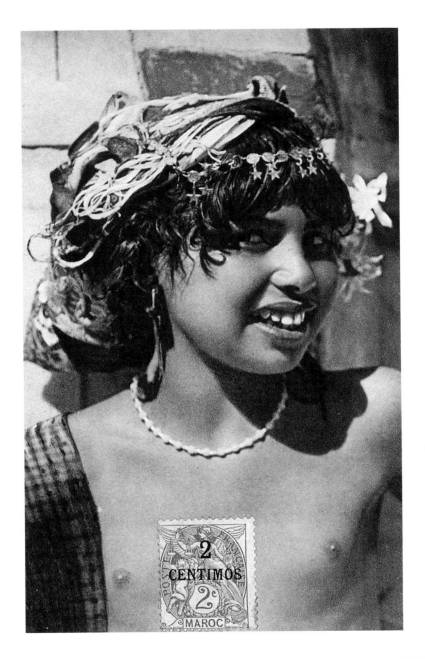

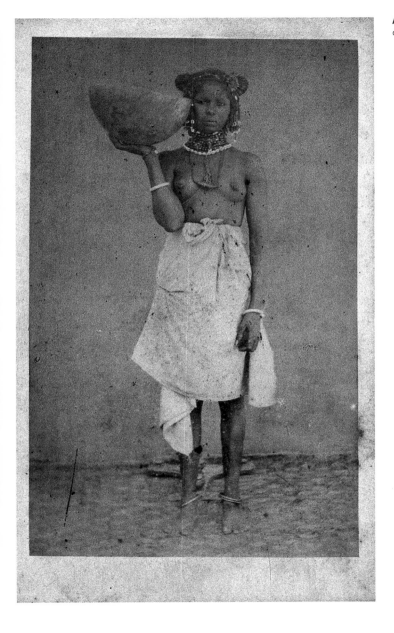

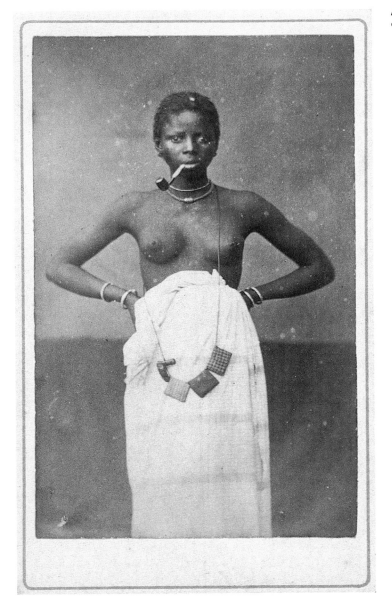

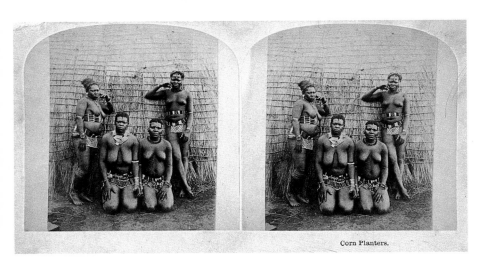

Corn Planters.

Anonymous
Corn Planters
c. 1890

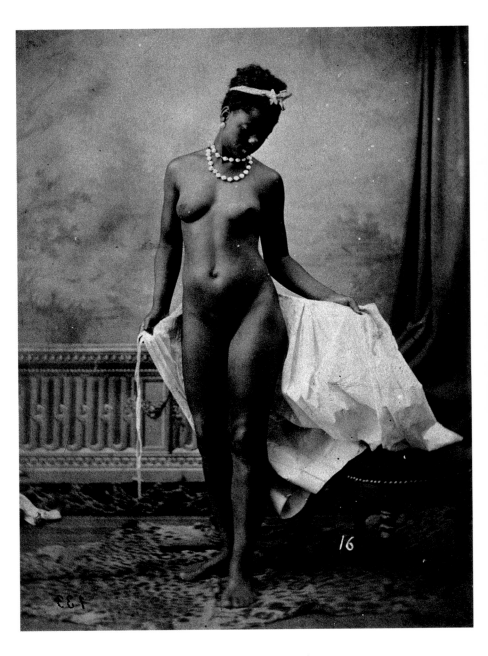

8
Pictorialism: painterly nudes

Pictorialismus: Der malerische Akt

Le pictorialisme: le nu artistique

As of the 1880s, when studio photography had fallen into somewhat of a rigid routine, the so-called "art photography" movement attempted to reform the medium, to breathe new life into a practice that had stagnated for several decades. The enthusiastic devotees of the new international movement proclaimed as their goal, that photography be recognised as an artistic means of expression. They believed they could achieve this recognition by selecting motifs which followed the same dictates as those of painting, and using out-of-the-ordinary formats in combination with complicated printing techniques, such as the gum dichromate and bromoil processes to obtain the desired "picture-like" effect. At first, art photography consisted mainly of landscapes, seascapes and still lifes. In time, however, portrait shots came to represent a welcome challenge: art photography disregarded studio norms, investing portraiture with renewed artistic vigor. Due to lack of a studio (most art photographers were amateurs), photographs were taken outdoors, using natural light. Photographers sought to capture their subjects in a relaxed stance, with an unstudied expression on their face. They experimented with the play of light and shadow, and strived to achieve balanced compositions. The art photographers were not particulary interested in nude photography as a genre. They were probably afraid, in those puritanical Victorian times, that art photography would thereby lose its credibility as an art form. Nonetheless, a few photographers – such as Clarence H. White, Steichen in his early work, Frank Eugene, Puyo and Demachy – did specialize in depicting the human body. In doing so, they were careful to de-eroticize their work as much as possible by resorting to soft-focus or otherwise distortive printing techniques, or sought to relate their work to the subject matter of painting by using narrative elements, allegorical subjects or mythological scenes. World War I shocked the world to such an extent that the pictorial concerns of art photography found themselves shoved to the sidelines, with the exception of a few professional photographers who were to remain loyal to the movement's techniques well into the 1930s.

In Opposition zu der in Routine erstarrten Atelierfotografie suchte ab den achtziger Jahren des 19. Jahrhunderts die sogenannte Kunstfotografie eine ästhetische Reform des Lichtbilds durchzusetzen und der Fotografie nach Jahrzehnten der Stagnation neue Impulse zu geben. Erklärtes Ziel dieser internationalen Bewegung ambitionierter Amateure war nicht zuletzt die Anerkennung der Fotografie als künstlerische Ausdrucksform. Zu erreichen glaubte man dies durch eine an der Malerei orientierte Motivwahl, durch außergewöhnliche Formate sowie aufwendige Edeldruckverfahren mit »bildmäßiger« Wirkung wie Gummi- oder Bromöldruck. Beschränkte sich ihre Tätigkeit zunächst auf Landschaften, Seestücke und Stilleben, so entdeckten die Kunstfotografen mit der Zeit als besondere Herausforderung das Porträt, dem sie unter Mißachtung gängiger Atelierkonventionen zu neuer künstlerischer Blüte verhalfen. Mangels Studio fotografierte man im Freien bei natürlichem Licht. Man bemühte sich um gelöste Haltung und Natürlichkeit im Ausdruck. Man experimentierte mit Licht und Schatten und strebte nach ausgewogener Komposition. Der fotografische Akt gehörte nicht unbedingt zu den zentralen Bildanliegen der Kunstfotografen. Möglicherweise fürchtete man – im sittenstrengen viktorianischen Zeitalter – um die angestrebte Musealisierung der Fotokunst. Wer gleichwohl – wie etwa Clarence H. White, der frühe Steichen, Frank Eugene, Puyo und Demachy – auf dem Feld der Körperdarstellung tätig war, tat alles, um seine Akte durch Weichzeichnereffekte oder verfremdende Printtechniken zu ent-erotisieren oder durch narrative Elemente, allegorische Sujets oder mythologische Szenen dem Themenrepertoire der Malerei anzunähern. Mit dem Schock des Ersten Weltkriegs hatte sich das ästhetische Programm des Pictorialismus im Prinzip erübrigt, wenngleich nicht wenige Fachfotografen sich bis in die dreißiger Jahre kunstfotografischen Techniken verpflichtet fühlten.

En réaction à la routine dans laquelle sommeillait la photographie d'atelier, le «pictorialisme» chercha, à partir des années 1880, à imposer à la photographie une réforme esthétique et à lui donner de nouvelles impulsions après des années de stagnation. L'objectif déclaré de ce courant international d'amateurs pleins d'ambition était de faire reconnaître la photographie comme un art. Ils pensaient y parvenir en se consacrant à des motifs empruntés à la peinture, à des formats non conventionnels et à des procédés d'impression coûteux, comme la flexographie ou l'oléobromie, qui permettaient d'obtenir des effets «picturaux». Les pictorialistes se consacrèrent tout d'abord aux paysages, aux marines et aux natures mortes, puis ils se passionnèrent pour le portrait à qui ils firent connaître un nouvel âge d'or en s'affranchissant des conventions qui avaient cours dans les ateliers. Ne disposant pas de studio, ils photographiaient en plein air, à la lumière naturelle, recherchant des poses naturelles et la spontanéité. Ils tentèrent des expériences de contrastes de lumière et recherchèrent l'équilibre dans la composition. Le nu ne fut pas un sujet particulièrement traité par les pictorialistes désireux de faire entrer la photographie dans les musées; peut-être faut-il également y voir une certaine prudence face à l'austérité morale de l'époque. Quant à ceux qui s'intéressaient à la représentation du corps, comme Clarence H. White, Steichen à ses débuts, Frank Eugene, Puyo et Demachy, ils s'efforcèrent d'atténuer l'érotisme de leurs images par des effets de flou ou des techniques d'impression spéciales, ou renouèrent avec la thématique de la peinture en intégrant des éléments narratifs, des sujets allégoriques ou des scènes mythologiques. Devant le choc de la Première Guerre mondiale, cette école esthétique s'éteignit d'elle-même, encore qu'un certain nombre de photographes soient restés fidèles à ses techniques jusque dans les années 30.

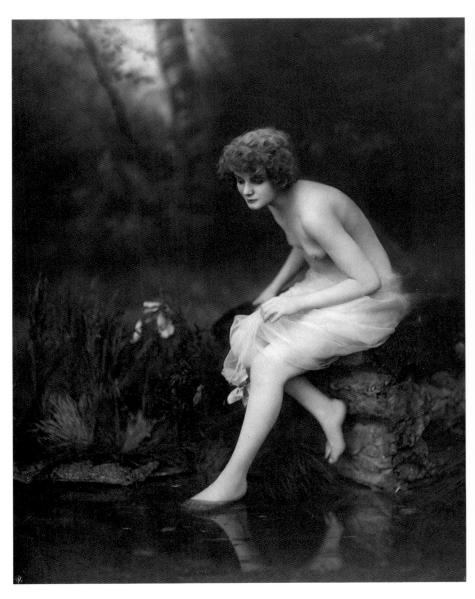

Anonymous
c. 1900

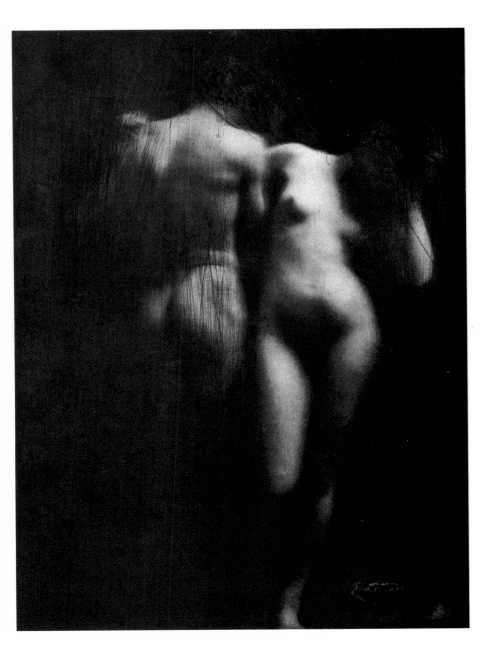

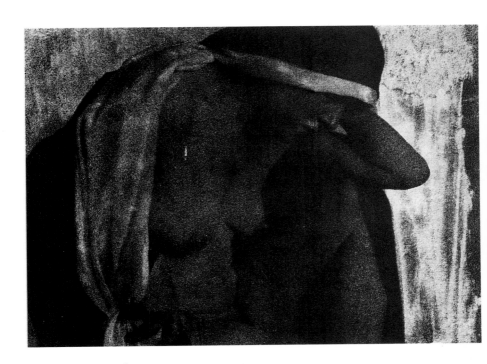

Anonymous
C. 1925

Frank Eugene
Adam and Eve
1910

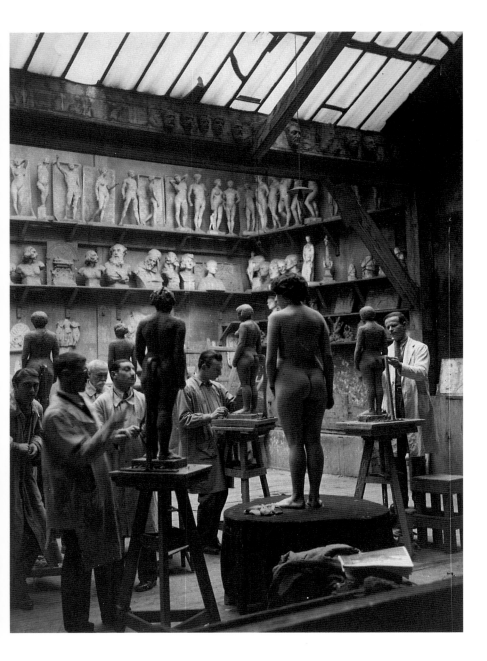

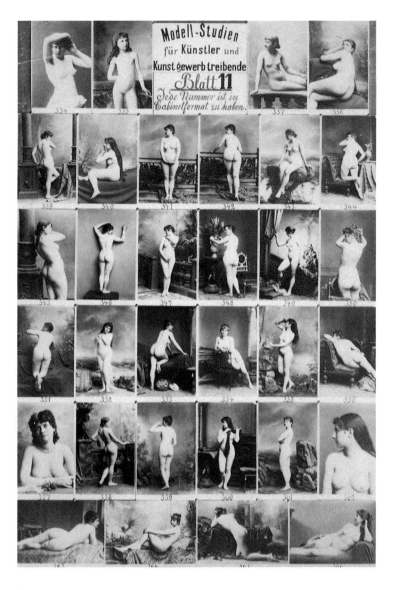

Within the image, text reads:
Modell-Studien
für Künstler und
Kunstgewerb treibende
Blatt 11
Jede Nummer ist in
Cabinetformat zu haben.

◄
Brassaï
1932

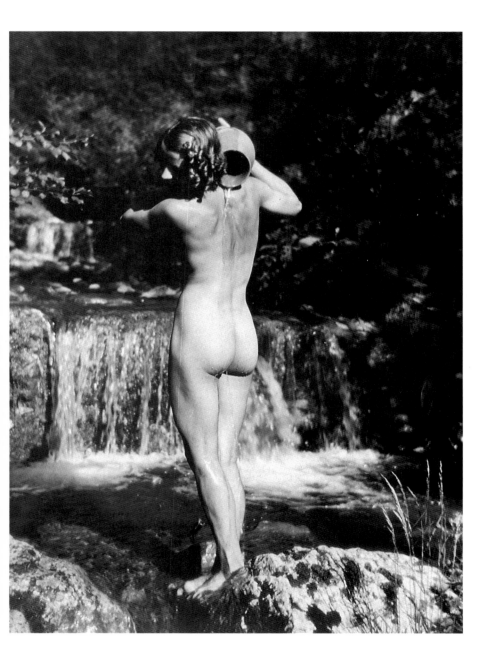

Lala Aufsberg
Cool Water
C. 1935

Rudolf Koppitz
C. 1925

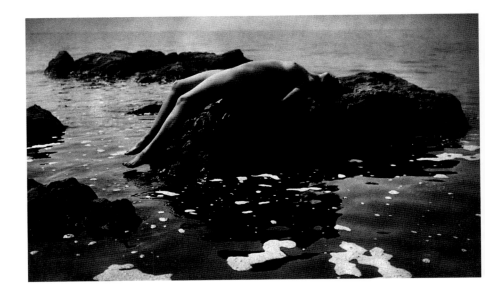

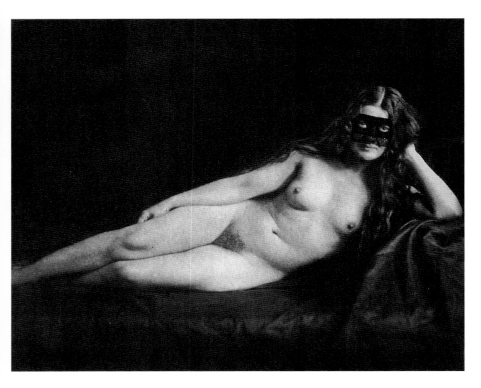

Paul Gerhardt
1920

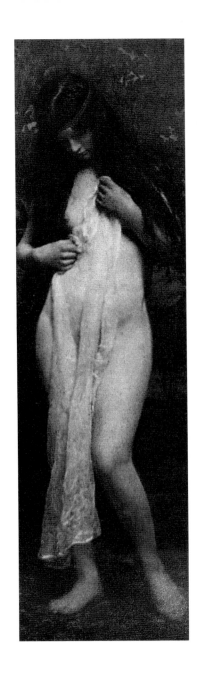

▶
Madame d'Ora
1925
▶▶
Anonymous
c. 1900

Fiedler
c. 1920

498 | 499

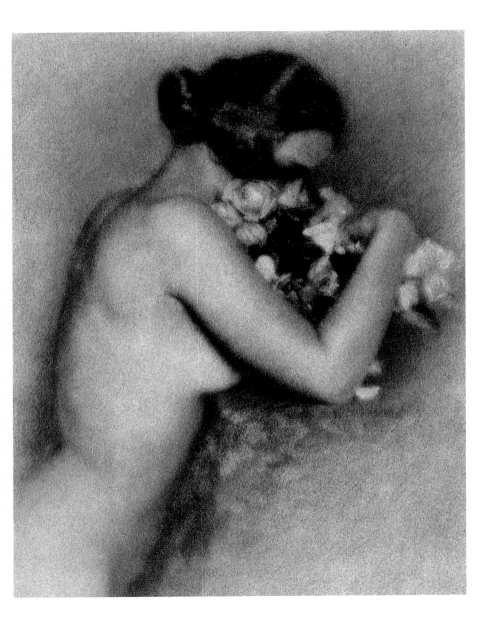

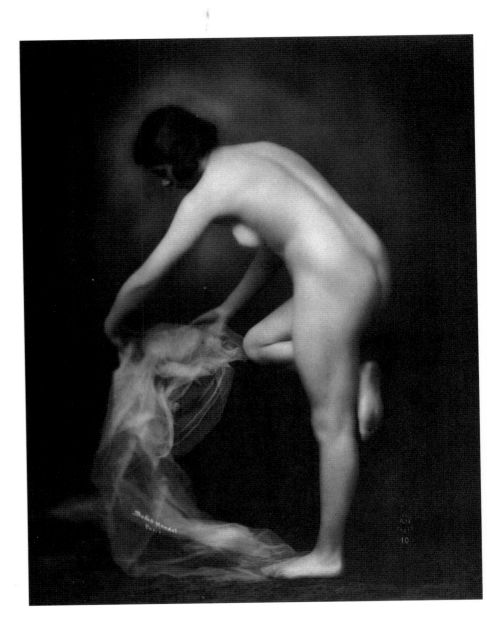

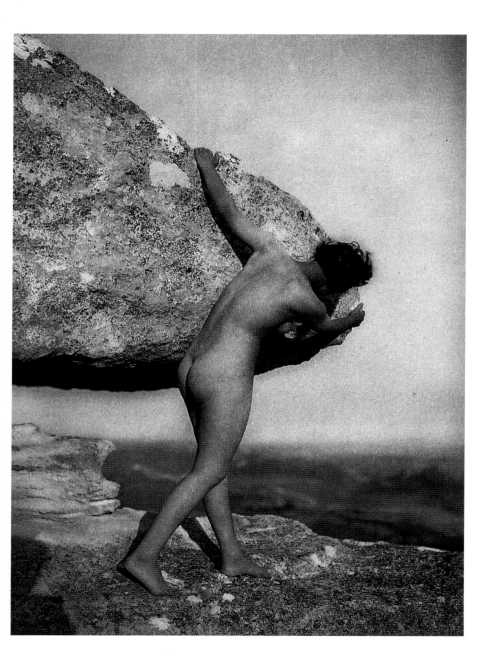

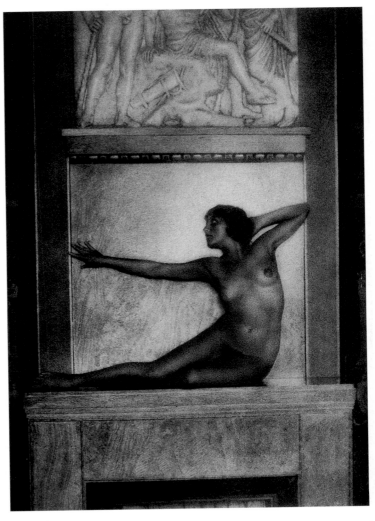

Hermann Schieberth
C. 1910

G.L. Arlaud
C. 1910

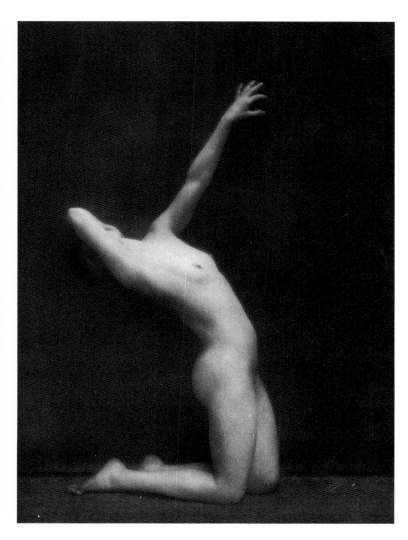

Laryew
C. 1925

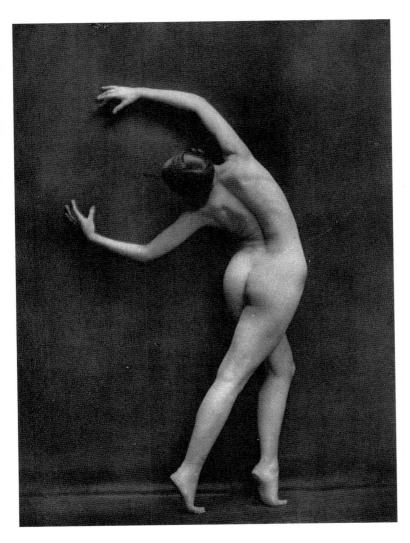

Laryew
C. 1925

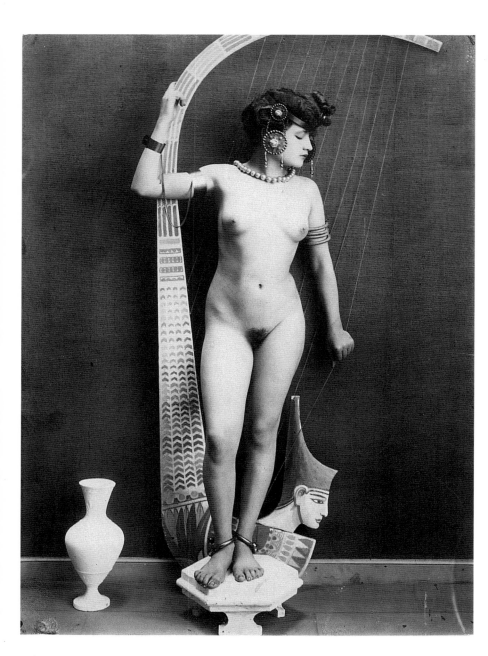

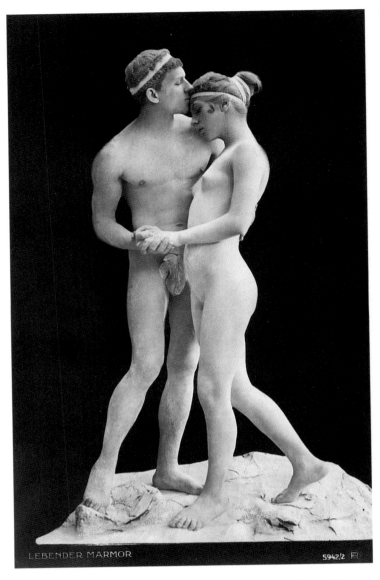

LEBENDER MARMOR

5942/2 R

Anonymous
c. 1910

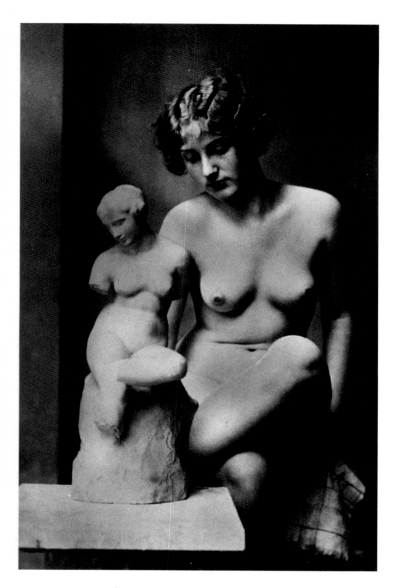

Anonymous
C. 1925

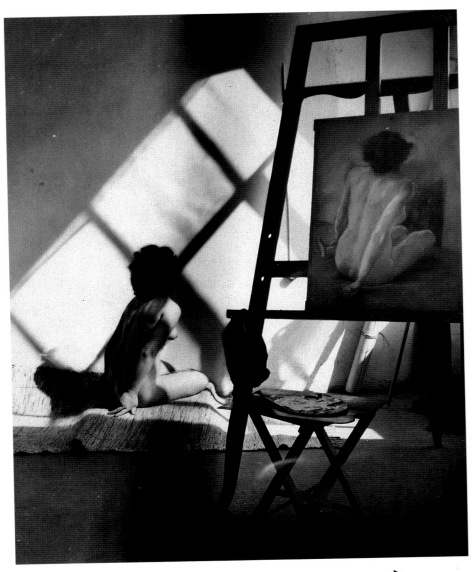

Manassé
c. 1935

▶
Othmar Streichert
Black and Blond
c. 1930

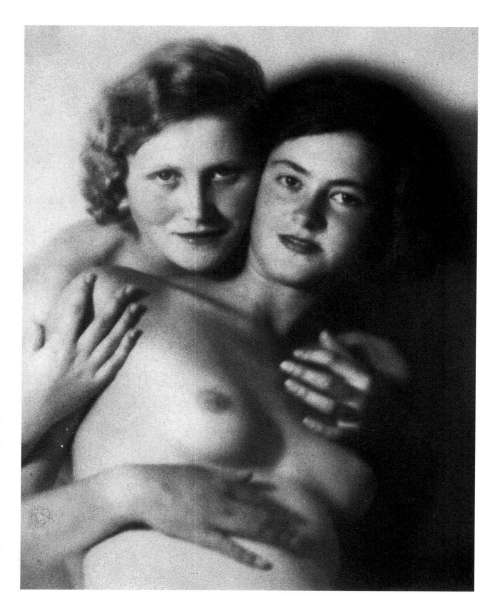

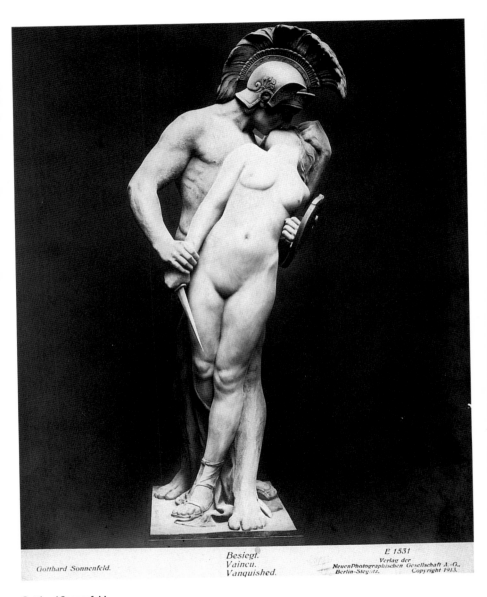

Gotthard Sonnenfeld
Vanquished
1913

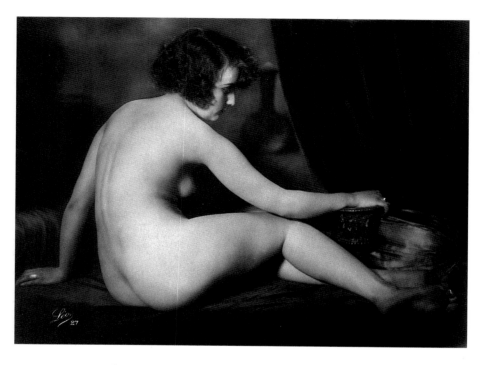

Anonymous
C. 1925

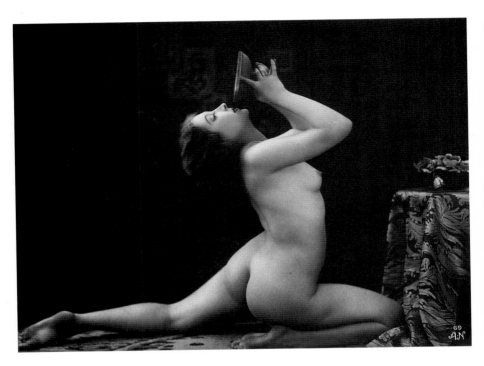

Anonymous
c. 1925

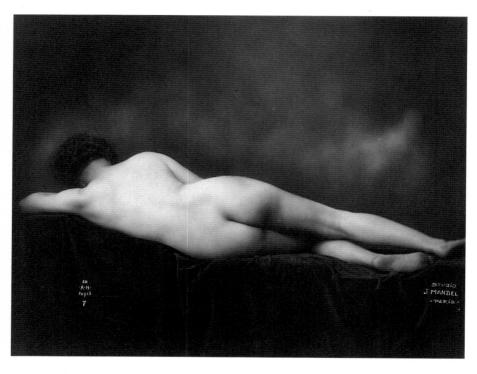

Studio J. Mandel
C. 1920

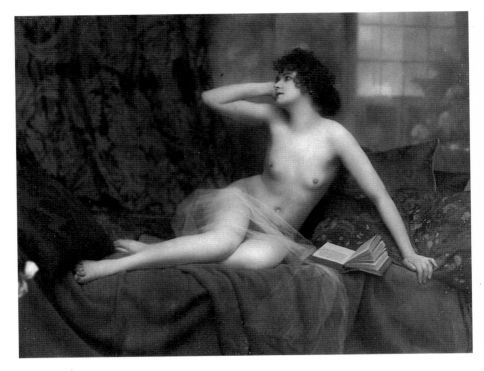

Anonymous
C. 1900

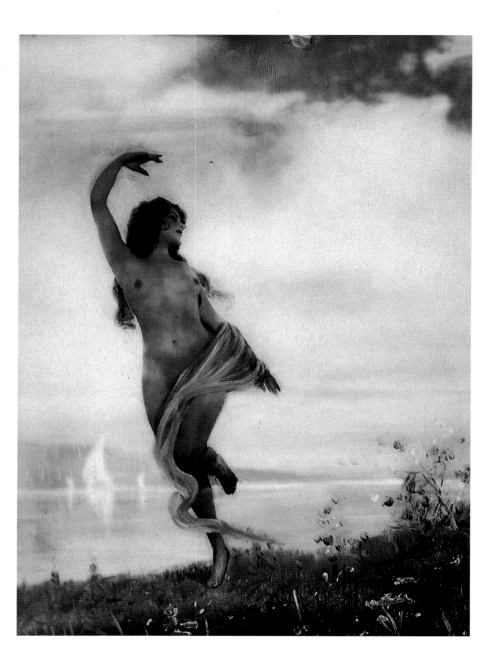

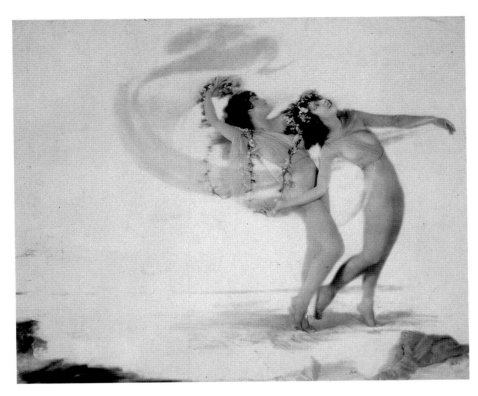

George Maillard Kesslere
C. 1930

George Maillard Kesslere
C. 1930

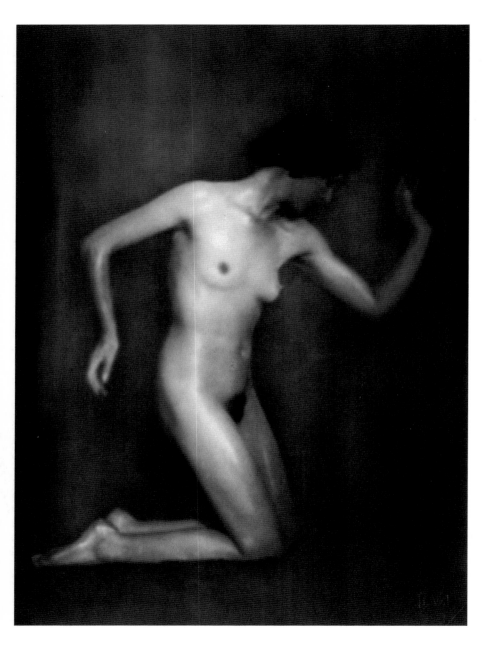

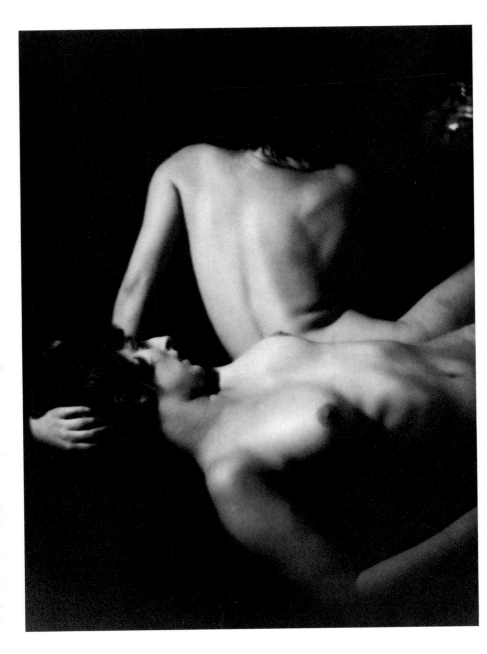

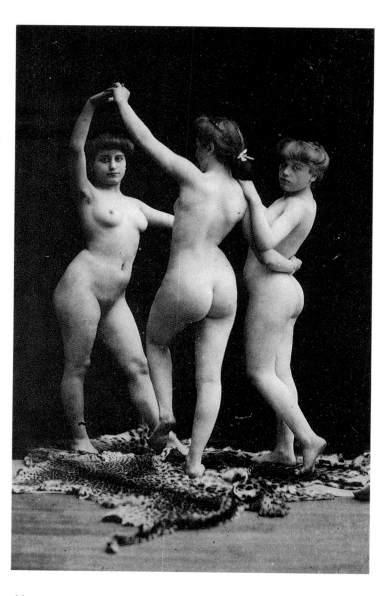

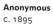

◄◄
H. Matthiesen
1923

◄
Heinz von Perckhammer
C. 1930

Lotte Herrlich
C. 1920

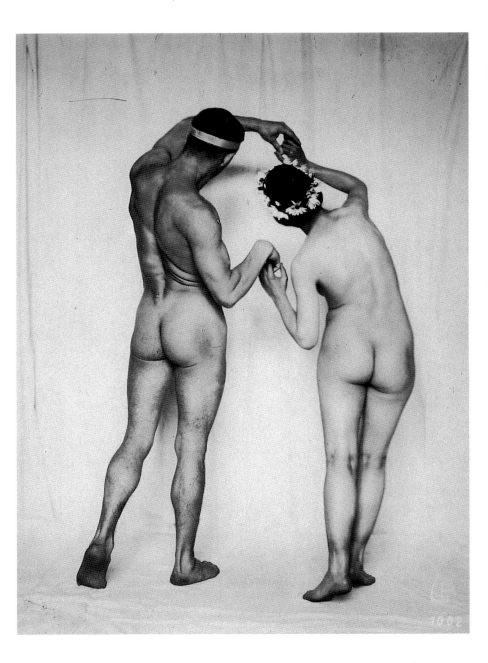

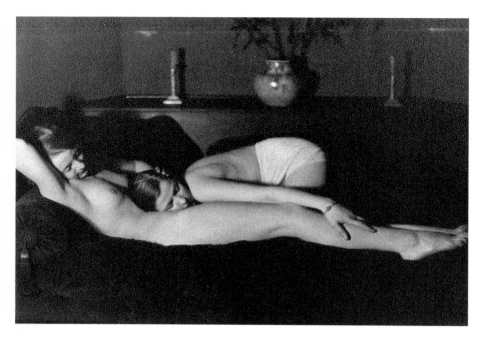

Heinz von Perckhammer
c. 1930

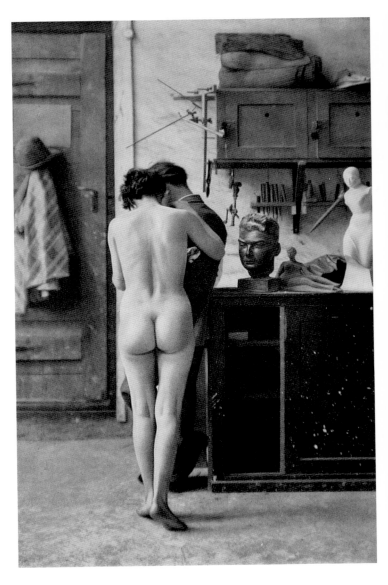

Anonymous
C. 1900

9
Arcadian works: Baron von Gloeden and Co.

Arkadien: Baron von Gloeden und Co.

L'Arcadie du baron von Gloeden

Around 1900, Baron Wilhelm von Gloeden, a German national who had been living in the Sicilian town of Taormina since 1877, was not the only photographer cultivating a particular form of outdoor nude photography, one in a Classicist vein and with clearly homoerotic overtones. Two other photographers worth mentioning in this context are Galdi and Plüschov, both of whom worked in Rome. Far more widely acclaimed, then as now, are the 7,000 photos – roughly estimated – comprising Gloeden's œuvre. The latter's work first gained international recognition under the auspices of the London Royal Photographic Society's annual show in 1893. Later, it gained more widespread attention through regular appearances in art photography magazines, popularized ethnological works, or forums of the emerging homosexual liberation movement. Meanwhile, his images have come to be considered as a landmark, if not the beginning proper, of a homosexual aesthetic in photography. It was mainly his miserable state of health that drove the Baron, born in 1858 in Wismar and son of a forestry official, to Sicily. Another important impulse seems to have been a certain "longing for Arcadia", a feeling which was then widespread. At a time of industrial and social upheaval, such longing had a great deal of mental and emotional appeal for countless intellectuals in Germany. In any case, Gloeden, with his artistic background, found Sicily to be a real source of inspiration, and photography to be an appropriate means of expressing his creativity. In contrast to the art photography that was then fashionable, Gloeden's "straight" photography was devoid of soft-focussing or any special dark-room effects. Up until World War I, Gloeden produced an extensive oeuvre consisting of landscapes, views of Taormina, genre scenes, portraits inspired by folklore, as well as artistically staged nude youths in Arcadian surroundings. After World War I, Gloeden was mainly occupied with the commercial exploitation of his works. He died in Sicily in 1931, and thus did not live to see the destruction by the Italian Fascists of a major portion of his oeuvre.

Der seit 1877 im sizilianischen Taormina lebende deutsche Baron Wilhelm von Gloeden war nicht der einzige, der um 1900 eine an antiken Idealen geschulte Freilicht-Aktfotografie mit deutlich homoerotischen Interessen pflegte. Erwähnt seien nur die beiden in Rom arbeitenden Fotografen Galdi und Plüschow. Ungleich populärer allerdings war und ist bis heute das auf insgesamt rund 7000 Aufnahmen geschätzte Œuvre Gloedens, das 1893 im Rahmen der Jahresausstellung der Royal Photographic Society in London seine erste internationale Anerkennung erfuhr, später immer wieder über kunstfotografische Zeitschriften, populärwissenschaftliche Werke der Ethnologie oder Foren der sich anbahnenden Homosexuellen-Emanzipation Verbreitung fand und mittlerweile als Markstein, wenn nicht Beginn homosexueller Sehweisen in der Fotografie gehandelt wird. Vordergründig war es der desolate Gesundheitszustand, der den 1856 bei Wismar geborenen Sohn eines Forstbeamten nach Sizilien trieb. Wesentlich dürfte eine zu der Zeit verbreitete »Sehnsucht nach Arkadien« hinzugekommen sein, die in einer Phase des industriellen und sozialen Umbruchs das Denken und Fühlen zahlreicher Intellektueller in Deutschland bestimmte. Auf Sizilien jedenfalls fand der künstlerisch vorgebildete Gloeden die Muse zu kreativer Tätigkeit und entdeckte in der Fotografie ein adäquates Ausdrucksmittel, das er im Gegensatz zur herrschenden Kunstfotografie »straight«, also ohne Weichzeichnereffekte oder Manipulationen bei der Ausarbeitung, nutzte. So entstand bis zum Ersten Weltkrieg ein umfängliches Œuvre aus Landschaften, Ansichten von Taormina, Genreszenen, folkloristisch inspirierten Porträts sowie kunstvoll inszenierten Knabenakten in arkadischer Umgebung. In der Zeit nach dem Ersten Weltkrieg war Gloeden vor allem mit der kommerziellen Verwertung seiner Arbeiten beschäftigt. 1931 starb er auf Sizilien. Die Vernichtung bedeutender Teile seines Œuvres durch die italienischen Faschisten hat er nicht mehr erlebt.

Le baron Wilhelm von Gloeden, un Allemand qui vint s'installer en 1877 à Taormine, en Sicile, n'est pas le seul à avoir pratiqué une photographie de nu en plein air nourrie d'idéaux antiques et marquée par une forte tendance homosexuelle. Il faudrait en effet également citer Galdi et Plüschow, deux photographes qui travaillèrent à Rome. L'œuvre de Gloeden, estimée à quelque 7 000 images, bénéficia toujours d'une grande popularité. Elle obtint en 1893 une première reconnaissance internationale à l'occasion de l'exposition annuelle de la Royal Photographic Society de Londres. Par la suite, elle connut de plus en plus de succès dans les revues de photographie, dans des ouvrages grand public d'ethnologie et dans les milieux luttant pour la cause homosexuelle. Elle constitue, sinon la naissance d'une manière de voir homosexuelle, une étape importante de l'histoire de la photo. Au départ, c'est pour des raisons de santé que ce fils de garde forestier de Wismar partit pour la Sicile. Il faut y ajouter cette «nostalgie de l'Arcadie» très répandue à l'époque, et qui est à la base des idées et de la sensibilité de nombreux intellectuels d'une Allemagne alors en plein bouleversement social et industriel. C'est ainsi que Gloeden, qui avait reçu une formation artistique, trouva l'inspiration en Sicile et découvrit dans la photographie un moyen d'expression à sa mesure. A l'inverse du mouvement pictorialiste en vogue à l'époque, il pratiqua une «photographie pure», c'est-à-dire sans effet de flou, ni réglages spéciaux. Jusqu'à la Première Guerre mondiale, il produisit une œuvre abondante qui comprend des paysages, des vues de Taormine, des scènes de genre, des portraits d'inspiration folklorique et de magnifiques nus de jeunes garçons au milieu d'un décor idyllique. Après la Première Guerre mondiale, Gloeden se consacra surtout à l'exploitation commerciale de ses œuvres. Il mourut en 1931, en Sicile, ce qui lui épargna de voir les fascistes italiens détruire une partie importante de son œuvre.

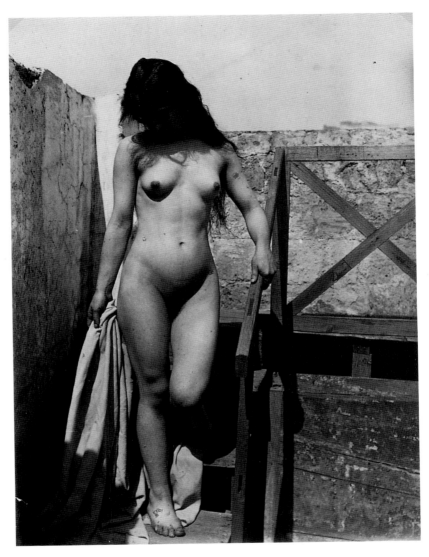

Wilhelm von Gloeden
1902

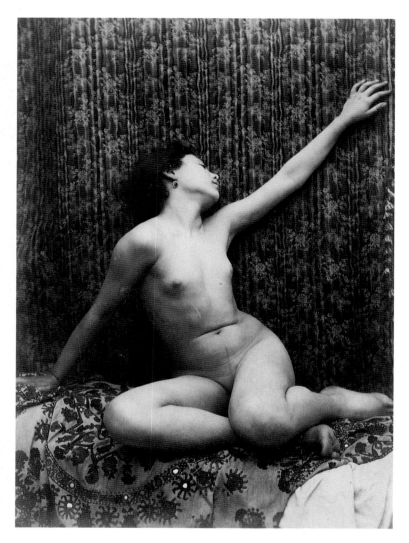

Vincenzo Galdi
C. 1900

Vincenzo Galdi
C. 1905

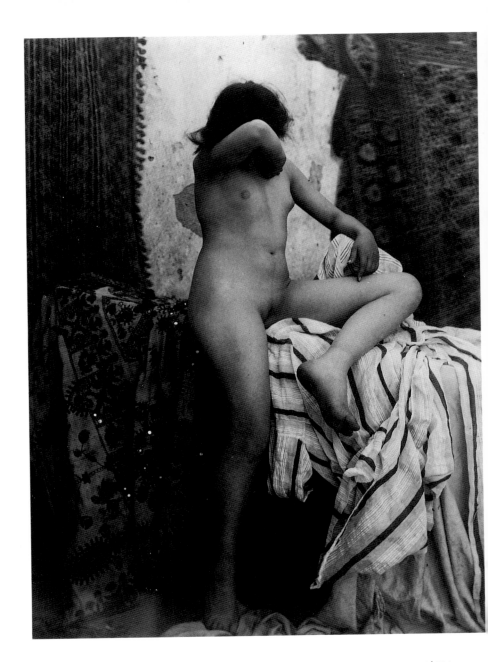

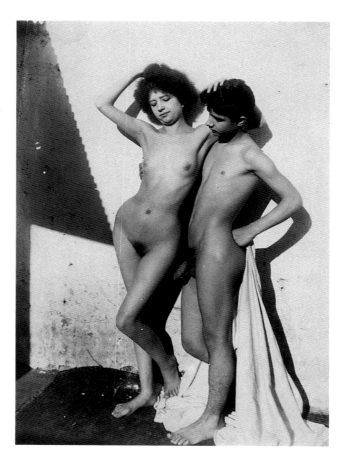

Vincenzo Galdi
C. 1910

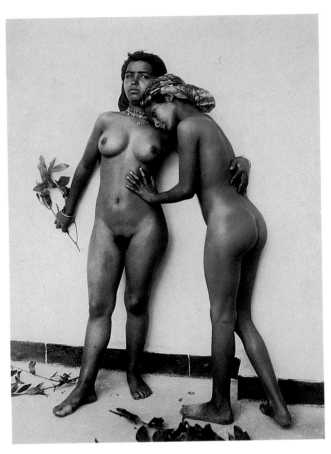

Wilhelm von Gloeden
C. 1910

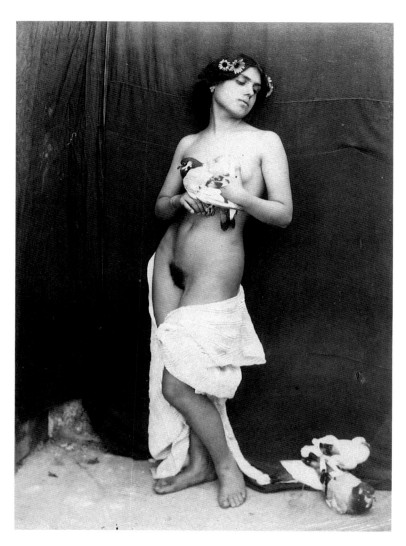

Vincenzo Galdi
C. 1900

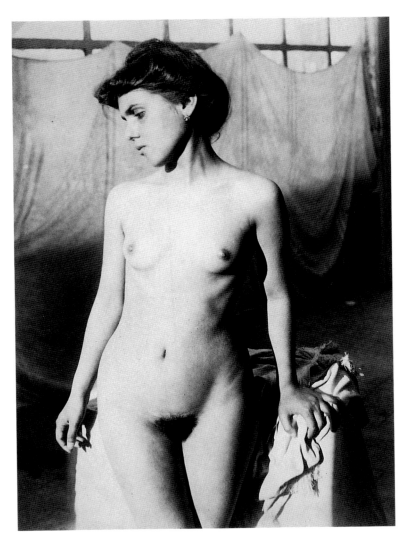

Guglielmo Plüschow
c. 1895

►
Vincenzo Galdi
c. 1905

►►
Guglielmo Plüschow
c. 1895

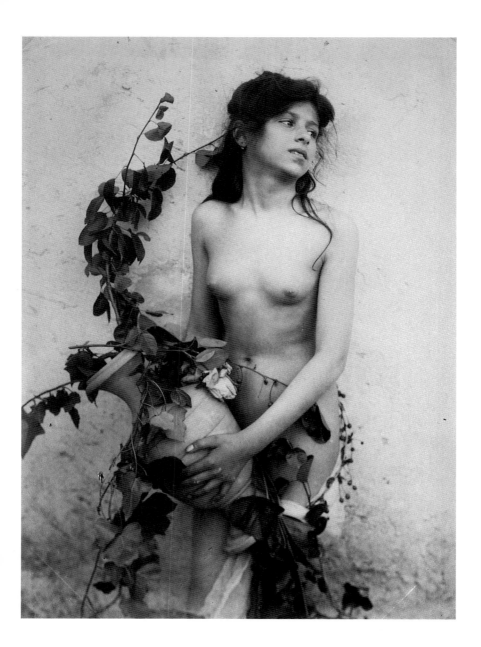

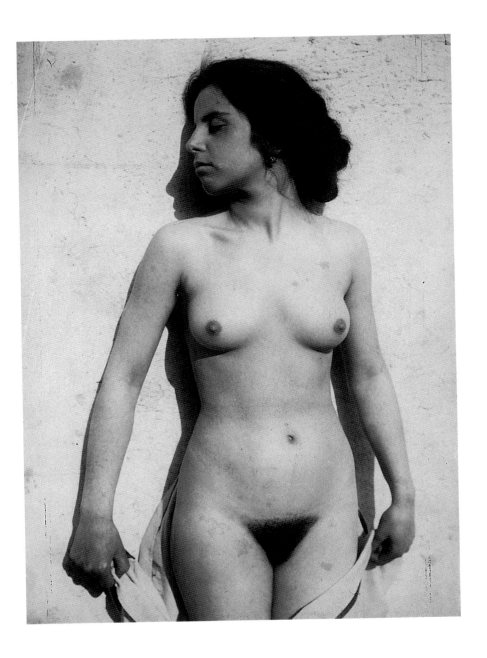

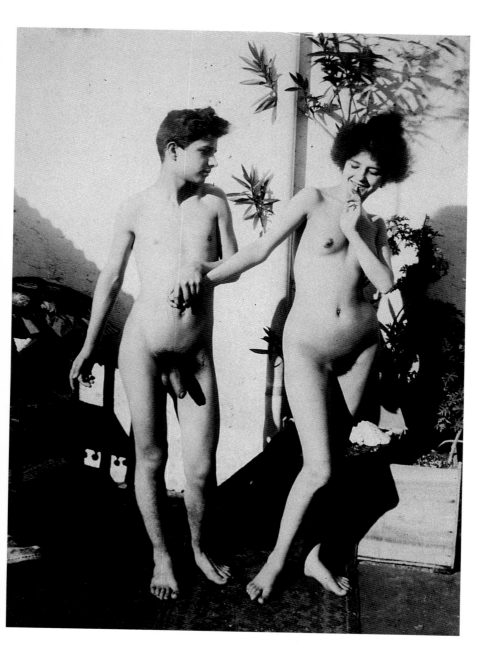

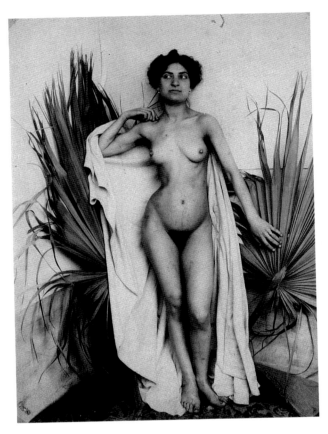

Guglielmo Plüschow
c. 1895

Vincenzo Galdi
c. 1910

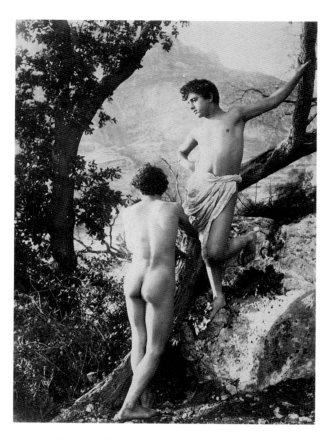

Wilhelm von Gloeden
C. 1905

**Vincenzo Galdi/
Guglielmo Plüschow**
C. 1895

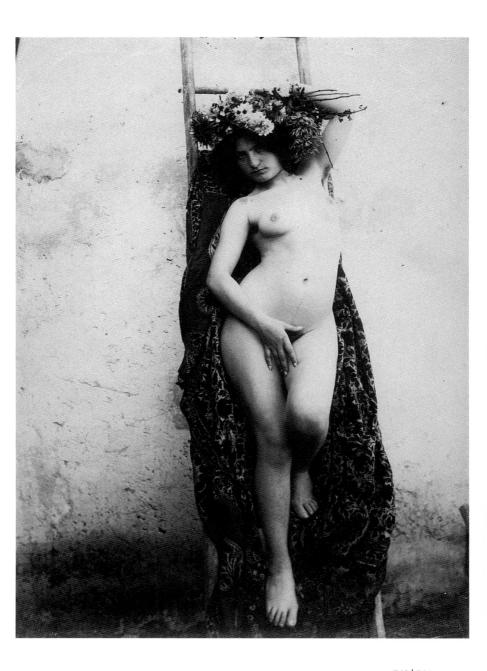

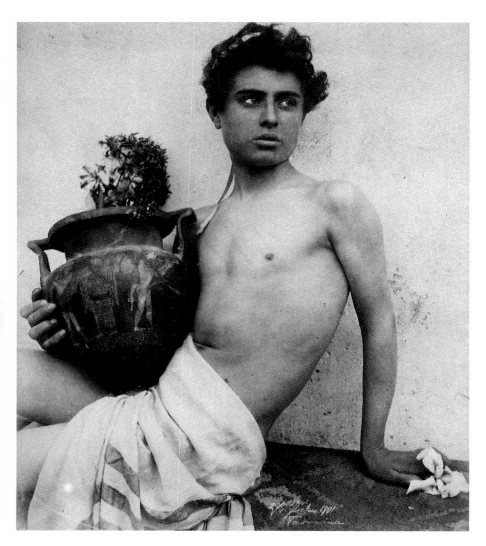

Wilhelm von Gloeden
C. 1901

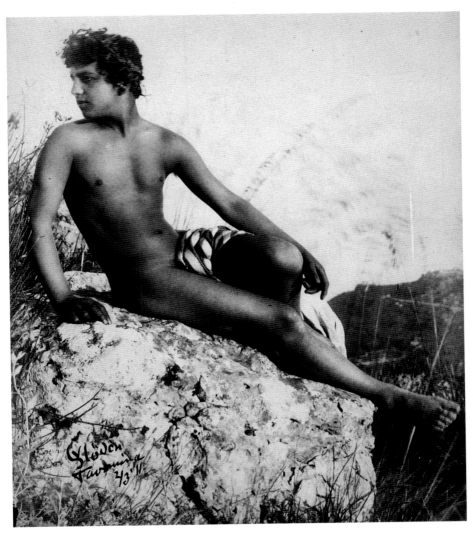

Wilhelm von Gloeden
1911

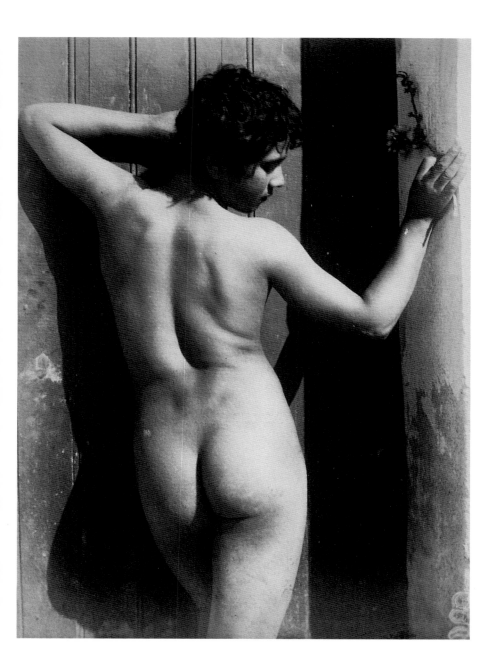

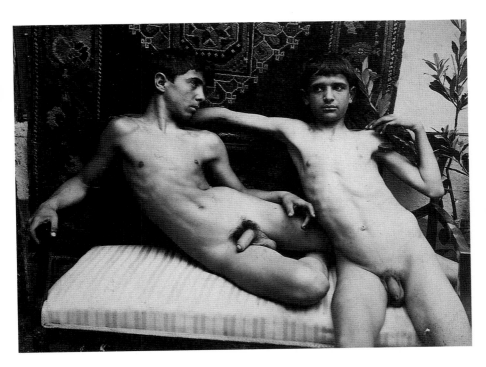

Guglielmo Plüschow
c. 1895

Wilhelm von Gloeden
c. 1900

▶
Anonymous
c. 1910

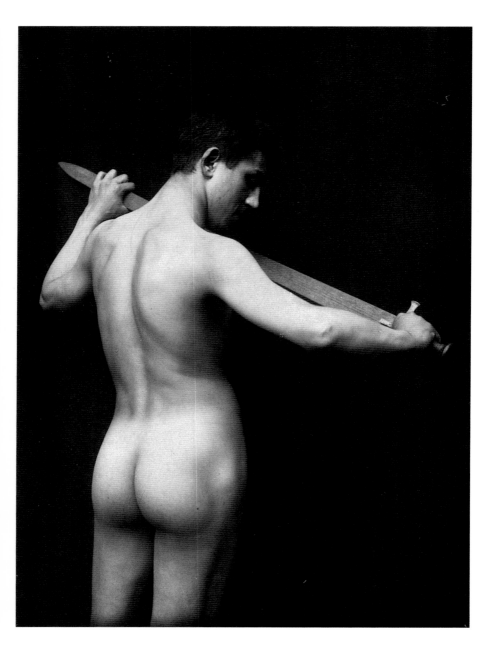

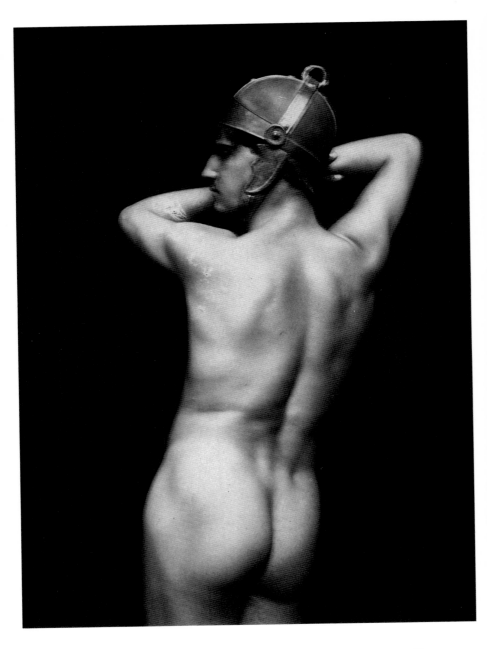

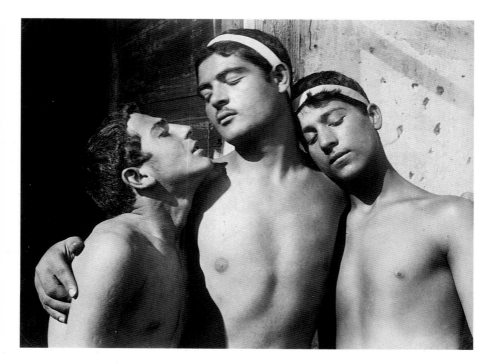

Wilhelm von Gloeden
C. 1900

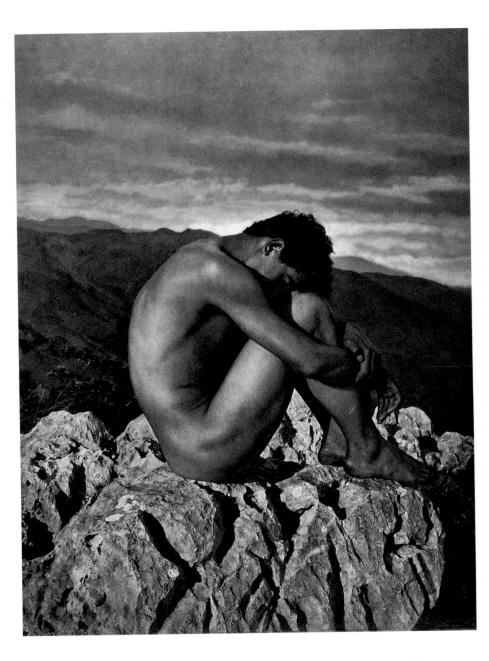

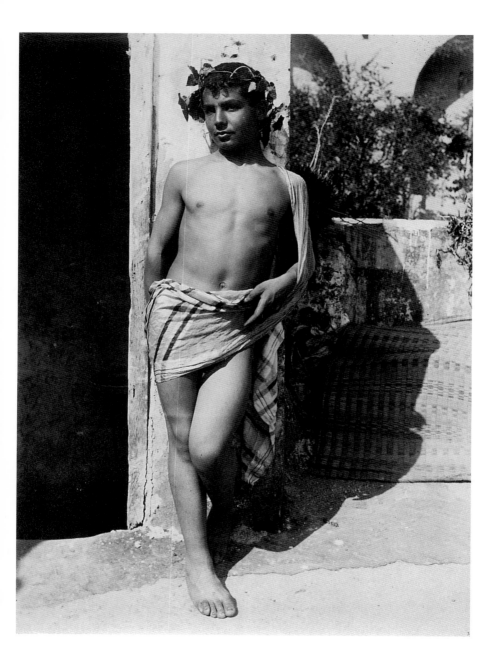

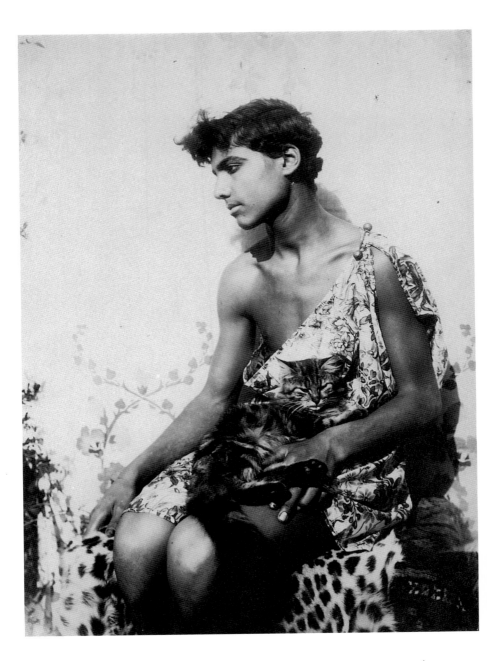

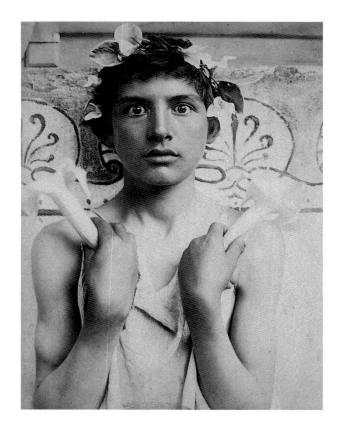

Wilhelm von Gloeden
c. 1895

◄◄
Wilhelm von Gloeden
c. 1900
◄
Guglielmo Plüschow
c. 1900

Wilhelm von Gloeden
c. 1910

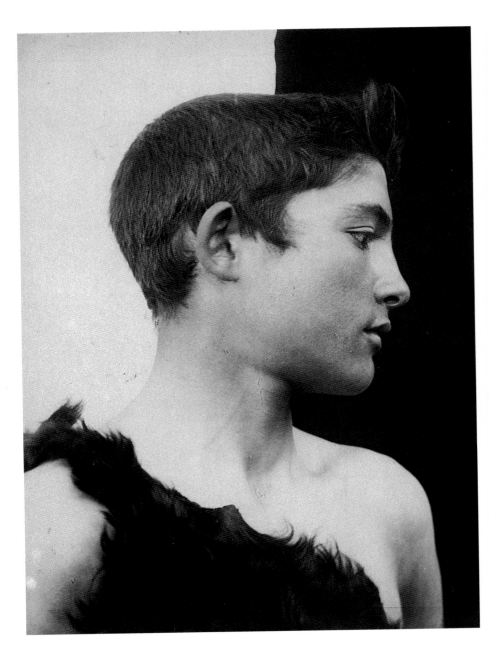

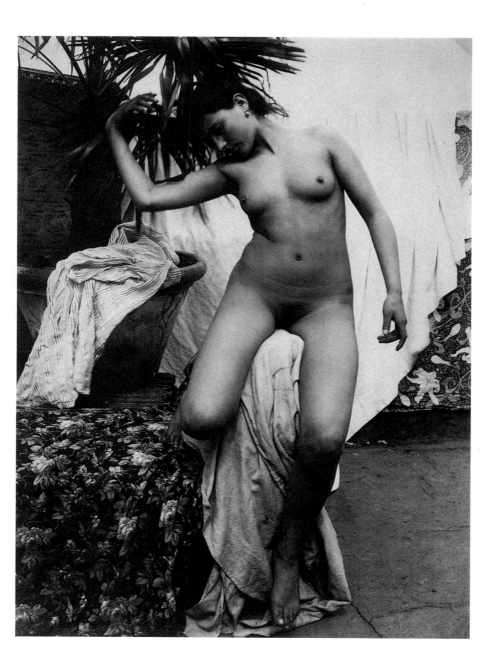

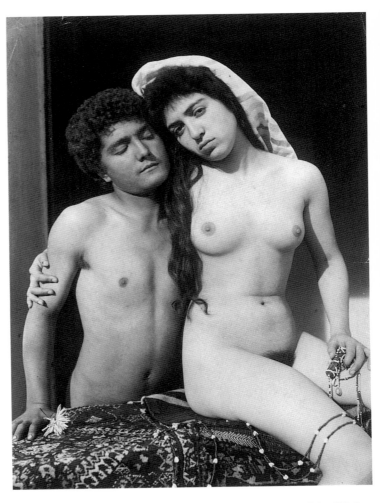

Guglielmo Plüschow
c. 1895

Guglielmo Plüschow
c. 1890

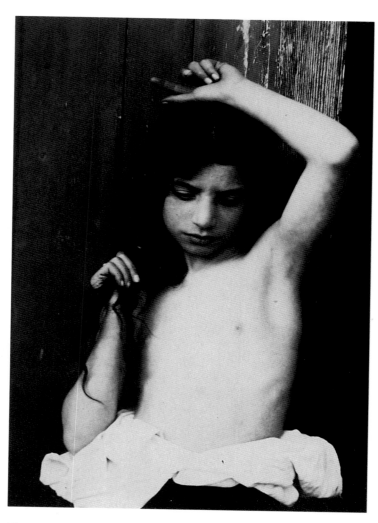

**Vincenzo Galdi/
Guglielmo Plüschow**
C. 1910

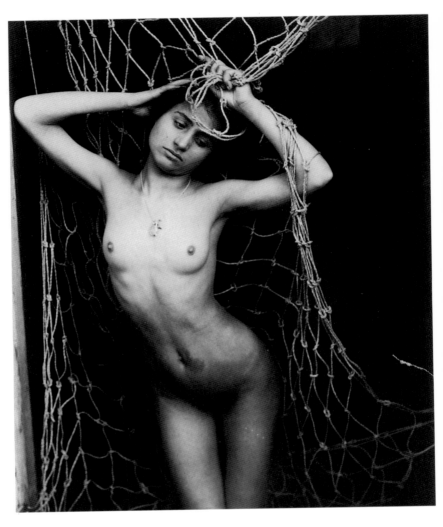

Vincenzo Galdi
c. 1895

10
The nude in nature: the nudist movement in Germany

Nackt in der Natur: FKK-Bewegung in Deutschland

Nature et nudité: le mouvement naturiste en Allemagne

Photography in conjunction with the practice of nudism came into being as a special type of open-air nude photography at the start of the 1920s, although evidence exists that the trend started much earlier, at the turn of the century. Yet the real breakthrough of this type of photography did not occur until after World War I, in the wake of the rethinking of all values, including "the body question", which took place around that time. Even if not all of this was new, it was at least being dealt with in the open and more vociferously. The ideological roots of nudist photography are to be found in the various middle-class reform movements of the late 19th century – born, in turn, as a reaction to industrialization, urbanization, housing problems, food shortages and the like. Intellectuals resorted to a variety of platforms in their criticisms of the prevailing culture of the Emperor William II (1888–1918) era; they found temporarily effective solutions in nudism and dance, vegetarianism and gymnastics, fashion changes, and sexual and marital reform. Around 1900, the painter Hugo Höppener, who became known under the pseudonym Fidus, laid the cornerstone of a clearly defined iconography that later served to orient camera artists as well. The term "nudism" was coined just after the turn of the century by the concept's most outstanding advocate, Heinrich Scham/ Pudor. And it was Fedor Fuchs who could lay claim to having set up the first fenced-off nudist site (just outside Berlin). The movement's spread after 1920 resulted in the creation of various ideologically differentiated associations (from bourgeois to socialist), many of which published their own newspaper under titles like "Land of Light" or "The New Age". The increasing demand for illustrative material generated by these newspapers was met by professional photographers such as Lotte Herrlich, Kurt Reichert and Gerhard Riebicke. That the stereotypic motifs they employed reappeared elsewhere, in the form of stereocards and postcards, only serves to underscore the erotic significance of the genre, despite frequent disclaimers.

Als Sonderform der Freilicht-Aktfotografie trat Anfang der zwanziger Jahre die FKK-Fotografie auf den Plan. Zeugnisse dieser Richtung sind bereits um die Jahrhundertwende nachzuweisen. Ihren Durchbruch erlebte die Bildgattung allerdings nach dem Ende des Ersten Weltkriegs, als im Zuge einer Umwertung aller Werte auch die Frage nach dem Körper nicht unbedingt neu, aber lauter und öffentlich gestellt wurde. Ihre ideologischen Wurzeln hatte die FKK-Fotografie in den diversen bürgerlichen Reformbewegungen des späten 19. Jahrhunderts, die wiederum als Reaktion auf Industrialisierung, Verstädterung, Wohnungselend, Ernährungsmißstände etc. entstanden waren. Aus unterschiedlichen Positionen heraus formulierten Intellektuelle ihre Kritik an der Kultur des Wilhelminismus und fanden in Nacktkultur und Tanz, Vegetarismus und Gymnastik, Kleiderreform, Sexual- und Ehereform die vorläufig gültigen Antworten. Der unter dem Pseudonym Fidus bekannt gewordene Maler Hugo Höppener legte um 1900 den Grundstein für eine unverwechselbare Ikonographie, an der sich später auch die Kamerakünstler orientierten. Heinrich Scham/Pudor, herausragender Propagandist der Idee, prägte nach der Jahrhundertwende den Begriff »Nacktkultur«. Fedor Fuchs darf für sich in Anspruch nehmen, das erste abgezirkelte FKK-Gelände (vor den Toren Berlins) eingerichtet zu haben. Nach 1920 hatte sich die Bewegung weitgehend organisiert in ideologisch unterschiedlich ausgerichteten Verbänden (von bürgerlich bis sozialistisch), mit eigenen Zeitschriften wie »Licht-Land« oder »Die neue Zeit«, deren wachsender Bildbedarf von professionellen Fotografen wie Lotte Herrlich, Kurt Reichert und Gerhard Riebicke gedeckt wurde. Daß ihre – mitunter griffigen – Bildformeln auch als Stereo- und Postkarten in den Handel kamen, unterstreicht die häufig geleugnete erotische Funktion des Genres.

La photographie naturiste, forme particulière de la photo de nu en plein air, apparut au début du 20ème siècle. Les premiers clichés remontent à la fin du 19ème siècle, mais le genre ne connut son véritable apogée qu'après la Première Guerre mondiale. A une époque de remise en cause générale des valeurs, la question du corps fut abordée publiquement de façon plus précise, sinon nouvelle. Les origines idéologiques de la photo naturiste remontent aux différents mouvements réformateurs bourgeois de la fin du 19ème siècle, qui s'étaient eux-mêmes manifestés en réaction à l'industrialisation, à la concentration urbaine, aux problèmes de logement et de nutrition. Selon leurs convictions, les intellectuels formulèrent des critiques à l'égard de la société wilhelminienne, et ils trouvèrent des réponses provisoirement satisfaisantes dans le naturisme et la danse, le régime végétarien et la gymnastique, les réformes vestimentaire, sexuelle et matrimoniale. Le peintre Hugo Höppener, devenu célèbre sous le pseudonyme de Fidus, jeta vers 1900 les bases d'une iconographie très particulière, adoptée par la suite par les cinéastes. Heinrich Scham/Pudor, ardent défenseur de la cause, forgea au début du siècle la notion de «naturisme». Quant au premier centre naturiste, ouvert aux environs de Berlin, c'est Fedor Fuchs qui en fut l'initiateur. A partir de 1920, le mouvement s'organisa en associations ayant différentes couleurs politiques (bourgeoises, socialistes...), disposant de leurs propres revues, comme «Licht-Land» ou «Die neue Zeit». Pour répondre à un besoin croissant d'illustrations, ces revues s'adressèrent à des photographes professionnels comme Lotte Herrlich, Kurt Reichert et Gerhard Riebicke. Le fait que certains de ces clichés aient été commercialisés sous forme de cartes postales ou stéréoscopiques, souligne la teneur érotique, bien qu'elle soit souvent niée, inhérente à ce genre.

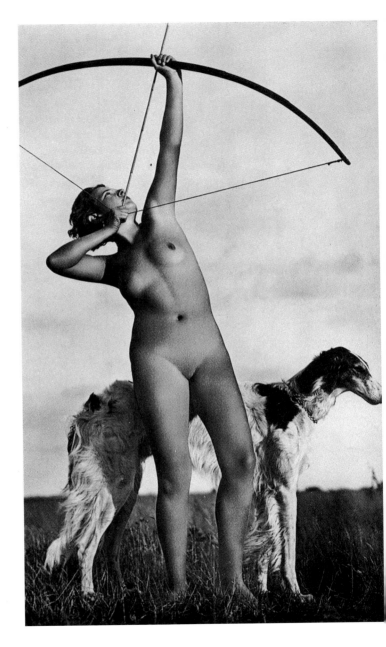

Gerhard Riebicke
1930

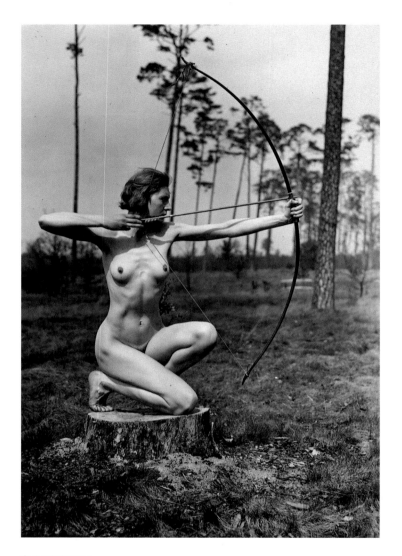

Gerhard Riebicke
C. 1925

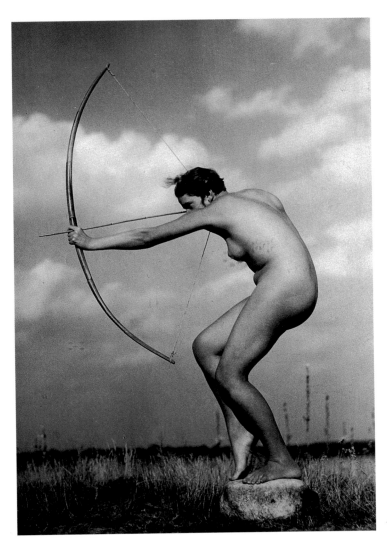

Gerhard Riebicke
C. 1925

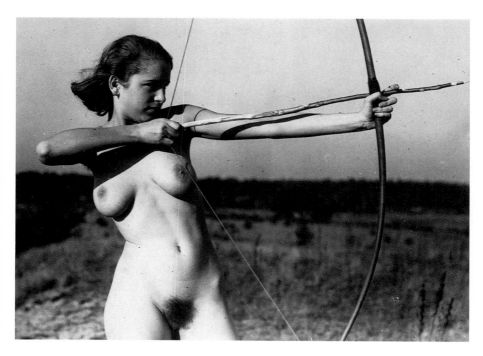

Gerhard Riebicke
c. 1925

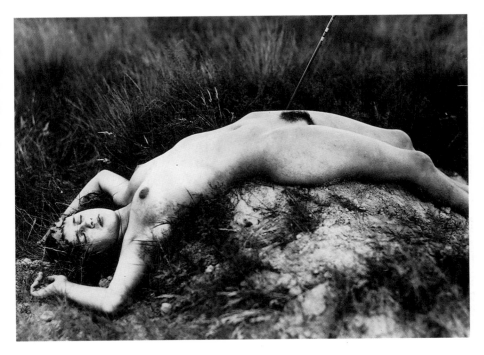

Gerhard Riebicke
C. 1925

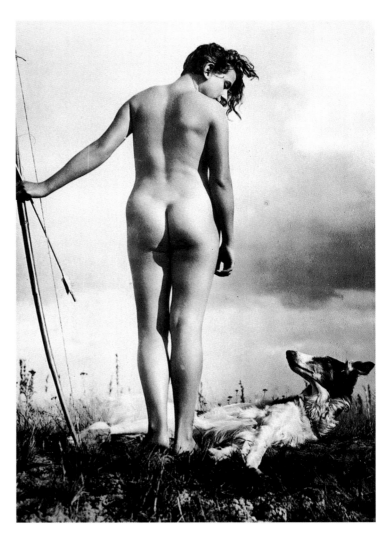

Gerhard Riebicke
c. 1930

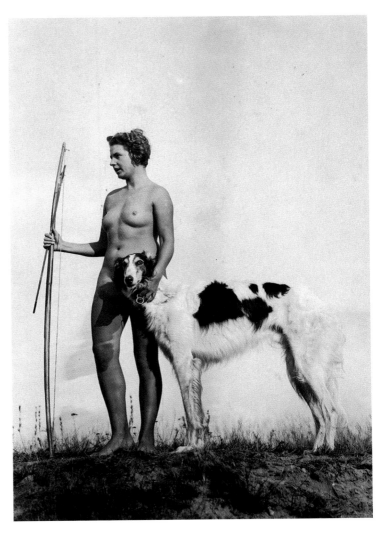

Gerhard Riebicke
1930

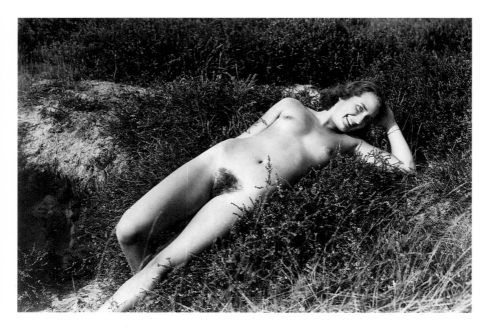

Gerhard Riebicke
C. 1930

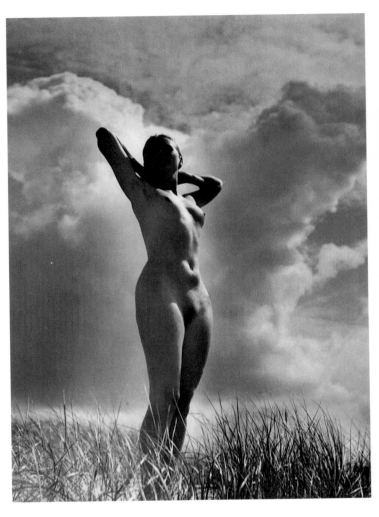

Heinz von Perckhammer
C. 1935

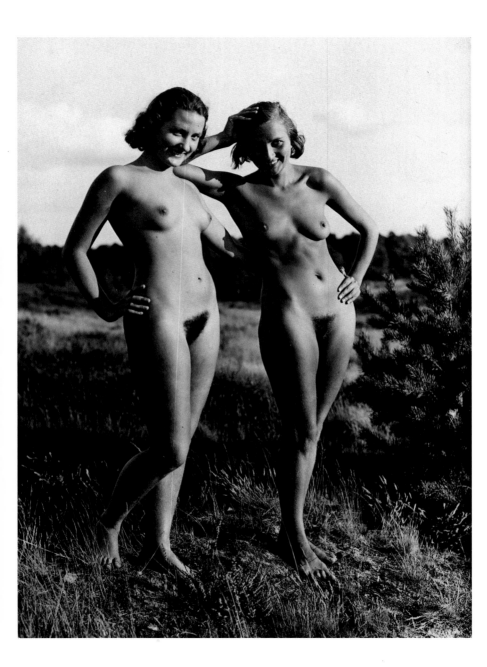

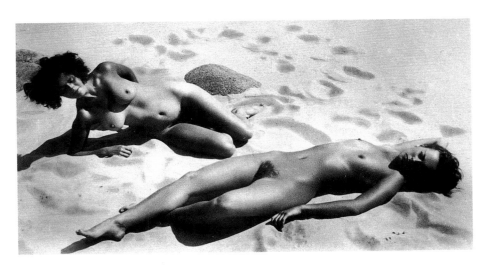

Anonymous
c. 1930

Gerhard Riebicke
c. 1930

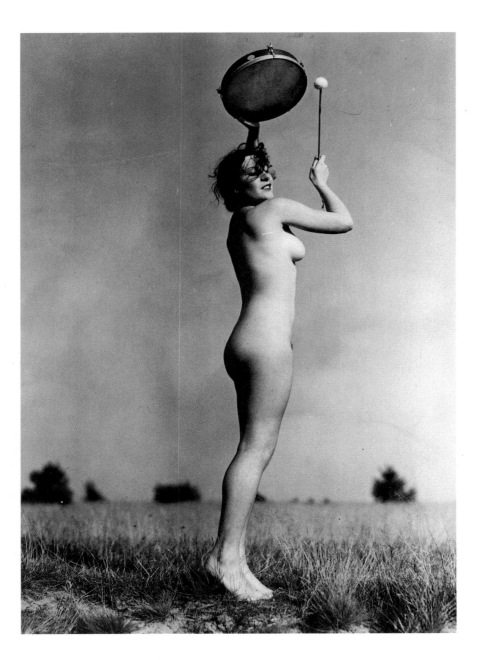

Gerhard Riebicke
c. 1935

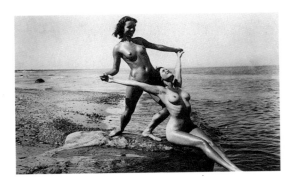

Anonymous
c. 1930

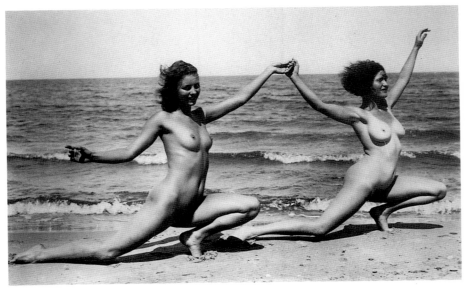

Anonymous
c. 1930

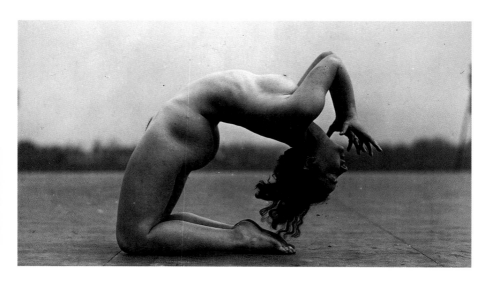

Gerhard Riebicke
C. 1930

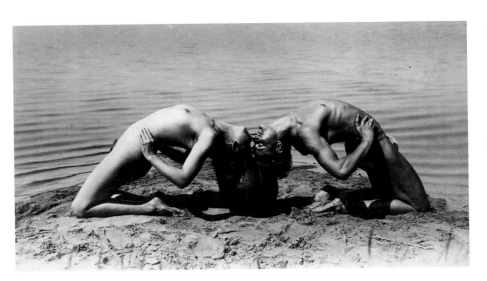

Gerhard Riebicke
C. 1930

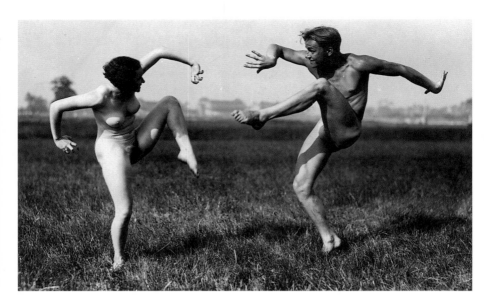

Gerhard Riebicke
C. 1935

Anonymous
C. 1935

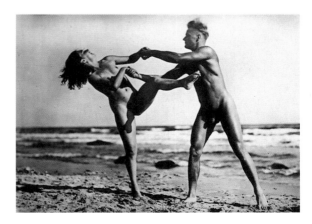

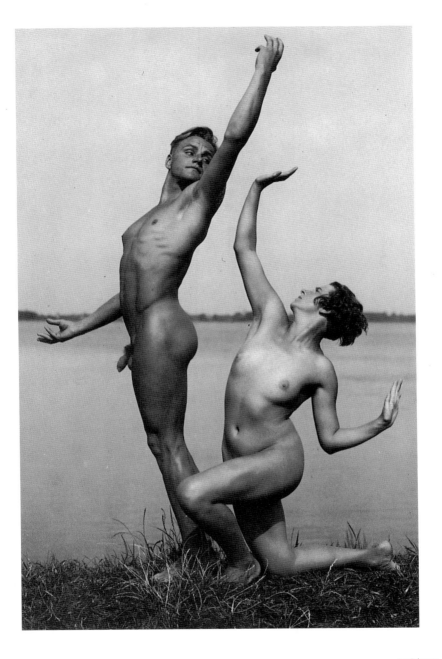

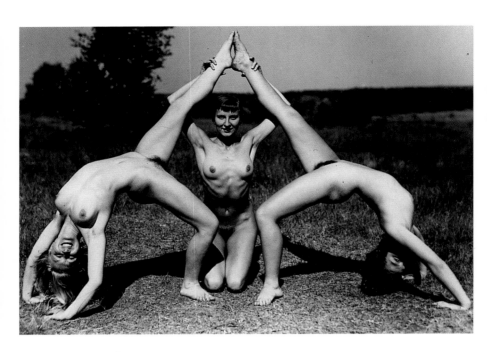

Anonymous
C. 1935

◄
Gerhard Riebicke
C. 1935

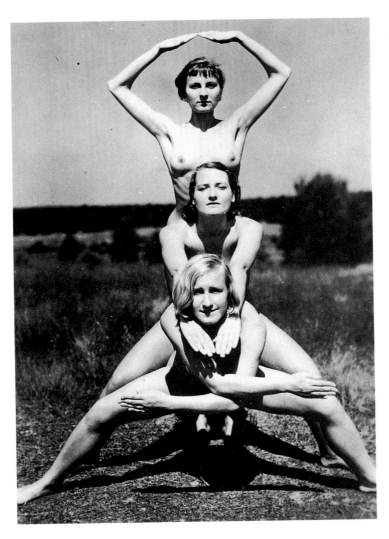

Anonymous
c. 1935

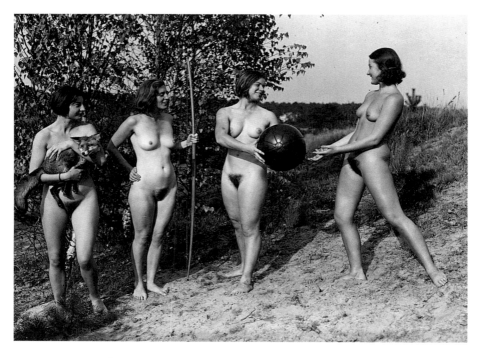

Anonymous
c. 1935

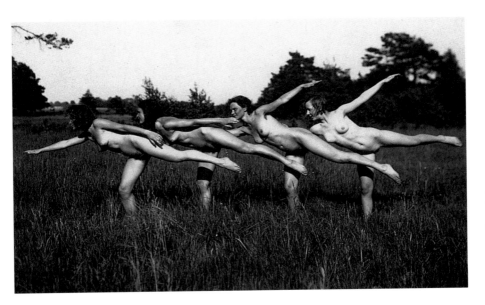

Anonymous
c. 1930

H.B.
c. 1925

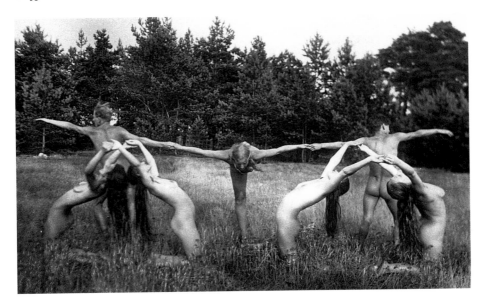

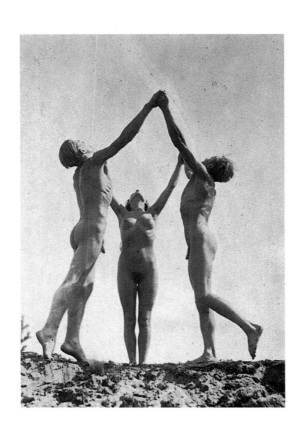

Anonymous
C. 1925

Anonymous
C. 1920

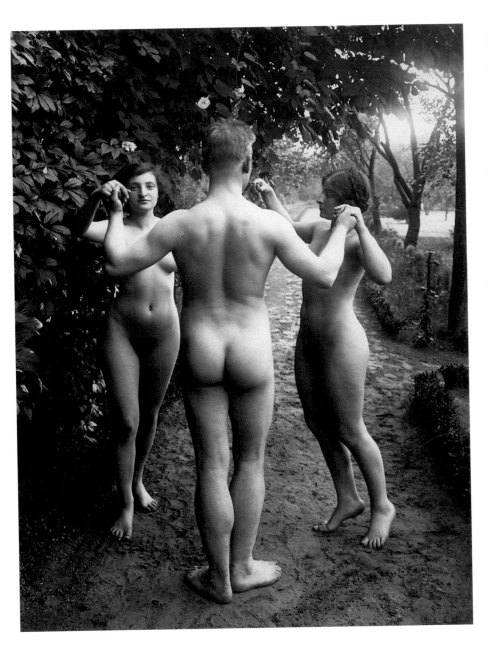

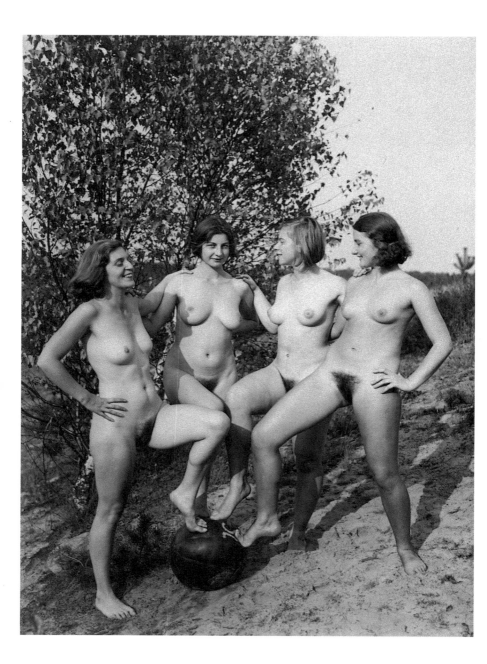

Anonymous
c. 1930

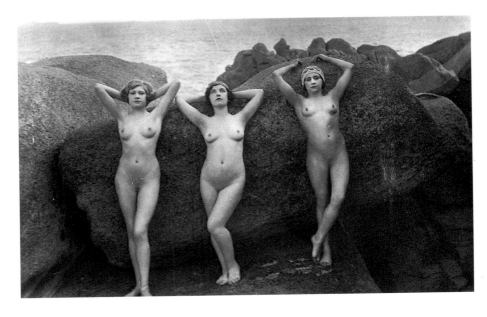

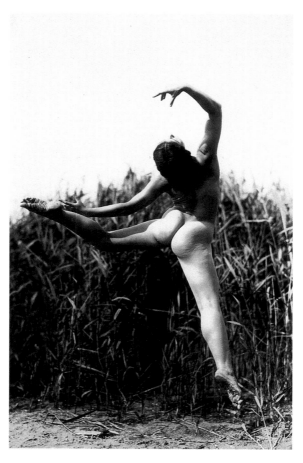

Anonymous
C. 1930

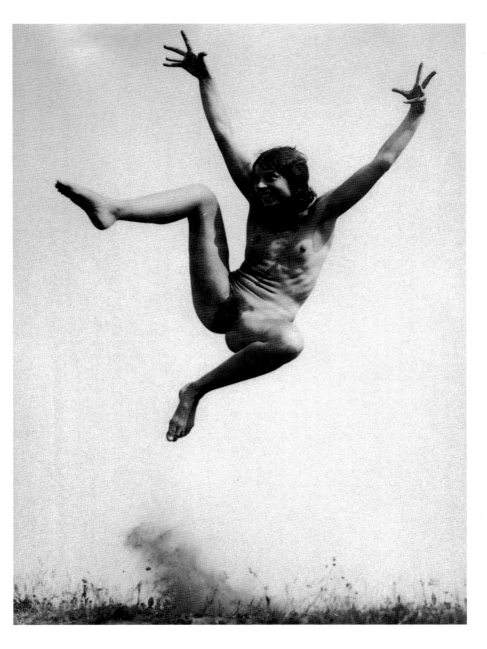

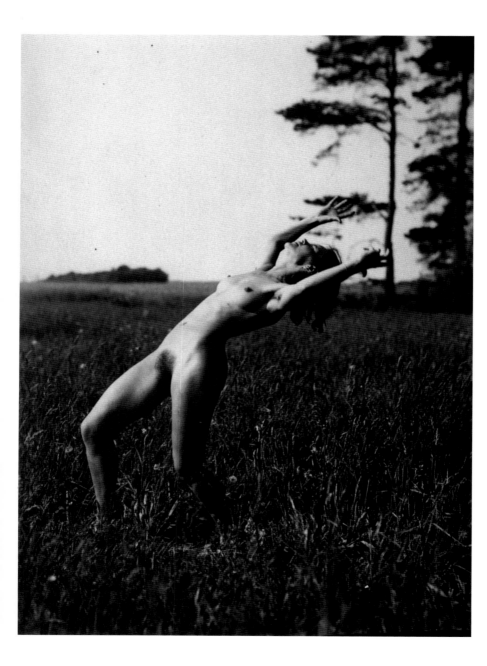

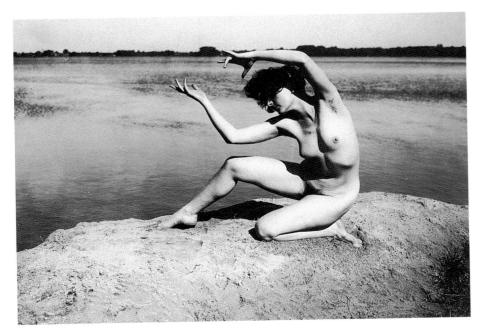

Gerhard Riebicke
c. 1930

Anonymous
c. 1930

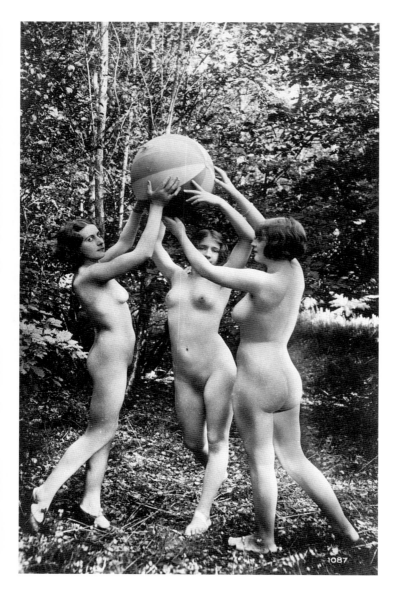

Anonymous
C. 1930

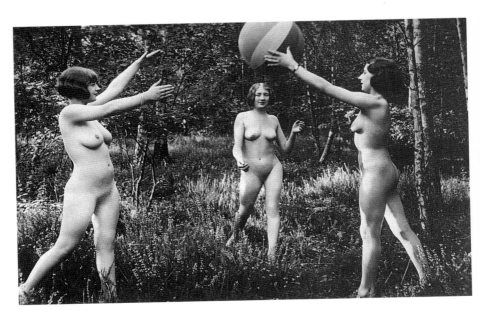

Anonymous
c. 1930

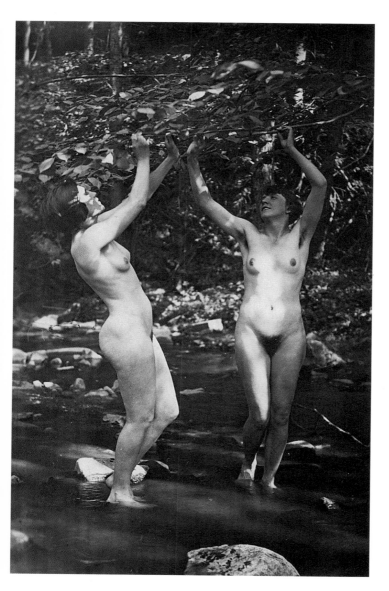

Anonymous
C. 1925

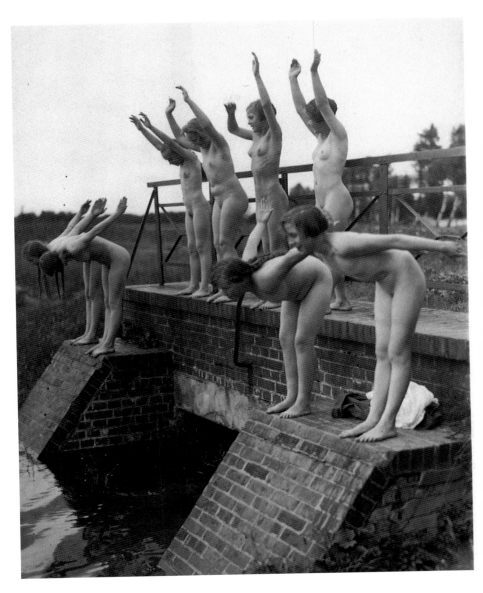

Anonymous
c. 1925

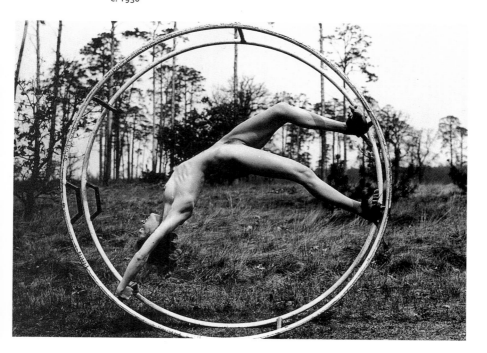

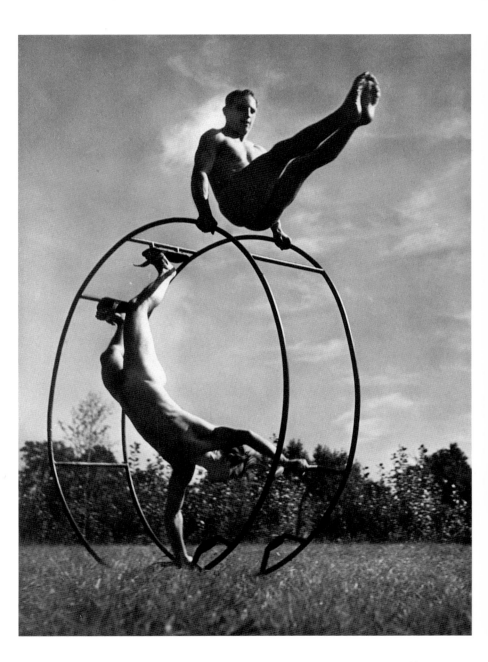

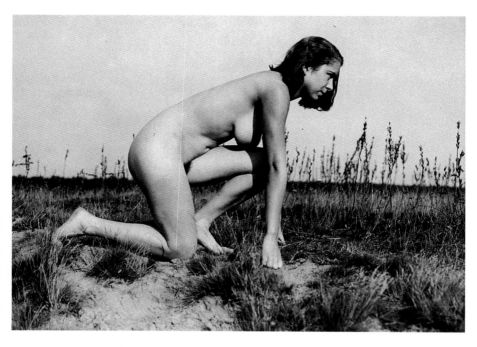

Gerhard Riebicke
C. 1925

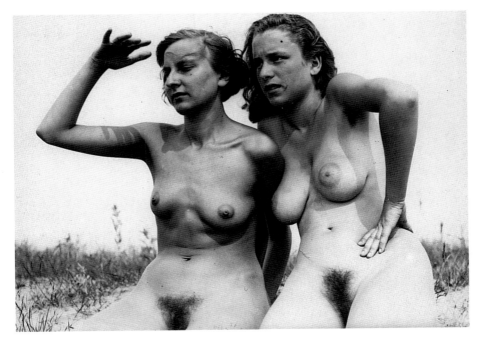

Gerhard Riebicke
C. 1925

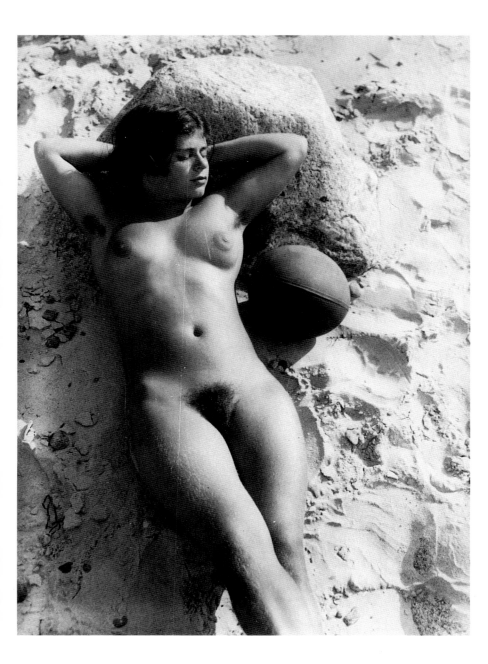

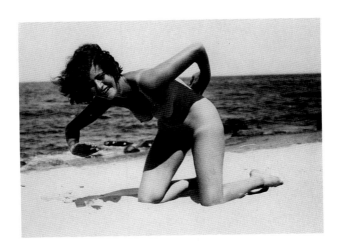

Anonymous
c. 1935

Anonymous
c. 1935

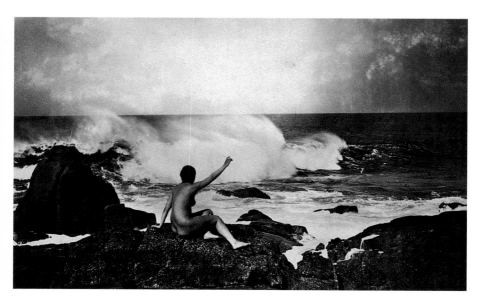

van Jan
C. 1920

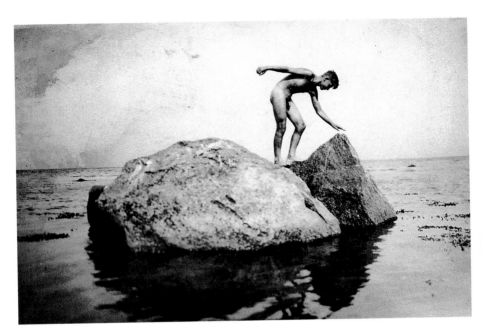

Max Franz Nielsen
C. 1925

11

The longing for sun, light and nature: open-air nudes

Sehnsucht nach Sonne, Licht und Natur: Freilichtakte

Soif de soleil, de lumière et de nature: le nu en plein air

The two main categories of early nude photography – "academy figures" and "saucy scenes" – were accomplished almost exclusively within the studio. That state of affairs was not so much due to technical reasons as to formal aesthetic considerations, since a certain amount of staging was required. If artistically oriented work, totally focussed as it was on the sitter's pose, could afford the simplicity of a neutral background, erotic photographic work, in contrast to this, required an intimately boudoir-like atmosphere in keeping with the taste of the day. Open-air nudes, meaning studies of the human figure in outdoor settings using natural light, did not – but for the rare exception – fit in with the aesthetic values to which early nude photography aspired. A change in paradigm occured only towards the end of the nineteenth century, when art photographers, in the wake of the Impressionists, also took to working "en plein air". Anne W. Brigman, Imogen Cunningham, Clarence H. White, Constant Puyo and Paul Bergon were among those who preferred to represent the human body under open skies and in relation to natural elements charged with allegory or myth (for instance, springs, streams, cliffs and the like). It was the photographer René Le Bêgue who put the reason for the trend towards the open-air nude into words: "All painters who work in the open air and use live models are aware of what pure and chaste beauty the naked female body acquires if set in a landscape under the manifold effects of light". Along with pictorialism, it was mainly the nudist movement that discovered the study of the human body in the open countryside, making this its central motif. "Light Greetings", "Sun Prayer" and so forth were repeated in a thousand different variations, displaying a deliberate simplicity (especially on a technical level) which was intended to distinguish the genre clearly from the sophisticated glamour shots taken in the studio. The advent of roll film and the 35mm format led to photographic equipment becoming ever smaller and easier to use, a welcome development for the enthusiastic nudists who were also amateur photographers. Indeed, the process became so simplified that studies of the human body in nature could be done by anyone, according to their personal taste (with more or less erotic overtones), and without creating a stir.

Die beiden zentralen Akt-Kategorien der Frühzeit – »Akademie« und »Pikanterie« – wurden praktisch ausnahmslos im Atelier aufgenommen. Dies hatte weniger technische als formal-ästhetische bzw. inszenatorische Gründe. Bedurfte die ganz auf Pose konzentrierte Künstlerstudie der Schlichtheit eines neutralen Hintergrunds, so suchte das erotische Lichtbild die intime Atmosphäre des dem Zeitgeschmack angepaßten Boudoirs. Freilicht-Akte, also Körperstudien in der Landschaft bei natürlichem Licht, gehörten – von Ausnahmen abgesehen – nicht zum ästhetischen Programm der Frühzeit. Ein Paradigmenwechsel erfolgte erst gegen Ende des 19. Jahrhunderts, als im Gefolge der Impressionisten auch die Kunstfotografen »en plein air« zu arbeiten begannen. Anne W. Brigman, Imogen Cunningham, Clarence H. White, Constant Puyo und Paul Bergon gehörten zu jenen, die ihre Körperbilder vorzugsweise unter freiem Himmel und unter Einbeziehung allegorisch oder mythologisch besetzter Naturelemente (wie Quelle, Bach, Felsen usw.) realisierten. Stellvertretend für die ganze Richtung begründete der Fotograf René Le Bêgue die Hinwendung zum Freilicht-Akt: »Alle Maler, welche in freier Luft nach lebendem Modell arbeiten, wissen, wie sehr das nackte Weib im landschaftlichen Rahmen unter den mannigfachen Wirkungen der Lichter eine reine und keusche Schönheit annimmt.« Neben dem Pictorialismus war es vor allem die FKK-Bewegung, die die Körperstudie in der freien Natur entdeckte bzw. zum zentralen Bildgegenstand erhob, »Lichtgruß«, »Sonnengebet« usw. wurden zu immer wieder neu abgewandelten Bildmustern, die sich in ihrer (nicht zuletzt technischen) Schlichtheit ganz bewußt vom Studio-Raffinement der Glamour-Aufnahme abzusetzen suchten. Entgegen kam den Intentionen der FKK-begeisterten Foto-Amateure die seit der Einführung von Rollfilm und Kleinbildfotografie immer einfacher zu handhabende Bildtechnik, so daß bald jeder, ohne Aufsehen zu erregen, seinem Bildgeschmack entsprechende (mehr oder minder erotisch inspirierte) Körperstudien in freier Natur realisieren konnte.

Les deux genres initiaux du nu – l'académie et la scène grivoise – se pratiquaient exclusivement dans les ateliers, moins pour des raisons techniques que pour des raisons formelles et esthétiques de mise en scène. Alors qu'un simple fond neutre suffisait pour réaliser une étude dont le principal intérêt résidait dans la pose, l'image érotique était généralement liée à l'atmosphère intime du boudoir caractéristique du goût de l'époque. A quelques exceptions près, le nu en plein air, c'est-à-dire l'étude du corps dans un paysage et à la lumière naturelle, ne correspondait pas aux préoccupations esthétiques des débuts de la photographie. Le choix des motifs n'évolua que vers la fin du 19ème siècle, lorsqu'à l'exemple des impressionnistes, les photographes commencèrent eux aussi à travailler en plein air. Anne W. Brigman, Imogen Cunningham, Clarence H. White, Constant Puyo et Paul Bergon étaient de ceux qui préféraient travailler en plein air, intégrant des éléments naturels – source, ruisseau ou rochers – chargés de sens allégorique ou mythologique. Résumant l'esprit de ce courant, voici comment le photographe René le Bègue décrivait l'intérêt que présentait le nu en plein air : «Tous les peintres qui peignent en plein air d'après un modèle vivant savent à quel point, dans un cadre champêtre, sous les effets changeants de la lumière, une femme nue acquiert une beauté pure et chaste.» Outre le pictorialisme, c'est surtout le mouvement naturiste qui fit découvrir l'étude du corps dans la nature en en faisant son sujet de prédilection. Des sujets comme «Le salut à la lumière» ou «La prière au soleil» furent déclinés de façons constamment nouvelles. A travers la recherche de la simplicité, qui ne se limitait pas à l'aspect technique, ils cherchèrent à se démarquer du raffinement des clichés glamour réalisés en studio. Les photographes-amateurs adeptes du naturisme eurent une démarche similaire. Avec l'apparition de la pellicule et de la photo en petit format, il fut de plus en plus facile d'accéder à la technique photographique, de sorte que chacun put bientôt, dans la plus grande discrétion, réaliser en plein air des études d'inspiration plus ou moins érotique selon son goût.

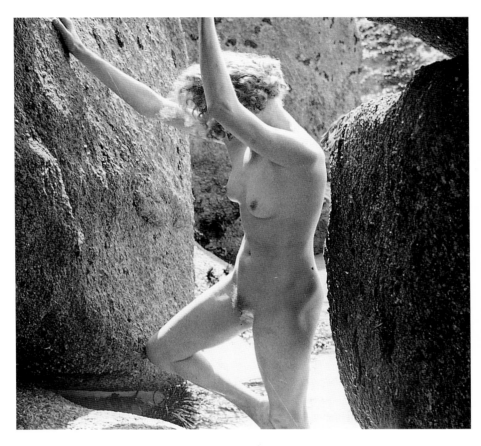

Anonymous
C. 1920

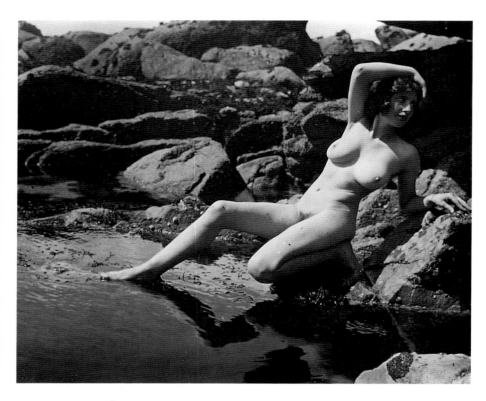

Anonymous
c. 1920

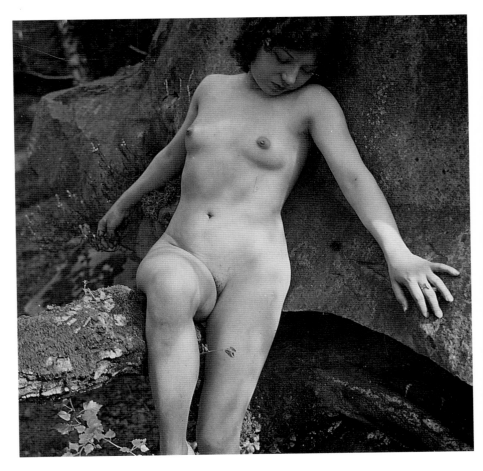

Anonymous
C. 1920

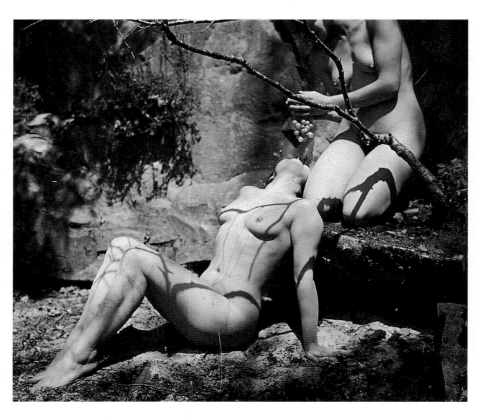

Anonymous
C. 1920

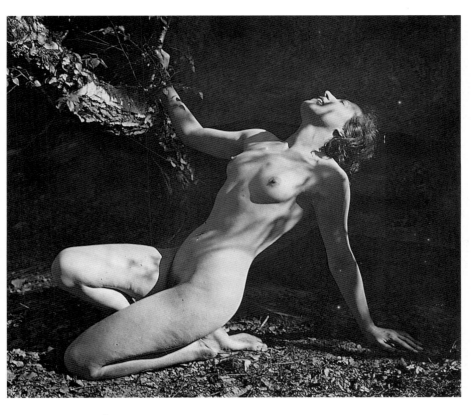

Anonymous
C. 1920

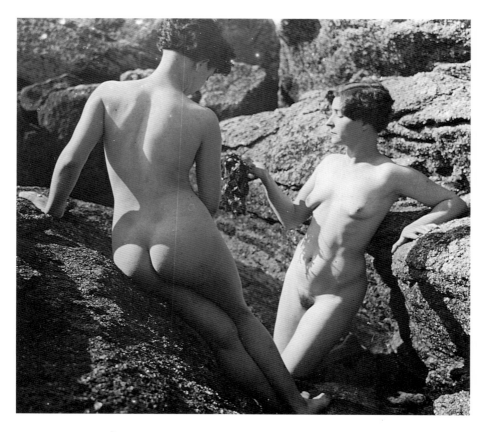

Anonymous
C. 1920

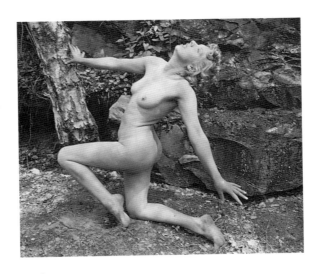

Anonymous
C. 1920

Anonymous
C. 1920

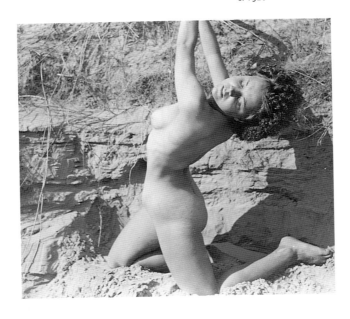

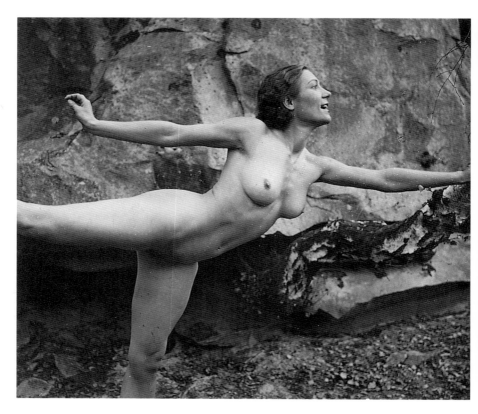

Anonymous
C. 1920

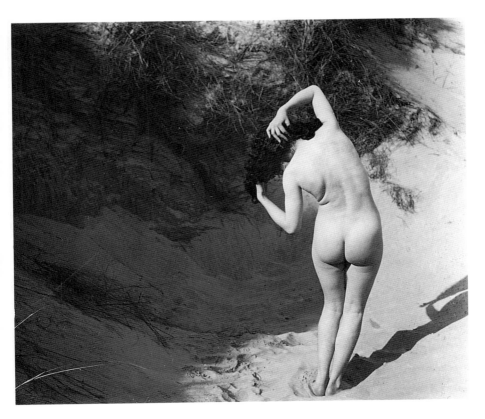

Anonymous
c. 1920

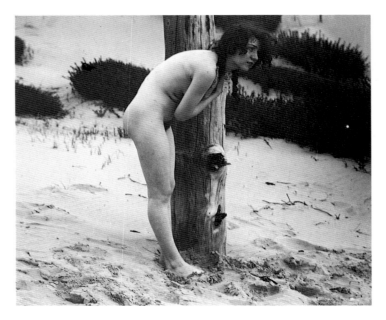

Anonymous
C. 1920

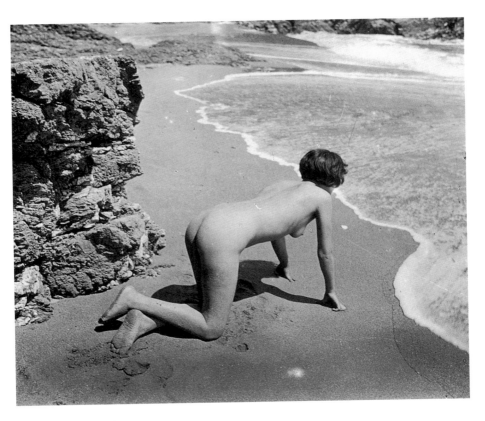

Anonymous
C. 1920

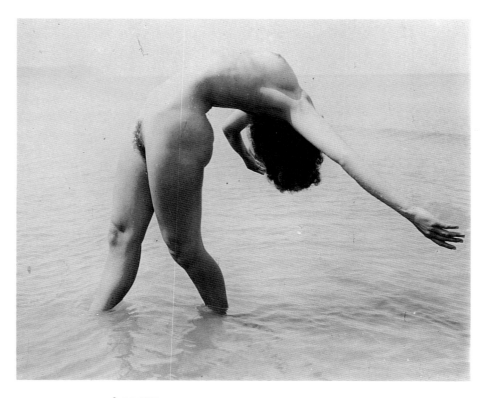

Anonymous
C. 1920

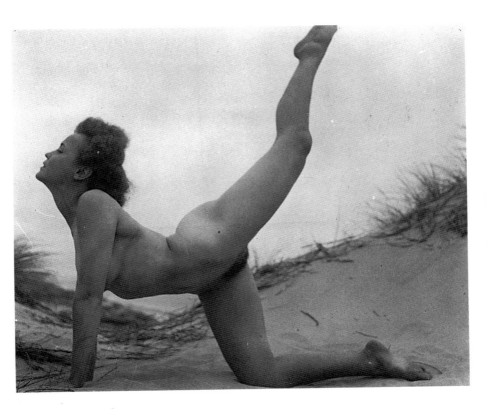

Anonymous
C. 1920

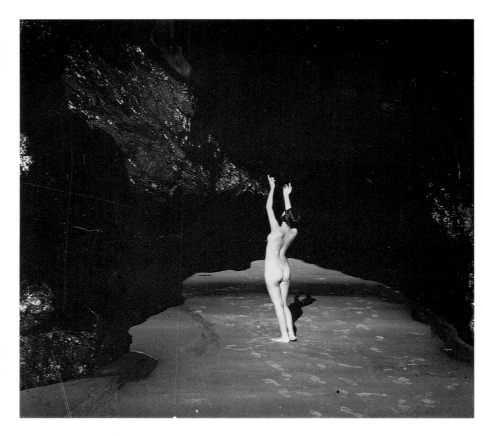

Anonymous
C. 1920

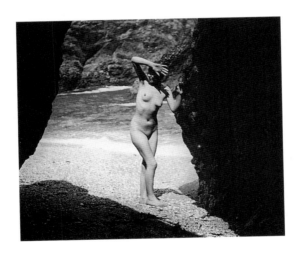

Anonymous
C. 1920

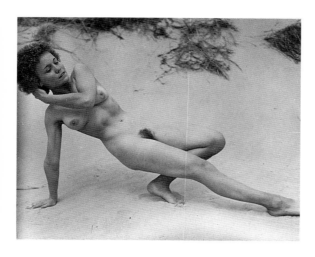

Anonymous
C. 1920

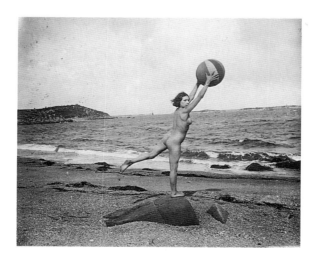

Anonymous
C. 1920

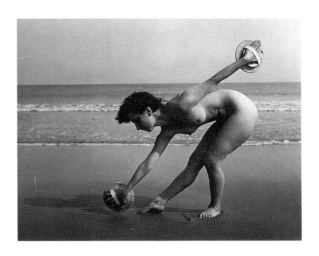

Anonymous
C. 1920

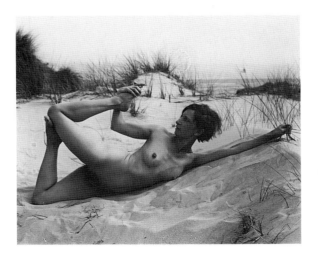

Anonymous
C. 1920

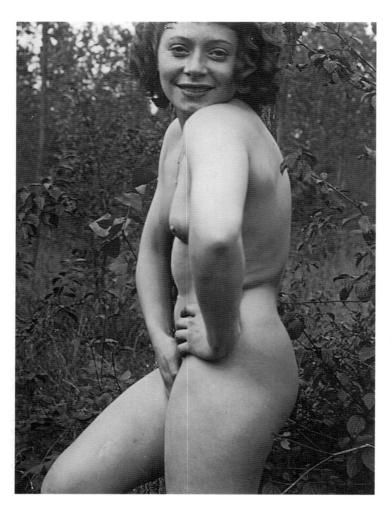

Anonymous
C. 1920

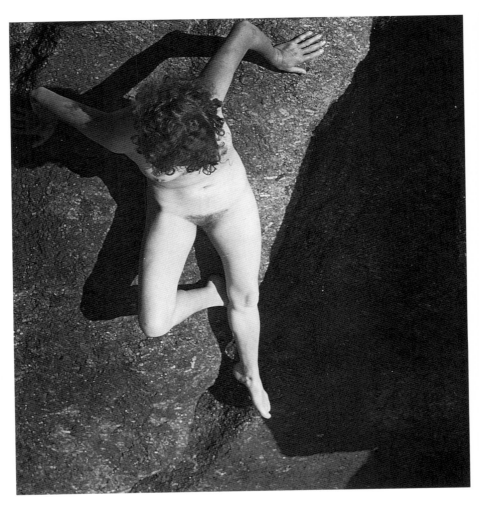

Anonymous
c. 1920

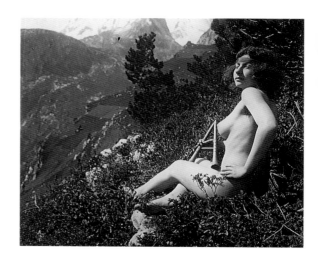

Anonymous
C. 1920

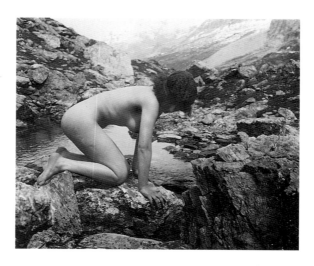

Anonymous
C. 1920

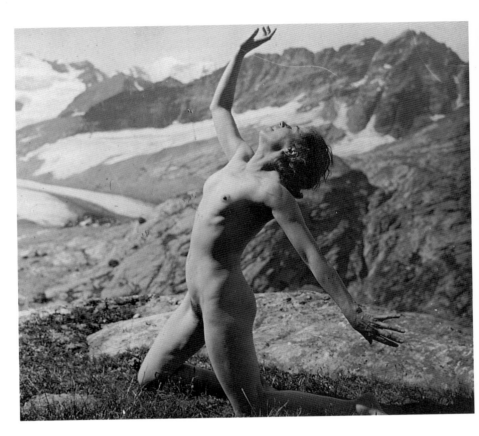

Anonymous
c. 1920

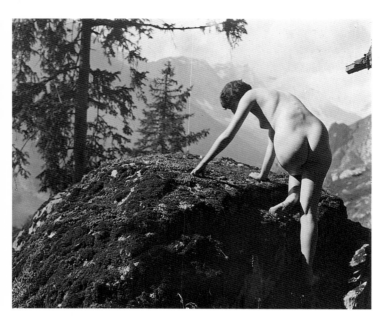

Anonymous
C. 1920

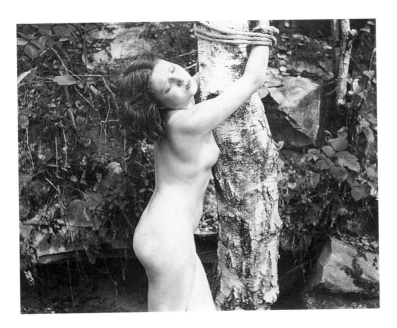

Anonymous
c. 1920

12
New trends in nude photography

Neue Wege in der Aktfotografie

Les nouvelles tendances de la photo de nu

The shock of World War I had a liberating effect on the fine arts, literature, theatre, dance and photography. The disintegration of the traditional political world order and bourgeois value systems was reflected in the decline of classicism in the arts and opened the door to innovative aesthetic concepts, which, with respect to photography, were initially expressed in terms of a rejection of art photography's tenets. Above all, pictorialism's aversion to technical devices was overcome, as was made clear by the fact that, on the one hand, machines and manufactured consumer goods were henceforth deemed to be acceptable subjects and, on the other hand, photography itself was accepted as a technical medium, thus encouraging the use of, and experimentation with, its intrinsic features. As was already the case for art photography at the turn of the century, this "new photography", spanning the years between the two World Wars, became an international phenomenon, with centres in North America, the USSR and Western Europe. In the last two issues of the legendary photographic review "Camera Work" (1916/17), Alfred Stieglitz, the review's publisher, heralded the start of this development by presenting the dedicatedly "straight photography" of Paul Strand. The proponents of the "new objectivity" were mainly concerned with faithful detail, sharp images and quality tonal rendering: an approach which entailed paying equal attention to the object and photographic technique, "pure and without tricks", as Stieglitz put it, whereas the international representatives of a "new vision" sought to achieve a photographic style which reflected the speed of the Machine Age, the outlook of a new era, the psychological implications of modern science. From then on, multiple exposures, solarization, photomontages, bold perspectives from above and below, belonged to the style vocabulary of the visualists, who shared a common artistic interest in the human (female) body with the proponents of the "new objectivity", a body now freed from the need to justify its presence by means of token allegorical or narrative settings.

Geradezu befreiend gewirkt hatte der Schock des Ersten Weltkriegs auf bildende Kunst, Literatur, Theater, Tanz und Fotografie. Mit der überkommenen politischen Welt- und bürgerlichen Werteordnung war ein an klassischen Idealen geschulter Kunstbegriff untergegangen und somit der Weg frei für innovative ästhetische Konzepte, die sich – im Bereich der Lichtbildnerei – zuallererst in einer Abkehr vom Programm der Kunstfotografie äußerten. Überwunden wurde vor allem die Technikfeindlichkeit der Pictorialisten. Einmal, indem etwa Maschinen oder industriell gefertigte Gebrauchsgüter nunmehr als bildwürdig anerkannt wurden. Zum anderen, indem man die Fotografie selbst als technisches Medium akzeptierte und somit gemäß der ihr innewohnenden Eigenheiten nutzte bzw. experimentell erkundete. Wie schon die Kunstfotografie der Jahrhundertwende war auch diese »neue Fotografie« der Zwischenkriegszeit ein internationales Phänomen mit Schwerpunkten in Nordamerika, der Sowjetunion und Westeuropa. Eingeläutet worden war die Entwicklung durch die letzten beiden Hefte der legendären Fotozeitschrift »Camera Work« (1916/17), in denen Herausgeber Alfred Stieglitz erstmals das einer »straight photography« verpflichtete Werk von Paul Strand vorstellte. Ging es den Vertretern einer »neusachlichen« Fotografie vor allem um Detailtreue, Bildschärfe und Tonwertreichtum, also um eine dem Gegenstand wie dem Bildmittel angemessene Vorgehensweise, »rein und ohne Kniffe« (Stieglitz), so suchten die internationalen Vertreter eines »Neuen Sehens« den fotografischen Stil der Geschwindigkeit des Maschinenzeitalters, den Perspektiven der Neuzeit, den psychologischen Erkenntnissen der modernen Wissenschaften anzunähern. Mehrfachbelichtung, Solarisation, Fotomontage, kühne Auf- und Untersichten gehörten folglich zum Stilvokabular der Visualisten, die mit der »Neuen Sachlichkeit« nicht zuletzt das künstlerische Interesse am (weiblichen) Körper verband – nunmehr frei von allegorischen oder sonstigen narrativen Rechtfertigungszwängen.

Le choc de la Première Guerre mondiale eut un effet tout à fait libérateur sur les beaux-arts, la littérature, le théâtre, la danse et la photographie. En même temps que s'écroulaient les valeurs bourgeoises et le monde politique traditionnel, disparaissait également une esthétique nourrie de l'idéal classique, ouvrant la voie à des conceptions novatrices qui se manifestèrent principalement, dans le domaine de la photo, par une redécouverte de la photographie artistique. On s'affranchit de la méfiance des pictorialistes à l'égard de la technique, d'une part en trouvant de l'intérêt à photographier des machines ou des biens de consommation produits industriellement, d'autre part en considérant la photographie comme un véritable moyen d'expression et en utilisant, y compris de façon expérimentale, toutes ses ressources techniques. Tout comme le pictorialisme au début du siècle, la «Nouvelle Photographie» de l'entre-deux-guerres fut un phénomène de portée internationale, dont les principaux foyers furent l'Amérique du Nord, l'Union Soviétique et l'Europe Occidentale. Cette évolution fut annoncée dans les deux derniers numéros de la légendaire revue de photographie «Camera Work» (1916/17), où l'éditeur, Alfred Stieglitz, présenta pour la première fois une œuvre représentative de la «photographie pure», celle de Paul Strand. D'un côté, les représentants de la «Nouvelle Objectivité» s'attachèrent à rendre l'exactitude des détails, la netteté de l'image et la richesse des nuances, privilégiant une approche «pure et sans artifices» (Stieglitz), respectueuse aussi bien de l'objet que de la technique photographique. De l'autre, les représentants internationaux d'une «Nouvelle Vision» cherchèrent à adapter leur style photographique à la vitesse de l'ère de la machine, aux possibilités de l'époque, aux acquis psychologiques de la science moderne. Double exposition, solarisation, photomontage, vues en plongée et en contre-plongée faisaient partie du vocabulaire stylistique des visualistes qui allièrent à la «Nouvelle Objectivité» l'intérêt artistique qu'ils portaient au corps (féminin), sans être obligé cette fois de s'imposer des contraintes allégoriques ou narratives.

Herbert List
Athen
1938

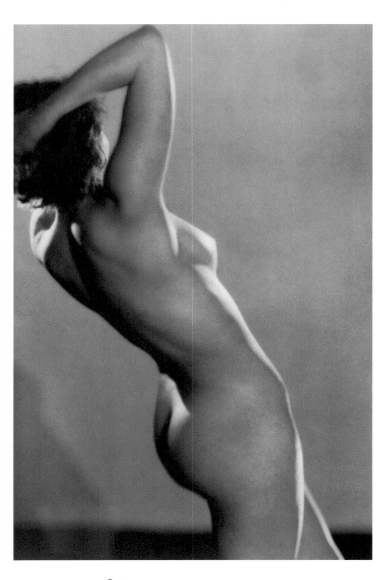

Paco
C. 1935

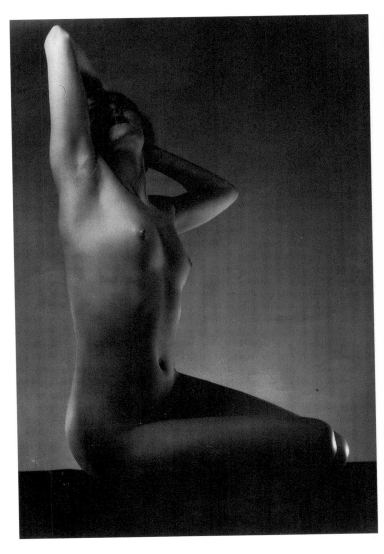

Edward Steichen
Miss Sousa
1933

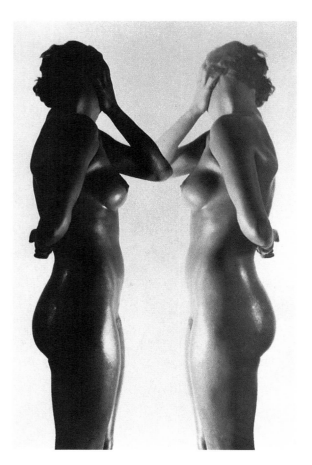

Heinz Hajek-Halke
c. 1938

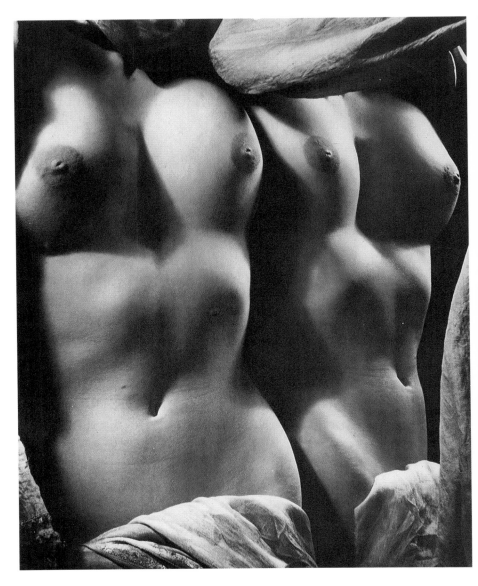

Erwin Blumenfeld
C. 1930

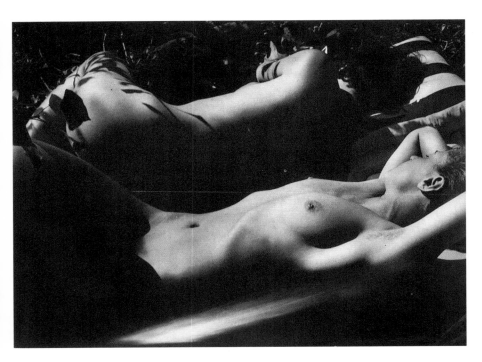

László Moholy-Nagy
1935

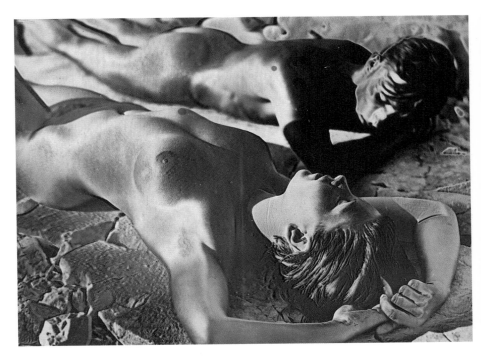

Edmund Kesting
C. 1935

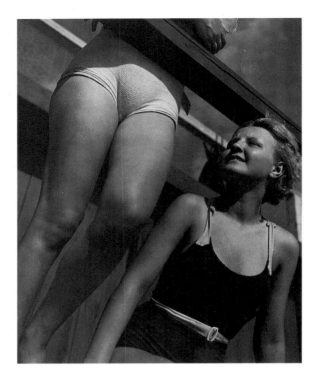

Václav Jíru
c. 1940

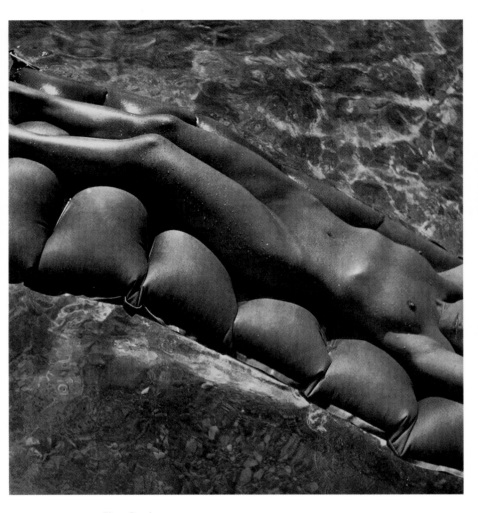

Pierre Boucher
1936

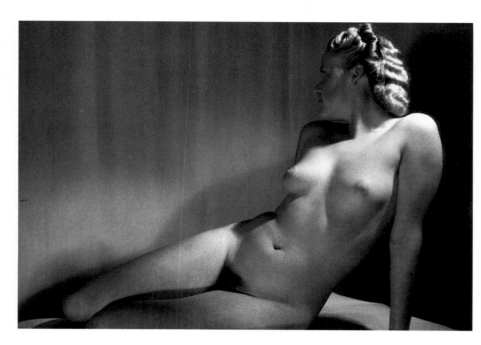

Lala Aufsberg
C. 1935

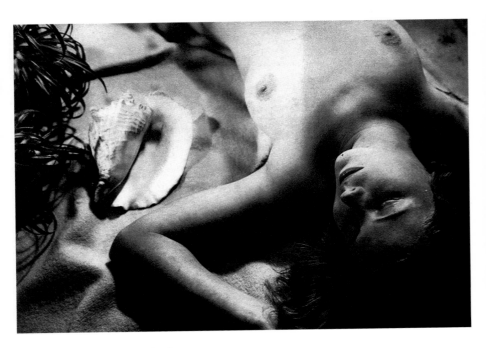

Florence Henri
1935

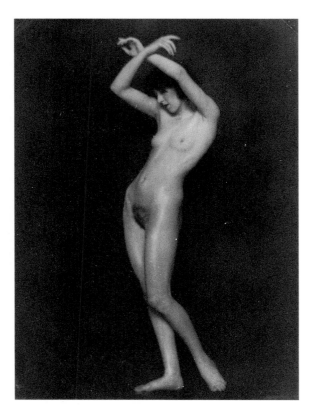

Trude Fleischmann
c. 1930

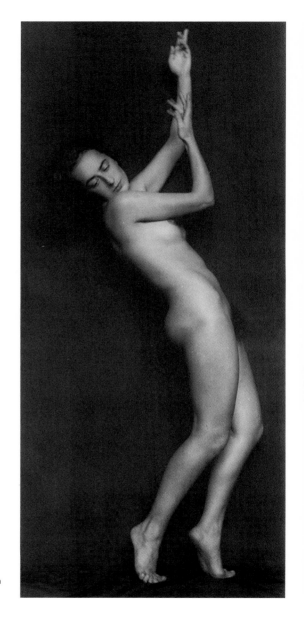

Trude Fleischmann
C. 1930

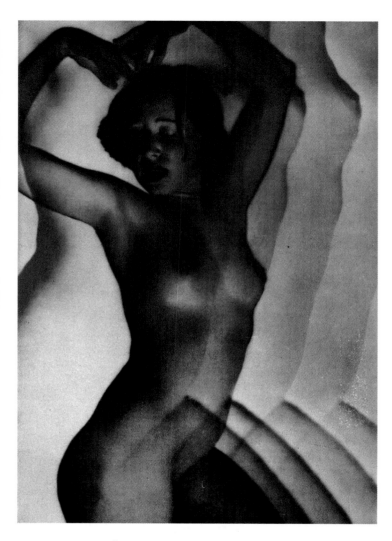

Anonymous
c. 1925

Gertrude Fehr
c. 1938

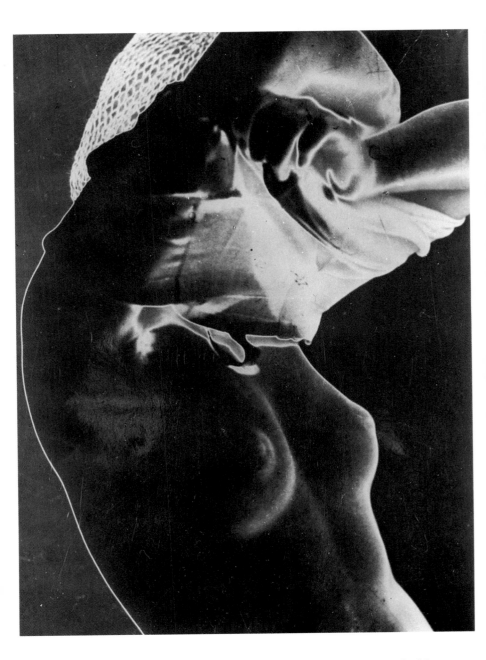

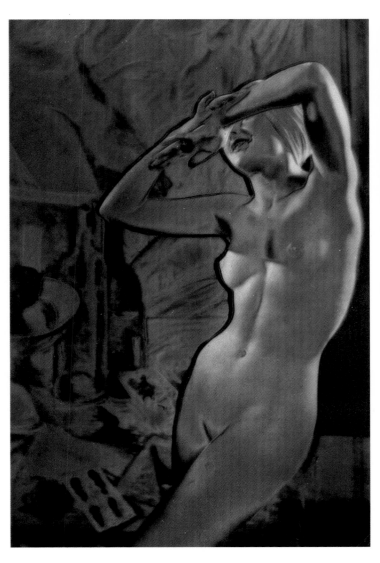

Paco
C. 1935

Franz Roh
c. 1925

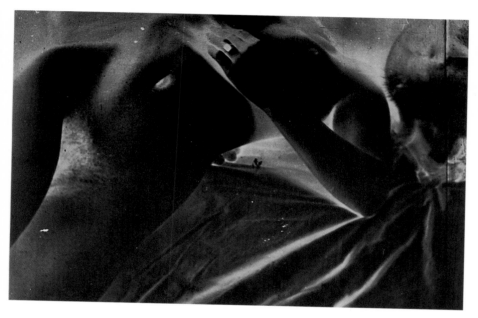

Franz Roh
C. 1925

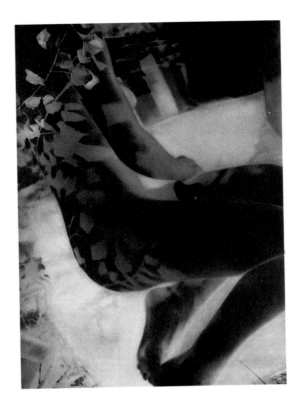

László Moholy-Nagy
C. 1935

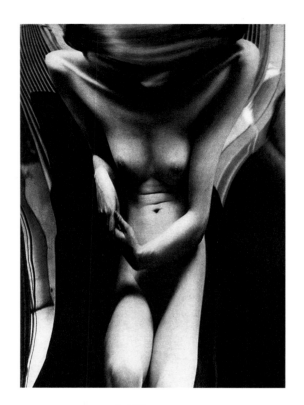

André Kertesz
C. 1935

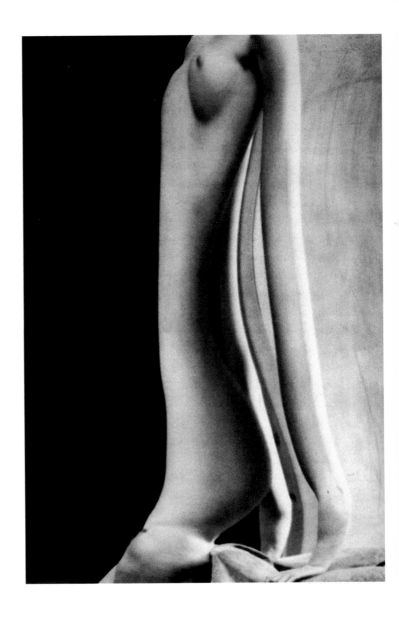

André Kertesz
c. 1935

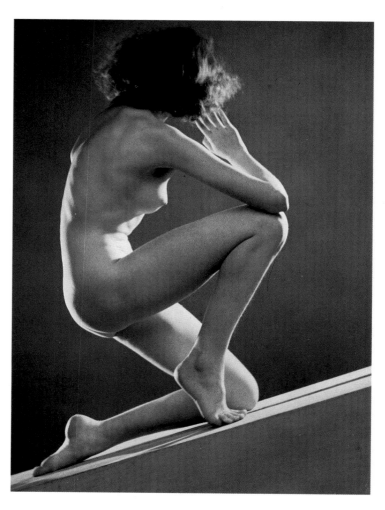

Paco
C. 1935

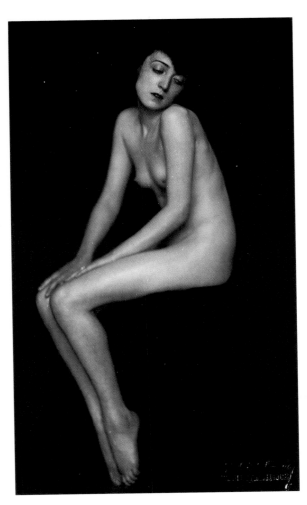

Trude Fleischmann
C. 1930

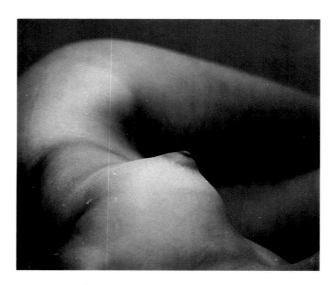

Karel E. Ludwig
C. 1935

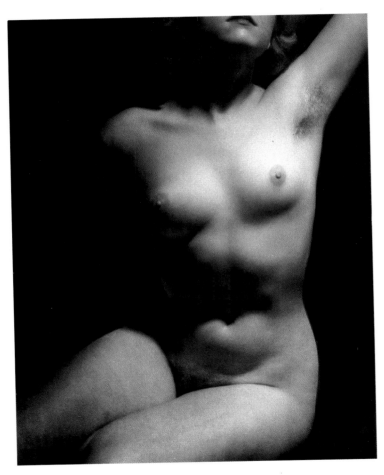

Alexander Binder
c. 1935

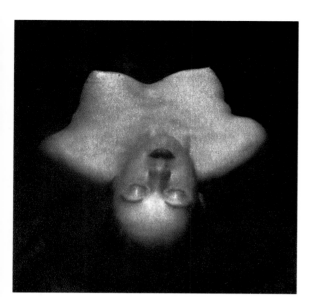

Bertram Park/Yvonne Gregory
1936

František Drtikol
C. 1925

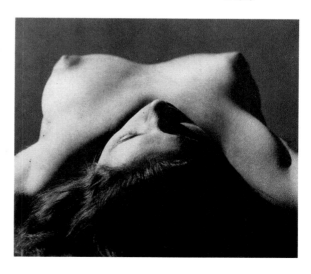

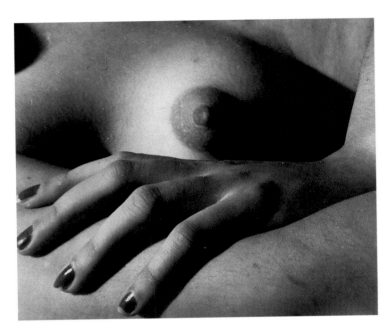

Karel E. Ludwig
1941
Detail

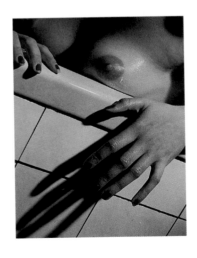

Karel E. Ludwig
After the Bath
1941

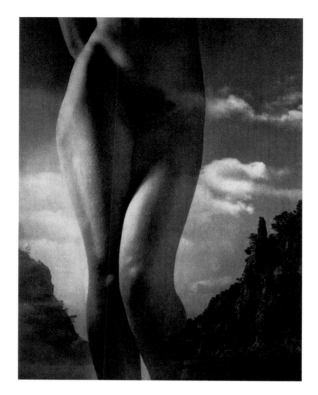

Pierre Boucher
Surrealistic Impressions
C. 1933

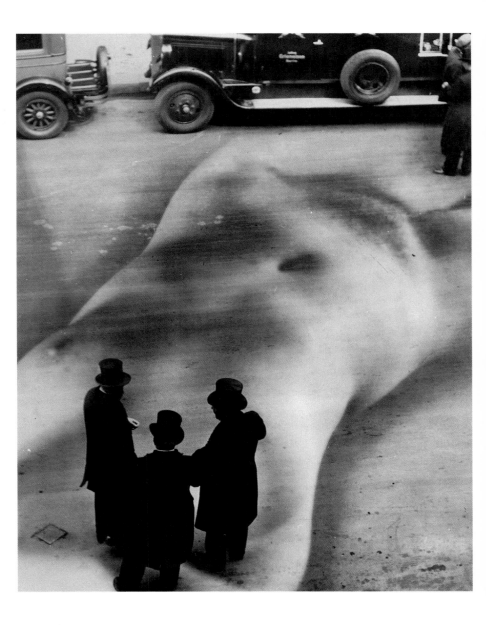

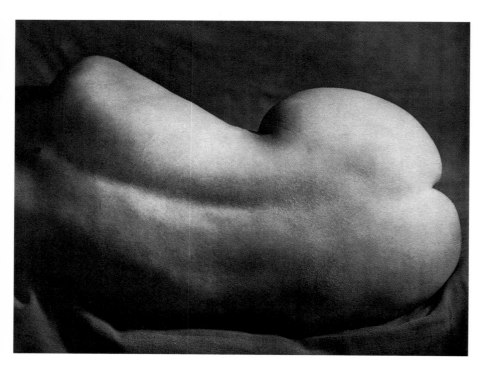

Brassaï
c. 1935

Raoul Hausmann
c. 1930

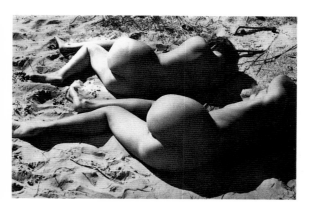

Willy Zielke
c. 1936

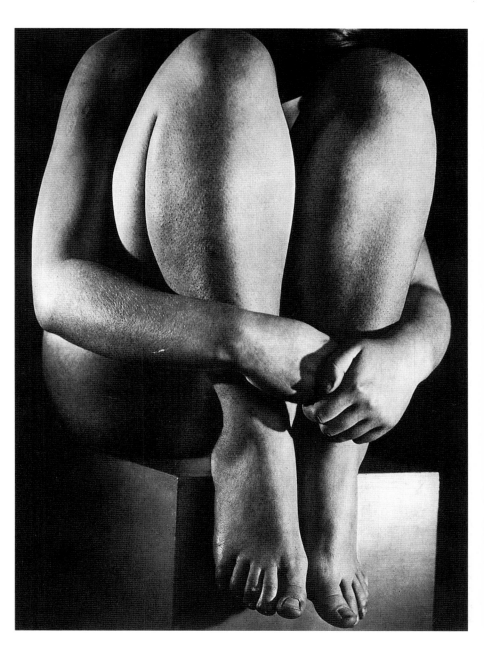

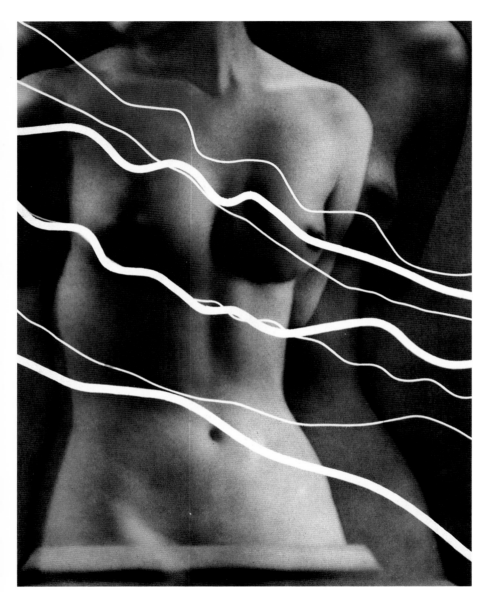

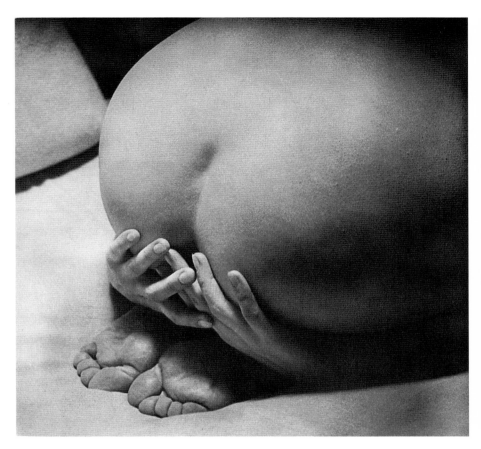

Man Ray
The Prayer
1930

Man Ray
Electricity
1931

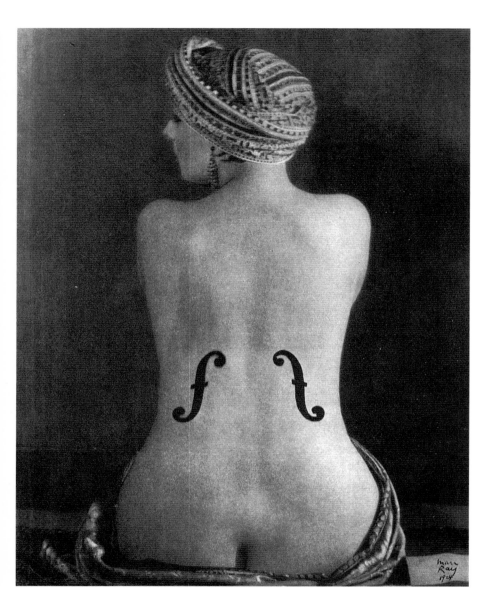

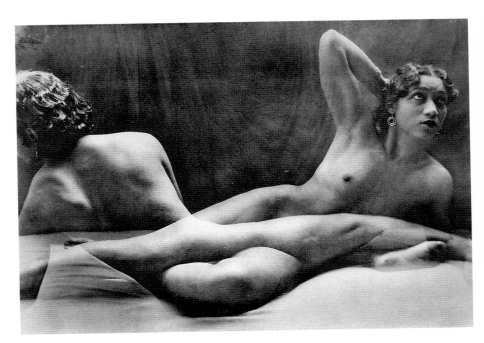

Germaine Krull
C. 1930

Man Ray
Violon d'Ingres
1924

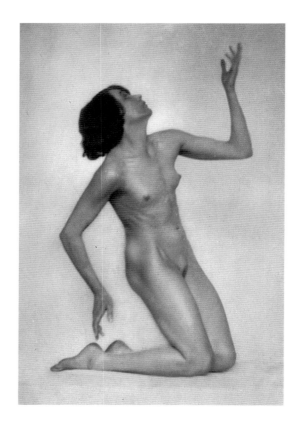

Trude Fleischmann
c. 1930

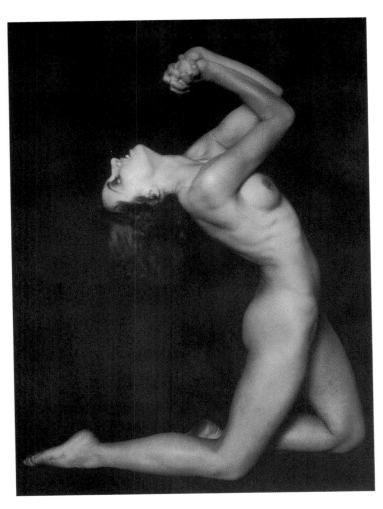

Rudolf Koppitz
Despair
c. 1930

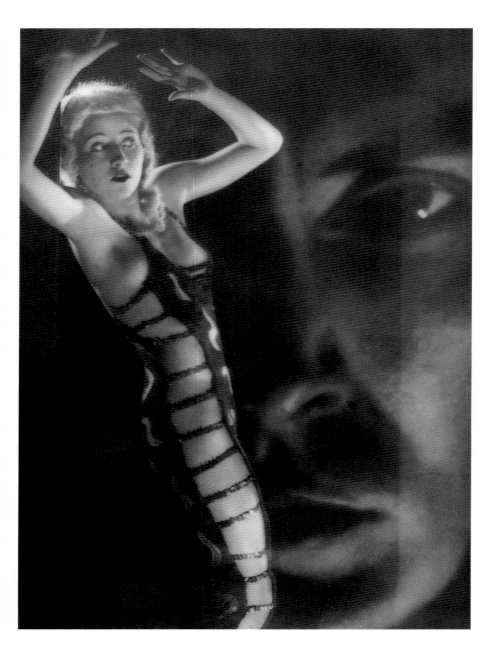

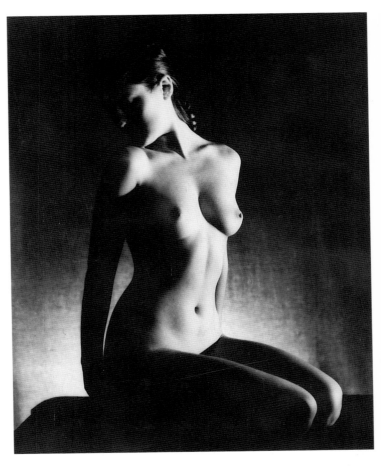

John Everard
C. 1935

Studio Keystone
C. 1938

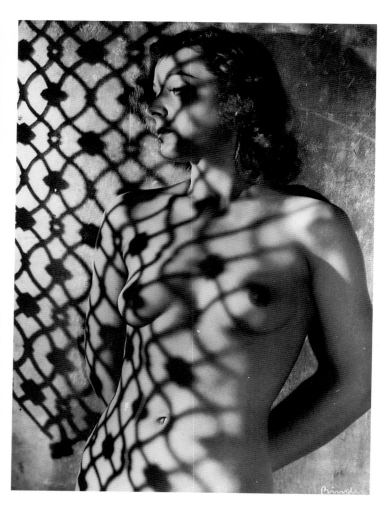

Alexander Binder
C. 1935

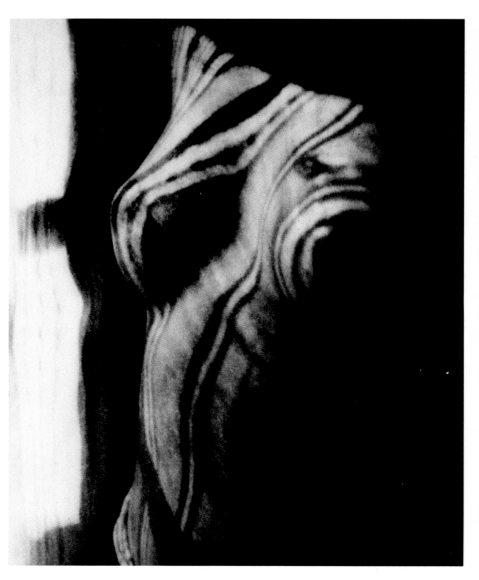

Man Ray
c. 1930

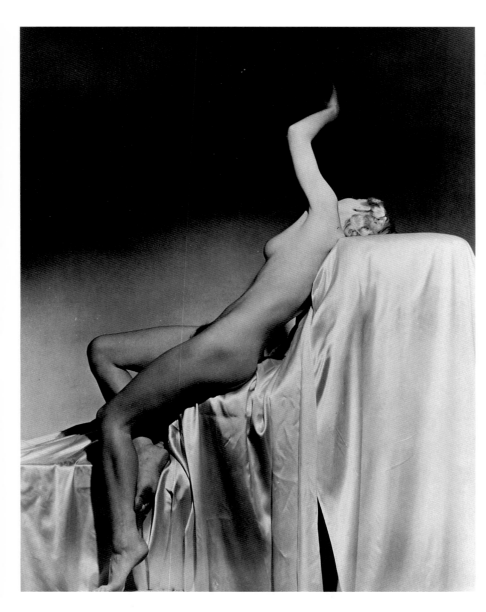

Anonymous
c. 1930

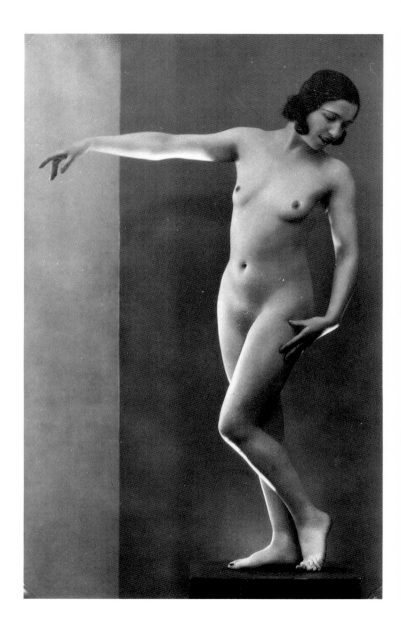

◄
Horst P. Horst
Lisa
1938

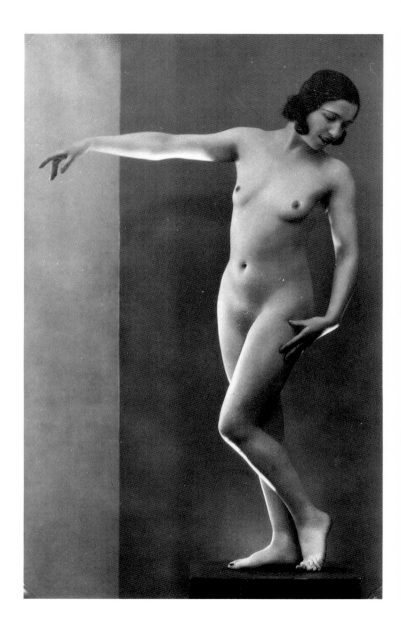

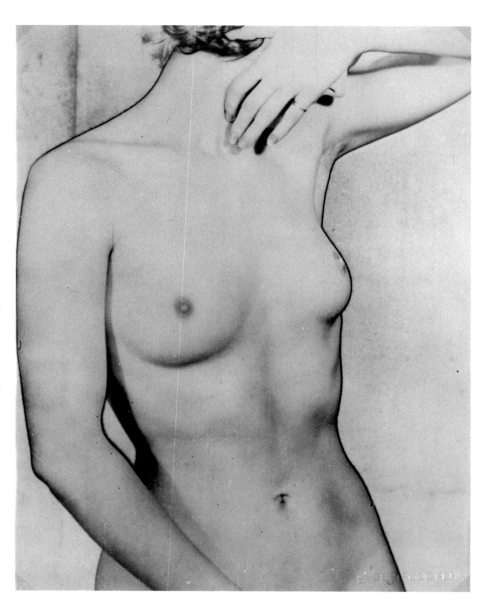

Gertrude Fehr
C. 1938

Gertrude Fehr
C. 1938

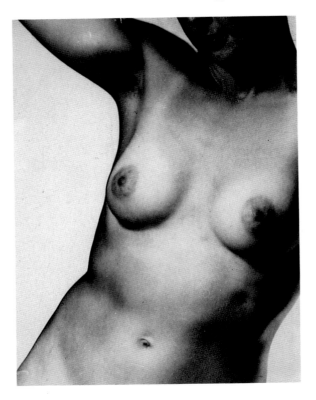

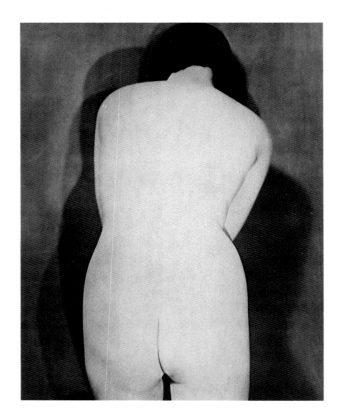

Man Ray
c. 1930

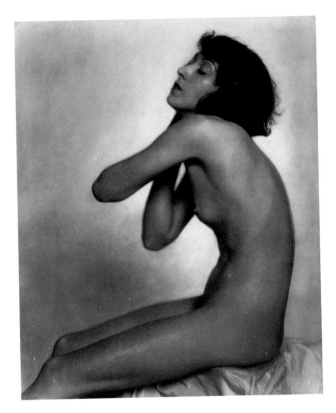

Trude Fleischmann
C. 1930

13
Glamour shots and pin-up girls

Glamour und Pin-up

Le portrait glamour et la photo de pin up

As of the early 1920s, any Hollywood studio worthy of the name had its own photography department, in order to satisfy the rising demand for publicity material. The development entailed two categories of imagery which became, towards the end of the twenties, integral to the motion picture industry's publicity campaigns: the film still and the glamour portrait. Contrary to popular belief, neither the film stills nor the portraits were done on set, that is, during shooting. Rather, they were prettily staged in the studio, in many cases – at least at the start – in accordance with the formal standards of somewhat middle-of-the-road art photography. Tungsten lamps and soft-focus lenses became standard equipment in the profession, as did also large format cameras (up to 8 x 11 inches), and retouching negatives was common practice. For in the final analysis, it was not character portraits that were sought but imagery charged with eroticism and poignancy. The general idea was to use lighting and create poses so as to bestow on the film stars as much sex appeal as their fans ("fanatics") and fan magazines ("fanzines") demanded on the one hand, and as society could take on the other. The famous Hollywood photographer George Hurrell once said, "For me, the word 'glamour' was only a way to avoid mentioning sex". In Europe as well, in the period between World War I and World War II, the glamour shot came to appeal to more and more commercial photography studios (such as Manassé in Vienna, Wilding in London, and Yva in Berlin), affording them a welcome opportuntity to present the public with a low key and socially acceptable form of erotica. It was mainly the illustrated magazine industry, which was expanding rapidly at the time, that saw to the distribution of such work. Big names from the entertainment world provided that combination of "celebrity" and "nudity" which was no less appealing then as it is today. And although movie and stage stars were reluctant to show anything beyond the plunging neckline, the dancers and music hall artists of the day – Joséphine Baker, Anita Berber and Irene Schuchowa come to mind – were often prepared to bare a great deal more, with results that may be considered the naive forerunners of the contemporary pin-up.

Ab Anfang der zwanziger Jahre unterhielten praktisch alle Holly-
wood-Studios eigene Fotoabteilungen, um den wachsenden Bedarf
an Werbematerial zu decken. In diesem Zusammenhang entwickel-
ten sich zwei spezifische Bildformen, die ab Ende der zwanziger
Jahre zum festen Bestand der das Filmschaffen begleitenden
Medienarbeit gehörten: das Film-Still und das Glamour-Porträt.
Entgegen einer verbreiteten Meinung wurden weder Stills noch
Porträts im Set, also während der Dreharbeiten aufgenommen,
sondern im Fotostudio bildwirksam inszeniert, wobei zumindest in
der Anfangszeit noch viele Fotografen den formalen Regeln einer
gemäßigten Kunstfotografie folgten. Warmstrahler (Tungsten) und
weichzeichnende (Vertone-) Objektive gehörten ebenso zum techni-
schen Standard wie großformatige Kameras (bis hin zu 8 x 10″) sowie
– recht ausgiebig – die Negativ-Retusche. Gefragt waren letztlich
keine Charakterbilder, sondern erotisch aufgeladene Pathosformeln.
Insgesamt ging es darum, den Porträtierten mittels Licht und Pose so
viel Sex-Appeal zu verschaffen, wie die Fans (»Fanatics«) und ihre
Fan-Magazine (»Fanzines«) verlangten und andererseits die Gesell-
schaft bereit war zu tolerieren. »Das Wort Glamour«, hat der be-
kannte Hollywood-Fotograf George Hurrell einmal erklärt, »war für
mich immer nur ein Vorwand, um nicht von Sex reden zu müssen.«
Auch im Europa der Zwischenkriegszeit entdeckten immer mehr
kommerzielle Fotostudios (wie Manassé in Wien, Wilding in London
und Yva in Berlin) im Glamour-Bild eine willkommene Möglichkeit,
eine gemäßigte und gesellschaftlich akzeptierte Form der Erotik an
den Mann zu bringen, wobei vor allem die sich stürmisch entwickeln-
de Illustriertenpresse die Bildvermittlung übernahm. Bekannte
Namen aus Film, Theater, Varièté sorgten für die bis heute attraktive
Verbindung von »Prominenz« und »Nacktheit«. Während allerdings
die Großen aus Kino und Theater selten mehr als ein Stück Dekolleté
zu zeigen bereit waren, gingen Tänzerinnen oder Revue-Girls – wie
Josephine Baker, Anita Berber und Irene Schuchowa – ein ganzes
Stück weiter und posierten für Aufnahmen, die wohl als naive Vor-
läufer unserer heutigen Pin-ups gelten dürfen.

Au début des années 20, pratiquement tous les studios hollywoodiens possédaient leur propre service photographique afin de répondre au besoin croissant en matériel publicitaire. C'est ainsi qu'apparurent deux genres d'images spécifiques qui devinrent, à partir de la fin des années 20, des classiques du document promotionnel cinématographique: la photo de plateau et le portrait glamour. Contrairement à ce qu'on pense souvent, photos et portraits n'étaient pas pris au moment du tournage, mais étaient mis en scène dans des studios où, au moins au début, beaucoup de photographes étaient encore attachés à une esthétique pictorialiste. Les lampes au tungstène et les écrans diffusants étaient des accessoires techniques courants. Les appareils photos étaient habituellement de grand format (jusqu'à 8 × 10") et la retouche du négatif était abondamment pratiquée. Il ne s'agissait pas simplement de réaliser des photos représentant des personnages, mais des images chargées d'érotisme. Grâce à la lumière et la pose, il fallait donner aux portraits des actrices autant de sex-appeal qu'en exigeaient les fans («fanatics») et les magazines des fans («fanzines»), sans toutefois dépasser le seuil que pouvait tolérer la société. Le célèbre photographe hollywoodien George Hurrell expliquait un jour qu'il a «toujours considéré le terme ‹glamour› comme un prétexte pour ne pas parler de sexe». Dans Europe de l'entre-deux-guerres, de nombreux studios commerciaux (comme Manassé à Vienne, Wilding à Londres et Yva à Berlin) découvrent, eux aussi, dans la photo glamour un moyen avantageux d'offrir à leur clientèle masculine des images d'une certain érotisme, et néanmoins acceptables pour la société. La presse illustrée, alors en plein essor, assure la diffusion de ses clichés. Ce sont les gloires du cinéma, du théâtre et des variétés qui se chargeront d'associer célébrité et nudité. Si les stars du cinéma et du théâtre acceptaient rarement d'afficher plus qu'un décolleté, les meneuses et danseuses de revues – comme Joséphine Baker, Anita Berber et Irene Schuchowa – allaient beaucoup plus loin et posaient pour des photos qui préfigurent candidement les photos de pin up d'aujourd'hui.

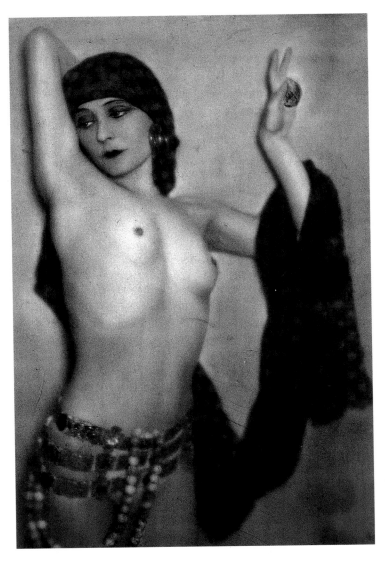

Angelo
c. 1935

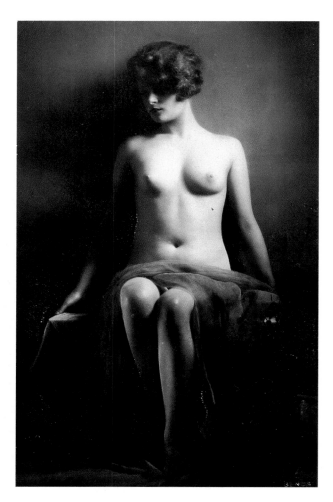

Anonymous
Miss Rivelli
C. 1930

Royé
C. 1940

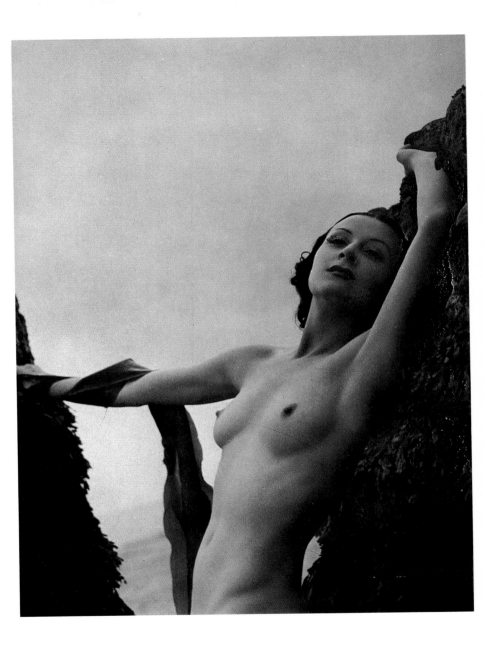

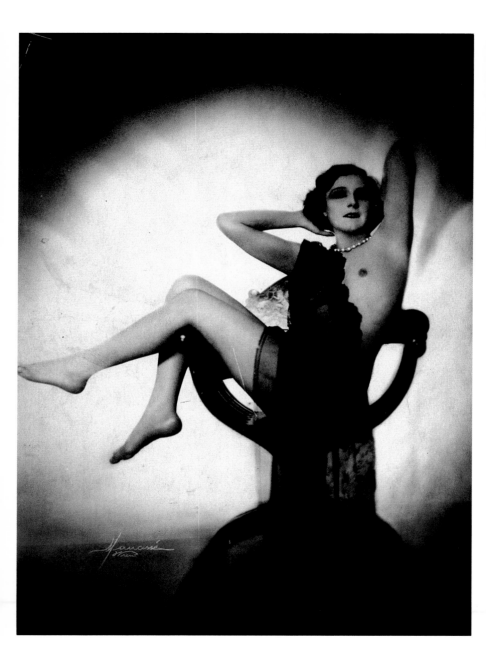

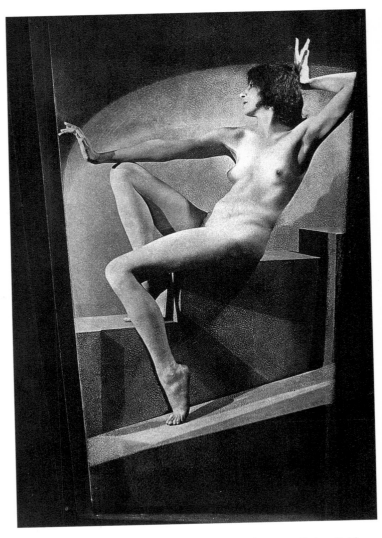

**Bertram Park/
Yvonne Gregory**
1936

Manassé
c. 1930

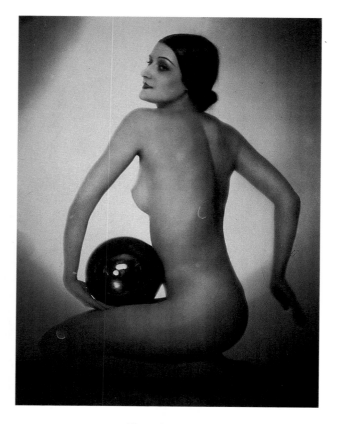

Manassé
Irene Schuchowa
c. 1930

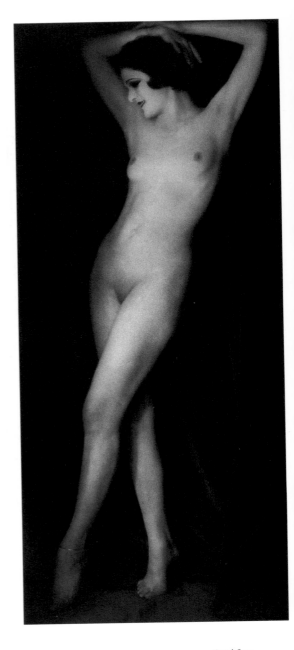

d'Ora
Anita Berber
1922

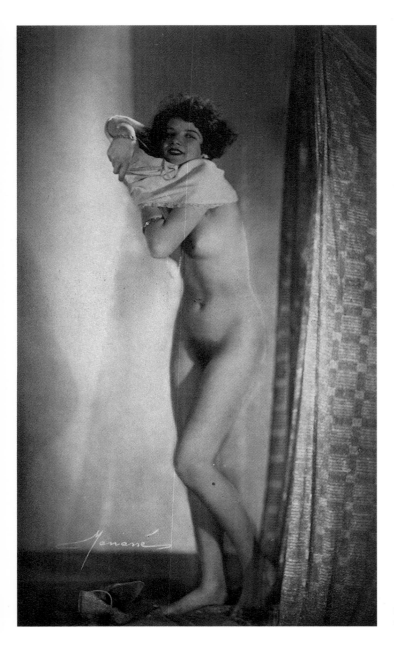

Manassé
C. 1930

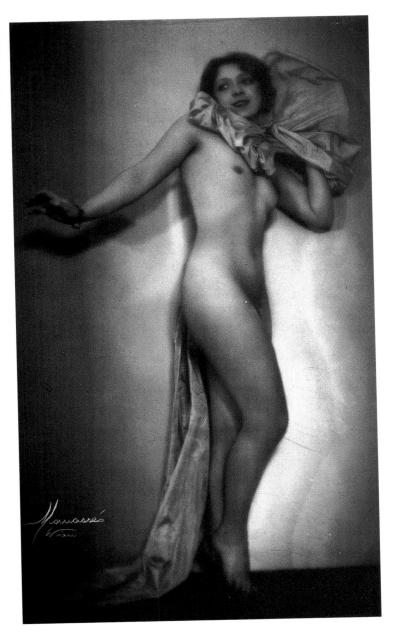

Manassé
c. 1930

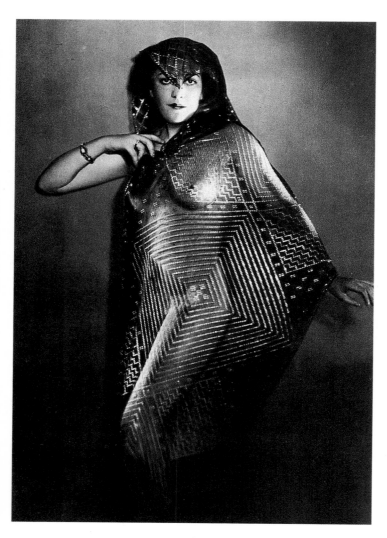

Manassé
c. 1930

Manassé
c. 1930

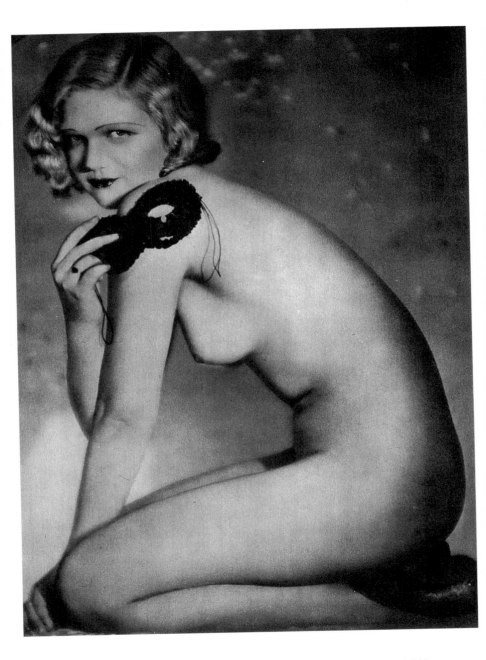

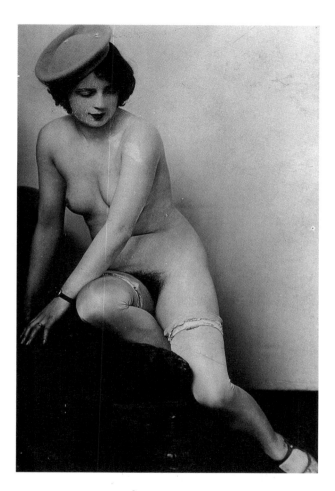

Anonymous
C. 1925

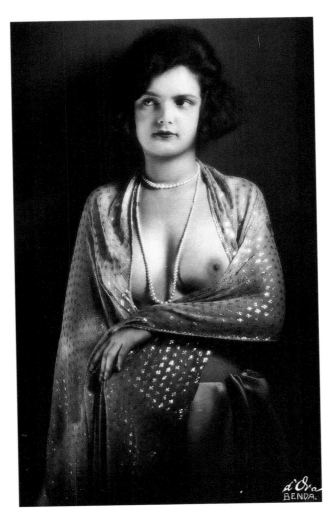

d'Ora/Benda
Miss Eskenasy
c. 1930

▶
Manassé
c. 1930

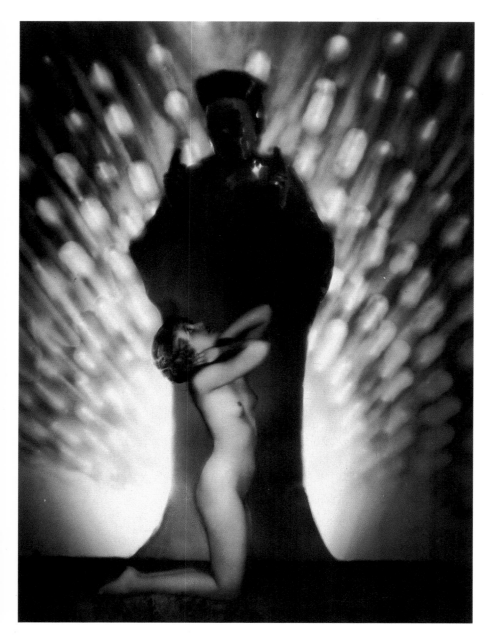

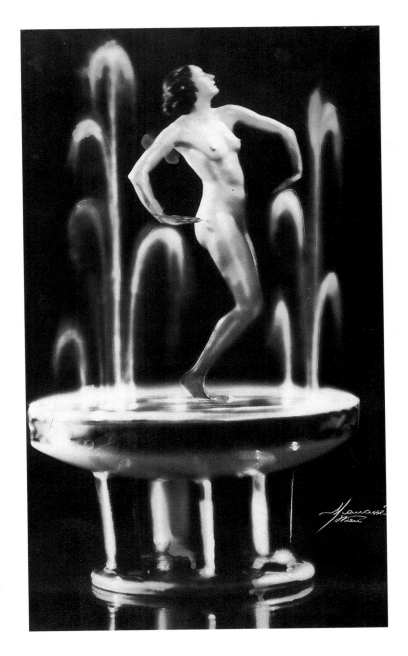

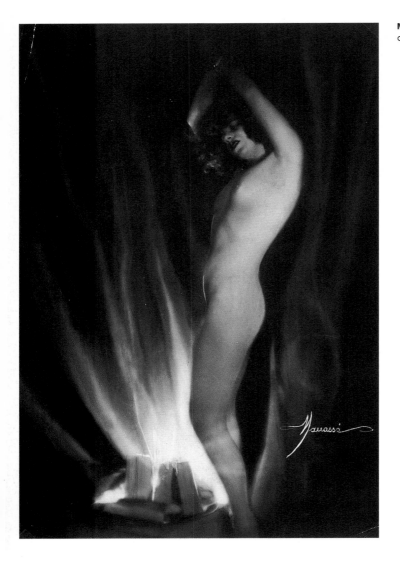

◀
Manassé
Theresa Paoly
C. 1930

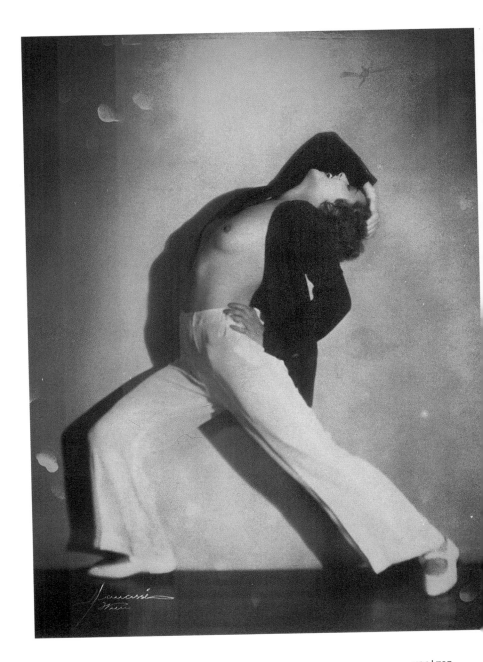

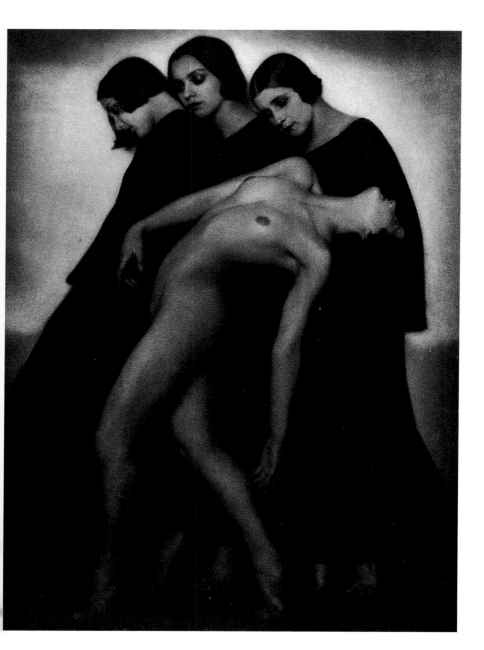

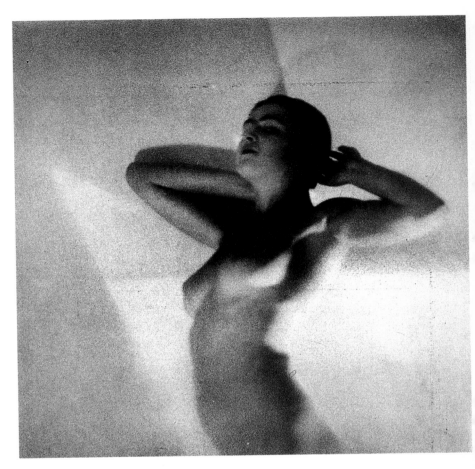

Othmar Streichert
C. 1935

Rudolf Koppitz
Study of Motion
1927

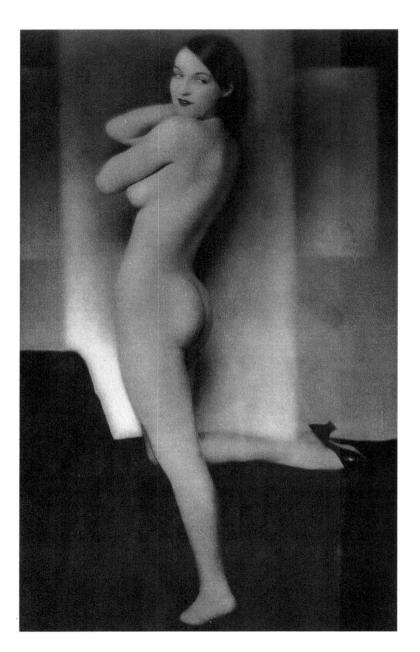

Angelo
C. 1935

Manassé
C. 1925

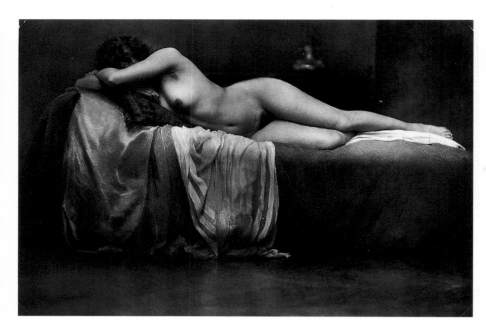

Anonymous
C. 1925

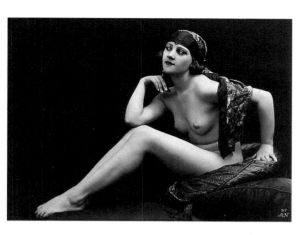

Anonymous
c. 1925

Anonymous
c. 1935

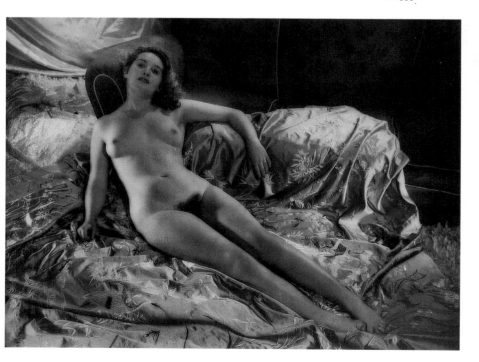

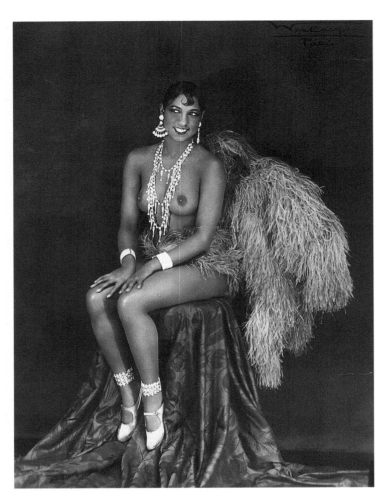

Waléry
Josephine Baker
C. 1925

Waléry
Josephine Baker
C. 1925

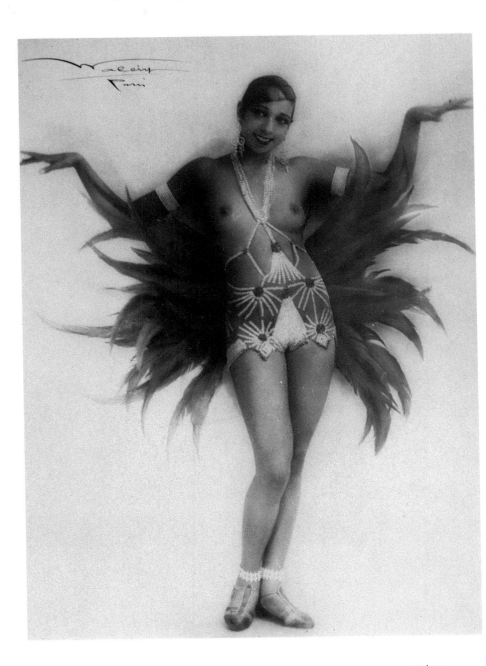

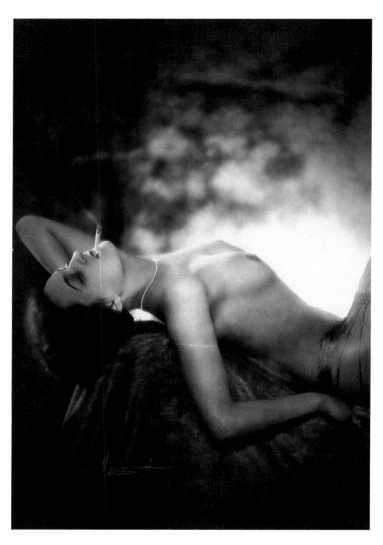

Manassé
C. 1935

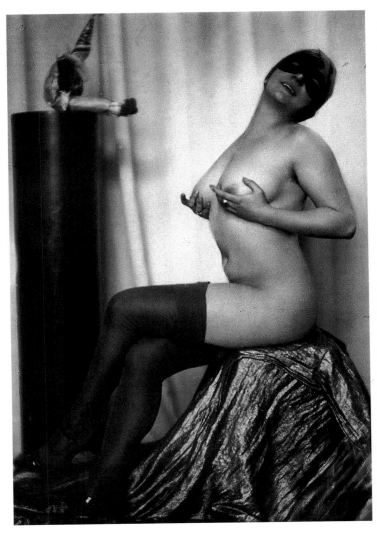

Residenz-Atelier
C. 1935

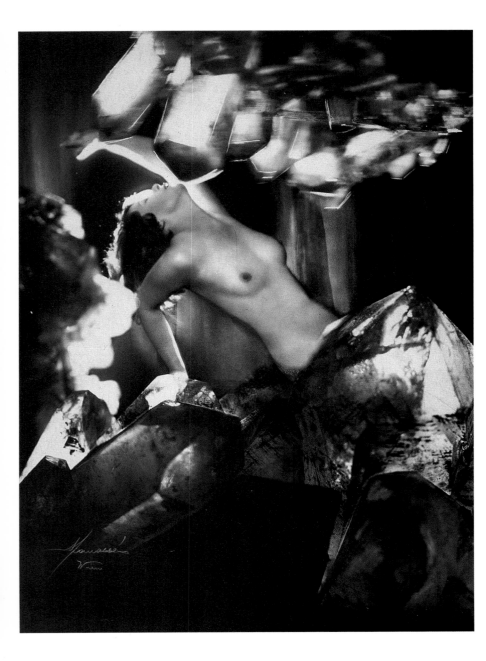

Manassé
c. 1930

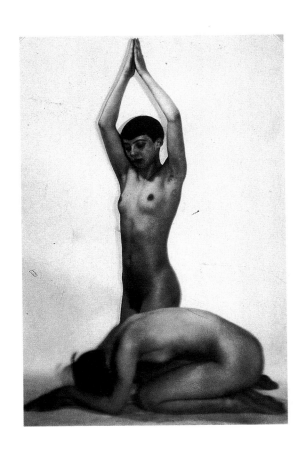

Rolf Herrlich
c. 1930

Laryew
c. 1930

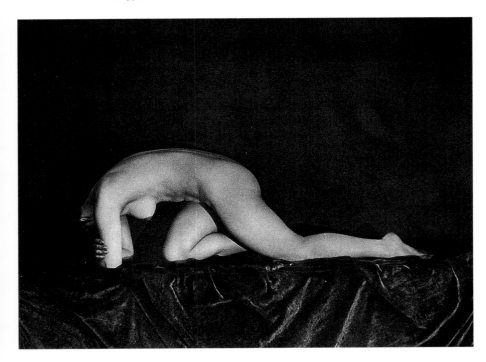

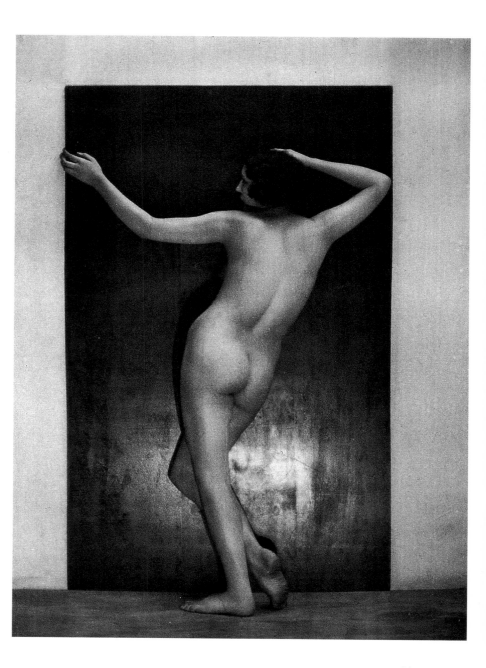

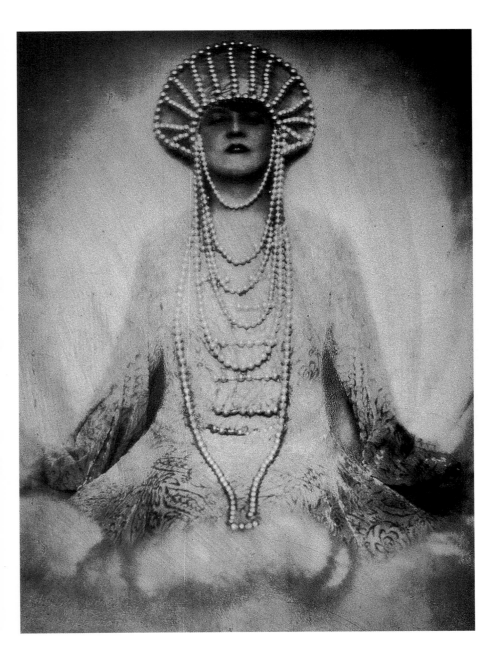

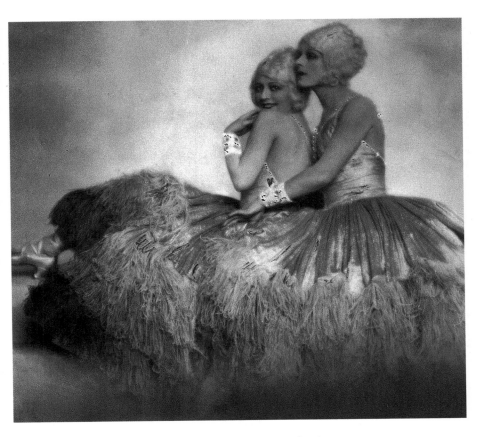

Angelo
c. 1935

Edith Barakowich
Funny Kosary
c. 1930

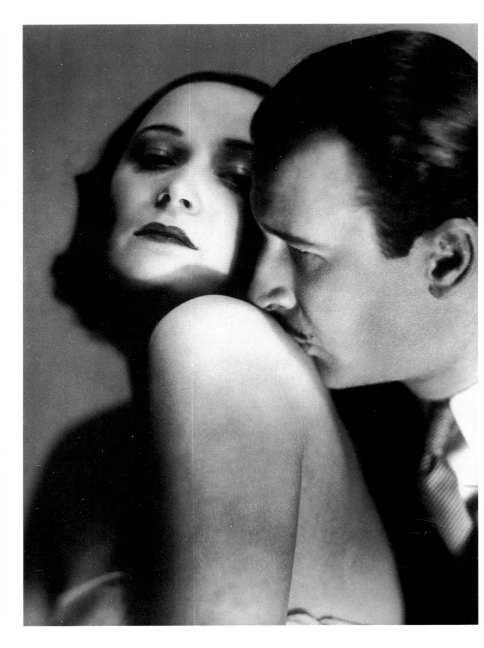

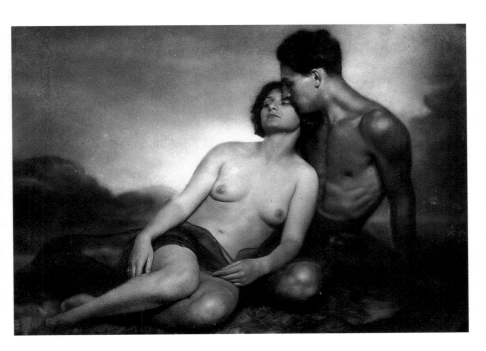

Erich Fuchs
C. 1930

Yva
C. 1940

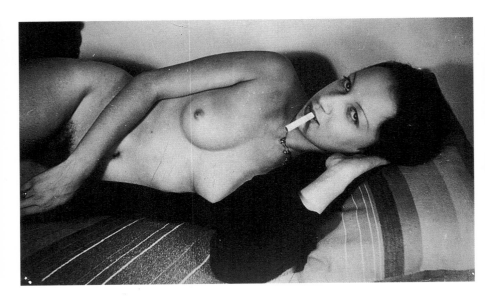

Franz Roh
C. 1925

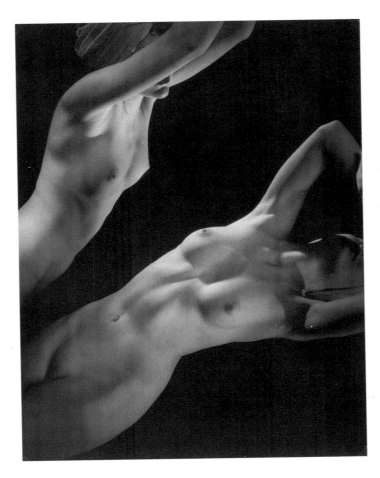

Paco
C. 1935

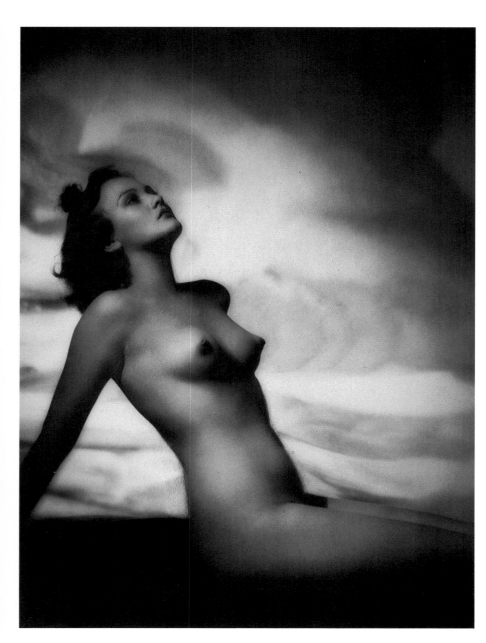

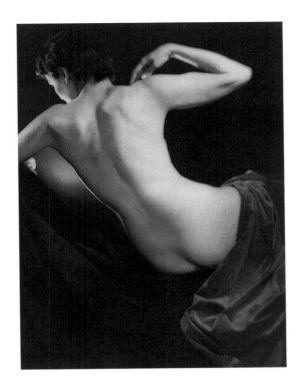

Paco
C. 1935

WOG (Olga and Adorian Wlassies)
C. 1940

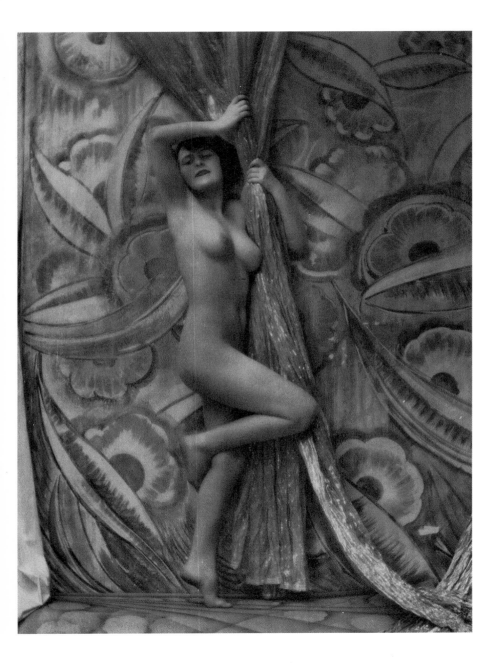

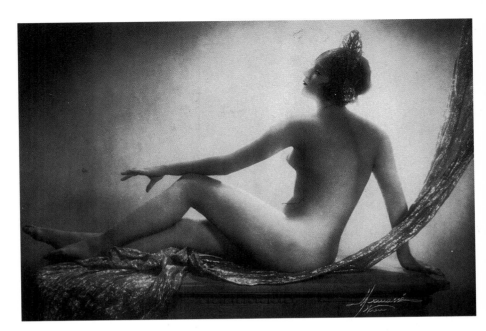

Manassé
Yvonne Molein
C. 1930

Laryew
C. 1930

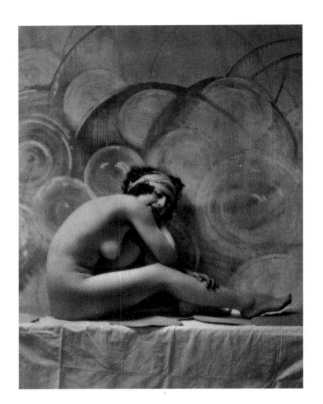

Laryew
C. 1930

Laryew
C. 1930

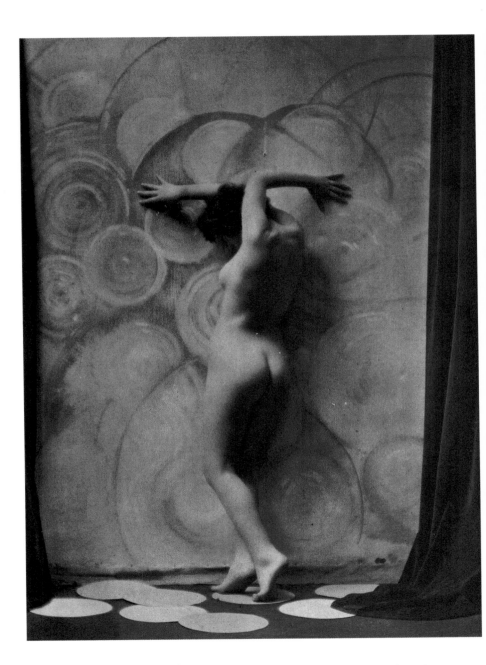

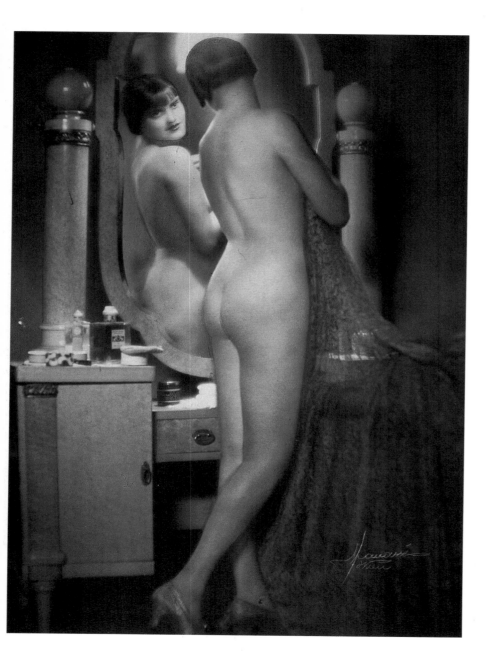

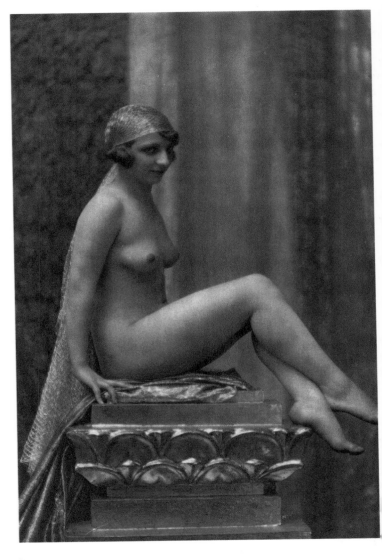

Laryew
C. 1930

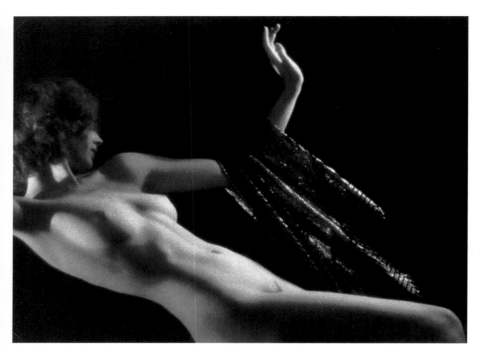

Paco
C. 1935

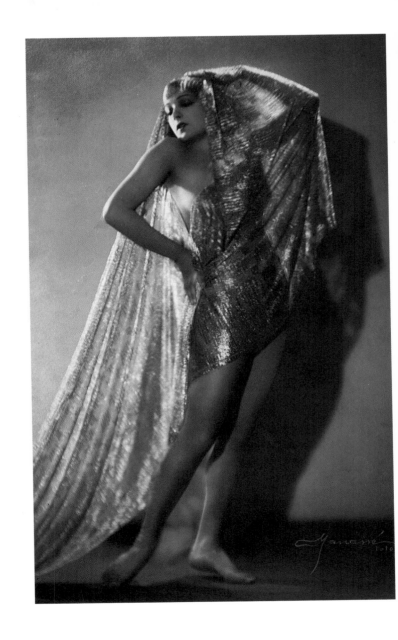

Manassé
Lily Damita
c. 1929

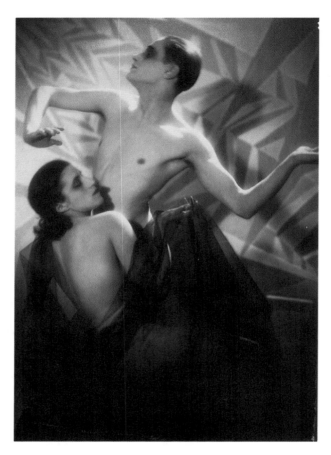

Manassé
The Dancers
C. 1930

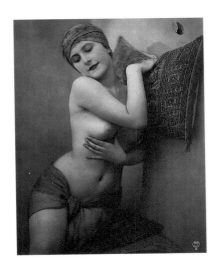

Anonymous
c. 1925

d'Ora/Benda
Kaja Marquita
c. 1930

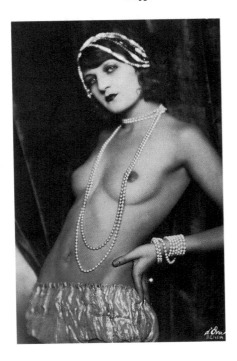

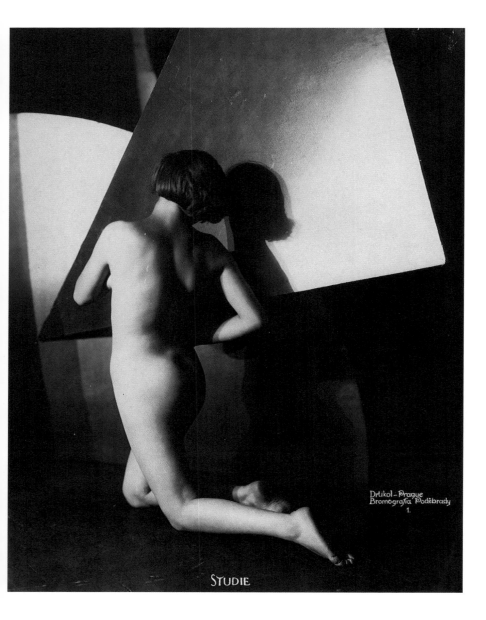

Drtikol - Prague
Bromografia Poděbrady
1.

STUDIE

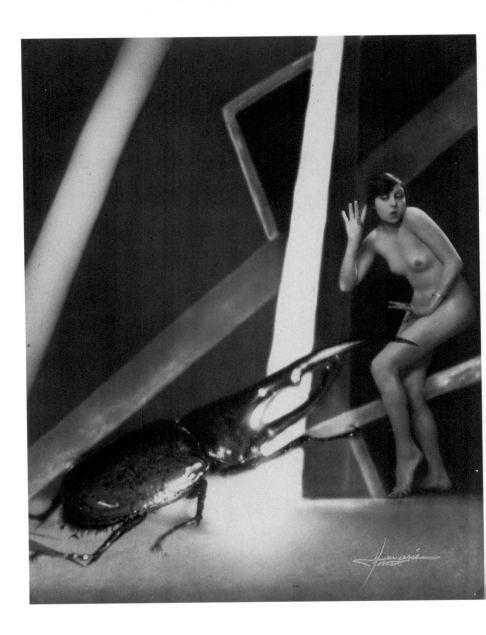

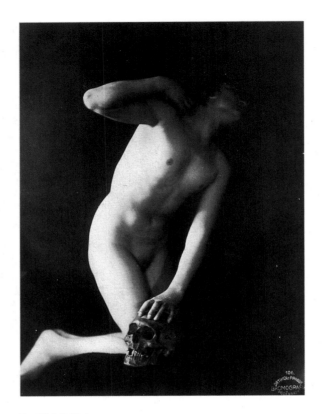

František Drtikol
C. 1925

◀
Manassé
C. 1930

František Drtikol
The Thinker
C. 1930

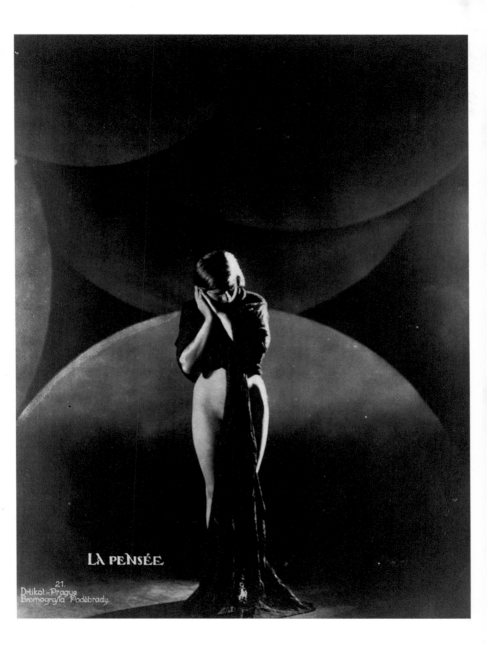

LA PENSÉE

21.
Drtikol–Prague
Bromografia Poděbrady.

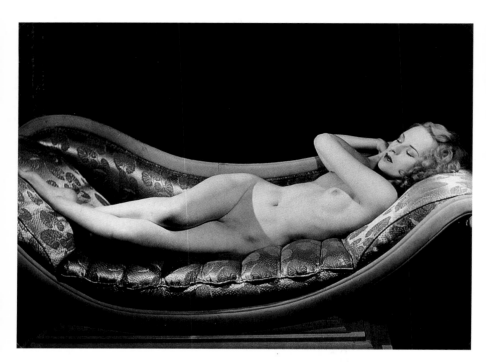

Stephen Glass
C. 1955

Paco
C. 1935

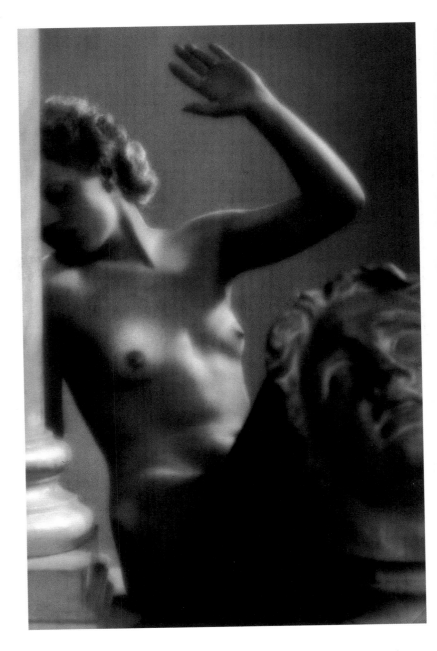

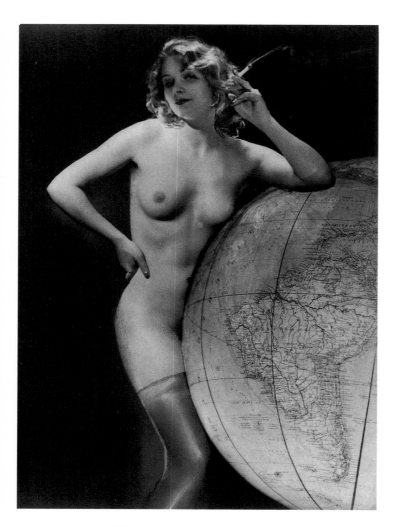

Manassé
C. 1935

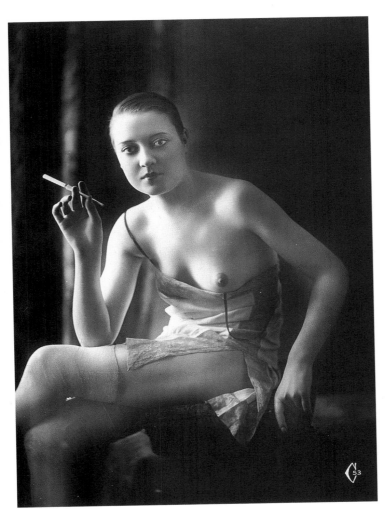

Anonymous
C. 1920

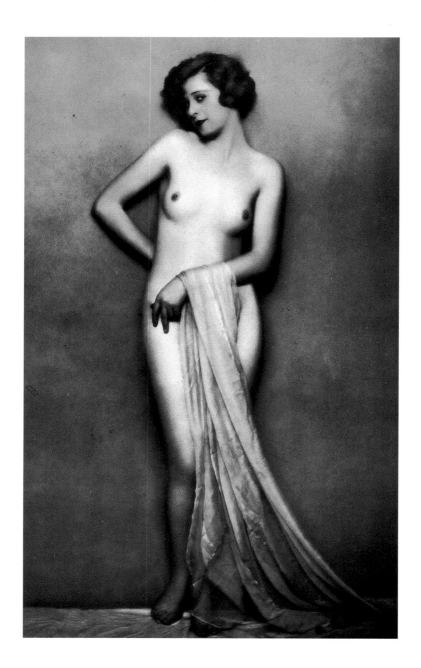

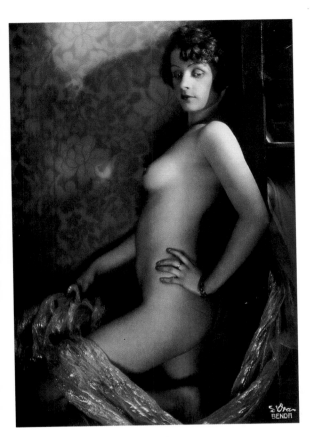

d'Ora/Benda
C. 1930

d'Ora/Benda
Miss Hübel
C. 1930

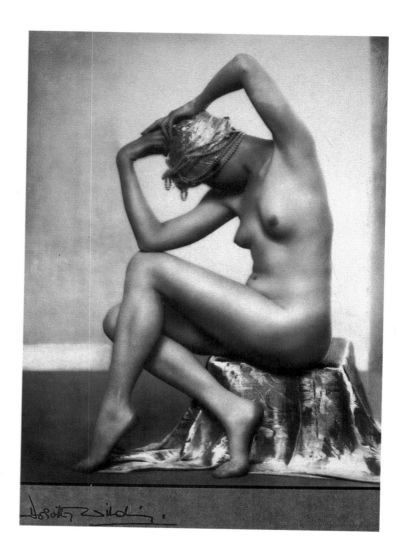

Dorothy Wilding
Silver Turban
c. 1928

d'Ora
Barbette
c. 1935

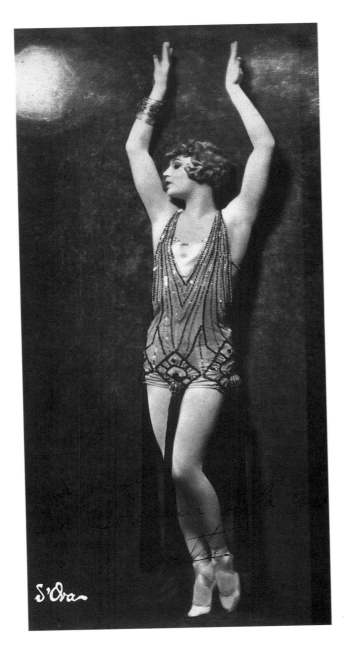

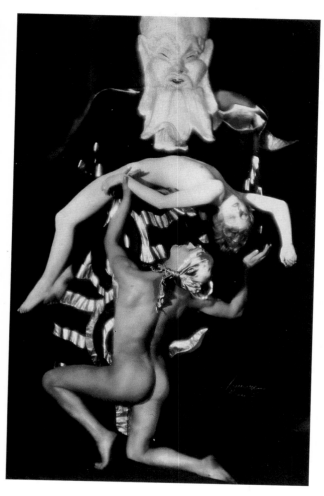

Manassé
Dance of Demons
C. 1930

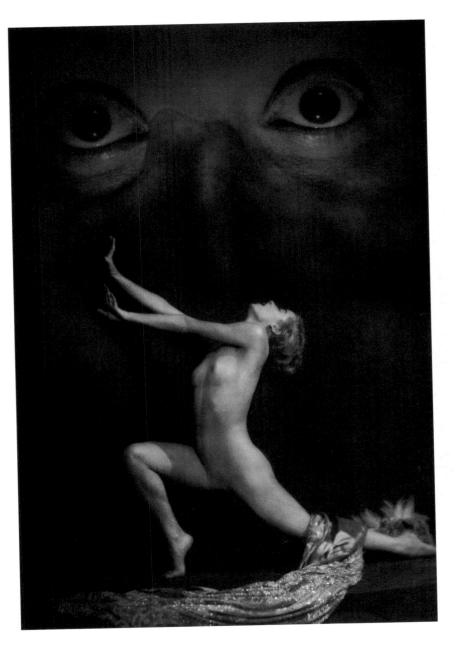

Biography

Uwe Scheid (born 1944) collects artistic and erotic photographs of nudes, dating mainly the early period and from the twenties and thirties. He started collecting objects related to the history of photography and photographic equipment more than two decades ago. Today, the Uwe Scheid Collection is one of the most important collections of erotic and nude photography.

Uwe Scheid is a member of the German Photographic Society, the European Society for the History of Photography, the Club Daguerre and the Daguerreian Society. More than 20 books based on the Uwe Scheid Collection have been published – including "Wheels and Curves", "Naughty Paris" and "Feu d'Amour" (Benedikt Taschen). The exhibitions "Die Erotische Daguerreotypie" (The Erotic Daguerreotype), "Nackt unter Nackten" (Naked Among the Naked), "BilderLust" (A Lust for Images), "Apropos Po" (The Bottom Line) and "Frivol" (Risqué), which dealt with various aspects of the nude photograph, were also based on his collection.

Uwe Scheid (geb. 1944) sammelt künstlerische und erotische Akt-
fotografien mit dem Schwerpunkt Frühzeit sowie zwanziger und
dreißiger Jahre. Er begann vor mehr als zwei Jahrzehnten mit dem
Sammeln von Objekten zur Fotografiegeschichte und -technik. Die
Uwe Scheid Collection zählt heute zu den bedeutendsten Samm-
lungen zum Thema Akt und Erotik.
Uwe Scheid ist Mitglied der Deutschen Gesellschaft für Photogra-
phie, der Europäischen Gesellschaft für die Geschichte der Photo-
graphie, des Club Daguerre sowie der Daguerreian Society. Zur
Sammlung Uwe Scheid erschienen mehr als 20 Publikationen – dar-
unter »Spritztour«, »Pariser Pikanterien«, »Feu d'Amour« (alle im
Benedikt Taschen Verlag). Ausstellungen zum Thema Akt: »Die
Erotische Daguerreotypie«, »Nackt unter Nackten«, »BilderLust«,
»Apropos Po«, »Frivol«.

Uwe Scheid (nè en 1944) collectionne des photos artistiques et éro-
tiques en mettant l'accent sur les plus anciennes et celles des années
20 et 30. Il a commencé il y a plus de vingt ans à rassembler des ob-
jets concernant l'histoire et la technique de la photographie. La
collection d'Uwe Scheid est actuellement l'une des plus célèbres au
monde dans le domaine du nu et de l'érotisme.
Uwe Scheid est membre de la Société allemande de Photographie,
de la Société européenne pour l'histoire de la Photographie, du Club
Daguerre ainsi que de la Daguerreian Society. Plus de vingt ouvrages
sont parus sur le thème de sa collection – entre autres «Partie de
campagne», «Les petites femmes de Paris» et «Feu d'amour» aux
Editions Benedikt Taschen. Les expositions suivantes rendent hom-
mage à la photo de nu: «Die Erotische Daguerreotypie» (La daguer-
réotypie érotique), «Nackt unter Nackten» (Nu entre les nus),
«BilderLust» (Désir d'images), «Apropos Po» (A propos fesses),
«Frivol».

Index

Kertész, André, real name Andor Kertész (1894, Budapest – 1985, New York) *656, 657*
Kesting, Edmund (1892, Dresden – 1970, Berlin) *643*
Keystone, Studio (France, active around 1920) *674*
Koppitz, Rudolf (1884, Silesia – 1936, Vienna) *497, 673, 706*
Krull, Germaine (1897, Poznań – 1985, Wetzlar) *671*

Laryew (France, c. 1925) *504, 505, 718, 719, 728, 730, 731, 733*
Lehnert & Landrock, Studio, run by Rudolf Lehnert (1878, Velká Upá, Bohemia – 1948, Rédeyef, Tunisia) and Ernst Landrock (1880, Saxony – 1957, Cairo) *473, 476, 477*
List, Herbert (1903, Hamburg – 1975, Munich) *637*
Ludwig, Karel E. (1919, Prague – 1977, Prague) *660, 663*

Manassé, Studio, run by Olga Spolarics (1896, Hungary – 1969, Vienna) and Adorian von Wlassics (1883, Hungary – 1946, Vienna) *509, 692, 694, 696, 697, 698, 699, 702, 703, 704, 705, 708, 714, 716, 729, 732, 735, 736, 739, 744, 750*
Mandel, Julien (France, active around 1920) *206, 514*
Marconi, Guglielmo (active 1864 – 1974) *131, 137, 150, 163, 164, 165, 166*
Moholy-Nagy, László (1895, Bácsborsod, Hungary – 1946, Chicago) *642, 655*
Muybridge, Eadweard (1830, Kingston-on-Thames, England – 1904, Kingston) *140, 141, 142, 143*

d'Olivier, Louis Camille (1827, Paris – c. 1870, Paris) *116*
d'Ora Benda, Studio, run by Madame d'Ora (Dora Kallmus) (1881, Vienna – 1963, Paris) and Arthur Benda (1885, Berlin – 1969, Vienna) *500, 695, 701, 737, 746, 747, 749*

Paco (Hungary, active around 1930) *638, 652, 658, 725, 727, 734, 743*
Park, Bertram and Yvonne Gregory (Great Britain, active around 1900) *662, 693*
Perckhammer, Heinz von (Austria/Germany, active around 1930) *519, 522, 571*
Plüschow, Guglielmo (Wilhelm) (Italy, active around 1930) *535, 537, 539, 545, 551, 554, 555*

Ray, Man, real name Emmanuel Rudnitshky (1890, Philadelphia – 1976, Paris) *668, 669, 670, 677, 682*
Reichert, Kurt (1920, Halle/Saale) *597*
Residenz-Atelier (Austria, active around 1920) *715*
Reutlinger, Léopold (Emile) (1863, Callao/Peru – 1937, Paris) *121, 128, 129*
Riebicke, Gerhard (1878, Sonnewalde/Lusatia – 1957, Berlin) *563, 564, 565, 566, 567, 568, 569, 570, 572, 574, 576, 577, 578, 579, 589, 591, 598, 599*
Roh, Franz (1890, Apolda. Thuringia – 1965, Munich) *653, 654, 724*
Royé (1906, Great Britain) *691*

Schieberth, Hermann (Austria, active 1910–1937) *503*
Steichen, Edward (Jean), real name Eduard Jean Steichen (1879, Luxembourg – 1973, West Redding/Connecticut) *639*